Outstanding
American
Gardens

Published in 2015 by Stewart, Tabori & Chang
An imprint of ABRAMS

Library of Congress Control Number: 2014959140
ISBN: 978-1-61769-165-2

Editor: Leslie Stoker
Designer: William van Roden
Production Manager: Denise LaCongo

The text of this book was composed in Throhand and Balance.

Printed and bound in China

10 9 8 7 6 5 4 3

ABRAMS
THE ART OF BOOKS SINCE 1949
115 West 18th Street
New York, NY 10011
www.abramsbooks.com

Funding provided in part by our foundation partners:
Stockman Family Foundation

Furthermore:
a program of the J. M. Kaplan Fund

Outstanding American Gardens

A CELEBRATION

25 YEARS OF THE GARDEN CONSERVANCY

Edited by Page Dickey
Photographs by Marion Brenner

Stewart, Tabori & Chang
New York

To Anne Cabot

Contents

Foreword

People garden to make a difference in their own and other people's lives. Gardening, which often begins as a pastime, can become an obsession. And like all forms of art, gardening can transform the mundane and ordinary into something transcendent and inspiring, something that refreshes the dry places in our spirit. Some people can even elevate gardening to their principal raison d'être.

Frank Cabot was passionate about many things in his life, from oysters to close-harmony singing to alpine rock plants. Luckily for him, he was able to share his enthusiasms with his friends, and ultimately with gardeners everywhere, thanks to the organization he and my mother dreamt up: the Garden Conservancy. He loved traveling the world looking for rare and interesting plants, and at the same time sought out gardens made by people who understood and loved the plants they used, and who also had the gifts and skills to integrate the disciplines necessary to make their gardens into works of art.

The Garden Conservancy was the expression of the side of my father that loved the community of souls united by the gift of being able to know, grow, and use plants to create a sum greater than the parts they started with. This value-added aspect of gardening that transforms mere musings into inspired flights of fantasy has inspired a lot of very generous people over the last twenty-five years to open their gardens to visitors, to share their expertise, and to contribute lavishly in support of what my father considered a neglected art form, especially in the United States. The visionary expressions of true garden artists are realized in ephemeral moments that often escape even their creators' notice. Too many variables are at play to actually enable the scheduling of the "performance" of a garden. A visionary gardener must collaborate with sun and wind and water and soil and all the permutations of seasonal variability before announcing to the awaiting audience that the moment of performance has arrived.

I remember very clearly a moment when my father came rushing into the house as the family was gathering for the evening meal and exhorted us to visit the perennial allée at the Quatre Vents garden because "It will never be better."

In truth, the play of light and the warmth of an evening in late July made sublime the extraordinary layering of delphinium, thalictrum, filipendula, iris, ligularia, cimicifuga, and digitalis (among many other exuberant plants) that filled the beds. We returned to the house refreshed, exhilarated, and totally unaware of the extraordinary amount of work and thought that had gone into the creation of that perfect moment in the garden. Nevertheless, the moment was unforgettable and would have gone unnoticed without my father's exhortation to seize the moment. Blessings on him for that.

The Garden Conservancy was created to preserve and share such moments with an ever-growing public. This book is an eloquent vindication of its ambitious goals. May gardeners revel in it, and may those of us yet to become gardeners find inspiration in its pages and learn to appreciate more fully what Francis Bacon called "the purest of pleasures." **—Colin Cabot**

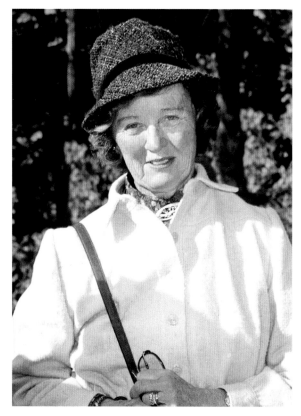

LEFT Frank Cabot's wife, Anne, made a light-hearted suggestion that encouraged him to found the Garden Conservancy in 1989, an organization that would become a champion for outstanding gardens across America.

BELOW Frank and Anne show their obvious delight at standing in a field of Texas bluebonnets during an early Society of Fellows tour.

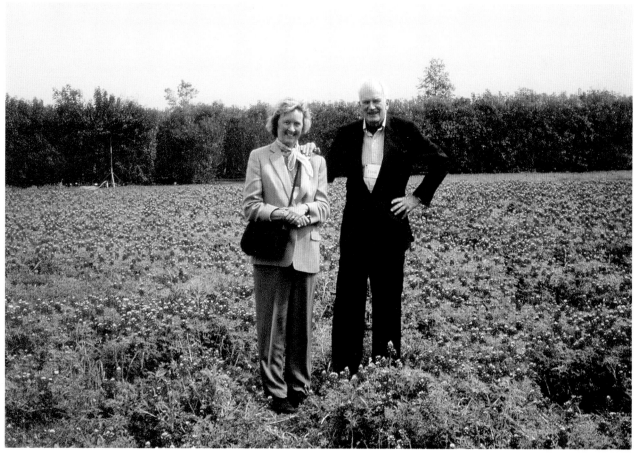

Introduction

Frank Cabot, the founder of the Garden Conservancy, liked to describe himself as a "horticultural enthusiast" whose interests were both passionate and varied. He was an active member of a number of horticultural organizations. He also designed and created two extraordinary gardens of his own: Stonecrop, in Cold Spring, New York; and Les Quatre Vents, in La Malbaie, Quebec. By 1988, when Frank and his wife, Anne, took a trip to California, the idea of forming a national organization to preserve exceptional American gardens had been on his mind for a long time. At the suggestion of English garden writer Penelope Hobhouse, he and Anne visited Ruth Bancroft's succulents garden near San Francisco. Here is how Frank tells the story: "It was a garden filled with cactus, which is not my thing at all. [But] we were so overwhelmed by the experience that, much to my great surprise, I remember actually shivering at the beauty of it."

During their visit, Ruth expressed her fear that her garden would disappear after she was no longer able to take care of it. "As we drove away, I said to my wife, 'We have to find some way to help this woman.' And she said, rather facetiously, 'Why don't you start a garden conservancy?' And, of course, that rang all sorts of bells."

The Garden Conservancy began the following year in a small office in Cold Spring, and Frank Cabot's vision for a national organization to preserve exceptional American gardens for the public was realized. Along with Antonia Adezio, the new Garden Conservancy's Executive Director, Frank sought the advice of his many friends in the gardening world to form an Advisory Committee of other leading "horticultural enthusiasts" and professionals, as well as a Screening Committee led by Marco Polo Stufano, the creator of the Wave Hill public gardens in New York City. These committees would help identify outstanding private gardens that might be preserved.

As Frank described the origins of the Garden Conservancy: "The original conception was to try to save the private works of art created by people like Ruth Bancroft. We would not only be an advocate for the preservation of that kind of garden but a catalyst that would actually make it happen. We would set up an organization that would facilitate the transition from private to public ownership for posterity."

By 1992, members of the Advisory Committee had evolved into a Board of Directors responsible for the Garden Conservancy's finances and policy. The president, Tom Armstrong, also created the Society of Fellows, a program for donors, which continued the advisors' popular garden-study tours. That same year, Ruth Bancroft's garden became the Garden Conservancy's first preservation project.

The Garden Conservancy is best known to the public as the sponsor of Open Days, the unique, nationwide, garden-visiting program. It began in 1995 when two professional Westchester County gardeners, Page Dickey and Penelope "Pepe" Maynard, persuaded 110 fellow gardeners to open their private gardens to the public for a day. The popular response was so enthusiastic that, just two years later, Open Days became a national program. Thanks to the support of hundreds of dedicated gardeners and volunteers across the county, private gardens in at least twenty states now welcome 75,000 visitors every year. Today, Open Days remains America's only nationwide garden-visiting program.

Outstanding American Gardens is a celebration of the Garden Conservancy's achievements in the twenty-five years since it was founded to preserve and share exceptional American gardens for the enjoyment and education of the public. Its staff works with garden owners, professional organizations, and local volunteers to identify and preserve America's rich cultural heritage as it is expressed in these remarkable and fragile places. Its Preservation Gardens have aesthetic, horticultural, historic, and cultural significance, as well as the important benefit of offering information and pleasure to their many visitors. The Garden Conservancy provides technical and managerial assistance to dozens of private gardens every year, and it maintains long-term stewardship of a select number of important American gardens.

A ten-year grant by a Conservancy board member enabled the Conservancy to offer the Marco Polo Stufano Garden Conservancy Fellowship to a gardener or horticulturist wanting to learn more about the preservation of America's gardens. Garden Conservancy fellows were placed at ten preservation projects, many staying on at their gardens as full-time employees, all of them continuing to make a contribution to horticulture in America.

In the twenty-five years since Ruth Bancroft inspired Frank Cabot, the Garden Conservancy has helped to preserve some one hundred private American gardens. Five are National Historic Landmarks, and seventeen are listed on the National Register of Historic Places. As the only national organization dedicated to garden preservation in the United States, the Garden Conservancy has received numerous awards, including the 2012 Historical Preservation Medal from the Garden Club of America "in recognition of outstanding work in the field of preservation and/or restoration of historic gardens."

In the future, as in the past, the Garden Conservancy's mission will continue to be based on the belief, as Tom Armstrong put it, that "gardeners are artists, and great gardens, like paintings and sculpture, must be preserved. Our cultural heritage must include, forever, gardens."

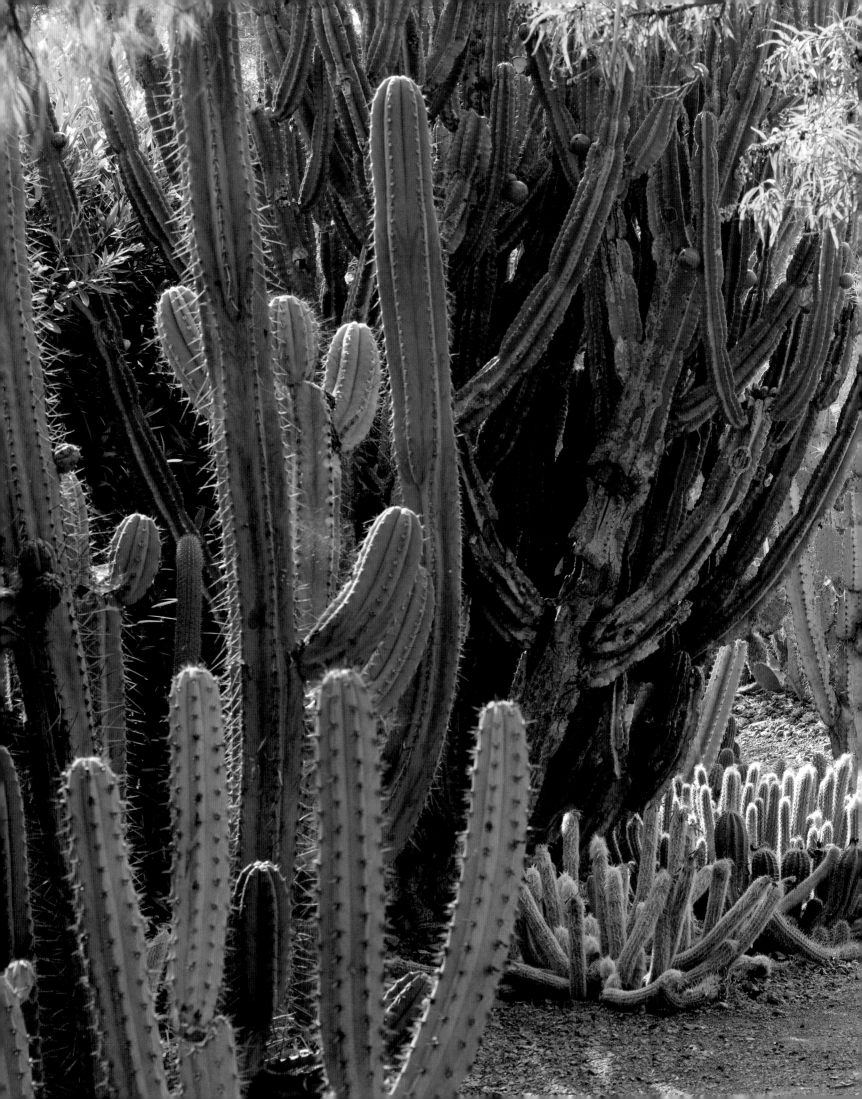

PART ONE:

PRESERVATION GARDENS

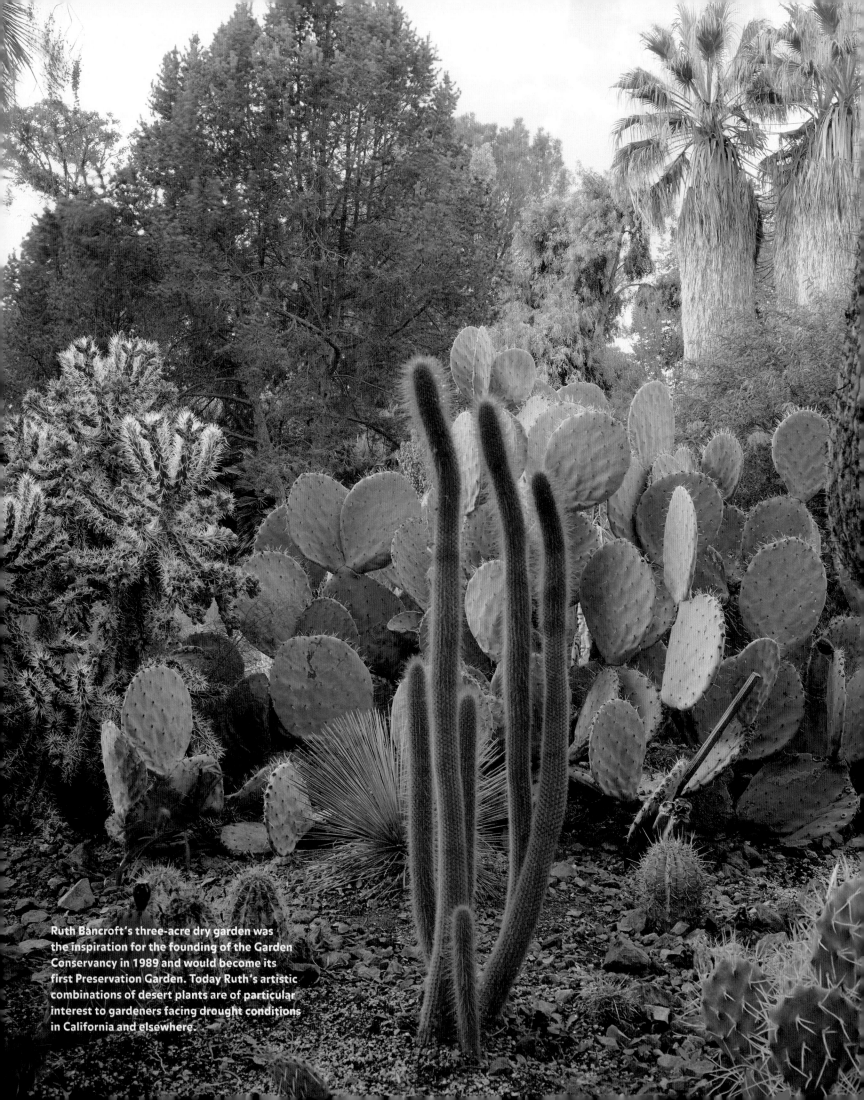

Ruth Bancroft's three-acre dry garden was the inspiration for the founding of the Garden Conservancy in 1989 and would become its first Preservation Garden. Today Ruth's artistic combinations of desert plants are of particular interest to gardeners facing drought conditions in California and elsewhere.

The Ruth Bancroft Garden

Walnut Creek, California

When he first saw her garden of succulents in 1988, Frank Cabot knew that Ruth Bancroft had created a stunning work of art. Soon thereafter, the Ruth Bancroft Garden became the first preservation project of the Garden Conservancy, and it is now recognized as one of America's finest public gardens. It is both a typically Californian dry garden, with an emphasis on water-conserving succulents and cacti, and the uniquely personal creation of a designer using plants as sculptural and architectural elements.

When Ruth Petersson enrolled in the University of California, Berkeley, in 1926, she planned to enter the new field of landscape architecture, but the Great Depression interrupted her studies. After she married Philip Bancroft Jr. in 1938, the couple moved into a cottage on his family's large property of award-winning walnut and pear orchards in the East Bay region of the San Francisco Bay Area. Long fascinated by plants and their diversity, Ruth at first planted a garden of traditional annuals and perennials that could withstand the challenging cool, dry climate and heavy clay soil of the region. A two-hundred-foot-long border of bearded iris in all its varieties, like a box of pastels, showed her budding collector's instinct. Soon she began experimenting with succulents. When the city of Walnut Creek rezoned the Bancrofts' property from agricultural to residential in the 1960s, the higher taxes forced the family to sell all but eleven of their original four hundred acres. Philip gave Ruth three and a half acres of her own to plant, and at the age of sixty-four, she began to lay out a dry garden.

With the help of nurseryman and garden designer Lester Hawkins, Ruth planted her collection of potted succulents along circuitous paths through her newly acquired acres. Later, she experimented with agaves, aloes, and yuccas, paying attention to their form and foliage as well as their brilliant red and orange flowers. The ongoing drought conditions in California make her design of desert plants of particular interest and importance to gardeners there.

The plan developed by the Garden Conservancy for the preservation of the Ruth Bancroft Garden became the model for other preservation projects to come. In 1989, the Conservancy was granted a conservation easement, the first ever used to protect a private garden, prohibiting the development of the Bancroft land for any purpose inconsistent with the preservation of the garden. A few years later, the Conservancy helped launch the Friends of the Ruth Bancroft Garden, which became the first board of directors when ownership of the garden was transferred to a nonprofit organization in 1994. Today, the Garden Conservancy continues to support the garden and helps develop its public programs.

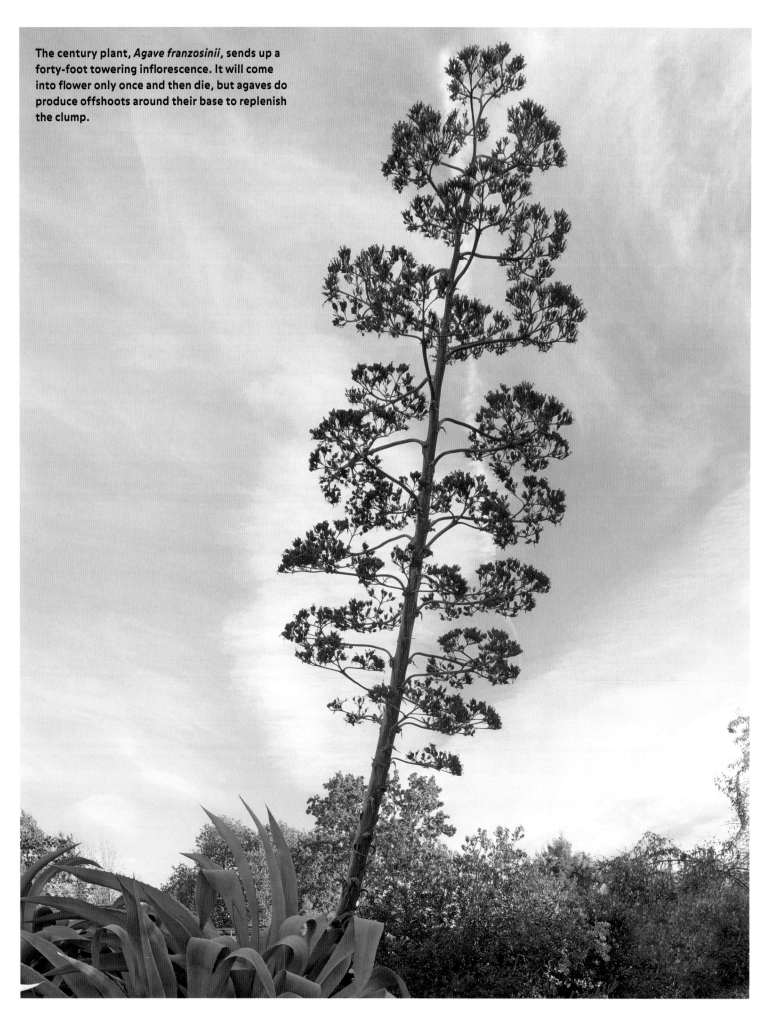

The century plant, *Agave franzosinii*, sends up a forty-foot towering inflorescence. It will come into flower only once and then die, but agaves do produce offshoots around their base to replenish the clump.

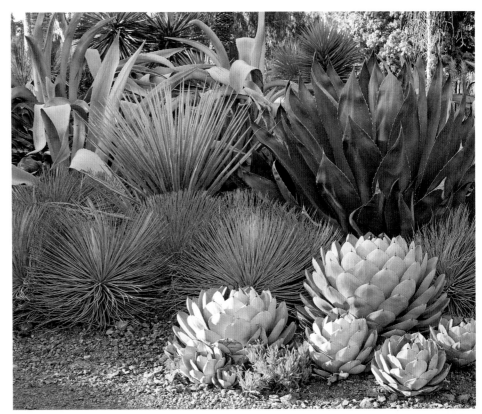

Ruth liked to experiment with succulents and other desert plants to see if they could survive in northern California's cool, dry climate. She used columnar cacti and California fan palms (*Washingtonia filifera*) to provide height, while contrasting their colors and textures with the spikes of the agaves and the low, rounded shapes of the echeverias.

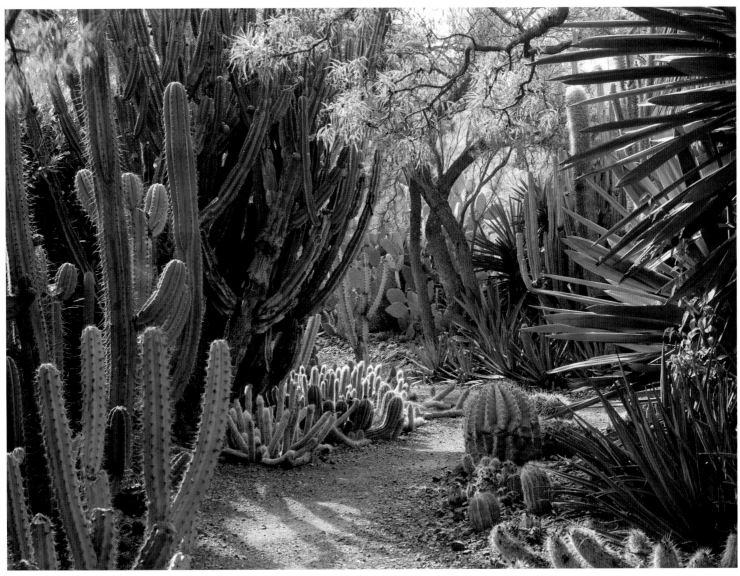

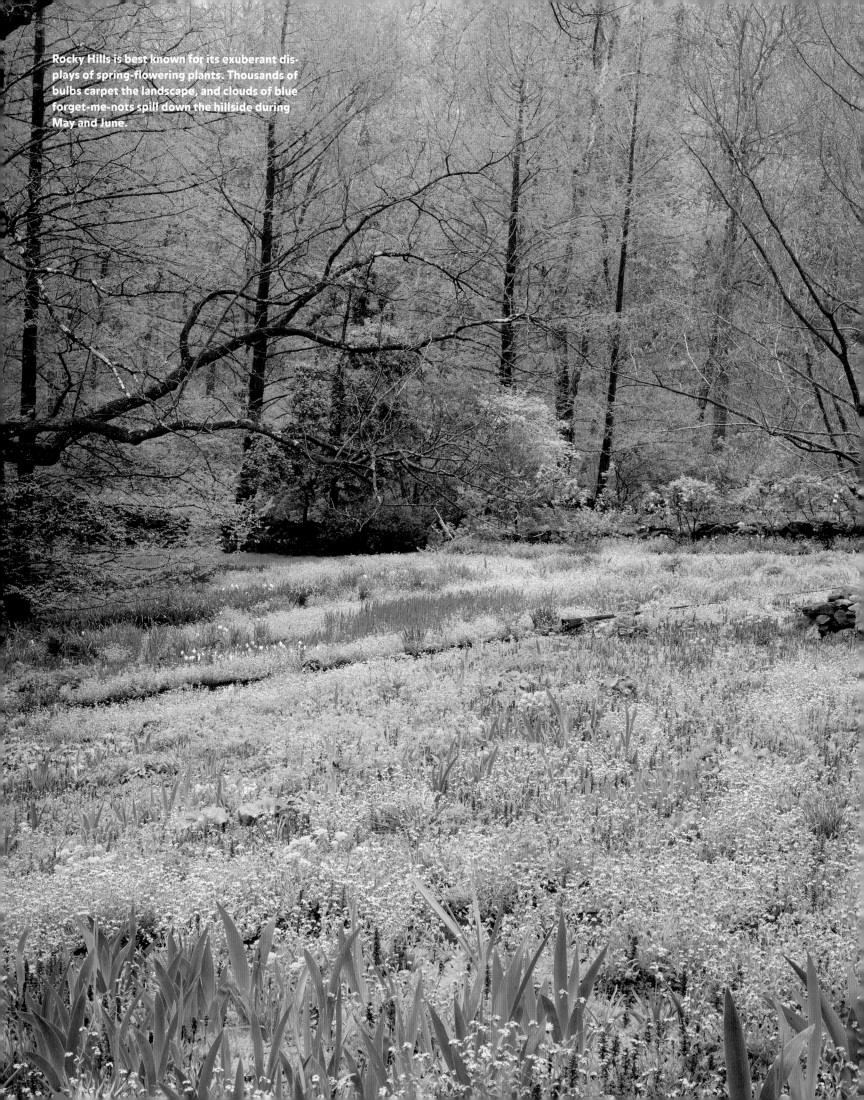

Rocky Hills is best known for its exuberant displays of spring-flowering plants. Thousands of bulbs carpet the landscape, and clouds of blue forget-me-nots spill down the hillside during May and June.

Rocky Hills

Mount Kisco, New York

In the mid-1950s William (Billy) and Henriette Suhr bought an old farm in Westchester County as a weekend retreat from their busy professional lives in New York City. The original house and the stacked stone walls dividing the fields dated back to the early 1800s. Since the steep hillside had always been unsuitable for farming, most of the thirteen acres was still being used as a cow pasture. A few walnut trees shaded the property, and a swift-running brook cascaded down the rocky slope below the house.

Billy and Henriette knew little about gardening at the time, but both were trained to have an artist's appreciation of color and design. Billy was an art conservator who restored Old Masters at the Frick Collection and at public museums and private collections in Europe. Henriette was an interior designer who specialized in home-furnishing displays at Bloomingdale's and other department stores. Gardening for the couple was a weekend hobby that became a way of life.

"We picked plants for their flower colors, for the interest of their shapes," Henriette said recently. "Then we put things together the way we thought they would look good." If a plant did not thrive, they moved it to another spot in the garden. They learned more about horticulture by reading books and visiting botanical gardens and local nurseries. Rocky Hills eventually became their permanent residence, and after her husband's death, Henriette continued to develop and expand their garden.

Rocky Hills is best known for its exuberant display of spring-flowering plants. Thousands of bulbs—snowdrops, crocuses, and wood hyacinths—carpet the landscape, together with clouds of pale blue forget-me-nots. The collections of rhododendrons and azaleas include rare varieties seldom seen in the area. Later, in the summer, drifts of ferns, punctuated by rock outcroppings, cover the woodland. Large specimen trees, which the Suhrs acquired when a neighboring estate was dismantled, are now prominent features of the garden, along with Japanese maples and conifers. When the Brooklyn Botanic Garden closed its research center in Westchester County, Rocky Hills became the new home of the famous yellow magnolias that were hybridized and cultivated there.

In addition to being an expression of the Suhrs' aesthetic vision, Rocky Hills preserves a welcome green space in an increasingly developed residential area. Since 2003, the Garden Conservancy has helped Henriette protect her garden by holding a conservation easement on the property and by exploring management options for its future. A local organization, the Friends of Rocky Hills, supports the garden as volunteers and fundraisers and works closely with the Garden Conservancy to offer lectures to the public on topics of horticultural and environmental interest. For twenty-one years, until her death in 2015, Henriette welcomed hundreds of visitors during Rocky Hills's popular Open Days.

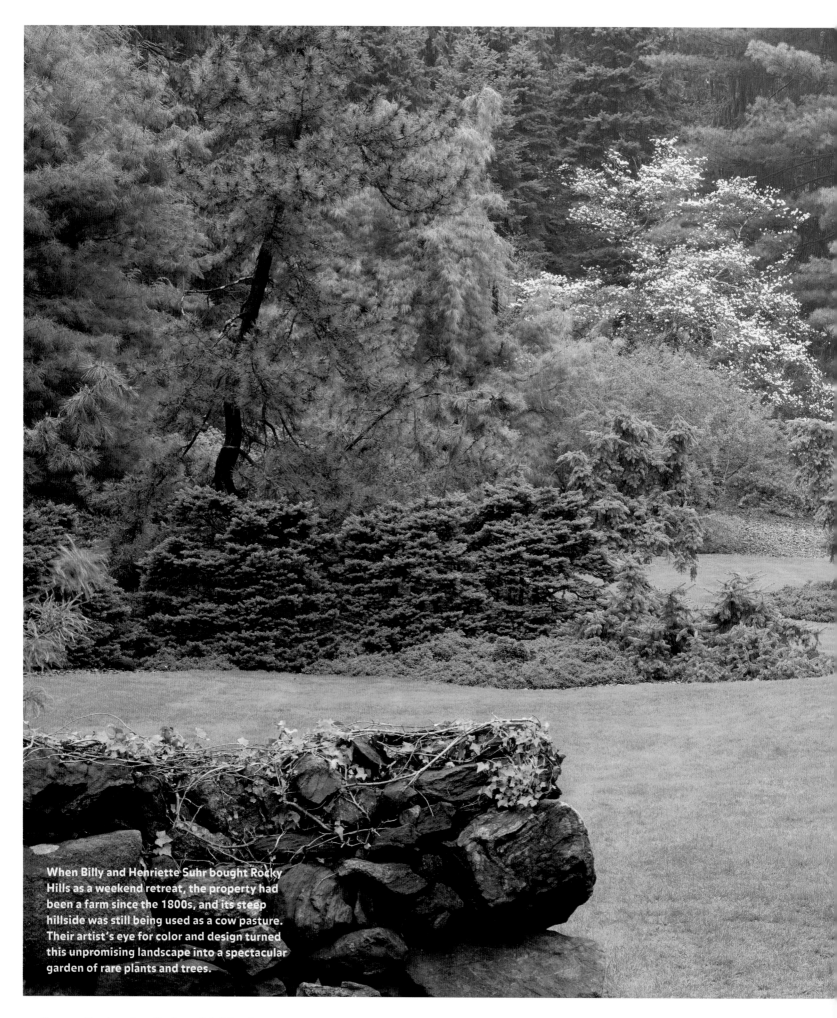

When Billy and Henriette Suhr bought Rocky Hills as a weekend retreat, the property had been a farm since the 1800s, and its steep hillside was still being used as a cow pasture. Their artist's eye for color and design turned this unpromising landscape into a spectacular garden of rare plants and trees.

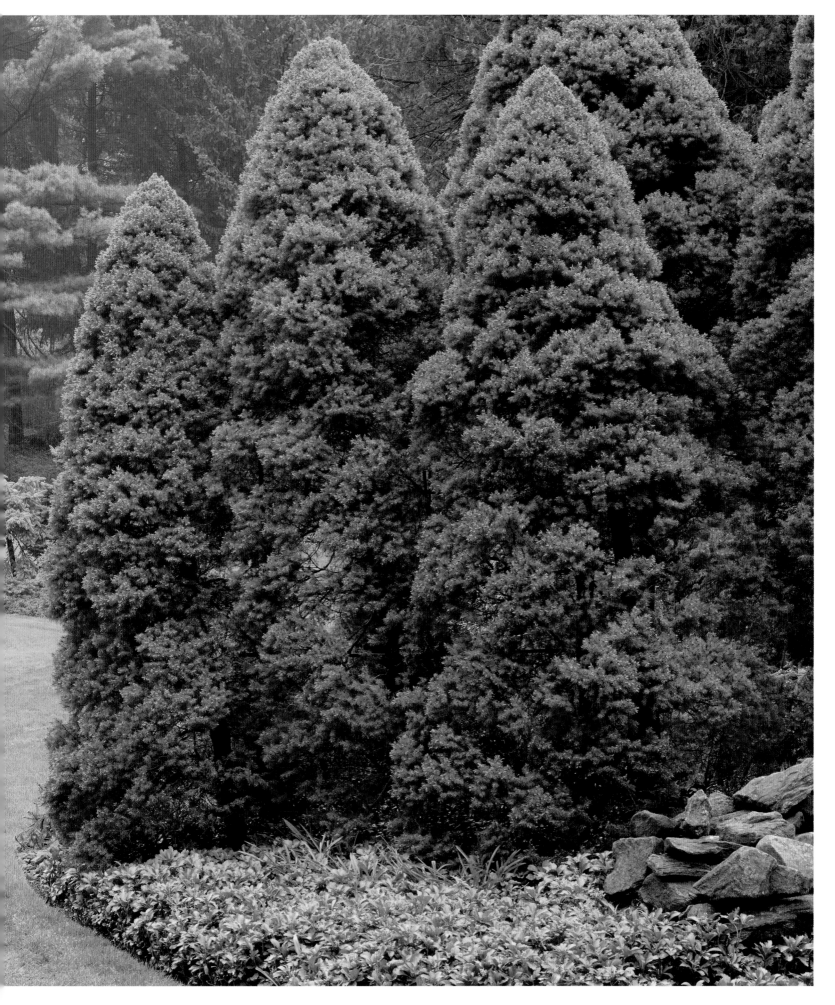

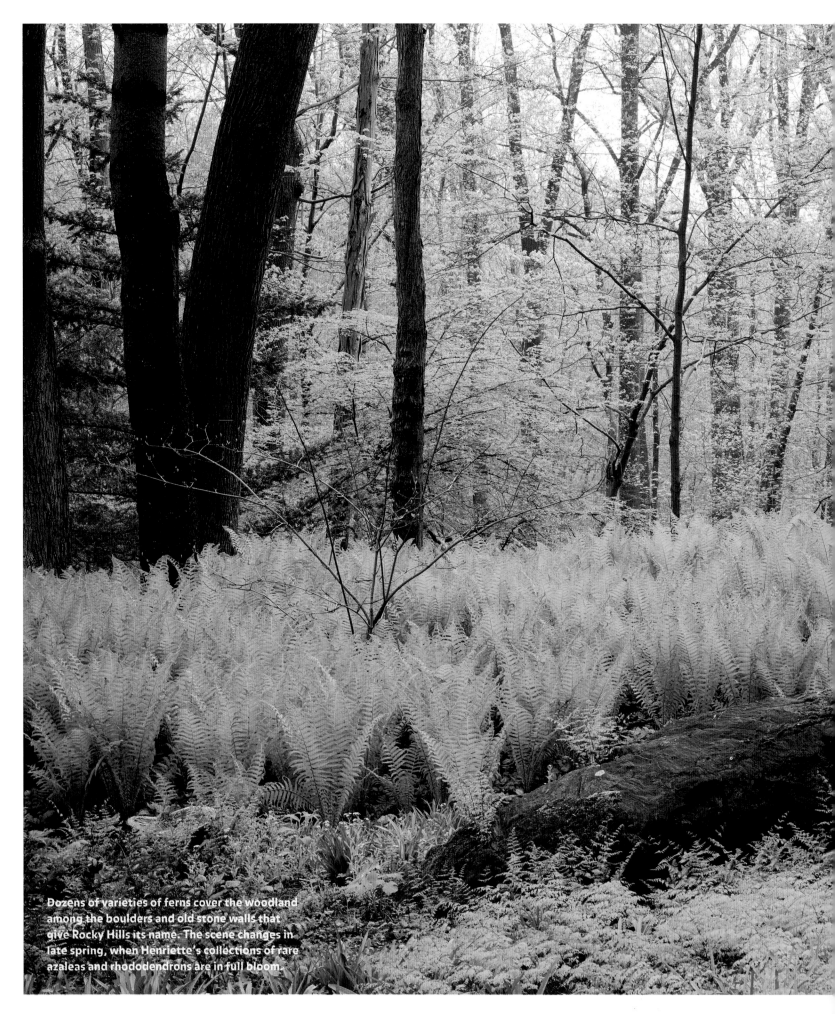

Dozens of varieties of ferns cover the woodland among the boulders and old stone walls that give Rocky Hills its name. The scene changes in late spring, when Henriette's collections of rare azaleas and rhododendrons are in full bloom.

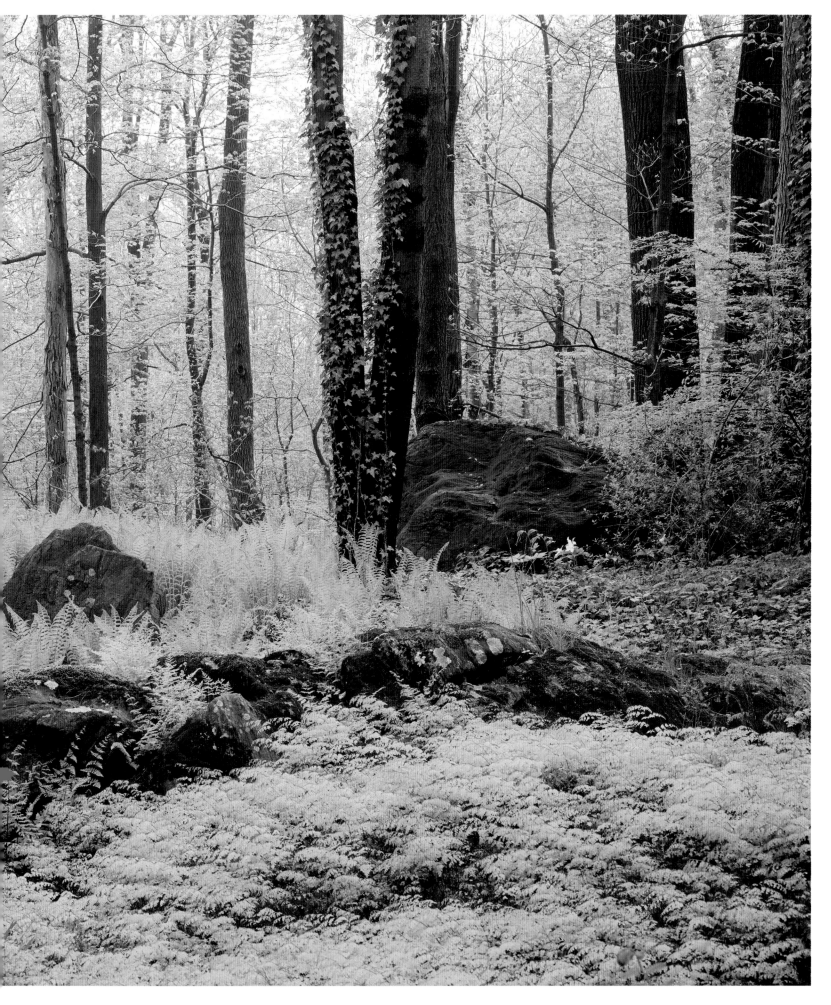

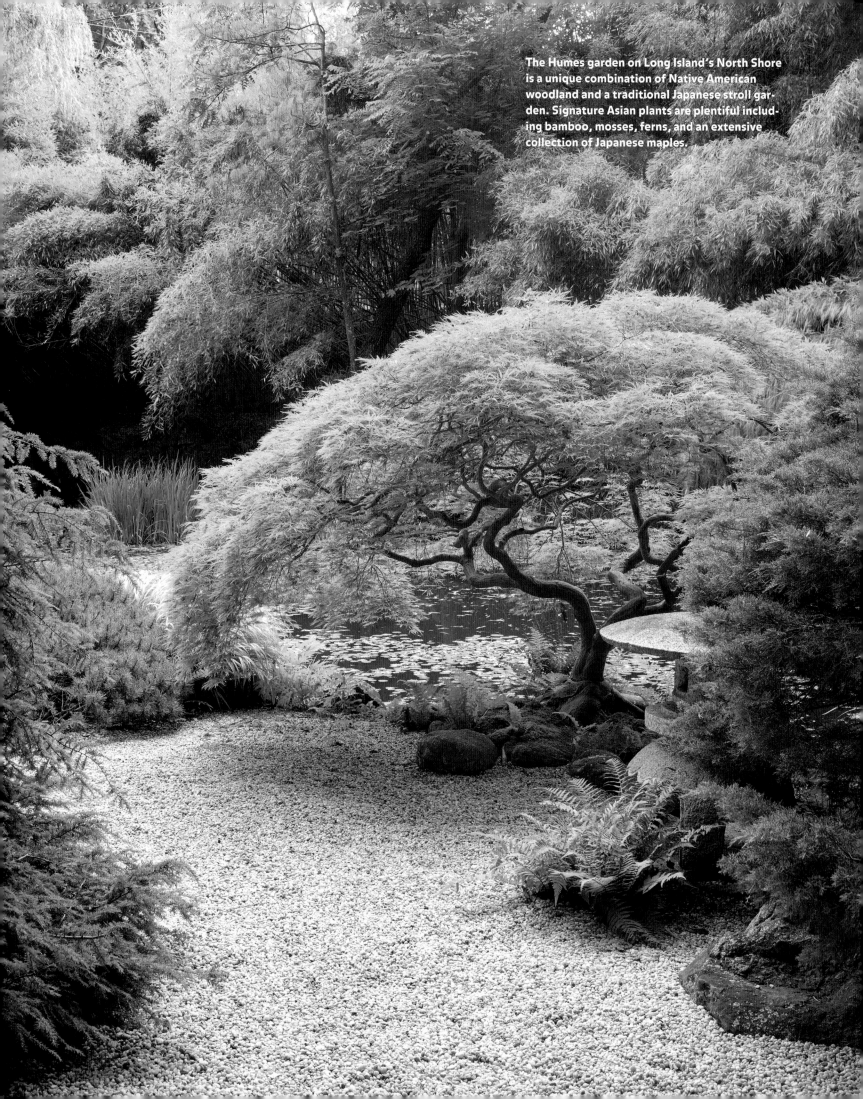

The Humes garden on Long Island's North Shore is a unique combination of Native American woodland and a traditional Japanese stroll garden. Signature Asian plants are plentiful including bamboo, mosses, ferns, and an extensive collection of Japanese maples.

John P. Humes Japanese Stroll Garden

Mill Neck, New York

A rare example of traditional Japanese garden design in the American Northeast, this garden was inspired by a trip to Japan that John and Jean Humes took in 1960. Both were fascinated by Buddhist aesthetics and enchanted by their visits to the ancient gardens of Kyoto. When they returned from their travels, they transformed a corner of their wooded Long Island property into a Japanese-style garden and imported a traditional teahouse as its centerpiece. Douglas and Joan DeFaya, a Japanese-American landscape designer and his wife, worked with a local contractor to carve paths into the steep hillside, set stones by hand, and plant the forest's understory with appropriate Japanese shrubs, trees, and ground cover.

In 1969, Mr. Humes was appointed Ambassador to Austria, where he and his family lived until 1975. During their absence, the garden became overrun with invasive plants and required restoration and repair. The Humeses decided not only to restore the garden but also to enlarge it, with the idea of eventually opening it to the public. They hired landscape architect Stephen Morrell, now the garden's Director and Curator, to develop the new garden, and he created an aesthetic that was true both to the North Shore of Long Island site and to the principles of a traditional Japanese stroll garden.

The defining feature of the John P. Humes garden is its winding stepping-stone and gravel path, which represents the spiritual journey to enlightenment through immersion in nature. The visitor first passes through a gate symbolizing the transition from the public, everyday world to the private, spiritual reality hidden behind it. The uphill climb from there represents the difficulties of that journey; narrow steps slow one down, and large stepping-stones provide places to stop and contemplate the view. The turns of the path control how the visitor sees the garden through a succession of constricted and open spaces, which create a feeling of pauses and movement. A second gate at the top of the hill offers a clearer view and inspires a spiritual response to the natural world. The descending path is pebbled to represent waters cascading down to the pond below. The final gate opens to the teahouse garden and symbolizes an enlightened return to worldly concerns.

Soon after the death of Ambassador Humes in 1985, the garden was opened to the public and supported by a foundation he established. In 1993, the foundation's financial situation looked bleak, and the Conservancy stepped in to launch an emergency fundraising campaign. The local community responded positively, and the Conservancy assumed the care, management, and preservation of the John P. Humes garden for the next twenty years.

Today, changes in ownership of the surrounding property have presented new opportunities for this garden, as has diminished financial support from the community. The Conservancy is continuing to explore opportunities to revive the preservation of this very special garden.

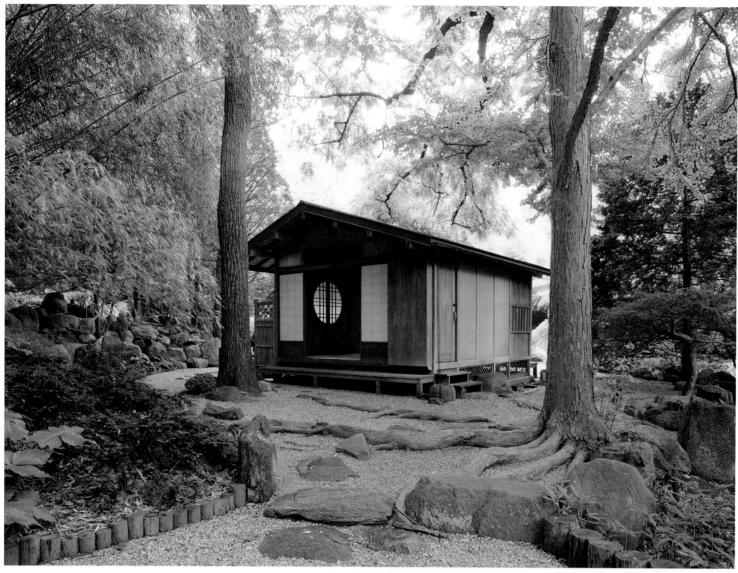

TOP After returning from a trip to Japan, Ambassador and Mrs. Humes began transforming a two-acre corner of their property on the North Shore of Long Island into a Japanese garden and imported a teahouse as its focal point.

BOTTOM Stone Japanese lanterns, each one unique, are found throughout the garden.

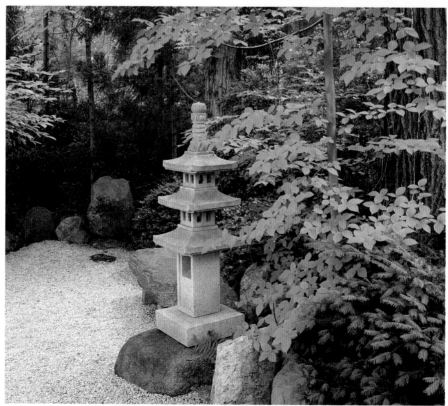

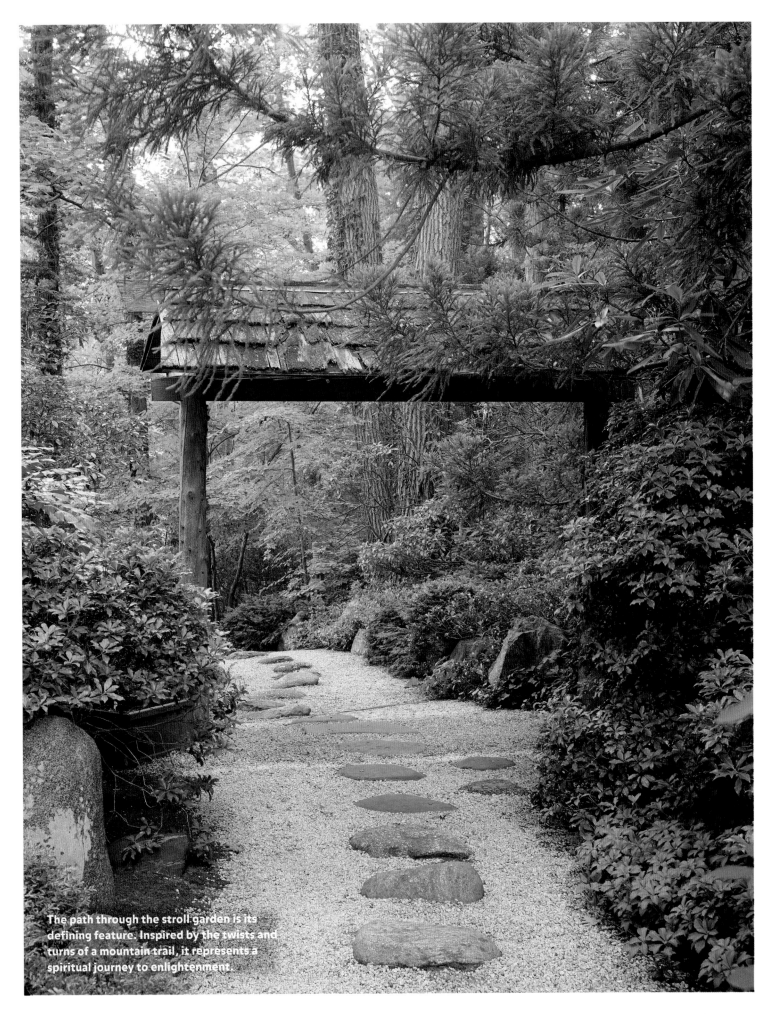

The path through the stroll garden is its defining feature. Inspired by the twists and turns of a mountain trail, it represents a spiritual journey to enlightenment.

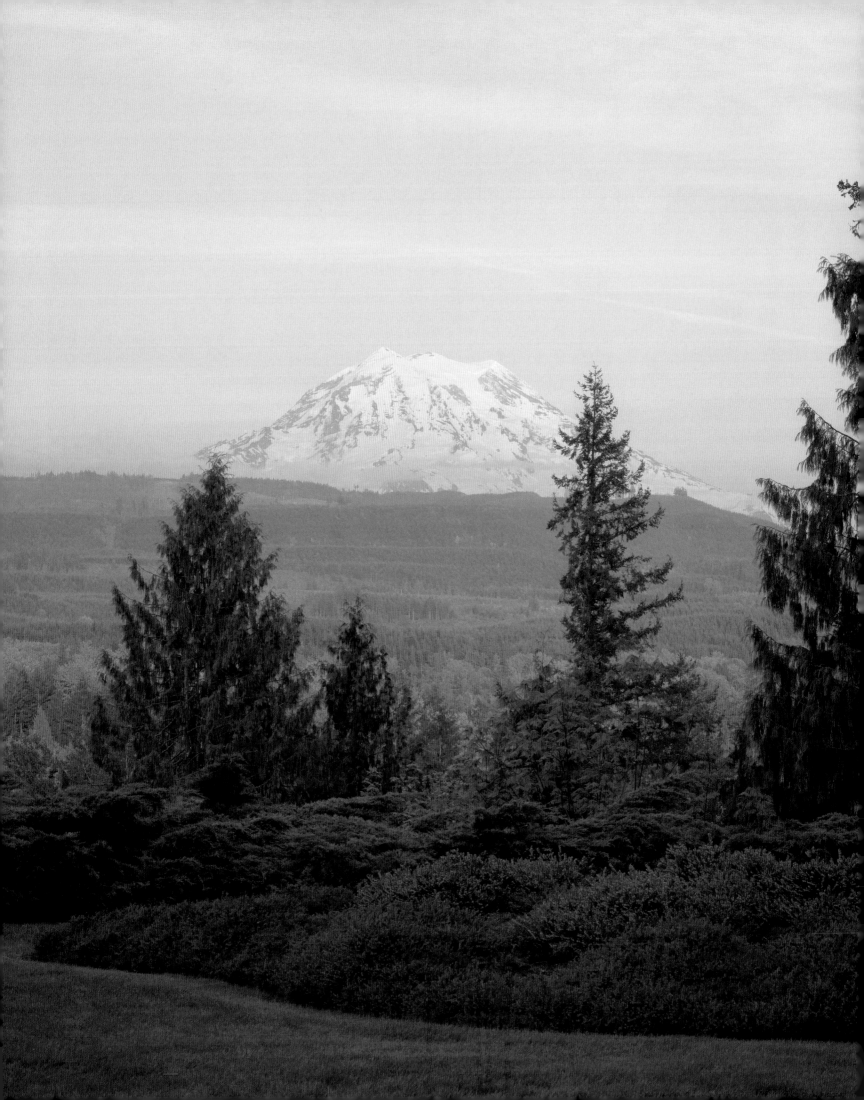

The Chase Garden

Orting, Washington

Marco Polo Stufano, former Chairman of the Screening Committee at the Garden Conservancy, calls the Chase Garden a "small gem . . . that should be preserved forever." This quintessential modernist garden of the Pacific Northwest represents the lifework of Emmott and Ione Chase, who spent more than forty years creating and refining it. In the late 1950s, they hired a young architect, K. Walter Johnson, to design their modest house, and they engaged a newly graduated landscape architect, Rex Zumwalt, to plan a Japanese-style garden around it. Using mostly native plants in a naturalistic arrangement, they created a garden of serene beauty in a dramatic setting atop a bluff with a majestic view of Mount Rainier.

The plan included a concrete terrace and a covered lanai, narrow stepping-stones and bridges, and pebbled reflecting pools. Though a novelty to the Pacific Northwest at the time, it later defined the region's prevailing garden style. Emmott and Ione did much of the work themselves, carting up boulders from the river valley and tracing paths into the slope behind the house. Today, their garden's outstanding features are its native, naturalistic woodlands, alpine meadows, and stylized rock gardens.

The Garden Conservancy adopted the Chase Garden as a preservation project in 1995 and three years later established the Friends of the Chase Garden to provide local support and to operate the garden. After the deaths of Emmott and Ione, the Conservancy inherited the property and holds a conservation easement on the site, protecting the scenic value of the garden. The Friends and the Garden Conservancy continue to raise the funds necessary to maintain the garden, open it to the public, and plan for its future.

The Chase Garden's dramatic setting on a bluff above the Puyallup River valley has a majestic view of Mount Rainier.

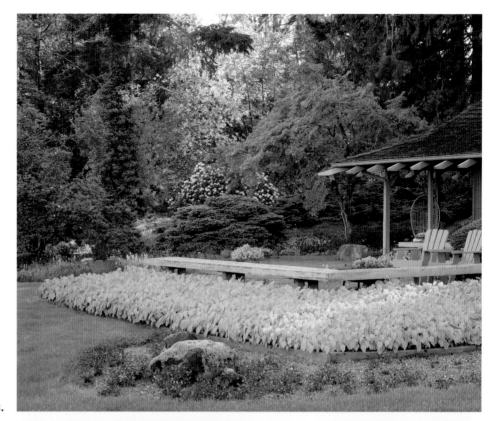

Emmott and Ione Chase spent more than forty years perfecting their vision of a Japanese-style garden of native plants. They traced paths and flower beds into the sloping landscape, creating a tapestry of color that reminded them of the alpine meadows they had seen on mountain hikes.

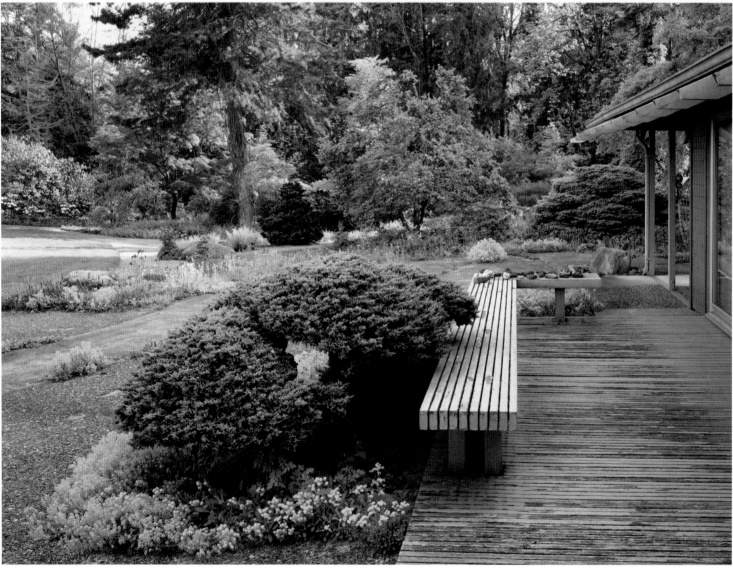

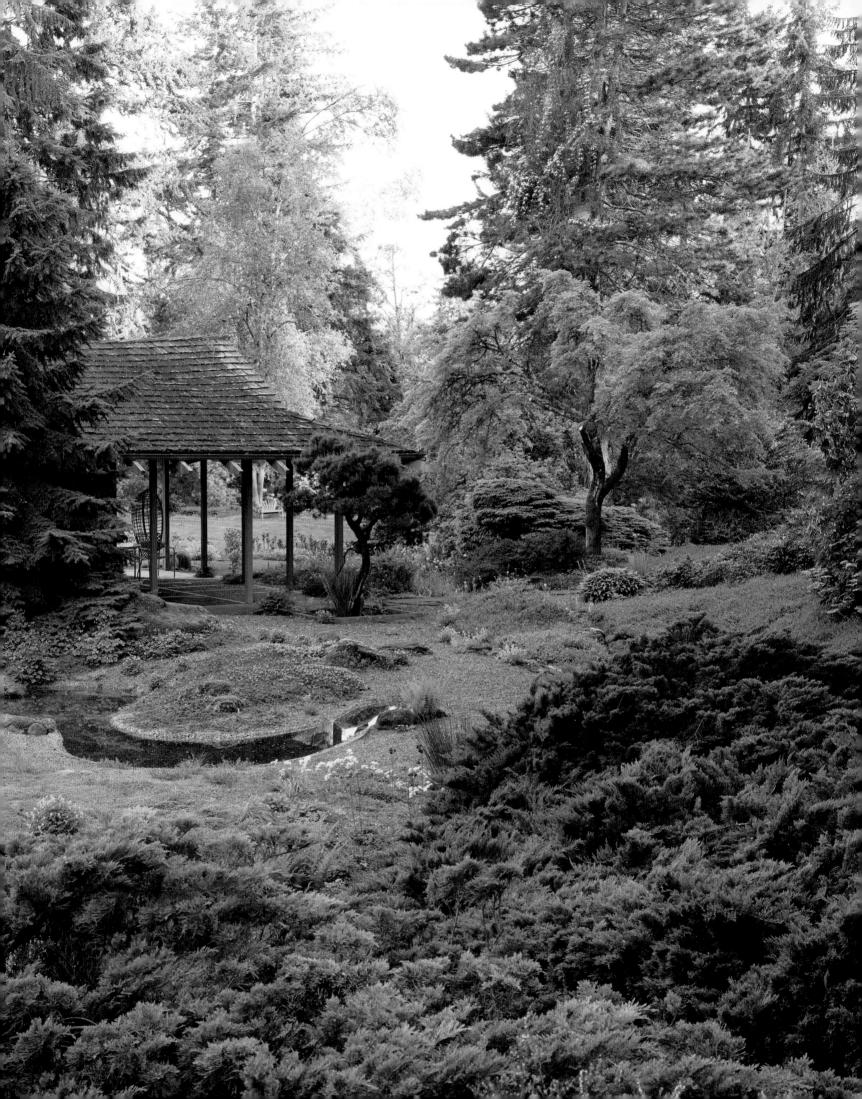

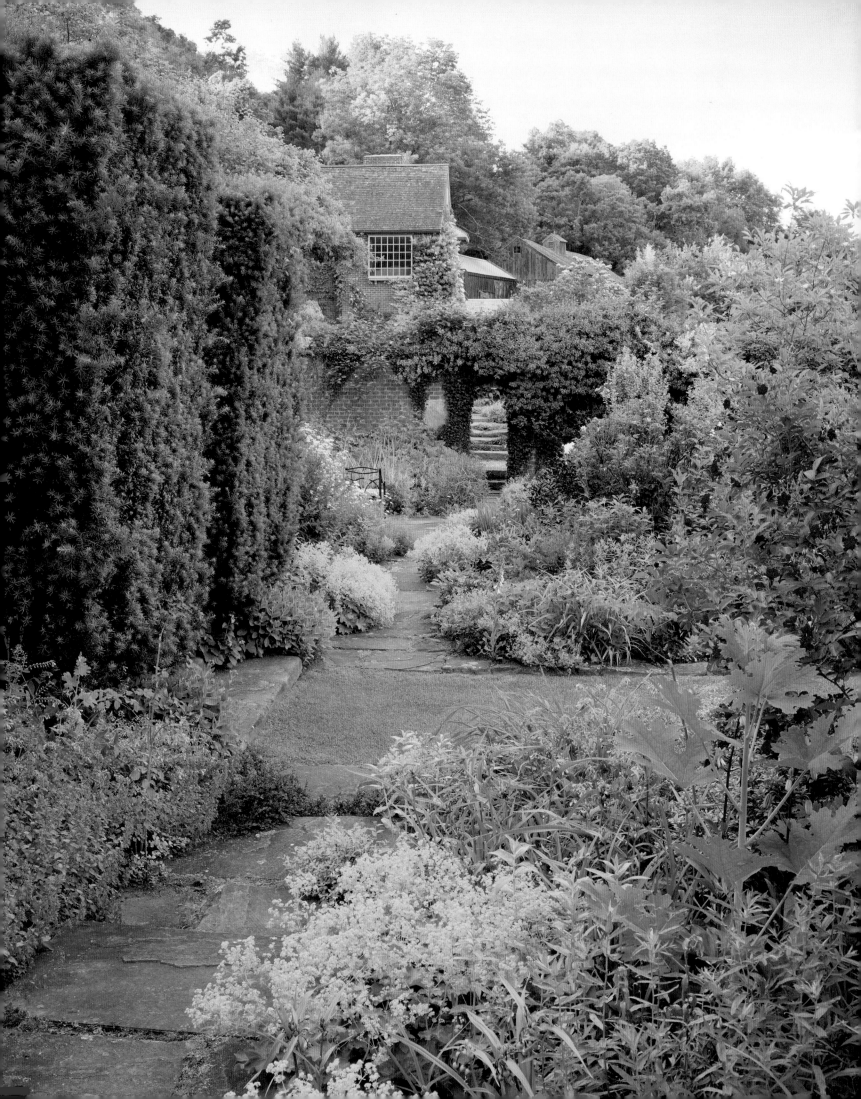

Hollister House Garden

Washington, Connecticut

Set in the picturesque hills of northwestern Connecticut, George Schoellkopf's Hollister House Garden represents an American interpretation of the classic English cottage garden. It reflects its rural New England setting in the unpretentiousness and hardiness of its plantings, while drawing inspiration from Vita Sackville-West's garden at Sissinghurst, where a series of walled or hedged "rooms" enclose horticulturally sophisticated combinations of shrubs, perennials, bulbs, and flowering trees.

Having spent his professional life as a collector of and dealer in eighteenth- and nineteenth-century American furniture and folk art, George was naturally attracted to Hollister House, a 1760 farmhouse set on twenty-five acres in the hills of Litchfield County. His garden, however, is based not on early American models, but on the twentieth-century designs he saw on a visit to England. The gardens at Sissinghurst seemed to him to strike an effortless balance of formal structure and loose planting style. The contrast between rectangular spaces and exuberant mixtures of colorful plants remains Hollister House's central, unifying design, while separate garden "rooms" with differing sizes and views lend variety to the plan. Asymmetrical axes and unpredictable entrances to these rooms also add spontaneity and intimacy within its strong structural lines. What George loves most, he says, "is architecture almost but not quite overwhelmed by plants."

George's desire to see his garden preserved is based on his belief that private American gardens, with their unique and personal aesthetics, can be as inspiring and educational as the classic English gardens were to him. Hollister House Garden has been open to the public through the Garden Conservancy's Open Days program almost since its inception in 1995. The garden became a preservation project in 2004, and then a nonprofit corporation. It is also the venue for the annual Garden Study Weekend, offering lectures by leading designers, landscape architects, and plantsmen. With the Garden Conservancy's help, Hollister House will eventually become a public garden and house museum.

A series of flower-filled garden spaces are connected by stone paths and contained by hedges and a brick wall below George Schoellkopf's eighteenth-century farmhouse and barns.

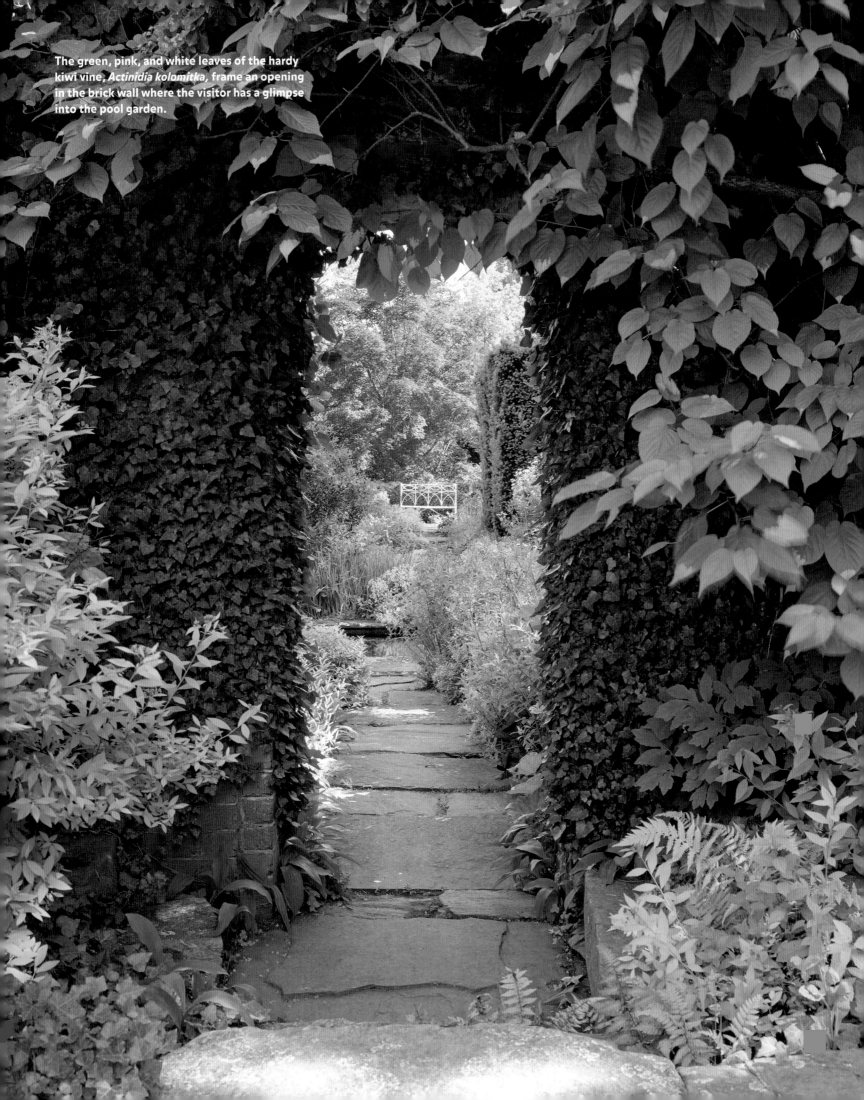

The green, pink, and white leaves of the hardy kiwi vine, *Actinidia kolomitka*, frame an opening in the brick wall where the visitor has a glimpse into the pool garden.

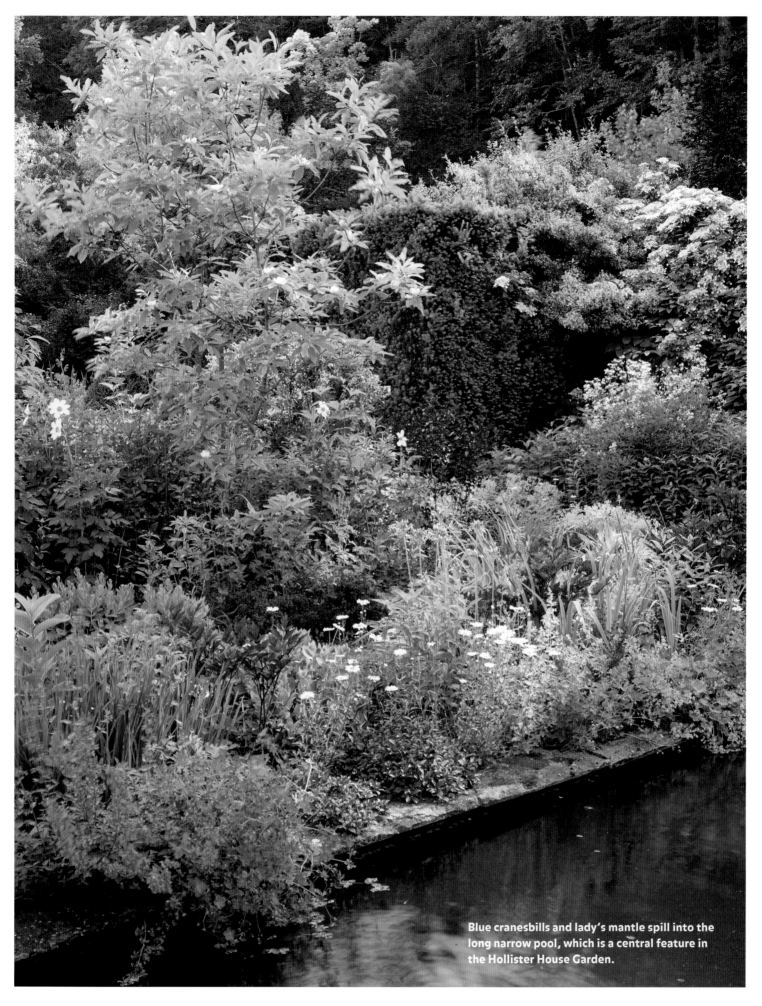

Blue cranesbills and lady's mantle spill into the long narrow pool, which is a central feature in the Hollister House Garden.

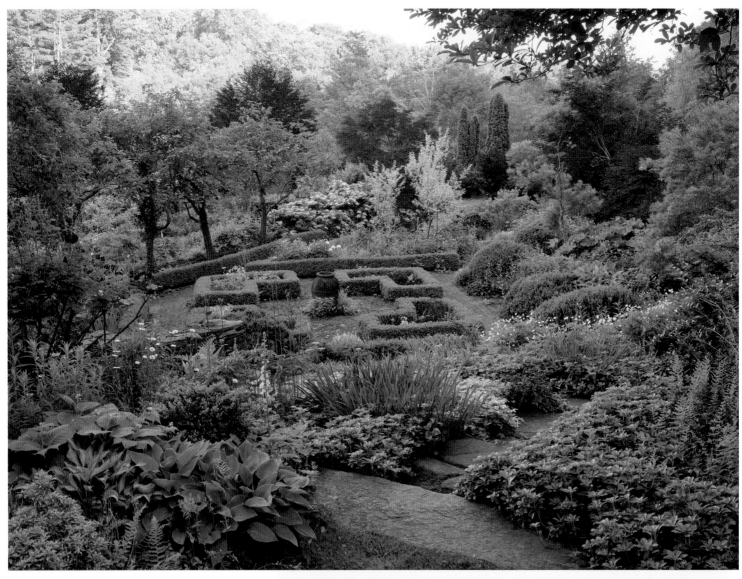

TOP Paths wind down from the house to the box-edged white garden. Blue-gray foliage is celebrated here, as well as white flowers, contrasting with the wine-colored foliage of the Japanese maples beyond.

BOTTOM Plume poppy (*Macleaya cordata*) seeds in the gravel by the long yellow border.

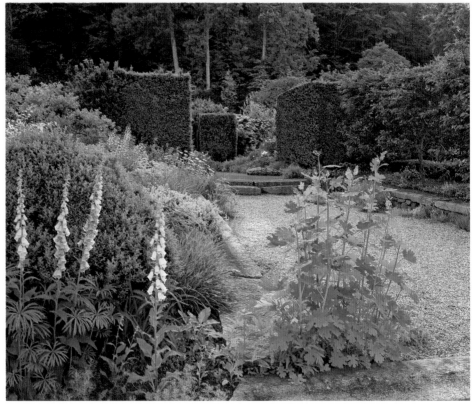

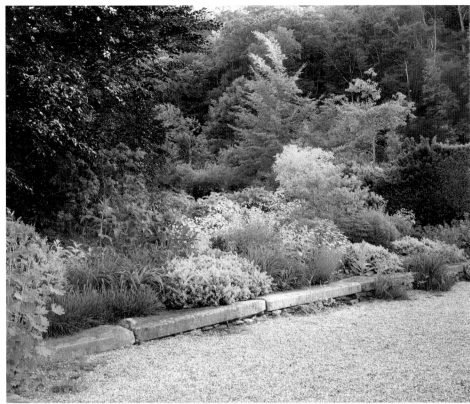

LEFT The golden-leaved hoptree, *Ptelea trifoliata* 'Aurea,' lights up a corner of a yellow border. Golden barberries repeat the sunlit color.

BELOW A clipped yew hedge divides the formal walled garden from the wild New England landscape beyond it.

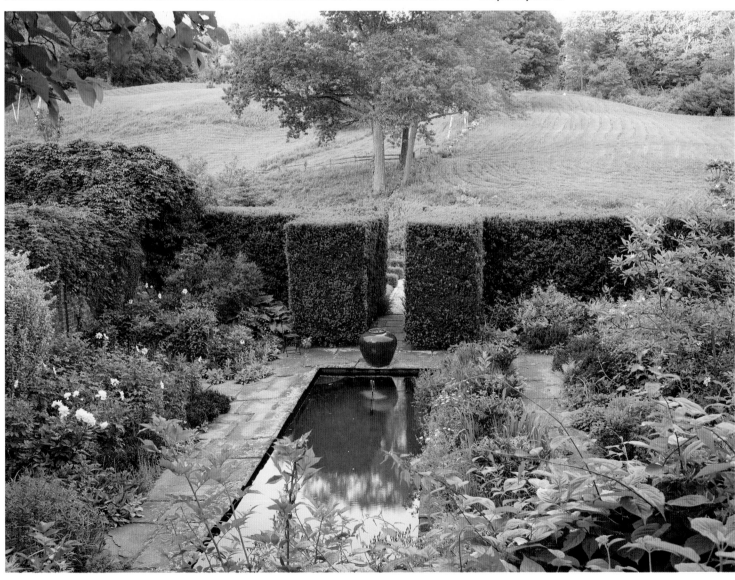

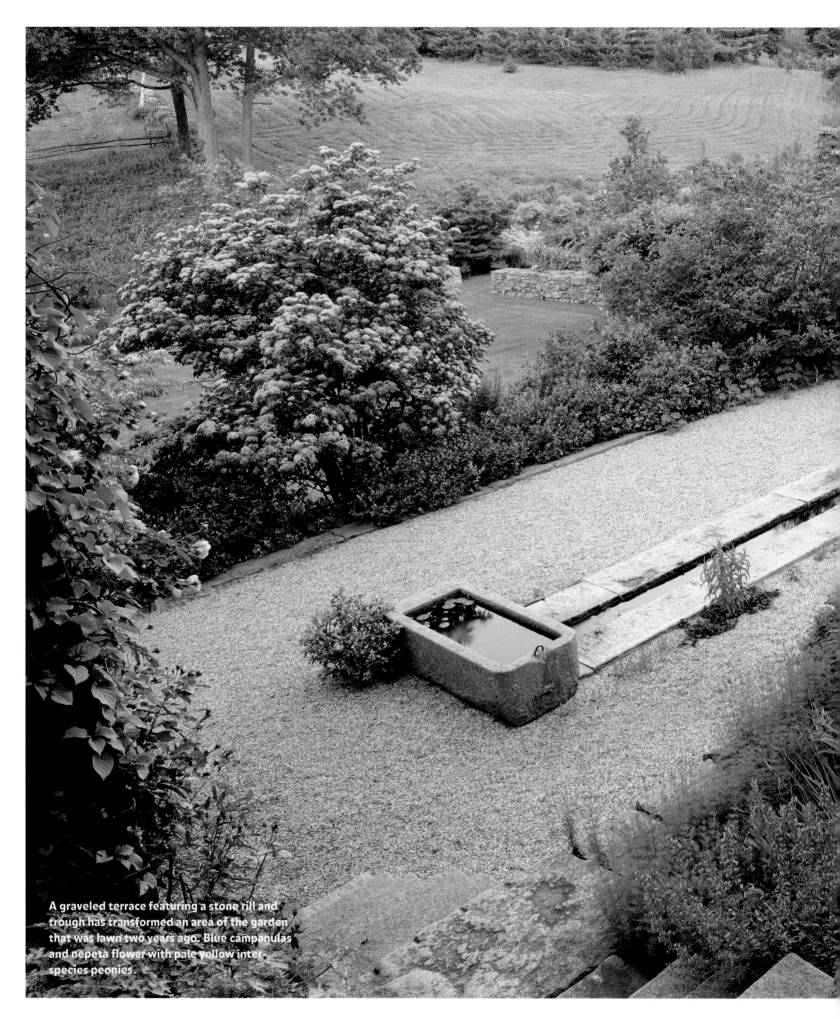

A graveled terrace featuring a stone rill and trough has transformed an area of the garden that was lawn two years ago. Blue campanulas and nepeta flower with pale yellow inter-species peonies.

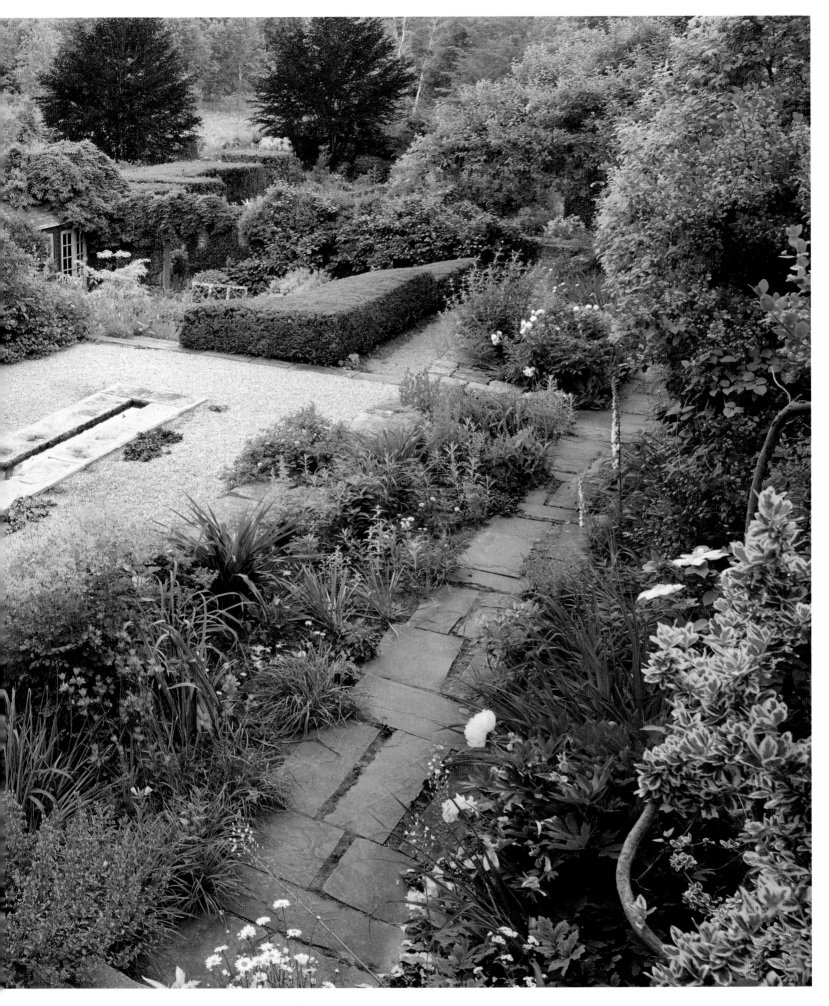

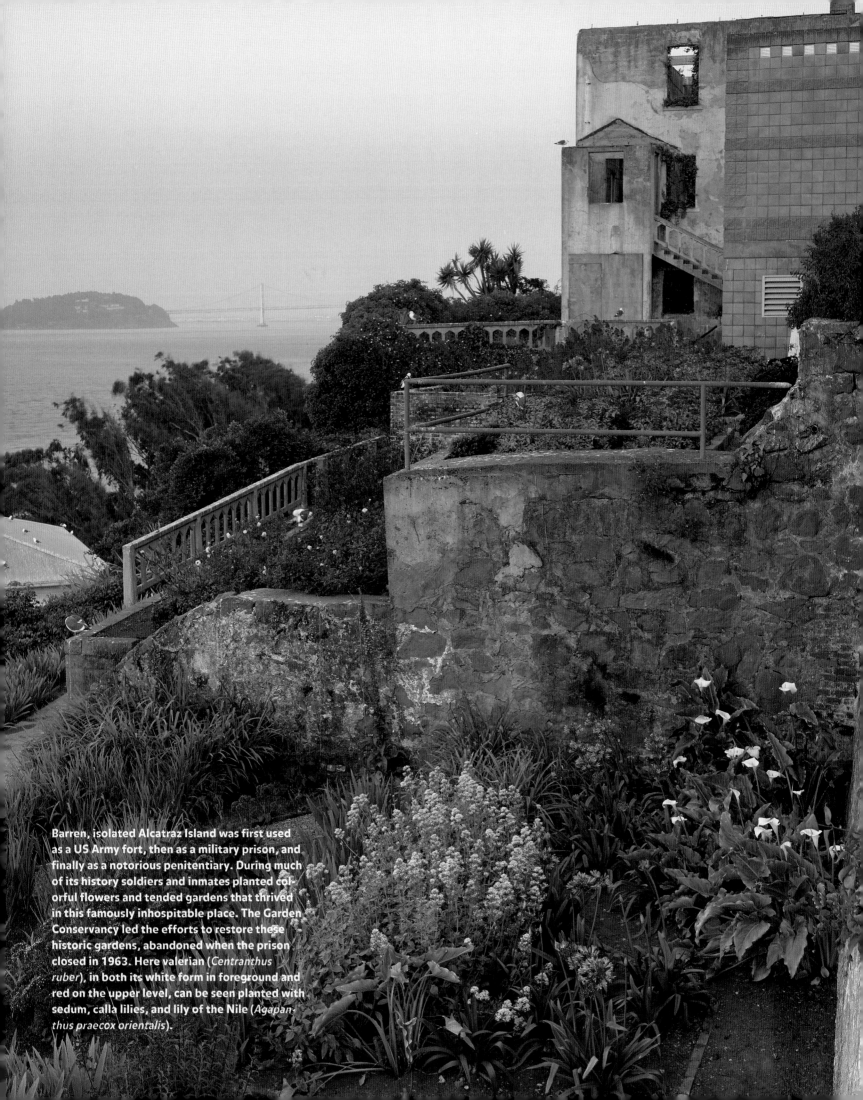

Barren, isolated Alcatraz Island was first used as a US Army fort, then as a military prison, and finally as a notorious penitentiary. During much of its history soldiers and inmates planted colorful flowers and tended gardens that thrived in this famously inhospitable place. The Garden Conservancy led the efforts to restore these historic gardens, abandoned when the prison closed in 1963. Here valerian (*Centranthus ruber*), in both its white form in foreground and red on the upper level, can be seen planted with sedum, calla lilies, and lily of the Nile (*Agapanthus praecox orientalis*).

The Gardens of Alcatraz

San Francisco, California

For more than 150 years, a succession of soldiers, families of correction officers, and prison inmates cultivated gardens on rocky, windswept Alcatraz Island in San Francisco Bay. Since 2003, in partnership with the National Park Service and the Golden Gate National Parks Conservancy, the Garden Conservancy has led the effort to restore these long-abandoned gardens, not just for the island's 1.5 million annual visitors to enjoy, but to demonstrate the importance of gardening to the people who lived in this notoriously harsh environment.

The barren, isolated twenty-two acres of Alcatraz Island were first occupied and used as a United States Army fort in the 1850s. Its slopes were graded into high cliffs to support the Citadel, a three-story barrack, and the necessary gun emplacements. As soldiers reshaped the rock for additional buildings and fortifications, more soil was transported from nearby Angel Island to control erosion and to create gardens for the houses on Officers' Row. When Alcatraz became a military prison during the Civil War, the gardeners who planted typically Victorian displays of colorful flowers, as well as lawns and native trees, were the inmates.

When Alcatraz was transferred to the Federal Bureau of Prisons in 1933, the new corrections officers were surprised to find that the Army had left behind flowering terraces, a rose garden, a greenhouse, and banks of colorful succulents spilling down the rocky slopes. The prison warden's secretary, Fred Reichel, took over garden maintenance and introduced many locally unknown Mediterranean plant species as well as native California plants that adapt well to wind and drought. Eventually Reichel trained a few inmates to garden, which became for them a welcome escape from the grim life of a high-security penitentiary. One of them, Elliott Michener (imprisoned from 1941 to 1949), spent years cutting rock terraces into the windy western hillside, building a greenhouse from old windows, and planting brilliant flower beds on the path that inmates walked every day.

After the prison closed in 1963, the gardens were abandoned. The plants that needed water and maintenance died out, while others spread wildly. The neglected gardens and structures became overgrown with weeds and disappeared. When the National Park Service opened Alcatraz as a public park in 1972, the landmark buildings were reopened, but the landscape had deteriorated to such an extent that no visitor would have guessed that the island had been cultivated for more than a century.

CONTINUED >>

In 2003, the ambitious project to restore the historic gardens of Alcatraz Island began. The next year, the Conservancy placed a Marco Polo Stufano Fellow on the island. This position evolved into that of a full-time Conservancy project manager responsible for recruiting and training what would become an incredibly productive and successful volunteer corps.

After careful research, the volunteers started their restoration with the areas they knew had once been planted with lawns and flowers. Beneath forty years' worth of overgrowth, they discovered that most of the original structural features—terraces, paths, railings, and walls—were still in place. Smaller-scale features, such as stepping-stones, reappeared, and flowers began to sprout from long-buried bulbs as the sunlight reached them. Almost two hundred surviving plants have already been found and catalogued.

Among the survivors were fifteen cultivars of roses, including the rare *Rosa* 'Bardou Job,' which was cultivated in France in 1887 but is no longer found in Europe. After the discovery of this "lost" rose on Alcatraz, cuttings were sent back across the Atlantic to the Museum of Welsh Life in Wales, where the flower had once grown.

The influence of the Gardens of Alcatraz extends well beyond the island itself. Through a comprehensive educational program, the Garden Conservancy and its partners enable thousands of people to appreciate the role of gardening in our cultural heritage, as well as the power of gardens to brighten an inhospitable landscape and provide solace to those living in it. Today, thriving gardens once again surround the somber prison walls, as they did during much of the island's history. Beyond restoring the historic character of Alcatraz, the Garden Conservancy and its partners have developed docent tours, interpretive signs, visitors' guides, lectures, and a Web site to tell the story of the "softer side of the Rock."

These gardens on Officers' Row, with the Warden's House ruins in the background, have been restored to their appearance during the federal-penitentiary period when staff and prisoners actively gardened there. During the restoration, volunteers introduced new plants that can tolerate the island's harsh conditions, such as this sea lavender (*Limonium perezii*), to give the look and feel of the cutting garden that had once been there.

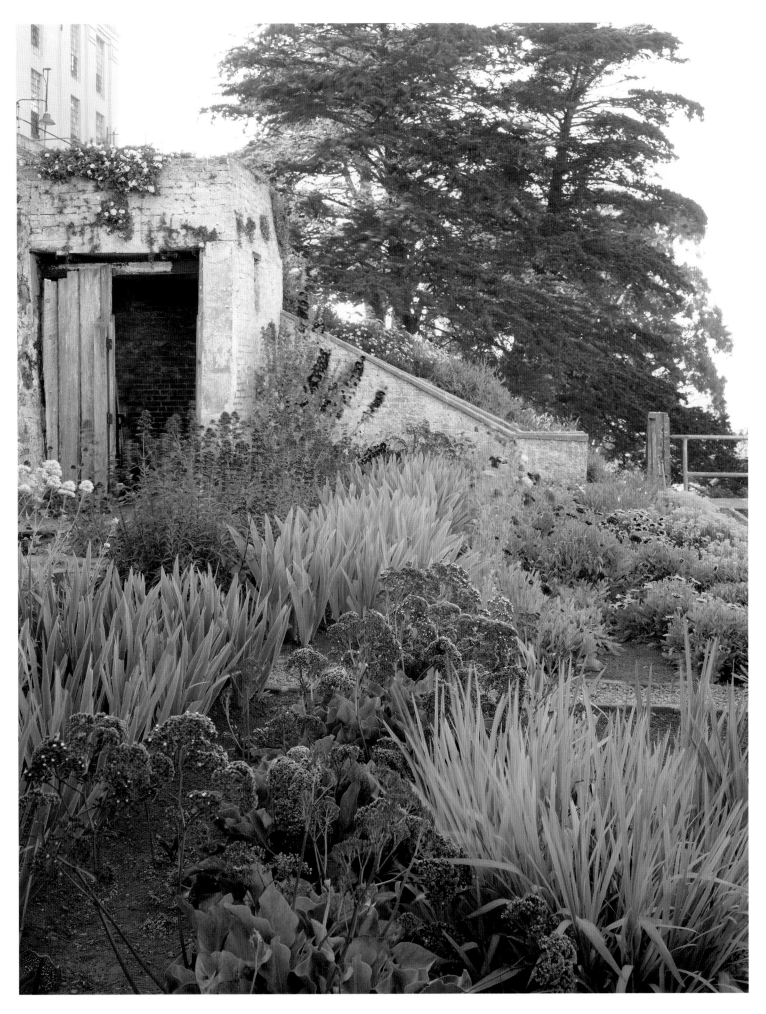

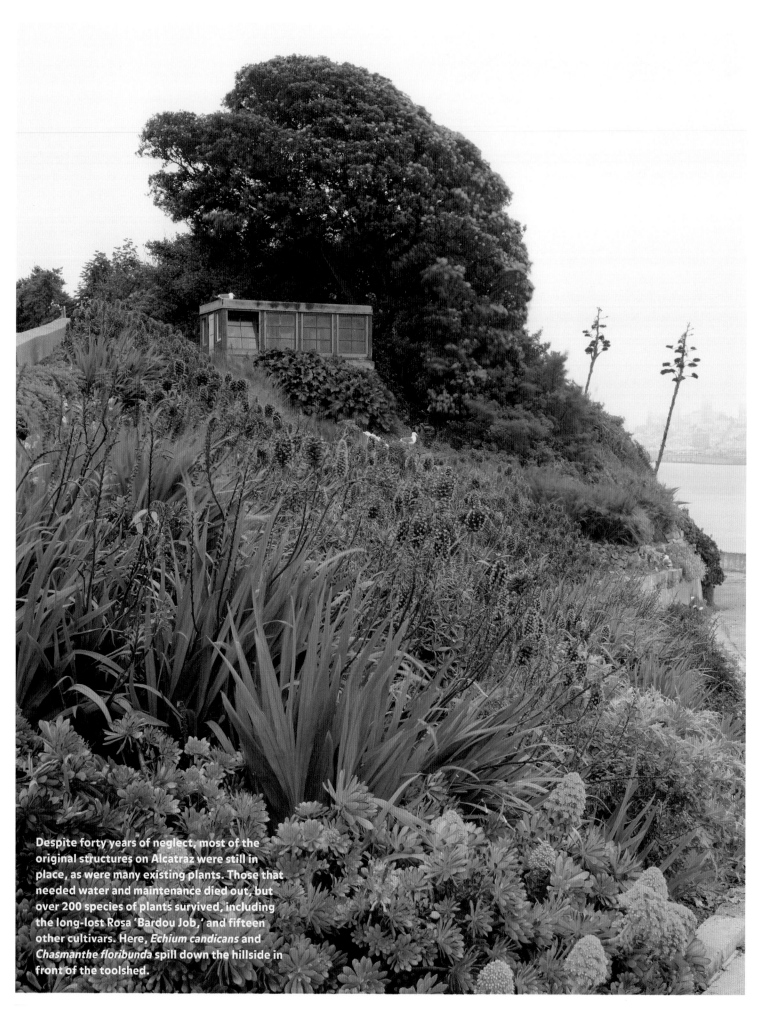

Despite forty years of neglect, most of the original structures on Alcatraz were still in place, as were many existing plants. Those that needed water and maintenance died out, but over 200 species of plants survived, including the long-lost Rosa 'Bardou Job,' and fifteen other cultivars. Here, *Echium candicans* and *Chasmanthe floribunda* spill down the hillside in front of the toolshed.

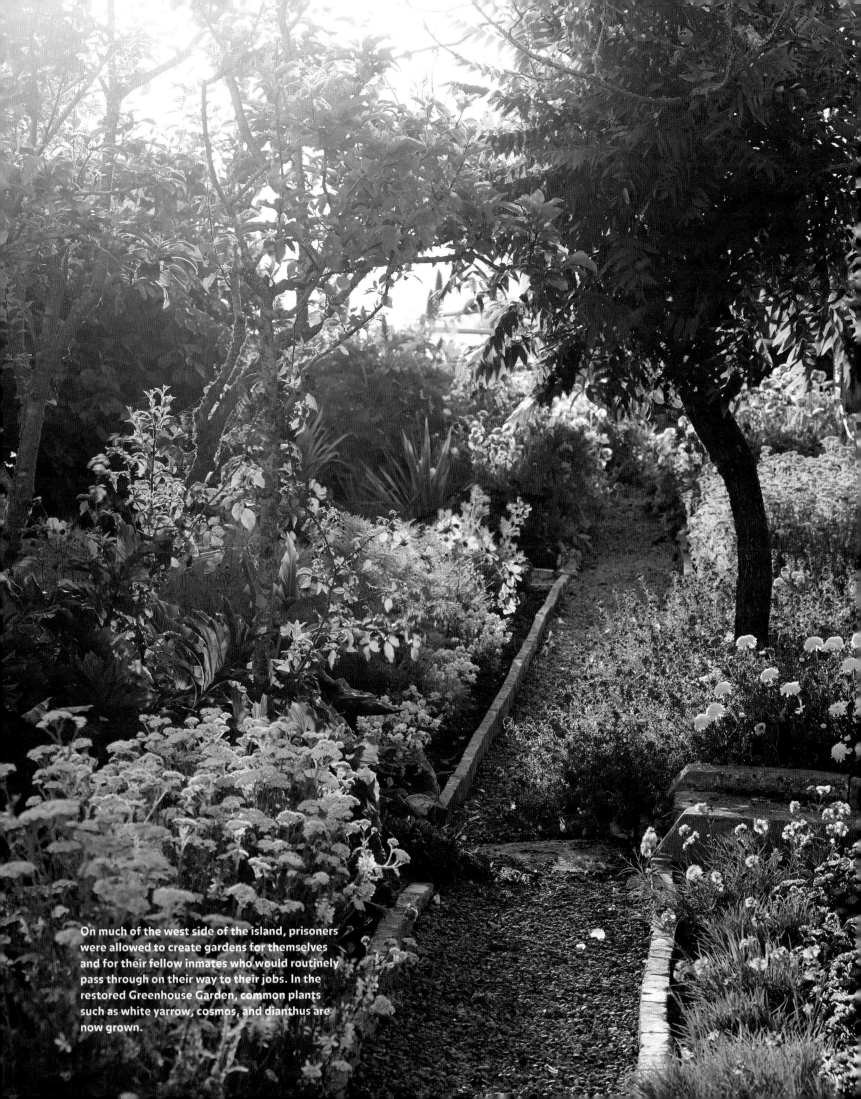

On much of the west side of the island, prisoners were allowed to create gardens for themselves and for their fellow inmates who would routinely pass through on their way to their jobs. In the restored Greenhouse Garden, common plants such as white yarrow, cosmos, and dianthus are now grown.

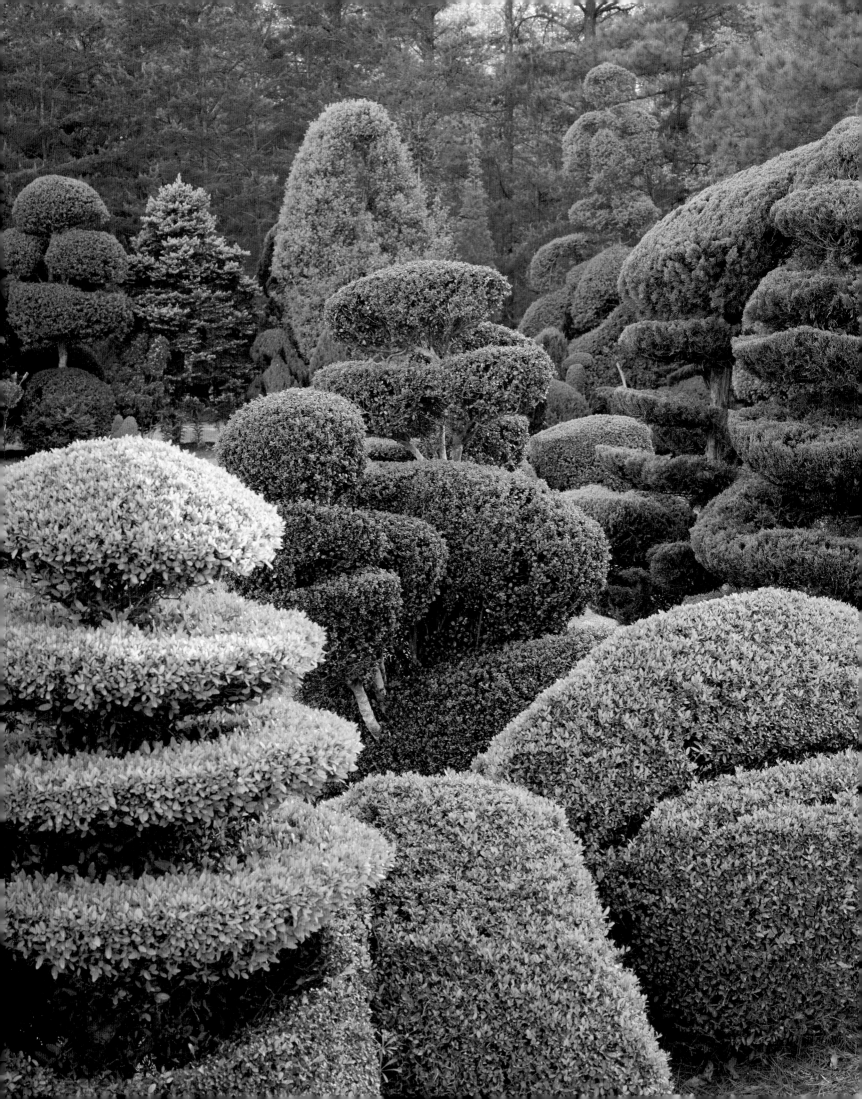

The Pearl Fryar Topiary Garden

Bishopville, South Carolina

The lifework of a visionary artist, this remarkable garden began with an ordinary hedge trimmer and an extraordinary imagination. Using only his own labor, resources, and time after work, Pearl Fryar transformed his three-acre property into a topiary garden that now has an international reputation far beyond his original goal: to show that an African-American man could win the Yard-of-the-Month award from the Bishopville Iris Garden Club.

Soon after Pearl and his wife Metra built their house in a former cornfield in the early 1980s, Pearl wanted to create something more interesting than the usual foundation plantings and hedgerows that typically surrounded a home. After a three-minute lesson on topiary at a local nursery, he began to sculpt these ordinary plants into fantastic shapes. With no formal training in art or horticulture, and using only his hedge trimmer and a stepladder, he gradually developed a range of topiary styles—tightly manicured geometric compositions, figurative shapes, and monumental abstractions. Today the garden contains five hundred trees and shrubs he planted over the years, many of them rescued from that local nursery's compost pile of plants discarded as too damaged or too sick to sell. His dazzling topiary designs attract thousands of visitors from around the world to the small town of Bishopville, the county seat of the poorest region in South Carolina, where his garden is a source of civic pride and inspiration for the whole community.

Pearl sees his achievement as a statement about the power of average individuals to do extraordinary things and to make an important contribution to society. His lectures motivate young people across the country and at nearby Coker College, where he is Artist-in-Residence. *A Man Named Pearl,* an award-winning documentary film, celebrates his artistic vision and his ability to effect social change in a small rural community.

As a cultural and educational asset to the state of South Carolina, the Pearl Fryar Topiary Garden has transcended racial, social, and economic barriers, making it worthy of preservation for years to come. In 2007, the Conservancy helped create and incorporate the Friends of Pearl Fryar Topiary Garden, whose mission is to help support the garden and its eventual transition into a public institution. The Conservancy employs a part-time gardener at the property and assists in its fund-raising and outreach.

Every year about five thousand visitors make their way to a small town in rural South Carolina just to see Pearl Fryar's fantastic topiaries. Beginning with only a hedge trimmer, a stepladder, and the light from a street lamp, Pearl devoted his time after work to transforming his three-acre property into a garden that has become a source of civic pride and an inspiration for the whole community.

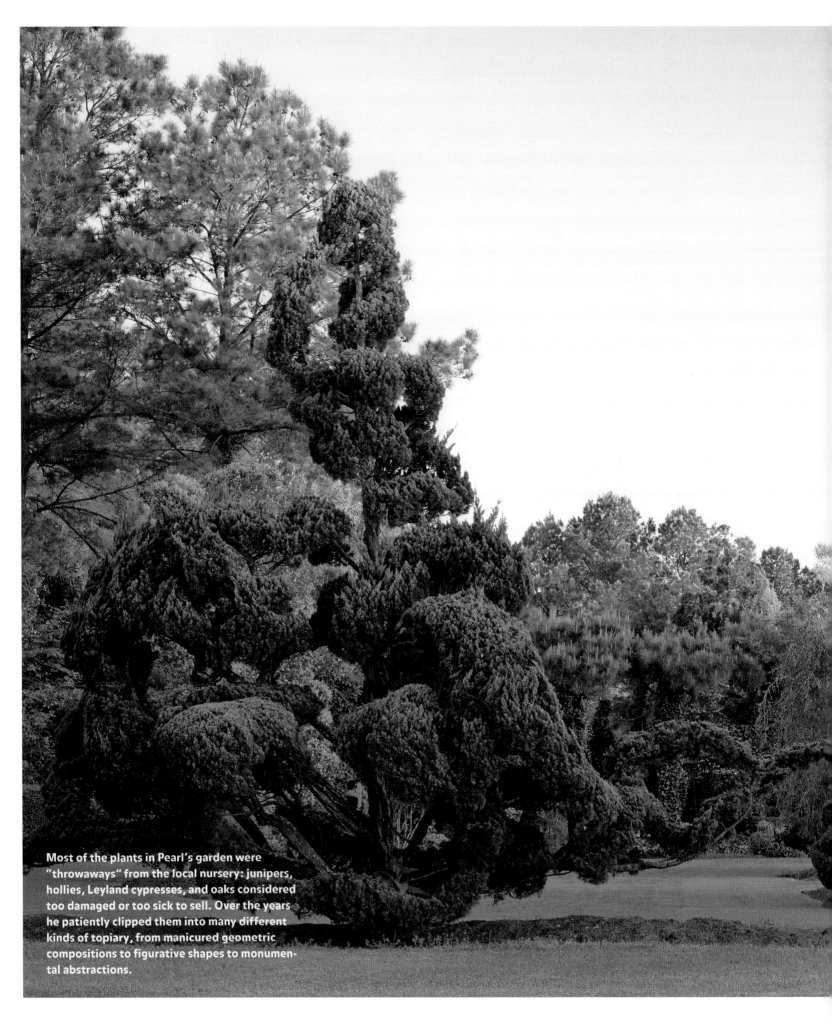

Most of the plants in Pearl's garden were "throwaways" from the local nursery: junipers, hollies, Leyland cypresses, and oaks considered too damaged or too sick to sell. Over the years he patiently clipped them into many different kinds of topiary, from manicured geometric compositions to figurative shapes to monumental abstractions.

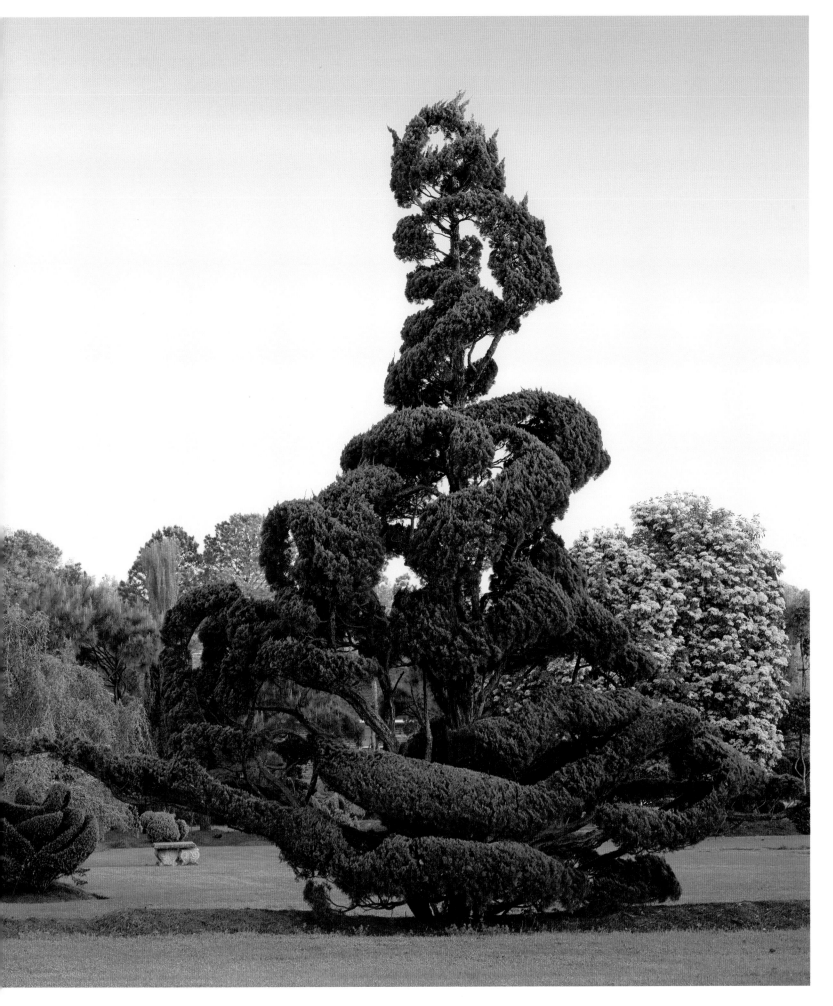

Peckerwood Garden

Hempstead, Texas

A painter and longtime professor of architecture at the University of Texas, John Fairey has made outstanding contributions to the science and art of gardening. His Peckerwood Garden is widely recognized for its original design, the extraordinary diversity of its plant collections, and its living demonstration of how to grow plants under challenging environmental conditions.

Peckerwood is, first of all, the consummate collector's garden. In his approximately one hundred botanizing expeditions to northeastern Mexico, John collected more than three thousand species, many of them either no longer found in the wild or threatened in their native habitat. He cofounded Yucca Do Nursery in order to make the best of these rarely cultivated plants available to the trade market and to individual gardeners. Thanks to his success in sharing his discoveries, a number of the plants he developed are now routinely used in gardens in the American South and Southeast.

Second, Peckerwood Garden's nine acres comprise three ecological zones—the piney woods, the coastal plains, and the Post Oak Savannah—which provide unusually varied growing conditions. From the shady banks of a spring-fed stream on one side to the intensely sunny, dry Texas climate on the other, the garden demonstrates techniques for cultivating plants capable of withstanding excessive moisture, drought, heat, and cold. Mounded beds of gravel hold plants from arid regions, woodland provides dappled shade for shrubs and perennials, and an arboretum displays rare trees grown from seeds gathered on expeditions to Mexico.

Finally, John's background as a painter trained him to see gardens as ever-changing patterns of textures, colors, and spaces. His garden follows the natural, shifting terrain, adjusting to the sun, soil, and wind in each environment. Brightly colored stucco walls and stone, steel, and wood structures punctuate Peckerwood, creating attractive settings for the plants and drawing the visitor's gaze through the garden.

In 1998, the Garden Conservancy designated Peckerwood Garden as a preservation project, citing its remarkable design, its plant collections, and its suitability as a leading public garden for Texas. Together with the Peckerwood Garden Conservation Foundation, the Garden Conservancy is working to maintain John Fairey's unique combination of rare plants and sustainable horticultural practices and their educational and scientific value for the public.

John Fairey's garden is widely known for its original design and the extraordinary diversity of its plant collections. Brightly colored stucco walls and stone, steel, and wood structures create a naturalistic setting for the plants.

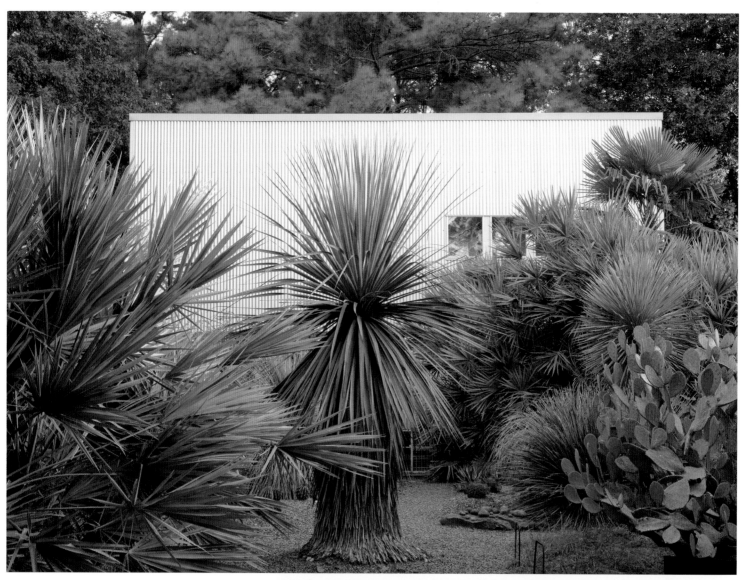

TOP During his many botanizing expeditions to northeastern Mexico, John collected over three thousand species. A number of the agaves, nolinas, and dasylirions he found are now growing in private gardens throughout the American South.

BOTTOM "Bambusa ceramica," an original work by Berkeley sculptor Marcia Donahue, emerges from the garden.

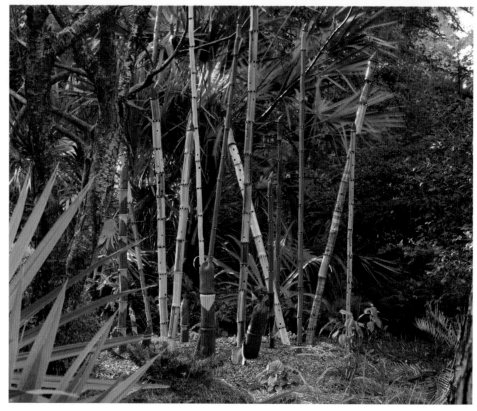

John planted these native Texan bald cypresses (*Taxodium distichum*) in 1974.

PRIVATE GARDENS

Open Days

We all learn from seeing other people's gardens. We might be struck by how a hedge is sheared into a swooping line, or a view that is revealed by a cut in the trees; we might be enchanted by a pot of Cape primroses on a terrace table visited by a hummingbird, or marvel at the gorgeous fruit of a previously unknown shrub. We come home thinking, "I need to be more imaginative with the line of my hedges," and, "Where can I enhance a view?" Or, "Maybe I should put my streptocarpus outdoors; I didn't realize it would attract hummingbirds," and, "I must Google that shrub and think where I could put it in my garden." By seeing different visions, different passions, different designs, we are inspired. As garden owners, too, we thrill to the sharing and collaboration that result from such exchanges with visitors.

The mission of the Garden Conservancy's national Open Days program is to bring together people and gardens for enjoyment, inspiration, and education. Twenty years ago, when it launched the Open Days program, the Conservancy published a small directory of 110 private gardens in the metropolitan New York region that would be open for a day. The event turned out to be a smashing success, and the program very quickly spread across the country. Since then, more than three thousand private gardens have participated in Open Days, welcoming more than a million visitors. Each year, nearly half the gardens are new to the program, a testament to the growing number of serious gardeners in America and their willingness to share their efforts with the public. The gardens vary in size and character, from small and intimate to large and imposing, from formal to naturalistic, from exceptional collections of plants to original and stunning designs. What follows is a sampling of these gardens.

THE MID-ATLANTIC

Cold if sunlit winters melt into glorious springs; hot, humid summers clear almost overnight into sparkling autumns. The weather that characterizes the mid-Atlantic region of the United States is dramatically varied, with wild fluctuations in temperature even within each season—the opposite of a temperate climate. It is, nonetheless, a beautiful place to garden. The inland landscape is primarily deciduous and lush with maples and oaks. With an average annual rainfall of forty inches and a temperature range typical of USDA Zone 6 and Zone 7, this countryside, often rolling with gentle views, nurtures a rich variety of native and nonnative plants.

The following examples of gardens in this region lie mostly in the metropolitan area around New York City, where the Garden Conservancy's Open Days program started—from the Manhattan exurbs to Long Island and the countryside of southern New Jersey. Fishers Island is included, too, as well as Pennsylvania, near the garden-rich Delaware Valley.

Ed & Vivian Merrin's Garden

Cortlandt Manor, New York

Ed and Vivian Merrin's one-story house is set high on ledge rock among oak trees and banks of venerable rhododendron and mountain laurel, *Kalmia latifolia*. From a stone terrace just outside the house, a dramatic, cantilevered lookout made of glass and wood affords a view of a small lake and the gardens below. Stone steps lead down through laurels to a graciously curved lawn backed by woodland and bordered by a rich variety of mostly specimen trees and shrubs, such as a large weeping beech and a handkerchief tree, *Davidia involucrata*. To one side of the mixed borders, a rock-bound pond is home to hundreds of lotus plants, their exotic blossoms of pink and white rising above circular leaves floating in the water. A Japanese zigzag bridge, or boardwalk, made of mahogany stitches its way through the lotus blooms for close-up gazing. A large pavilion, or "pond house," entwined with wisteria overlooks the water and is the romantic site of alfresco summer meals.

The seven-acre garden was developed with the expertise of landscape architect Patrick Chassé, and Ed is a hands-on participant. He is proud to show you the greenhouses where he keeps tropical plants in the winter and is sure to exclaim that he is just a man from Brooklyn, where he certainly didn't grow up knowing about flowers! Then he laughs and waves his hands and says, "But just look at me now."

Large pots of clivias brighten the entrance to the wisteria-shaded pavilion where Ed and Vivian Merrin entertain at summer meals.

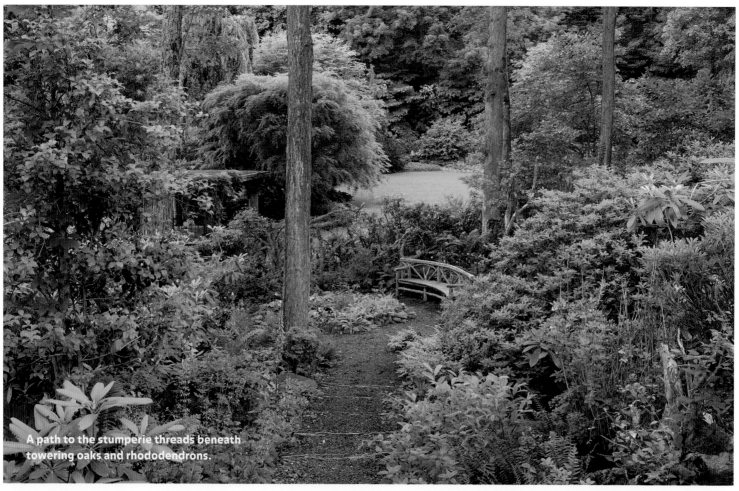

A path to the stumperie threads beneath towering oaks and rhododendrons.

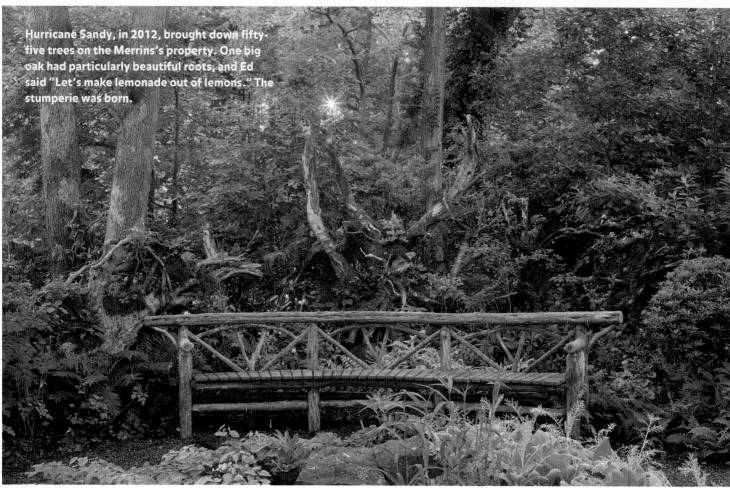

Hurricane Sandy, in 2012, brought down fifty-five trees on the Merrins's property. One big oak had particularly beautiful roots, and Ed said "Let's make lemonade out of lemons." The stumperie was born.

A purple-leaved redbud, *Cercis canadensis* 'Forest Pansy,' is underplanted with pink astilbes.

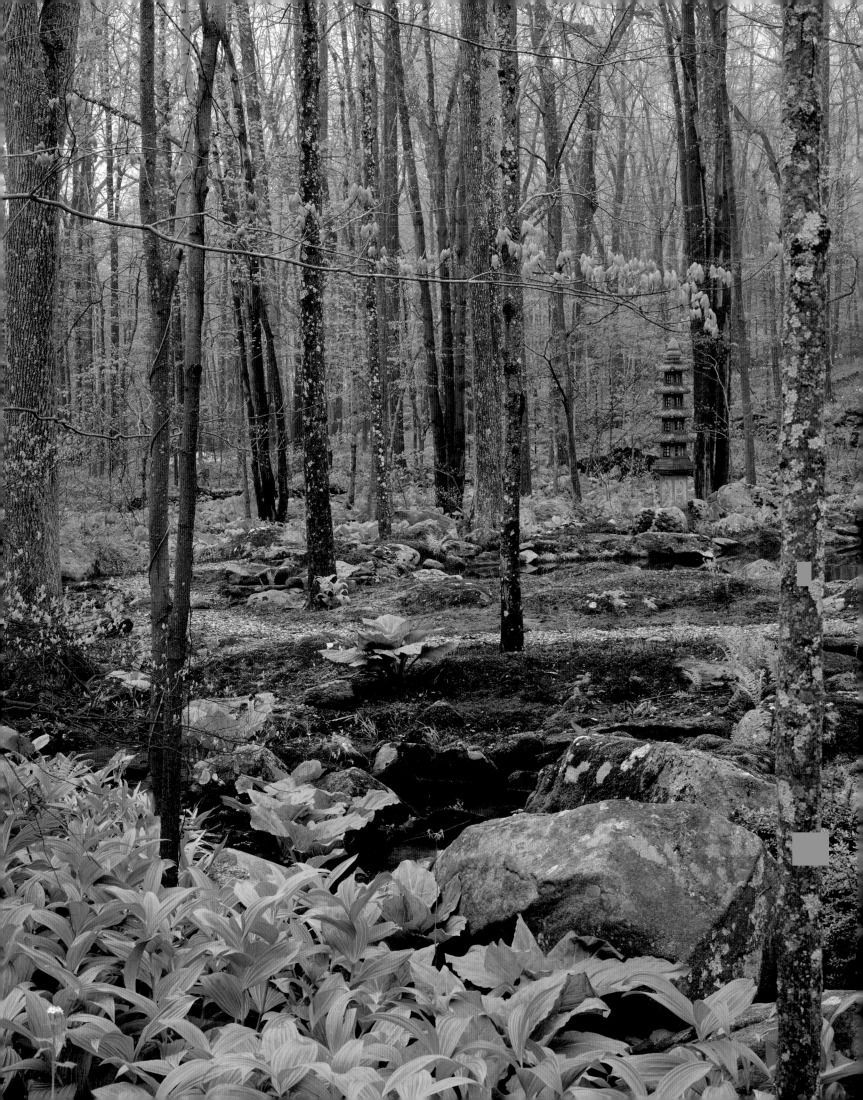

The White Garden

Lewisboro, New York

This garden welcomes visitors twice a year: in late April, when thousands of daffodils carpet the oak and hickory woodland, and in September, when the native plantings are richly mature and show hints of autumn. But there are classical conceits and water features that delight in every season. The forty-five-acre forest provides "a sacred grove" for the Greek Revival–style house, built of weathered, silvery-gray cedar, which is its centerpiece. Landscape architect Patrick Chassé, who designed the property, reminds us that, in Ancient Greece, most mountains were forested, and many of the temples we visit today in dramatically bare, deforested settings were, back then, embraced by greenery.

With humor and imagination, Patrick played with a classical template for the gardens nearest the house. The theater court, which serves as the entryway to the house itself, was modeled after Greek amphitheaters. Steps lead the visitor down to a circular space where granite stones radiate from a preexisting Renaissance well. Raised beds contained by granite curbs, like seating platforms, are backed by banks of rhododendron, out of which rise a pantheon of randomly collected busts—such notables as Caesar, Alexander the Great, Socrates, and Homer. The joke here, Patrick notes with delight, is that you, the visitor, are onstage, and all these notables are watching you. At one end of the house, a pergola that offers shade along a lap pool is made of white cedar from Maine, suggesting a primitive post-and-beam temple. There is a nymphaeum, or grotto, just below the pool with a circular window providing an underwater view (for the most part, without nymphs).

Water serves as the liquid "spine" of this landscape, running through the entire property in features as formal as the pool, its mirror-like quality enhanced by its four-sided illusion edge, and as naturalistic as a rock-strewn pond and waterfall with stepping-stones leading to the nymphaeum many feet below it. A sloping lawn descends from the back of the house to a larger pond, where a Temple of Apollo nestles on a small island. A moss garden in the woodland is home to the final water feature: a small pond, manmade but looking as if it has been there for centuries. Lichen-covered rocks are set around the pond, echoing the immense boulders already in the setting. A meandering stream bordered by bark paths feeds the pond, and native mosses carpet the ground in emerald-green right up to the water's edge.

Native *Veratrum viride*, called false hellebore or Indian poke, carpets the damp ground in the Japanese-inspired moss garden where a stone pagoda overlooks shallow, rock-bound pools of water.

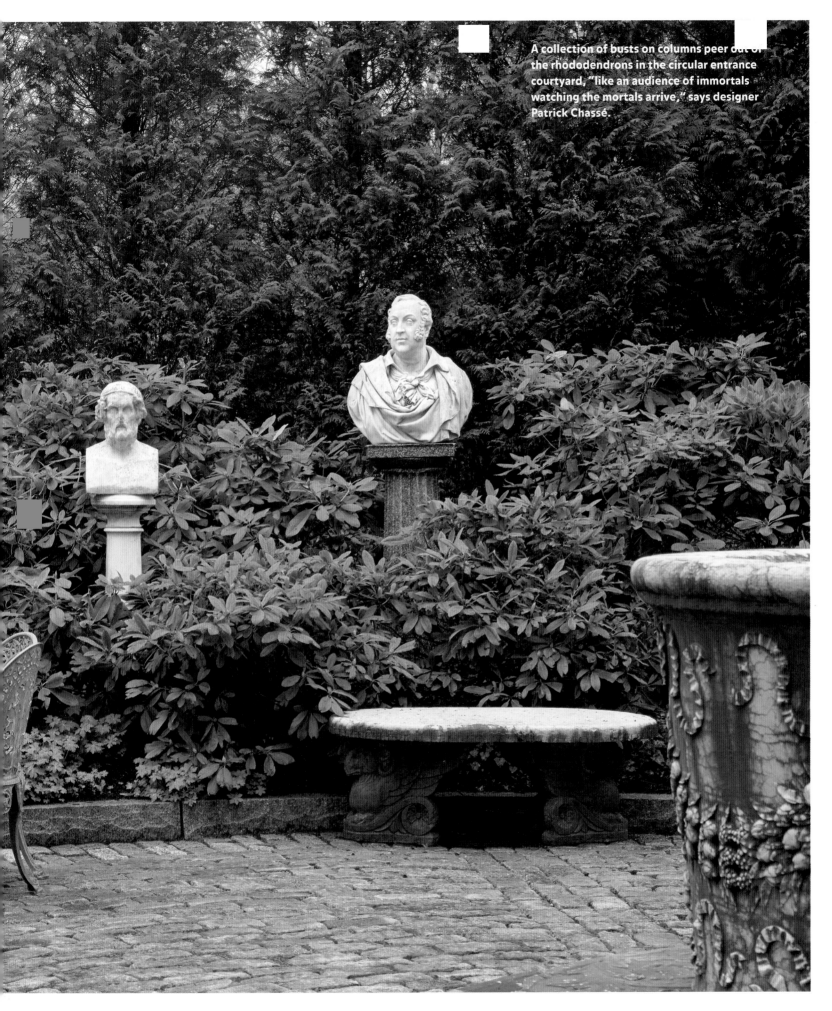

A collection of busts on columns peer out of the rhododendrons in the circular entrance courtyard, "like an audience of immortals watching the mortals arrive," says designer Patrick Chassé.

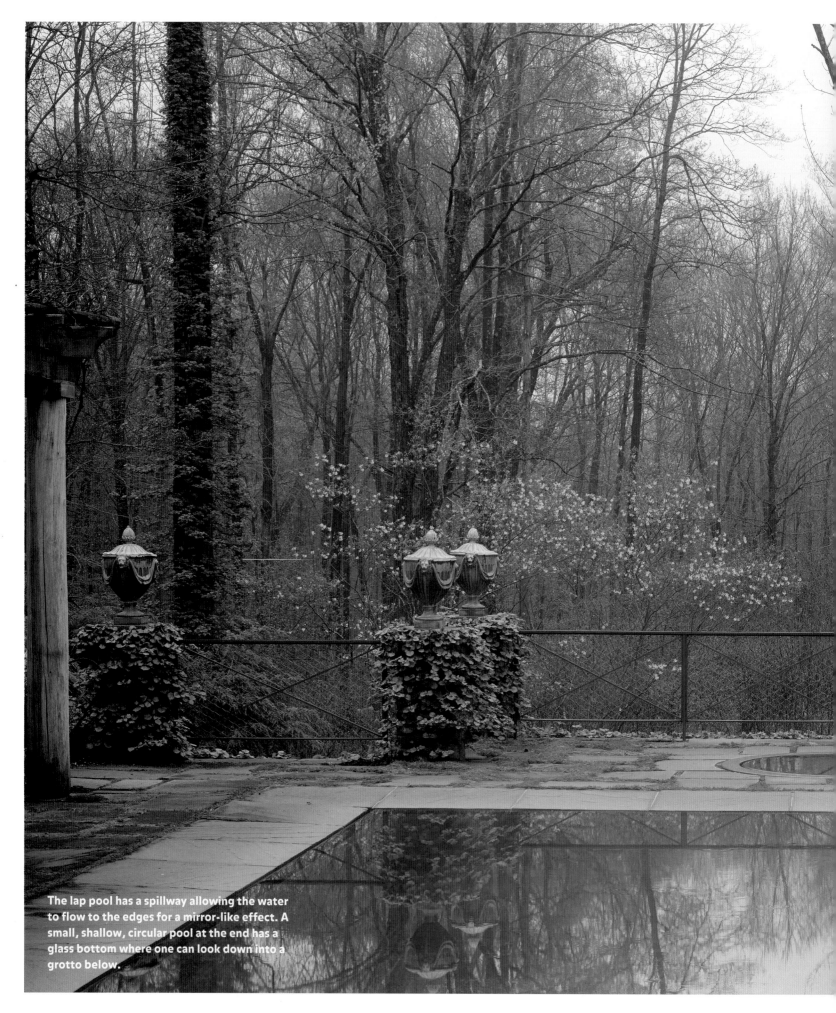

The lap pool has a spillway allowing the water to flow to the edges for a mirror-like effect. A small, shallow, circular pool at the end has a glass bottom where one can look down into a grotto below.

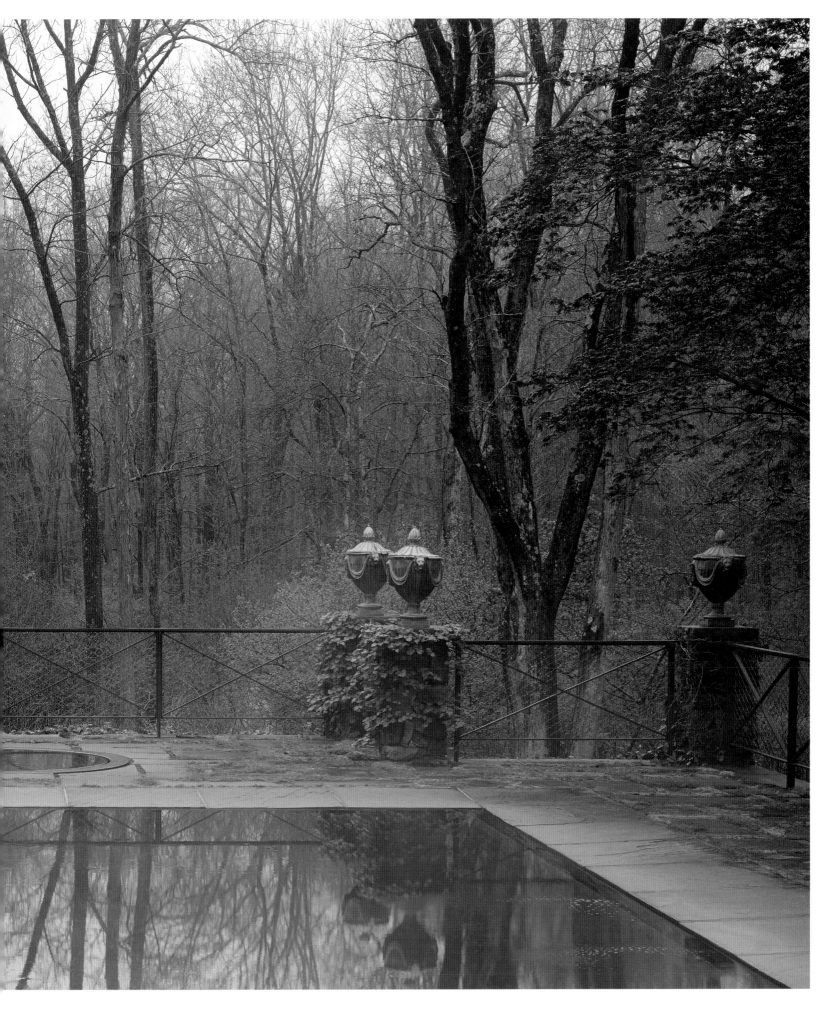

A smiling bust, topped by a pot of spilling flowers, greets visitors to Dick Button's hedged, double flower borders and is sometimes teasingly referred to as "Peggy Fleming on a bad-hair day" by the renowned ice skater.

Ice Pond Farm, the Garden of Dick Button

North Salem, New York

Dick Button's Ice Pond Farm of course features a pond—in this case, a historic and picturesque body of water in a woodland glade created by a stream dammed sometime in the nineteenth century to provide water and ice for the farmhouse that sits above it. (The ice was stored in a fieldstone house on the property.) How appropriate a home for a man who won two Olympic gold medals for ice skating and then went on to become a well-loved television commentator for international figure skating.

North Salem, a mile or two from the Connecticut border and sixty miles from New York City, was a thriving dairy town in the early nineteenth century. Its many open fields, once divided by rough walls of stones that the farmers had cleared for pastureland, remain remarkably intact today, although they are now more apt to be home to horses than cows. The land is rolling, and, because of its openness, it affords marvelous views and vistas. Nowhere do you understand the essence of this region's topography better than at Ice Pond Farm. From the farmhouse terrace you see across a valley to distant meadows framed by sugar maples and locust trees, with stone walls threading up the hills like stitching on a quilt. The great see-through sliding doors of the upper barn, kitty-corner to the house, establish the central axis of the gardens Dick has developed over the years. From there, your eye leads you to a central grass path through ebullient plantings of perennials and annuals backed by clipped arborvitae hedges, then on to a bocce court shaded by an allée of crab apples.

The long vista continues along a mowed path through high grass to a wooden farm gate. Beyond the gate lies another field, where Dick plays with the idea of setting a summer- house, or folly, to stop the eye. He now admits that, at age eighty-five, he has given up "on trying to do a five-story tower consisting of a run-in shed, under a hayloft-dining room with a chandelier and a table for two, under a pigeonniere . . . under a clock tower, under a bell tower," inspired by Frank Cabot's dovecote at his garden, Les Quatre Vents, in Quebec.

Throughout Dick's garden are references to skating. A golden skate appears on a gatepost in the flower borders. Off the double borders, the visitor steps down into a small circular garden through iron gates designed with looping figures from nineteenth-century figure skating. Knots of miniature boxwood are laid out in connecting circles, representing skating figures, and are planted with a ground cover of black ajuga to symbolize black ice. At the far end of a cross axis, an old stone well cover is set on end. Dick calls it, "Watch out for the hole in the ice."

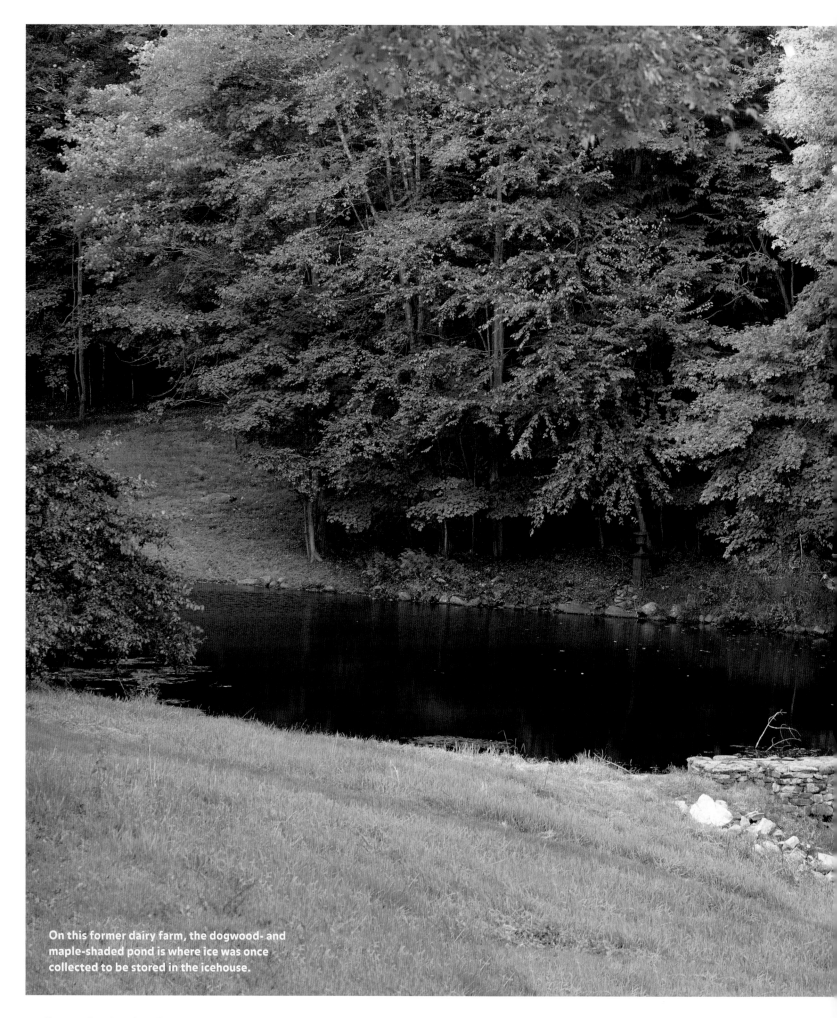

On this former dairy farm, the dogwood- and maple-shaded pond is where ice was once collected to be stored in the icehouse.

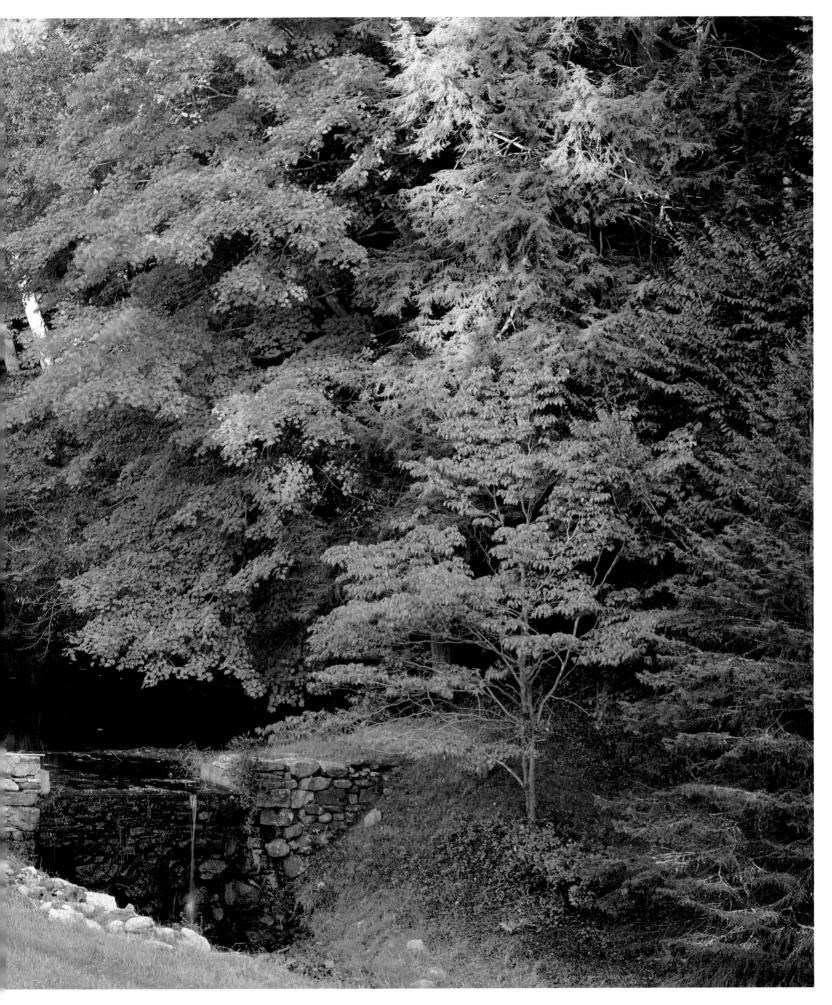

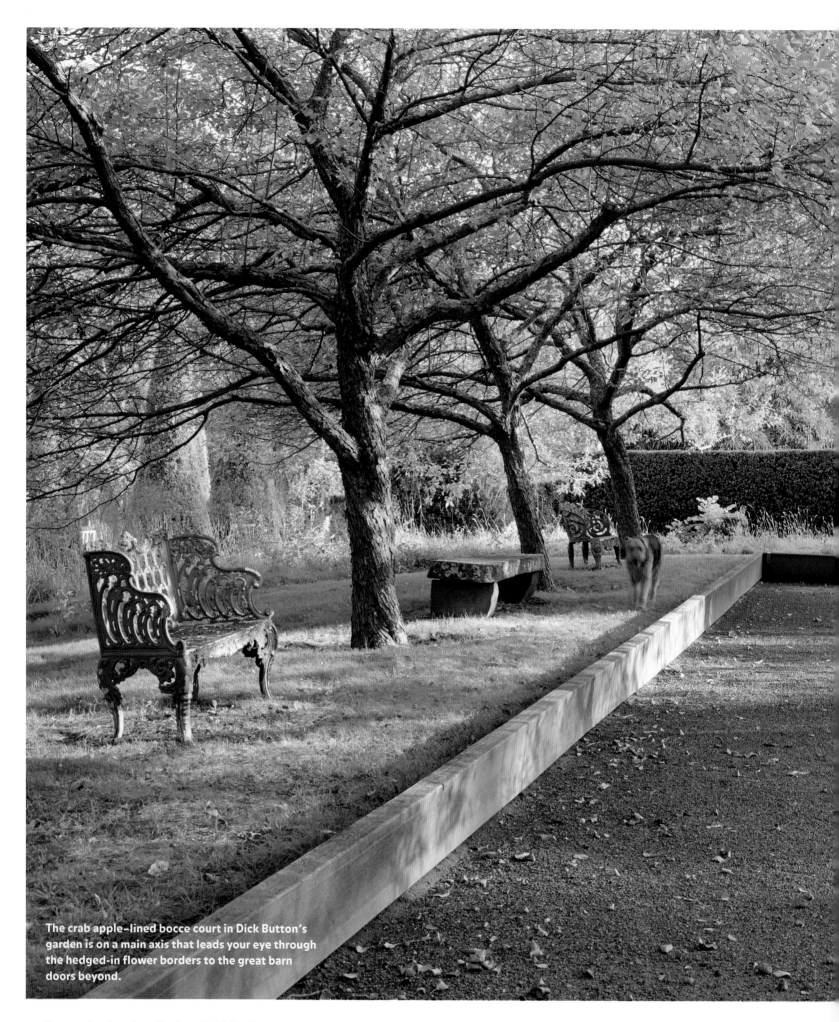

The crab apple–lined bocce court in Dick Button's garden is on a main axis that leads your eye through the hedged-in flower borders to the great barn doors beyond.

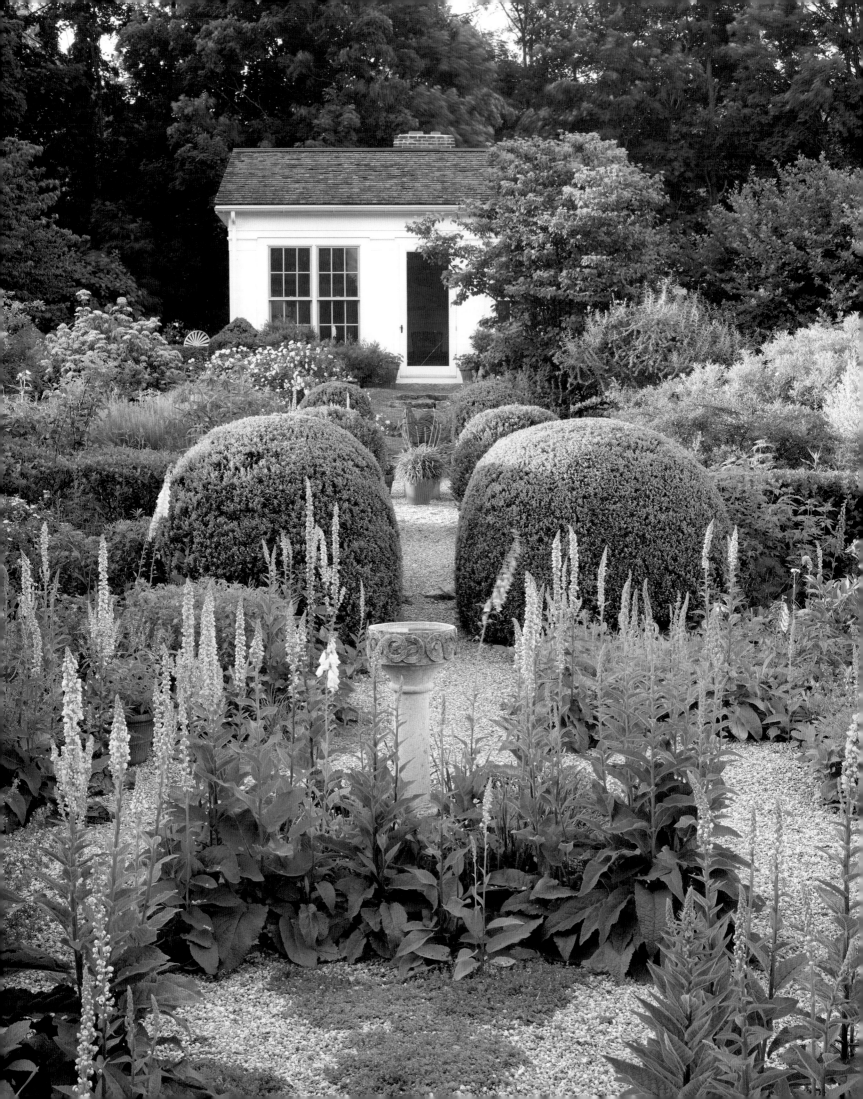

Duck Hill, the Garden of Page Dickey & Bosco Schell

North Salem, New York

A walk through several hayfields and up a dirt road will lead you from Dick Button's Ice Pond Farm to Duck Hill. Owned and gardened by Page Dickey and Bosco Schell, it is a small property in comparison—barely three acres—but it quietly opens up in back to a large preserve of meadows and woods that welcomes walkers and horseback riders. The 1840s farmhouse, originally part of a large dairy property, is today surrounded by a series of hedged-in gardens that are formal in outline, rather prim, like the old house, but containing an exuberant mixture of plantings. Great old boxwoods, many planted thirty-some years ago, are the soul of the garden, repeated like sentinels in the separate enclosures. The hedges—of privet, lilac, cornus, box, and hemlock—are clipped into a horizontal line and serve as a contrast to the rather wild mixture of flowering shrubs, crabapples, perennials, bulbs, and ground covers within their strictures.

To the west of these gardens, a path meanders along the perimeter of the property, shaded by sugar maples, locust, dogwood, and shadblow, and is home to woodland flowers, shrubs, and bulbs. Spring starts here with the vernal witch hazel blooming as early as February, along with carpets of snowdrops, winter aconites, and hellebores. "This is my favorite place to be in April and May, when a succession of delicate spring ephemerals (bloodroot, Jeffersonias, anemones, trilliums) bloom with epimediums, hellebores, and drifts of spring phlox," Page confesses. Later in the season, she and her husband are more apt to be found in the vegetable-cutting garden at the end of the woodland path, where spring lettuces and Shirley poppies give way to summer's tomatoes and dahlias. They are serenaded there by the clucks of chickens whose run surrounds the garden on two sides, radiating from a small clapboard Greek Revival temple, which is their house, and the folly around which the garden was built. An old fenced paddock by the barn is the final feature of the garden, no longer enclosing grazing horses but instead a lap pool, arbor, and native meadow. The split rails and posts, now clothed with chicken wire, support wildly arching canes of species roses and small-flowered clematis. Horticulturist Hugh Johnson once wrote, "The more you divide up a space, the bigger it becomes." In such a way, Duck Hill gives the illusion of being a larger property than, in fact, it is.

White and yellow *Verbascum chaixii* seeds in the gravel paths of the herb garden at Duck Hill. Steps and more gravel lead past a stone rooster to the Boscotel, Bosco's one-room house.

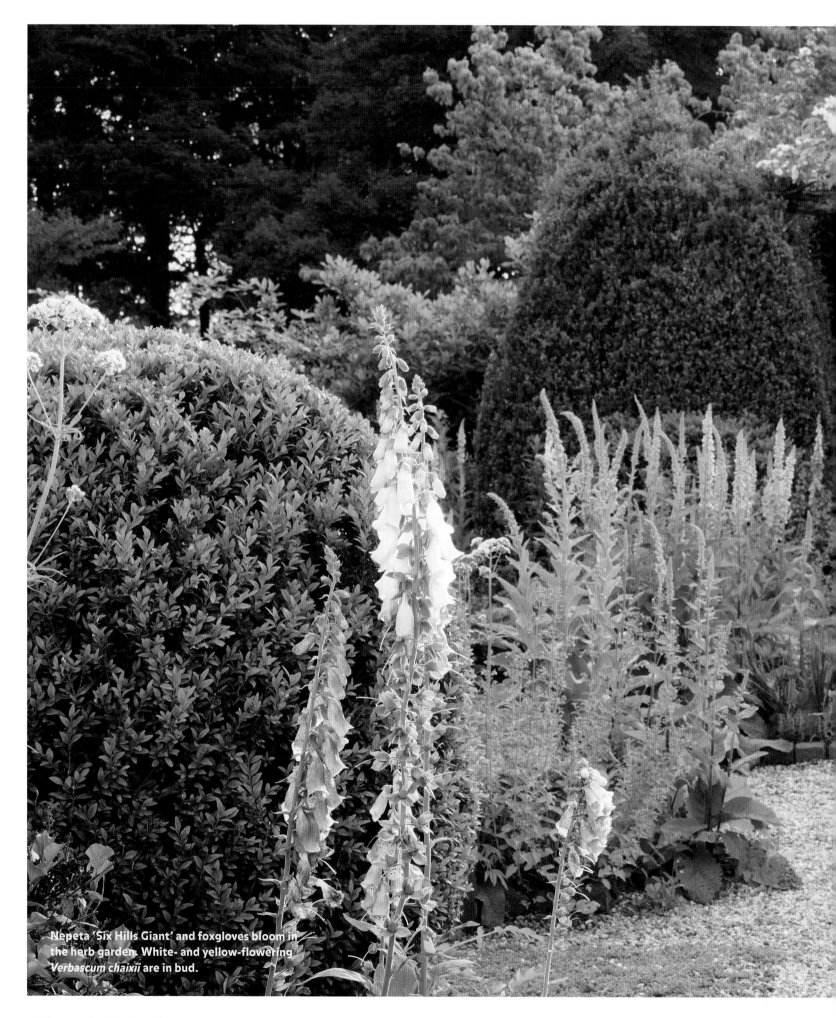

Nepeta 'Six Hills Giant' and foxgloves bloom in the herb garden. White- and yellow-flowering *Verbascum chaixii* are in bud.

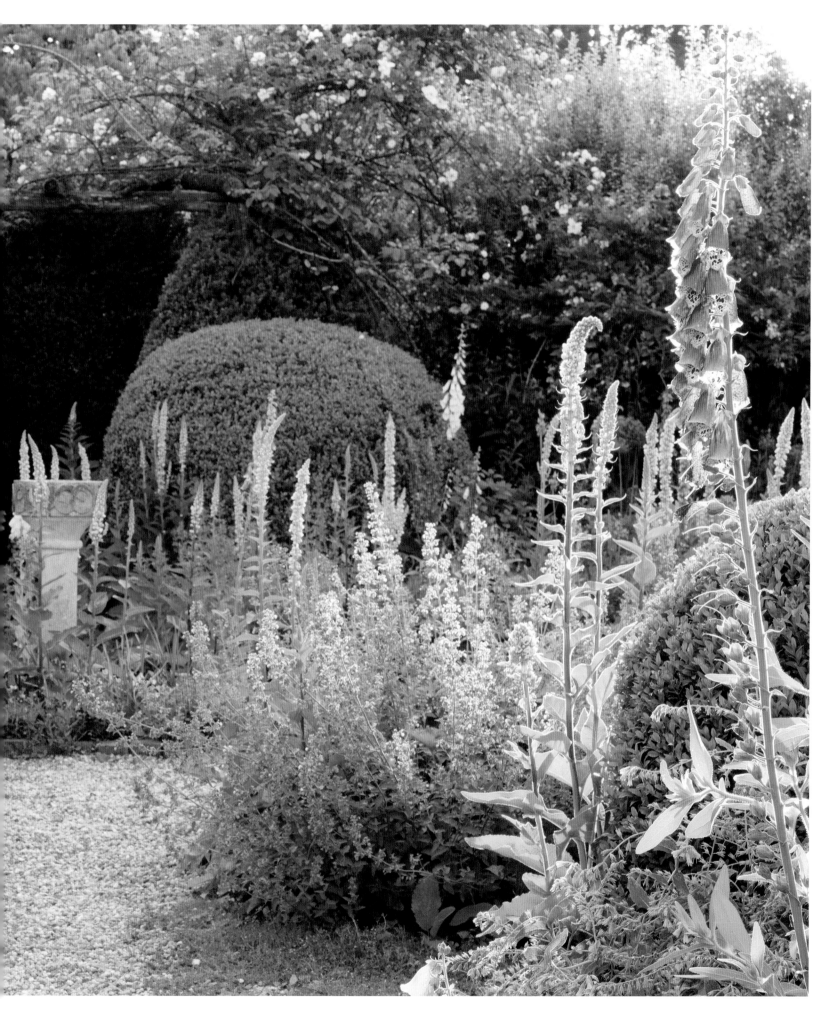

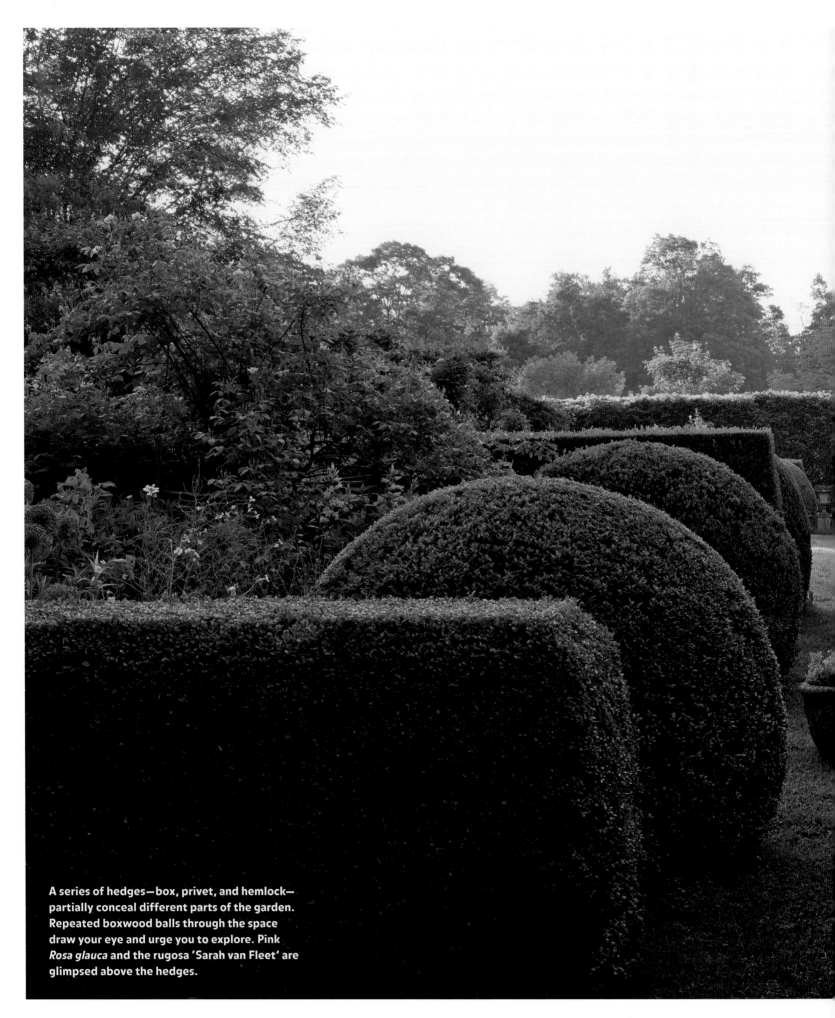

A series of hedges—box, privet, and hemlock—
partially conceal different parts of the garden.
Repeated boxwood balls through the space
draw your eye and urge you to explore. Pink
Rosa glauca and the rugosa 'Sarah van Fleet' are
glimpsed above the hedges.

An Oehme, van Sweden Garden

Westchester County, New York

The architect Elizabeth Demetriades designed this contemporary house of glass, bluestone, zinc, and wood to radiate warmth and light in its pastoral setting fifty miles north of Manhattan. The owners called in Eric Groft of the landscape design firm Oehme, van Sweden & Associates even before construction began to work with Demetriades on the siting of the house within the landscape. They decided to nestle the house into a slope between a knoll and a natural stretch of rock outcroppings, where it would have a protected entrance on one side and ravishing views of fields dotted with old maples, oaks, and dogwoods on the other. A generous platform of bluestone terraces extends from the house on these two long sides. On the very private western side of the house, vast windows outlined in mahogany look out onto the rock outcroppings and gently undulating meadows beyond. On the eastern side of the house, where the front door is situated, bluestone squares stretch out to the knoll, creating an entry garden and dining terrace. Here, a raised rill of water spills into a small rectangular lily pond adjacent to the house.

All the geometry of the terraces, as well as the linear outlines of the residence itself, are softened by luxuriant sweeps of grasses and perennials—one of the signatures of Oehme, van Sweden's style. Eric Groft massed the graceful Japanese forest grass *Hakonechloa macra* to seemingly spill down the knoll to the entry terrace, partially shaded there by an old oak tree. Shrubby *Stranvaesia davidiana* 'Prostrata' handsomely edges the terrace by the entrance, along with a stretch of Russian sage (*Perovskia atriplicifolia*) and low-growing asters. Creeping thymes thrive in the cracks of the bluestone paving. Groupings of winterberries (*Ilex verticillata*) and stretches of switch grasses (varieties of *Panicum virgatum*) relate the house and its terraces to the setting of the fields beyond.

The view from a window in the master bath frames a layered planting typical of the landscape firm Oehme, van Sweden. *Hakonechloa macra* **'Aureola,' is massed in front of ferns and white Japanese anemones, which glow against the burgundy autumn foliage of a native dogwood,** *Cornus florida.*

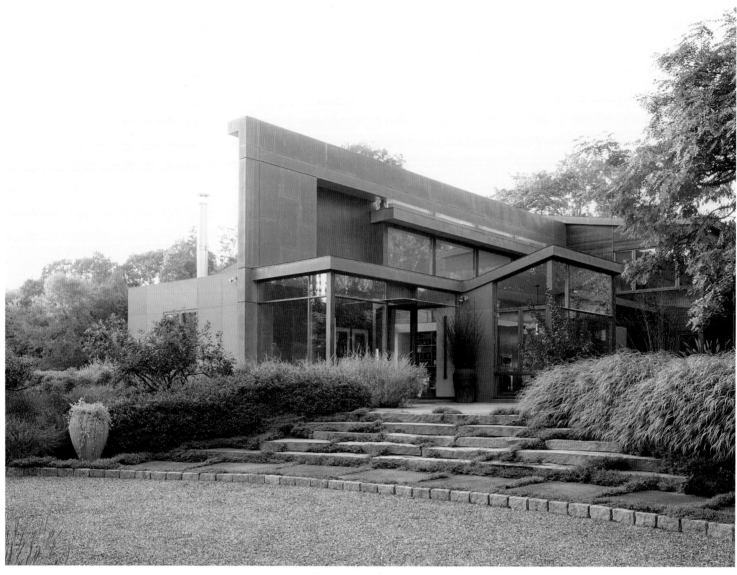

ABOVE Thyme-softened stone steps bordered by *Stranvaesia davidiana* 'Prostrata' on one side and *Hakonechloa macra* on the other, rise to a blue-stone terrace in front of the glass and bluestone house designed by Elizabeth Demetriades.

RIGHT On the back terrace, a wooden bench sets off massed plantings of *Aster oblongifolius* 'October Skies' and *Persicaria amplexicaulis* 'Firetail.' The flower plumes of *Panicum virgatum* 'Dallas Blues' can be seen in the background.

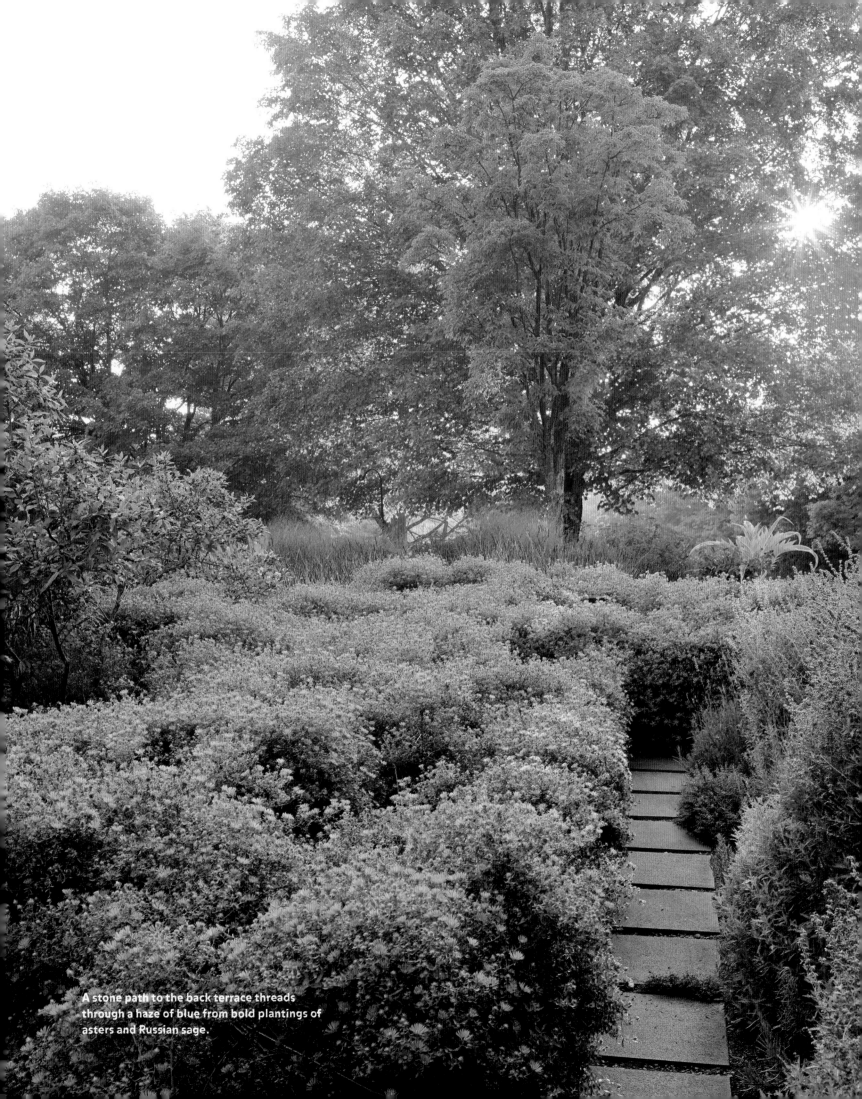

A stone path to the back terrace threads through a haze of blue from bold plantings of asters and Russian sage.

Iroki, the Garden of Judy & Michael Steinhardt

Mount Kisco, New York

Iroki, one of the most extravagant and whimsical gardens in the Open Days program, was created by Judy and Michael Steinhardt on their fifty-eight-acre estate in New York's Westchester County. Twice a year, in the late spring and in the fall, as many as 1,500 visitors—including hundreds of children—come to wonder at a real-life fantasy that combines a menagerie of exotic birds and animals with an encyclopedic collection of rare plants from all over the world.

To children, the Steinhardts' garden must look like a fabulous farm from a storybook. It has two barns for the livestock, rustic stone buildings, fieldstone walls, and a large greenhouse. Instead of cows and chickens, however, the farm animals here include antelopes, camels, zebras, and an aviary of exotic birds such as the Egyptian ibis and Siberian crane. The open-air "stick house" folly is another fantastic feature; others are the rope, moss, and Chinese bridges crossing the brook.

For plant lovers, the garden paths lead from one magical moment to the next. All the diversity of the plant kingdom is represented in the yellow garden of variegated foliage, the collection of conifers, the orchards with three hundred different fruit trees, the camellias and alpines, the ornamental grasses, and the perennial, vegetable, and cutting gardens.

The Steinhardts take special delight in their astonishing Japanese maple grove, planted with more than four hundred trees and counting. Every fall, the trees put on a stunning display of color—burning reds, yellows, oranges, and purples—especially exquisite when they are backlit by the low autumn sun.

Judy and Michael are very involved with the design and maintenance of Iroki. Michael pores over nursery catalogues, makes cross-country trips to purchase plants, and surveys the enterprise year-round, and he enjoys himself immensely doing so. "The idea," Michael sums up, "is to make it joyous."

Iroki welcomes 1,500 visitors, many of them children, on its two Open Days a year. The Steinhardts' remarkable collection of Japanese maples is a special attraction in the fall, when the mossy grove of trees put on a stunning display of red, yellow, orange, and purple foliage.

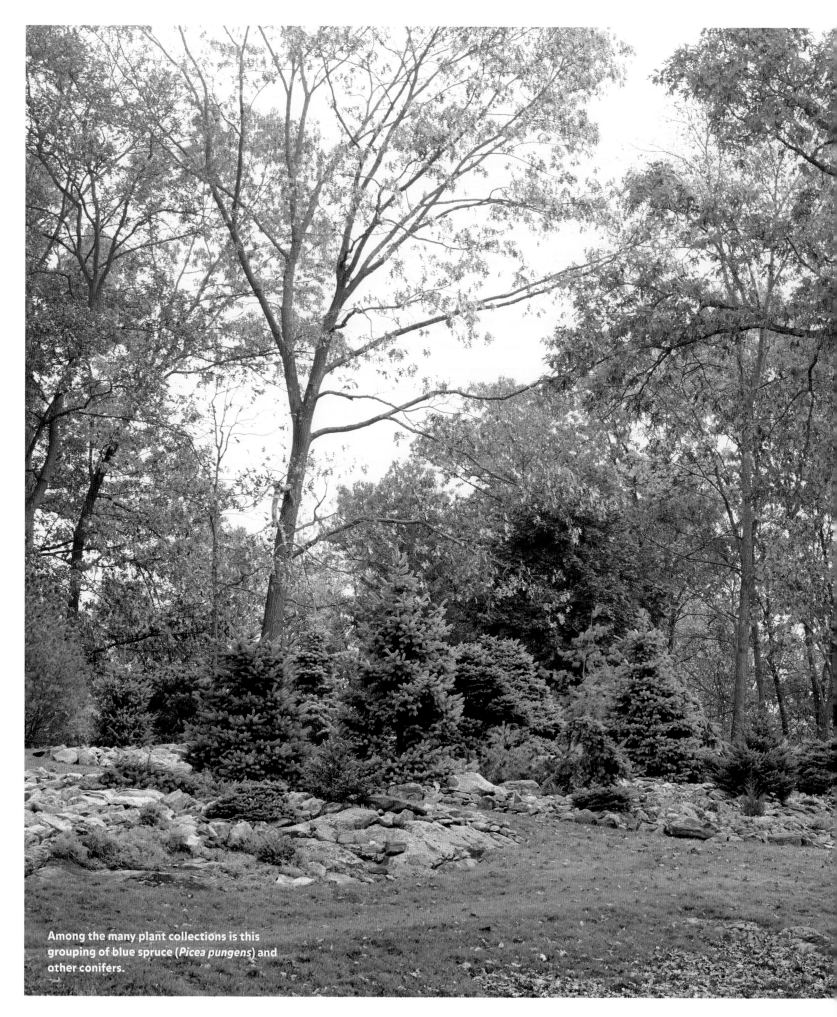

Among the many plant collections is this grouping of blue spruce (*Picea pungens*) and other conifers.

TOP Iroki is known for its spectacular Japanese maples. This *Acer palmatum var. dissectum* awaits a new home around a developing koi pond.

BOTTOM A menagerie of llamas, antelopes, camels, and other exotic animals delight children and grown-ups alike during their visit.

TOP The property has ponds full of exotic fowl.

BOTTOM Here a surprising Chinese bridge crosses the brook that runs through the property.

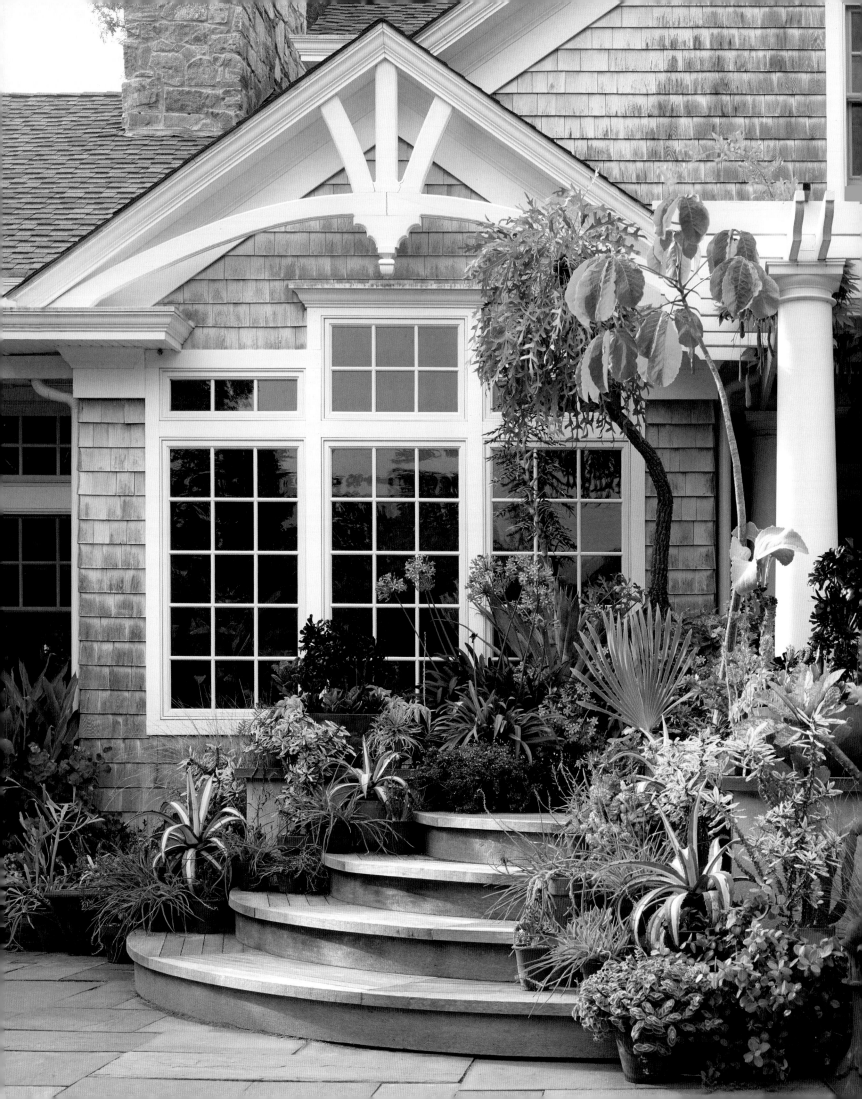

Landcraft Environments

Mattituck, New York

Dennis Schrader and Bill Smith are passionate collectors of tropicals, subtropicals, and annuals, which they display in their garden and sell at their wholesale nursery, Landcraft Environments, on the North Fork of Long Island. They cultivate warm-weather plants to flourish in a cold-weather environment.

Thousands of years ago, huge glaciers moved southward from New York and New England, picking up and transporting vast amounts of sediment to form terminal moraines at their outer edges. When the ice melted, one of these moraines became the North Fork of Long Island, with a loam so rich that putting a spade into it has been described as "digging into chocolate cake." The North Fork's sheltered location between Long Island Sound and Peconic Bay brings mild winters and hot summers ideal for growing fruits and vegetables. Farmers have raised crops here since colonial times, and today the fields continue to be planted with potatoes, corn, and fruit trees. The North Fork's rural character is still evident in its flat, open landscape, much of which is being converted into nurseries and vineyards.

In contrast to its setting among straight green rows of vegetables and vines extending to the horizon, Schrader and Smith's garden explodes with color, texture, and movement. Pots of rare begonias, agave, and other exotic plants climb the stairs to the porch of their 1840s farmhouse and decorate the terraces. Layered views go from a formal boxwood parterre to a double perennial border, to a meadow of native plants and grasses, to the tree line beyond. The visitor moves from the lawn around the house along paths opening to a series of garden experiences: vibrant perennial borders enclosed by hornbeam hedges, a vegetable and herb garden, natural ponds planted with water lilies and papyrus, and a shady woodland. The large meadow is alive with the movement of swaying grasses and the songs of birds. Frogs splash in the ponds, and lizards skitter around the walls. And there is more to come—a "ruin" garden is being created.

Dennis Schrader and Bill Smith created a wholesale nursery at their home on the North Shore of Long Island. Pots of rare begonias, agaves, agapanthus, and other warm-weather plants decorate the porch steps of their 1840s farmhouse.

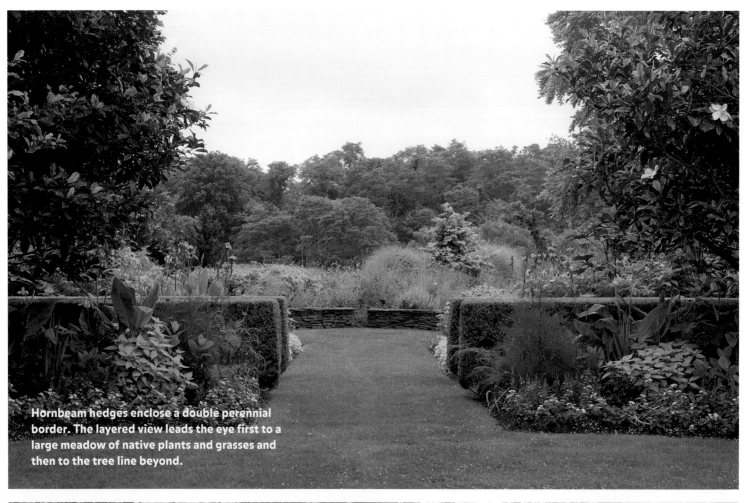

Hornbeam hedges enclose a double perennial border. The layered view leads the eye first to a large meadow of native plants and grasses and then to the tree line beyond.

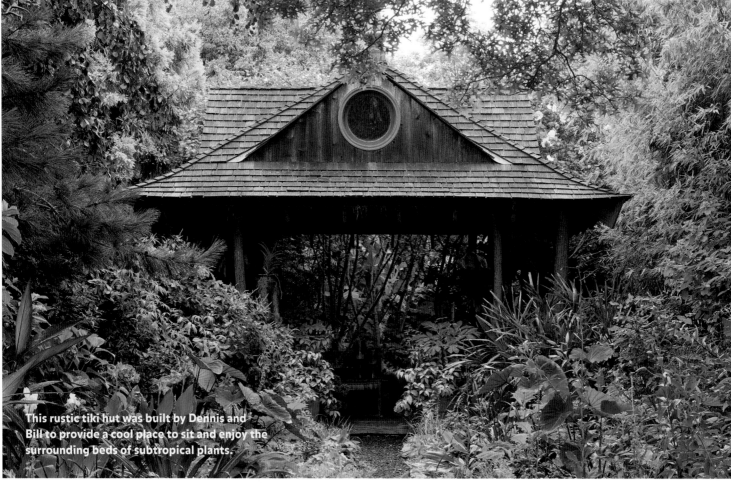

This rustic tiki hut was built by Dennis and Bill to provide a cool place to sit and enjoy the surrounding beds of subtropical plants.

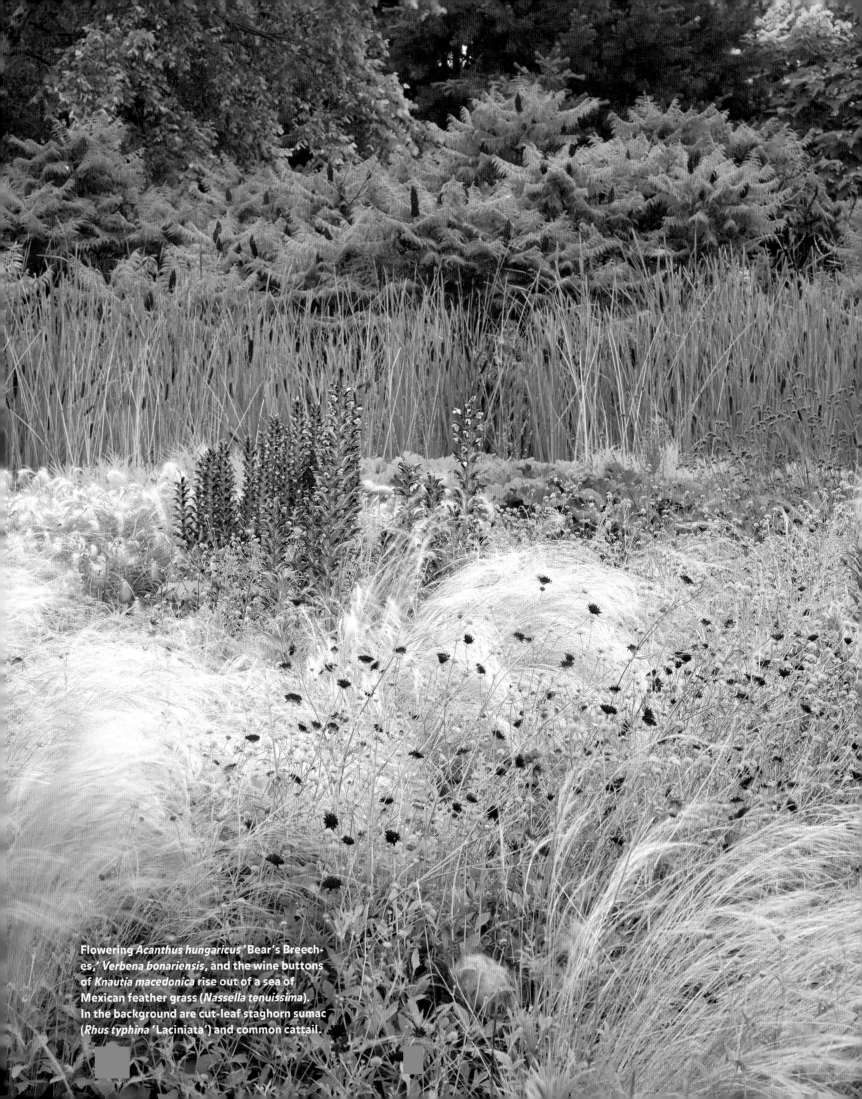

Flowering *Acanthus hungaricus* 'Bear's Breeches,' *Verbena bonariensis*, and the wine buttons of *Knautia macedonica* rise out of a sea of Mexican feather grass (*Nassella tenuissima*). In the background are cut-leaf staghorn sumac (*Rhus typhina* 'Laciniata') and common cattail.

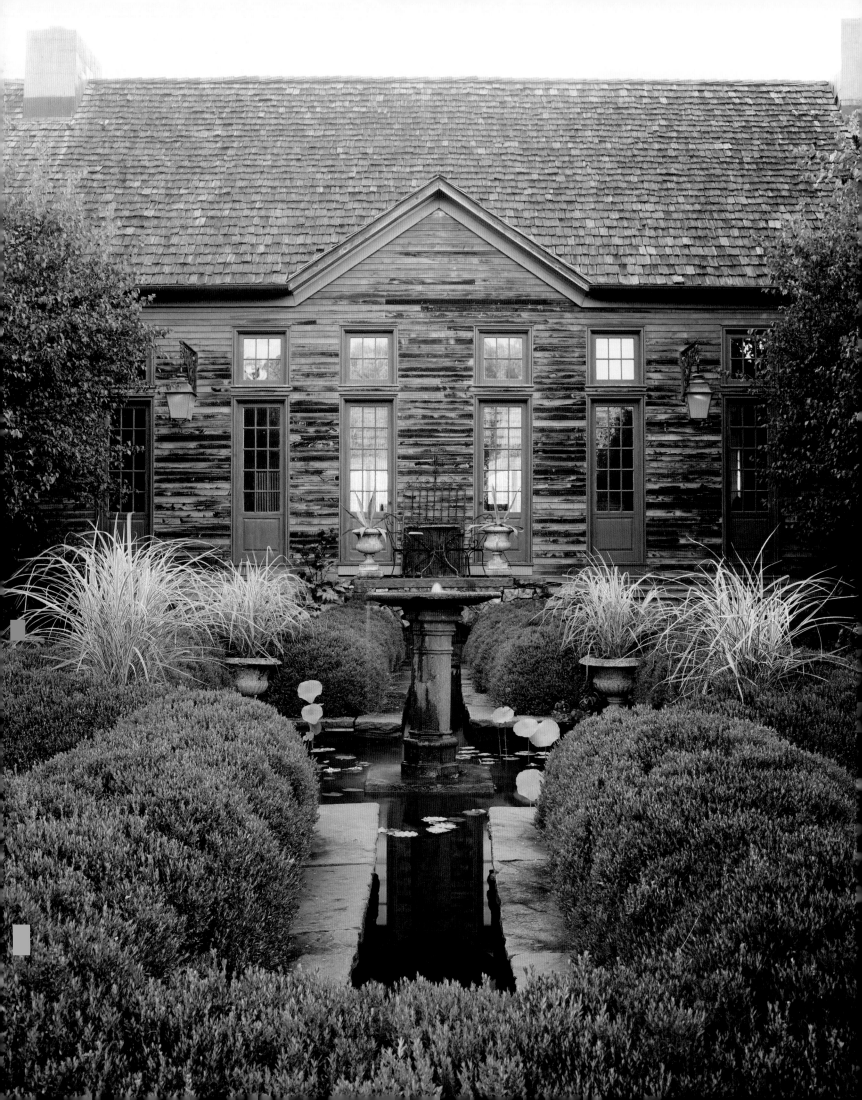

The Garden of Andrea Filippone

Pottersville, New Jersey

Andrea Filippone is a plant collector with a brilliant eye for design. She collects boxwood from around the world and is a renowned authority on its culture and use. Boxwood is the recurring presence—the heart of her garden. Allées and hedges of box define the many enclosures, or "rooms," surrounding her eighteenth-century dairy farm in the heart of New Jersey's Hunterdon Country.

Four barns were all that remained on the thirty-five-acre farm when Andrea and her then-husband, William Welch, took on its renovation twelve years ago. The barns were soon linked to become a home and showroom for the salvaged architectural treasures they acquired, and the buildings serve as a background for the plantings just outside.

The gardens closest to the barn/house complex are structured around three courtyards formed by the barns, stone walls, and boxwood. A stone parking court leads to the entrance of the house within a west courtyard, adjacent to a formal, sycamore tree and boxwood garden off the kitchen. Pots and vases of striped agaves on either side of the door, and in the center of the garden, contrast in shape and color with the box hedging. An eastern court features a long, narrow, Persian-inspired pool edged in the soft mounds of 'Justin Brouwers' boxwood. 'Justin Brouwers' is one of Andrea's favorite cultivars of box, for it is low-growing and graceful and does not need clipping. Severe and repeated clipping, she says, is detrimental to boxwood, causing it to become too dense, with not enough air and light coming through it to promote healthy growth. Andrea keeps her box bushes—in fact, all her plantings, including her lawns—healthy with servings of compost and compost tea and uses no other fertilizers or chemicals. She has recently joined forces with Eric T. Fleischer, a Manhattan-based expert on soil health, to use these compost mixes to renovate gardens for clients.

Other features on the farm are a fanciful potager with borders of nepeta and alliums, an impressive greenhouse salvaged from nearby Rutgers University, and a boxwood nursery tucked behind a cowshed. Andrea says, "The overall aesthetic was trying to find a balance between the things we love—the French formal boxwood gardens, English borders, and the informal play of trees and allées—that merge the formal grid [with] a much more informal sense of an American country landscape."

The low-growing boxwood 'Justin Brouwers' makes a soft, natural border around the Persian-inspired water feature seen from the windows of Andrea Filippone's house.

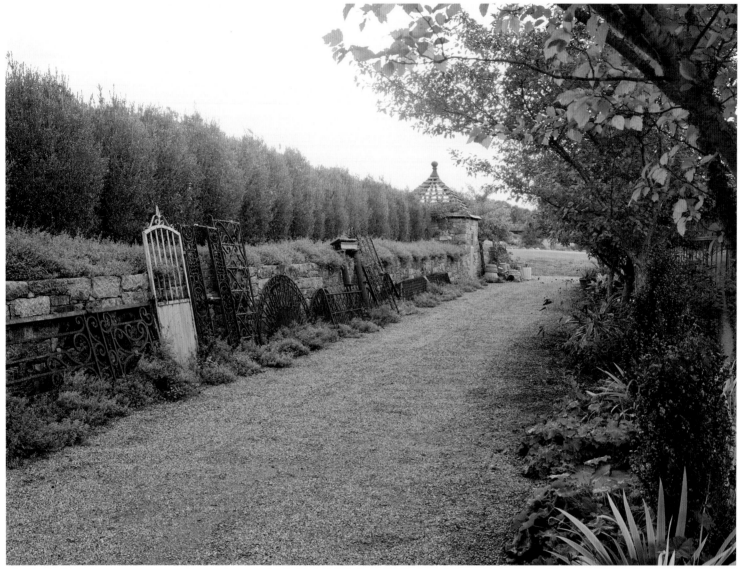

TOP Architectural fragments temporarily line a wall.

BOTTOM A passion for boxwood led to an active involvement in boxwood societies worldwide and a box nursery behind the cowshed. All Andrea's bushes are grown organically, fed with her own richly-made compost, and free of boxwood blight.

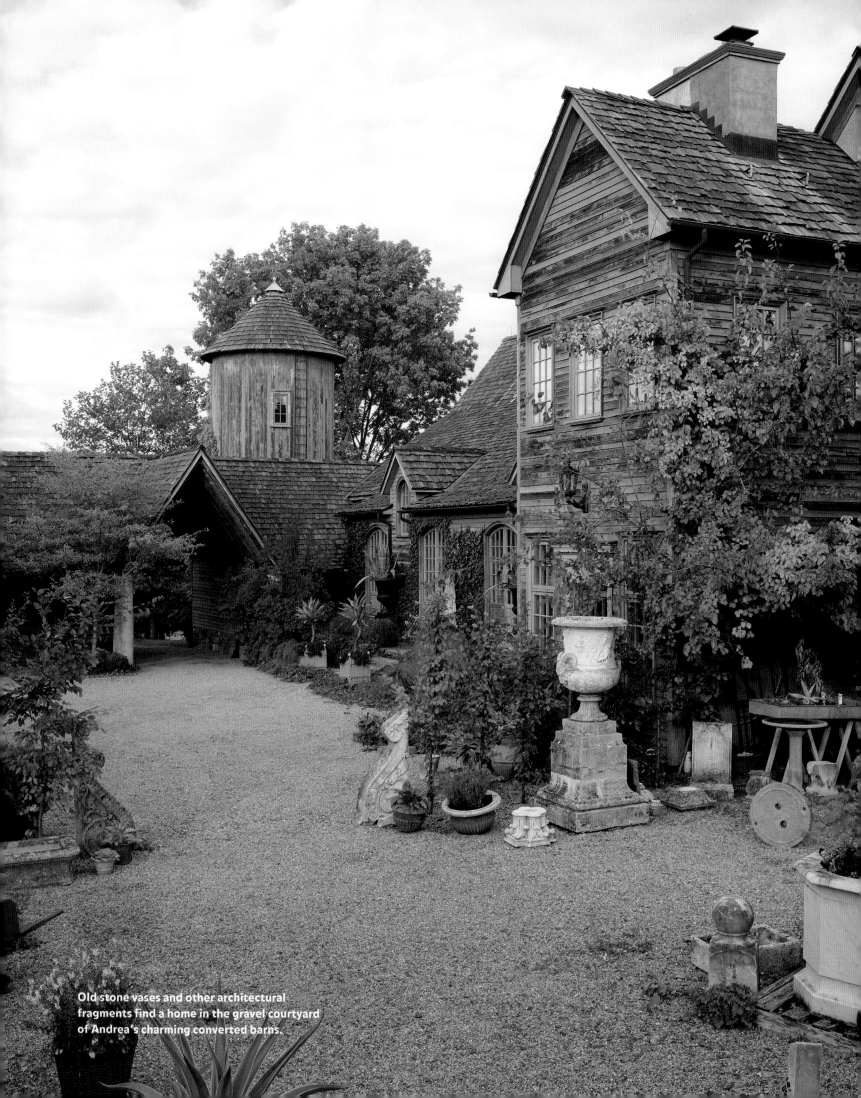

Old stone vases and other architectural fragments find a home in the gravel courtyard of Andrea's charming converted barns.

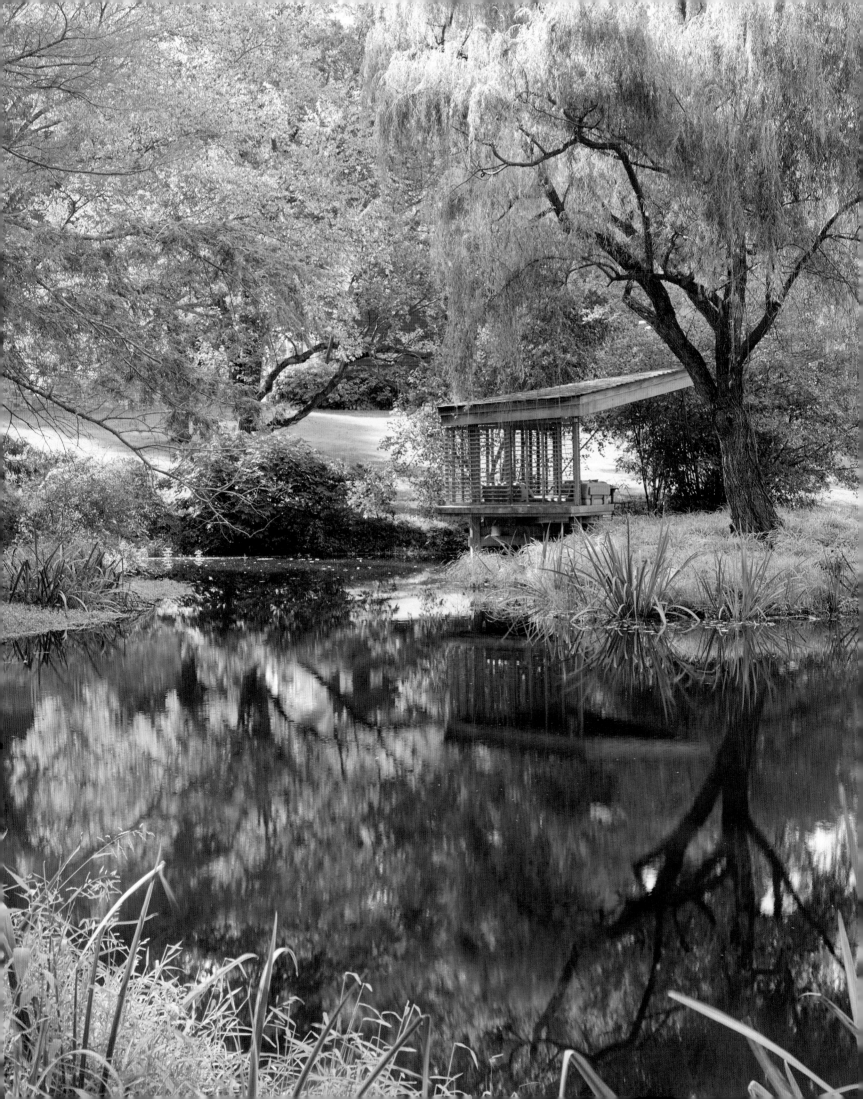

Bird Haven Farm, the Garden of Janet Mavec & Wayne Nordberg

Pottersville, New Jersey

Bird Haven Farm, the New Jersey home of Janet Mavec and Wayne Nordberg, is set in an open valley surrounded by a forest of ash, oak, and beech. The original, nineteenth-century stone house was linked with a contemporary house designed by Smith-Miller+Harkinson in the 1990s and, more recently, was extended to accommodate a guesthouse designed by the architects Parsons+Fernandez-Casteleiro. Old barns and an original stone icehouse face the residence, creating a large courtyard-like space. In 2002, a garden master plan was drawn up by Spanish landscape architect Fernando Caruncho to give visual clarity to this cluster of disparate structures. A generous gravel terrace is now the setting for an exquisitely simple round pool, which acts as a focal point for the buildings around it. Banks of mounded boxwood clothe the slope between the terrace and the driveway. From a walled terrace at the west end of the guesthouse, visitors look out onto a picturesque orchard of heirloom apples and peaches. Always eager to share their produce, Wayne and Janet throw a cider party on the terrace every autumn when the apples are ripe.

On the south side of the lower barn, a stone wall protects vegetables grown in extensive beds. Long beans hang from trellises, and flowers such as marigolds ("I love marigolds," Janet says) and snapdragons are interspersed with cabbages and cardoons. Steps lead up to the boxwood-bordered Monastery Garden, where pie-shaped beds planted with lady's mantle, pinks, lavender, and sedum surround an old plinth carved with twining ivy leaves. Underneath the eaves of the barn, you can sit and contemplate this quiet garden or its picturesque backdrop of hay meadows rising steeply up to the rim of the woods. To the east of the house, a spring-fed pond is framed by dogwoods and willows. Beyond the pond, a walk threads through the woods, where Janet and Wayne are eradicating the invasive barberry and bittersweet and planting native understory shrubs such as witch hazels and spicebush instead.

The romantic lean-to by the pond at Bird Haven Farm was designed by architects Parsons+Fernandez-Casteleiro.

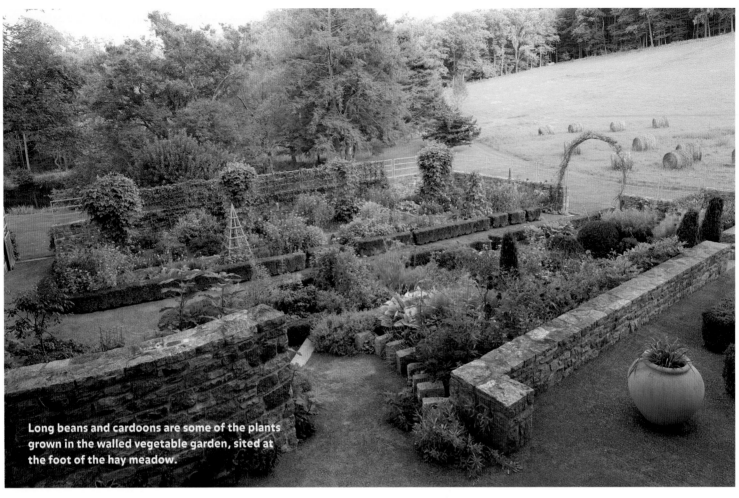

Long beans and cardoons are some of the plants grown in the walled vegetable garden, sited at the foot of the hay meadow.

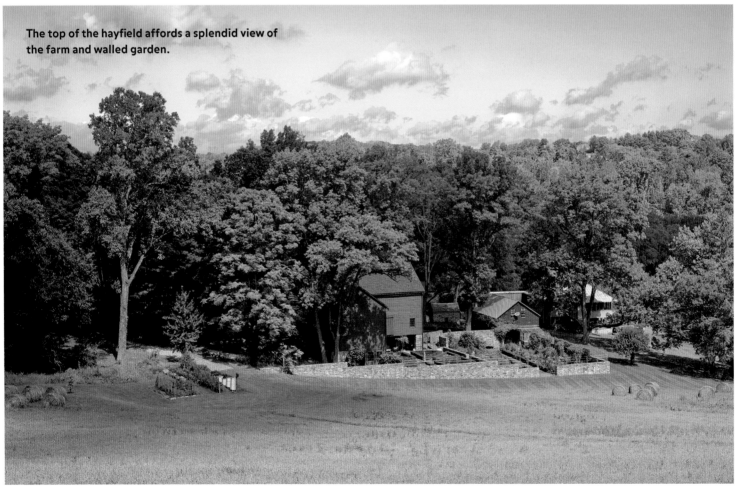

The top of the hayfield affords a splendid view of the farm and walled garden.

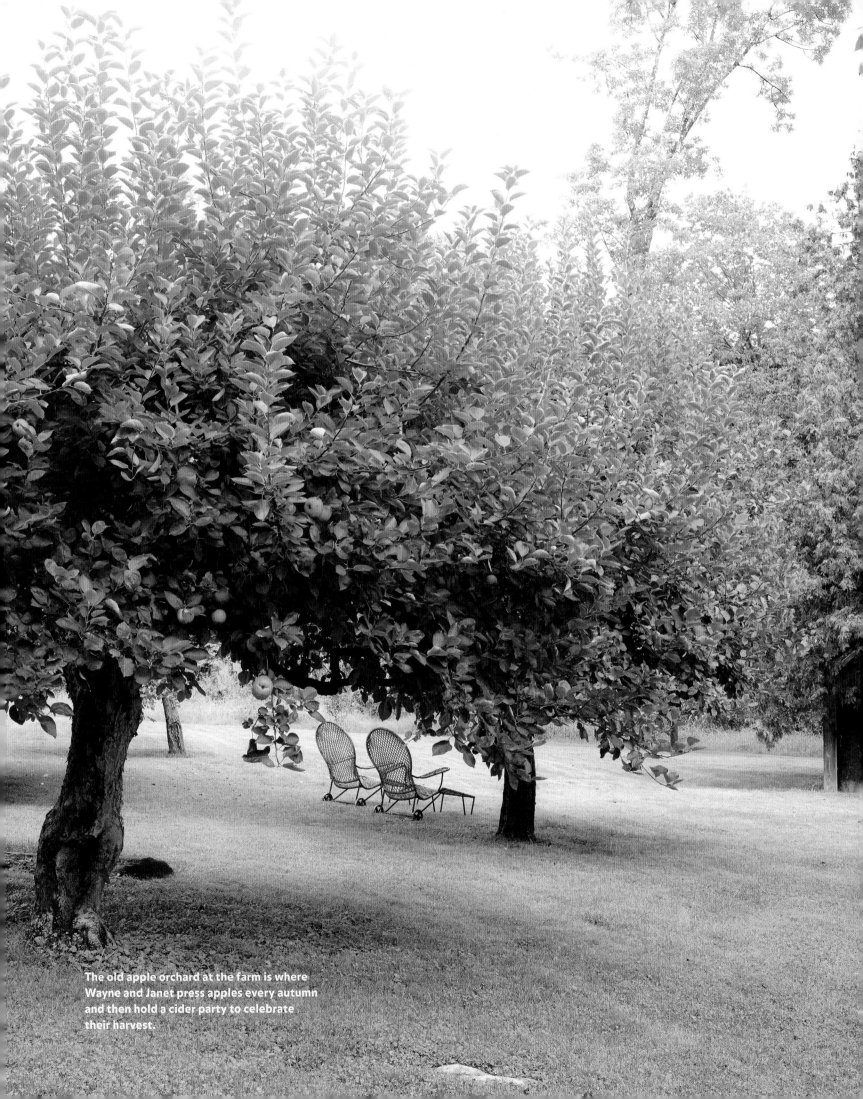

The old apple orchard at the farm is where
Wayne and Janet press apples every autumn
and then hold a cider party to celebrate
their harvest.

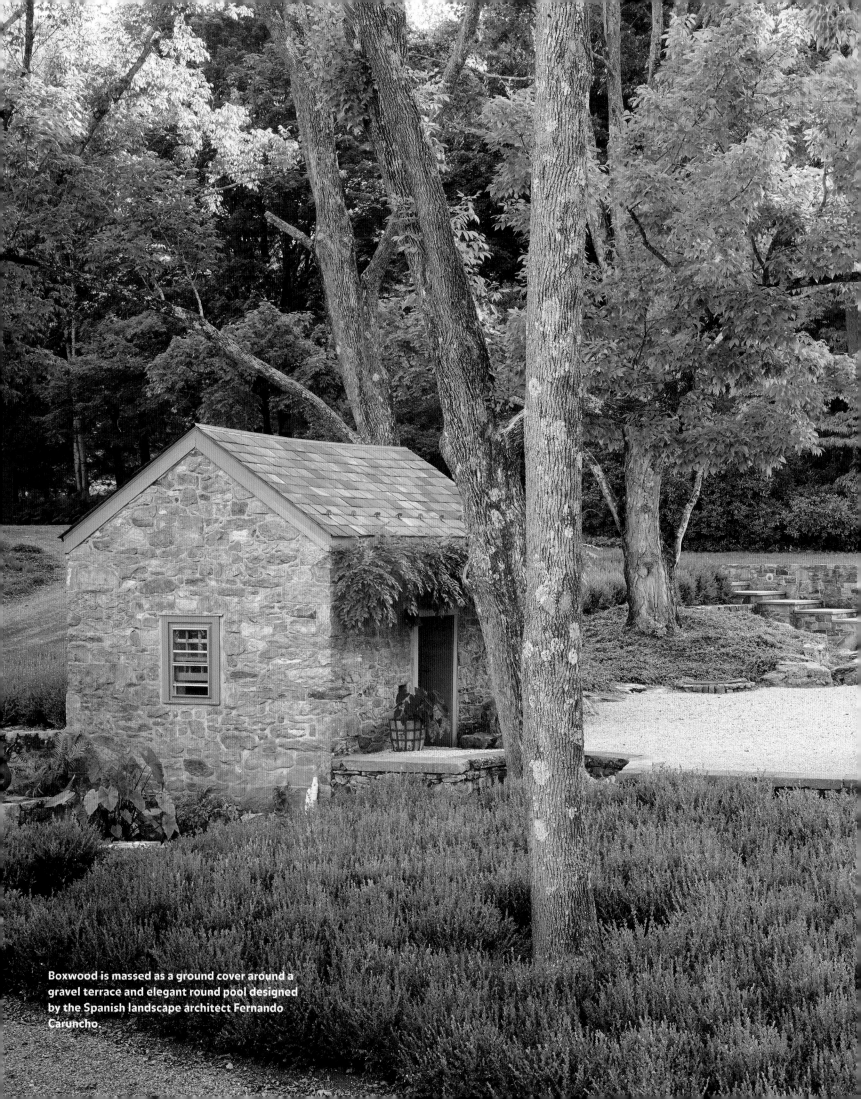

Boxwood is massed as a ground cover around a gravel terrace and elegant round pool designed by the Spanish landscape architect Fernando Caruncho.

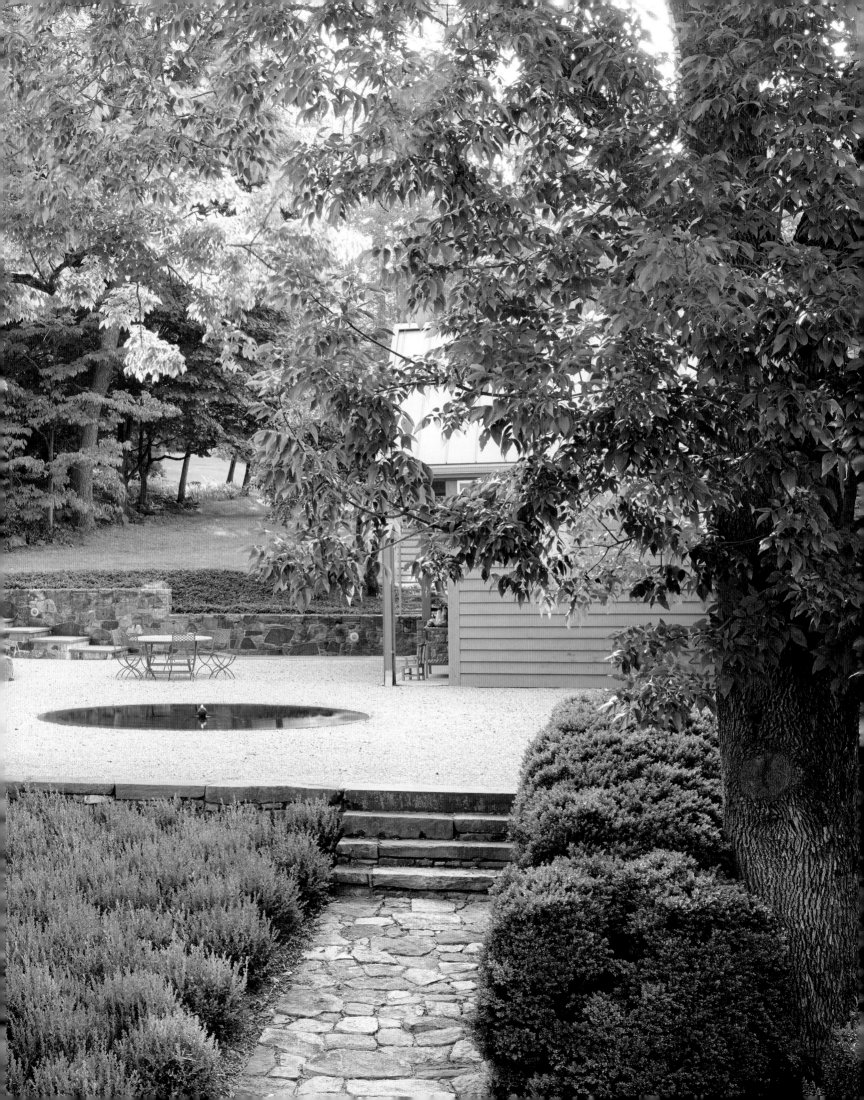

David Culp's Brandywine Cottage

Downingtown, Pennsylvania

"Gardening often brings me to my knees," David Culp writes in his book *The Layered Garden*. He is referring not to planting and weeding as much as to the act of getting close to the ground in order to peer at the jewel-like speckles and stripes inside the lampshade flowers of hellebores, and to admire the etched patterns of green within the white bells of snowdrops. These are two of his favorite flowers, which he gathers in great numbers to weave into his tapestry of plantings at Brandywine Cottage. David is that rare and special gardener—a renowned plantsman with an aesthetic eye, "painting" with plant colors and brilliantly layering scenes with a succession of flowering trees, shrubs, perennials, and bulbs to appeal in every season.

Twenty-five years ago, David and his partner, Michael Alderfer, settled into this charming 1790s Pennsylvania farmhouse of whitewashed stucco, typical of the time, and began to develop their two-acre garden. Starting nearest the house, they planted what they call the "jewel box garden" because you see it up close, walking from the driveway to the house and looking out the kitchen window. White-flowering dogwoods—the native *Cornus florida*, which is a showstopper in Pennsylvania—shade the area sufficiently to grow *Trillium luteum* and golden-leaved lilies-of-the-valley, bleeding hearts (*Dicentra spectabilis* 'Gold Heart'), lungwort, and hellebores with flowers of apricot and yellow. Small bulbs are tucked into the plantings for early-spring viewing—snowdrops, various species of scilla, and erythroniums, better known as dogtooth violets. The lovely, green-striped white tulip 'Spring Green,' filters through this garden area, echoing the dogwood trees and the stucco of the farmhouse.

A hillside across the driveway became David's canvas for more spring-flowering bulbs, hellebores, epimediums, disporums, Solomon's seal, and spring ephemerals. Under a canopy of locust, tulip poplar, redbud, and dogwood, he layered these signature plants around a collection of hydrangeas, witch hazels, and native azaleas. "I am addicted to plants," he says. "My garden may be a melting pot, but in the end, I have tried to create an American garden that both reflects and is sensitive to the countryside in the mid-Atlantic region and the simple, eighteenth-century farmhouse that it surrounds."

On a hillside beneath dogwoods and redbuds, David weaves together different cultivars of snowdrops, hellebores, hostas, epimediums, and disporums, which serve as a richly layered groundcover. Corylopsis and rhododendrons add spring color.

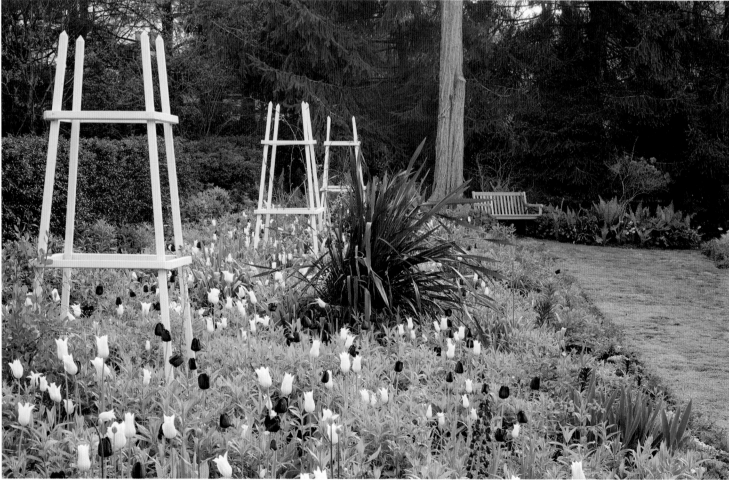

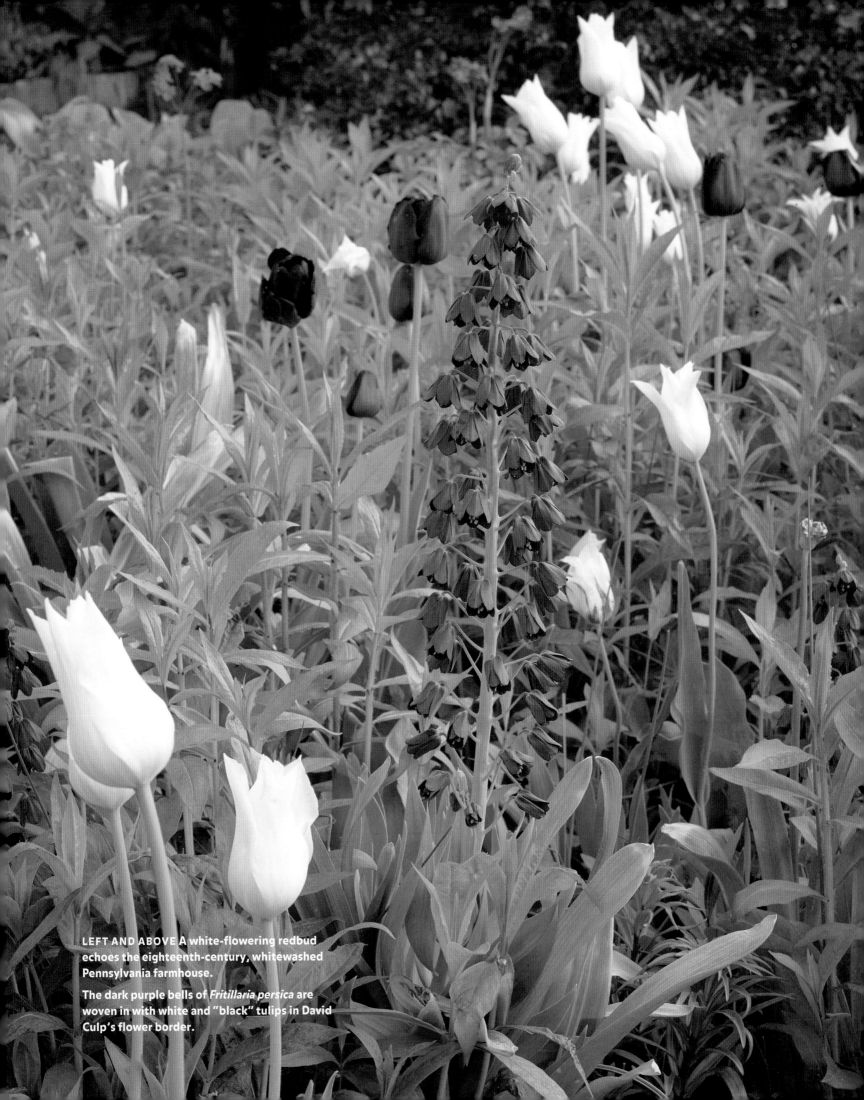

LEFT AND ABOVE A white-flowering redbud echoes the eighteenth-century, whitewashed Pennsylvania farmhouse.

The dark purple bells of *Fritillaria persica* are woven in with white and "black" tulips in David Culp's flower border.

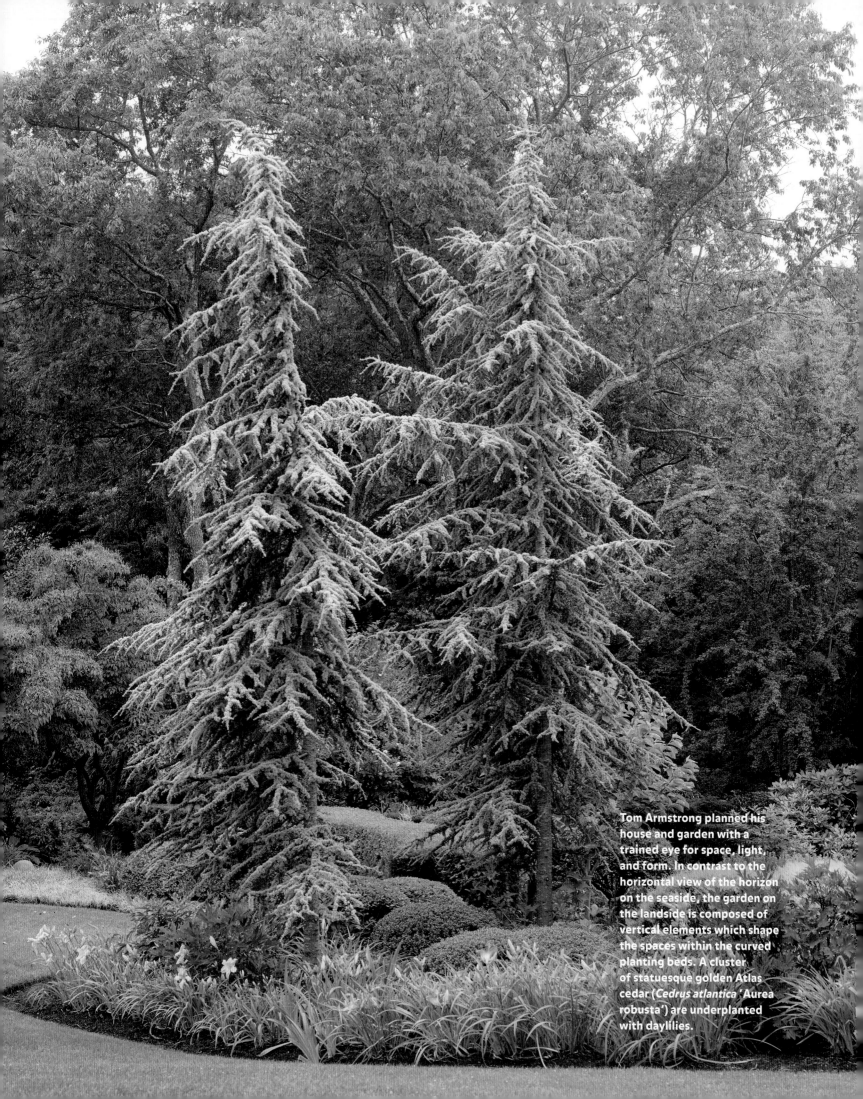

Tom Armstrong planned his house and garden with a trained eye for space, light, and form. In contrast to the horizontal view of the horizon on the seaside, the garden on the landside is composed of vertical elements which shape the spaces within the curved planting beds. A cluster of statuesque golden Atlas cedar (*Cedrus atlantica* 'Aurea robusta') are underplanted with daylilies.

Hooverness, the Garden of Tom Armstrong

Fishers Island, New York

Tom Armstrong's lifelong fantasy was to "live in a garden with art." His wish was finally realized when he built a stunning steel-and-glass modernist house, filled it with the abstract paintings and sculpture he loved, and set it in a landscape with a panoramic view of Long Island Sound on one side and an elaborate stroll garden on the other.

Fishers Island, like other small islands in Long Island Sound, is a glacial deposit scoured from the surface of Connecticut and left behind by the retreating ice in the form of high, rocky bluffs and inlets. For a moment in May, the thousands of shadblow (*Amelanchier* species) that cover those rocky bluffs and inlets become a haze of fragile white flowers, concealing the many private residences that, since the early twentieth century, make up the summer colony there. Tom and Bunty Armstrong owned one of those old summer cottages until December 2003, when, during a renovation, an accidental fire destroyed most of the house and many of the furnishings. The large garden, however, with impressive collections of daffodils and daylilies, was untouched by the fire and continued to flourish. The Armstrongs decided to build a new house on the footprint of the old ("Imagine a Japanese pavilion, all glass"), changing a few features of the garden around the new structure to complement its linear simplicity. In tribute to an old family joke about vacuum cleaners, their place would be called Hooverness.

Tom's career as an art student and museum director trained him to see both art and landscape through the modernist lens of abstraction and the formalist theories of space, light, and form. He planned his house so that its seaside is dominated by the thin, gently undulating line of the horizon—a geometric horizontal separating sea and sky. The landside, in contrast, is composed of vertical elements—lines of pollarded linden trees, clusters of rare conifers, flowering magnolias—that shape spaces within the garden's biomorphic, or curved, planting beds. The glass pavilion lies between the open view of the sea, which is experienced as a single encounter with space and light, and the planned complexity of the land, which draws the viewer into a progression of separate events. The new house seems to float above the landscape, offering continuous views of both garden and sea.

Tom called his garden his "ultimate creative endeavor . . . a place where I can be thrilled and surprised. After years of helping others realize the rewards of art, I have been able to create my own work of art."

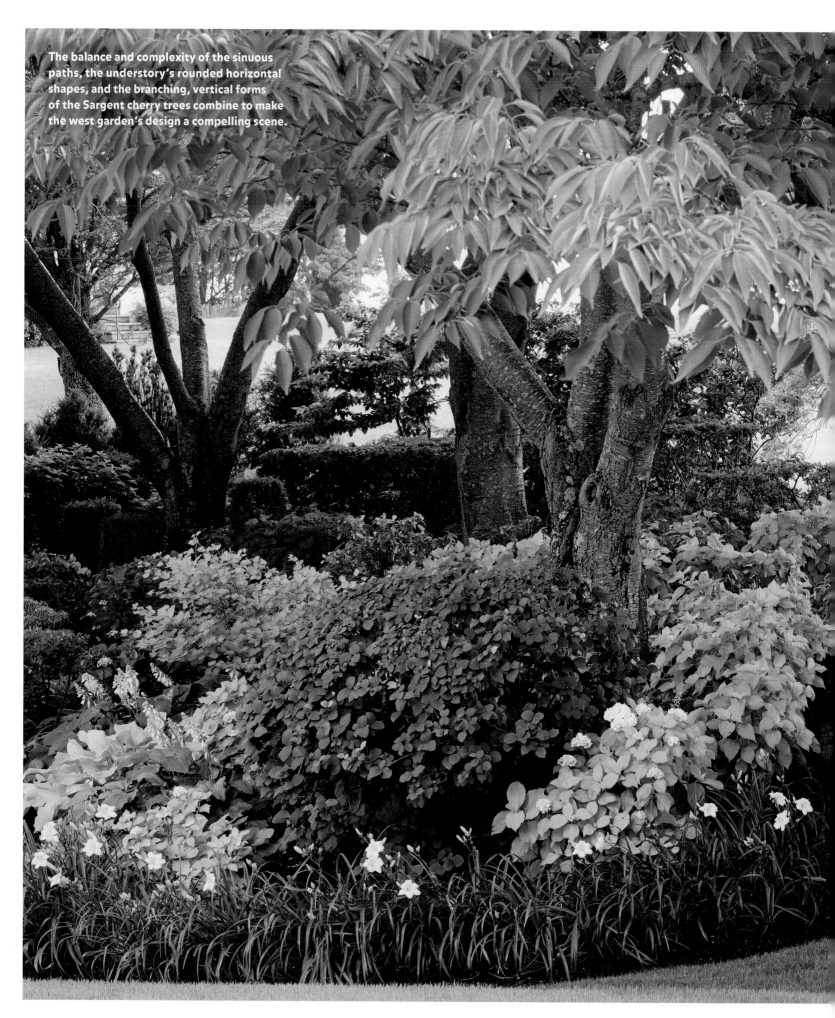

The balance and complexity of the sinuous paths, the understory's rounded horizontal shapes, and the branching, vertical forms of the Sargent cherry trees combine to make the west garden's design a compelling scene.

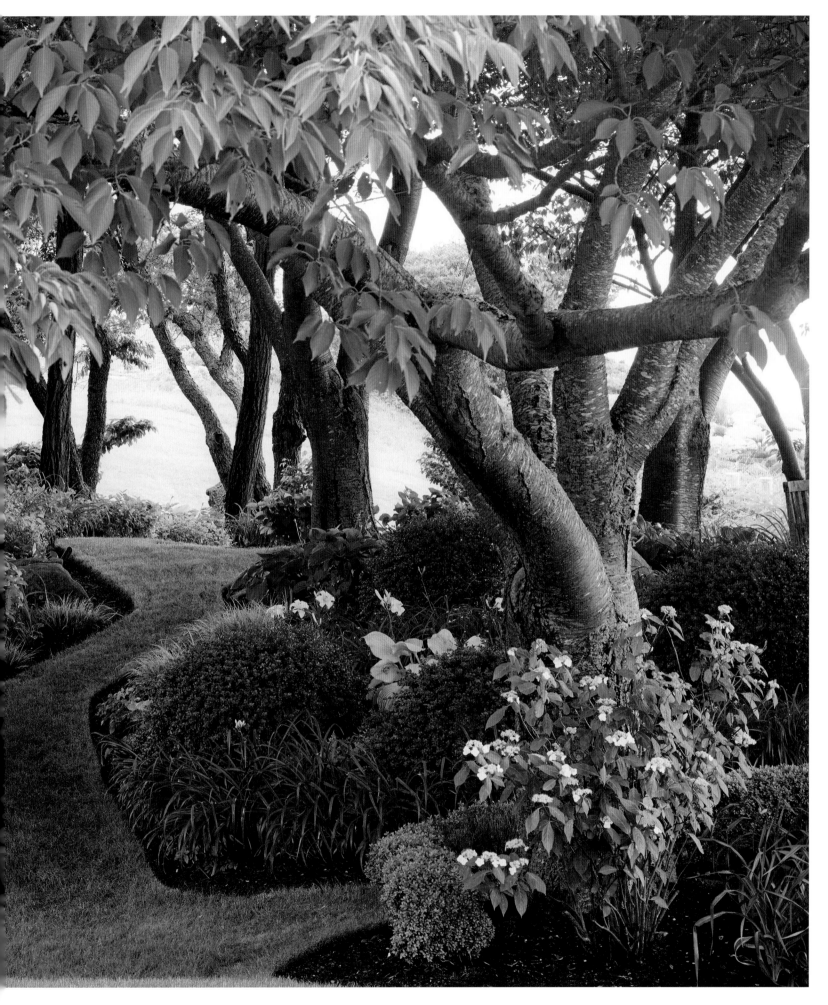

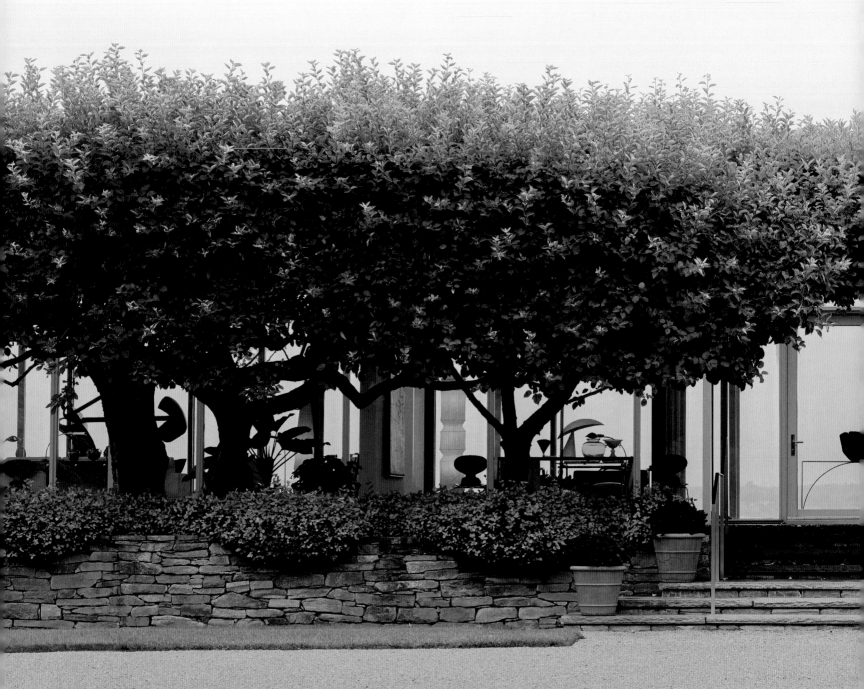

The house is a modernist steel-and-glass pavilion
set between a panoramic view of Long Island
Sound on the seaside and an elaborately planned
garden on the landside. Tom's collection of
abstract paintings and sculpture complete his
lifelong wish to "live in a garden with art."

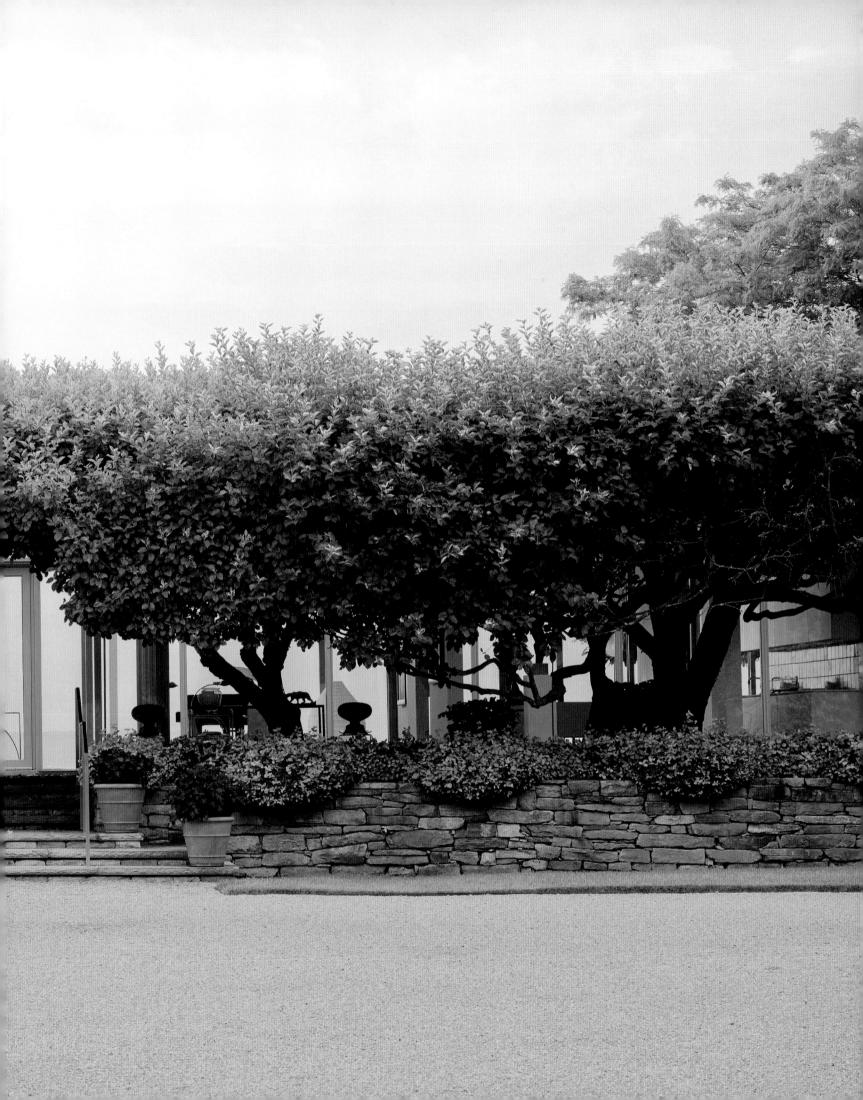

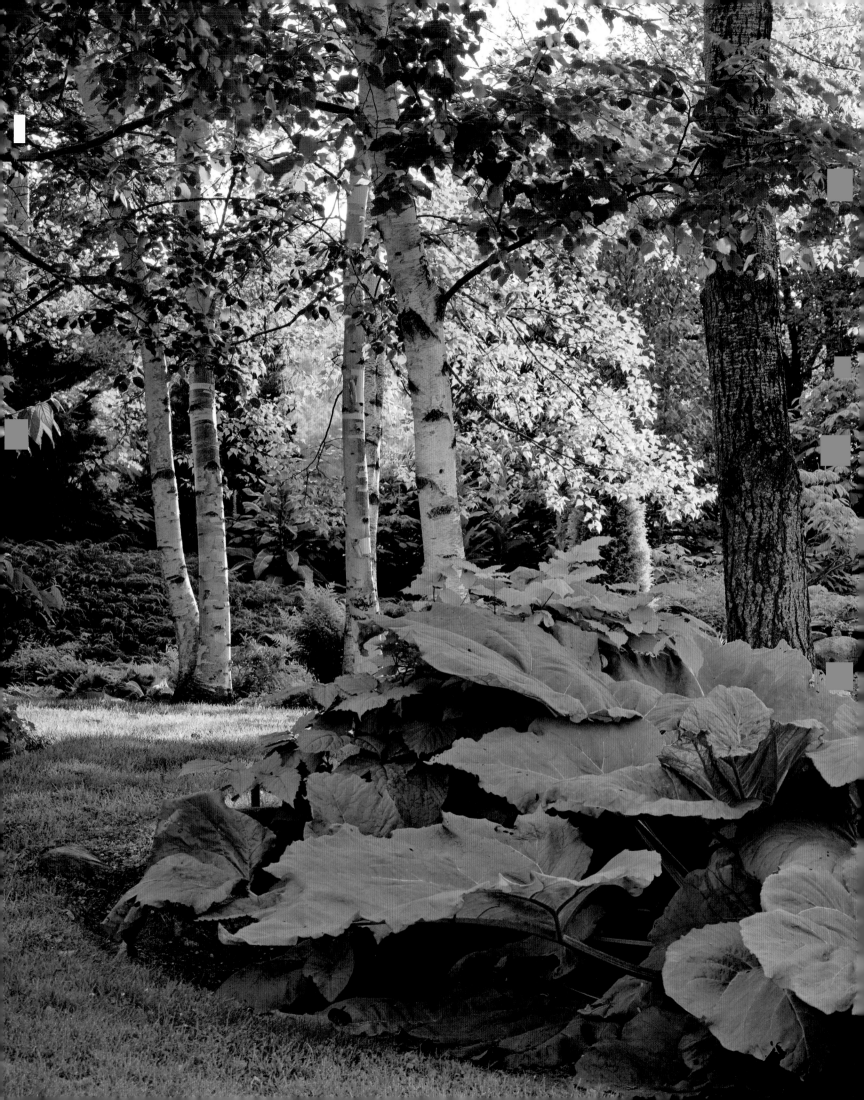

THE NORTHEAST

The first settlers of New York and New England had one goal: survival. They had landed in a heavily forested, forbidding wilderness in which they somehow had to make a living. Trees had to be felled for firewood and timber, fields cleared of boulders and fenced to make farmland and pastures, and the rocky soil planted to provide food and medicine. The iconic stone walls and split-rail fences of the Northeast remain as reminders of these early labors and hardships.

Gardens in such a setting had to be practical and close to the house for protection. These "dooryard" gardens were usually planted and tended by women who based their designs on memories of English cottage gardens. They grew vegetables and herbs for kitchen and medicinal uses as well as a few flowers brought from home or transplanted from the woods. They found that plants had to be hardy to survive the short growing season and severe, snowy winters.

By the nineteenth century, many farmers in the Northeast had abandoned their efforts and moved to richer farmlands in the Midwest. The forests gradually grew back, but instead of seeing them as an obstacle to be overcome, many gardeners now find inspiration in the beauty of the native American landscape. Sugar maples, paper birch, and beech turn Technicolor in the fall; graceful hemlocks, pines, and — to the north — spruce lend a rich green to the white of winter.

Many of the earliest American settlements were near the sea, where livelihoods were more likely to depend on fishing and shipbuilding than farming. Today, many of these seaside villages are summer retreats, but the traditional, colonial woman's cottage garden is still being honored with new and imaginative interpretations.

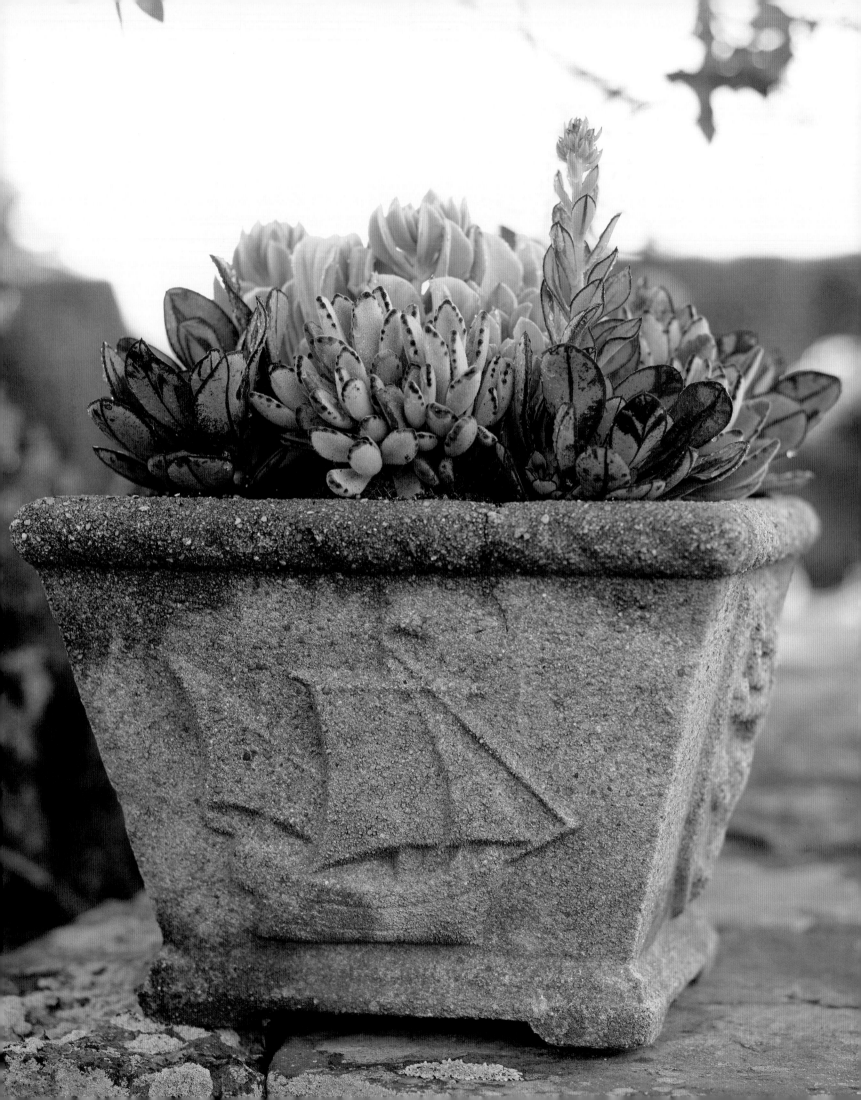

Susan Burke's Garden

Nantucket, Massachusetts

Susan Burke's Nantucket garden is in the tradition of cottage seaside gardens—not unlike that of her distant in-law Celia Thaxter on the island of Appledore, immortalized in paintings by Childe Hassam.

As flowery as it is, Susan's garden has a sophisticated twist. Twenty years ago, when she decided to make a garden, she asked her friend George Schoellkopf how she should start. Because she has a view of Nantucket Harbor from the porch of her house that needed no flowers to distract from its beauty, Schoellkopf suggested she dig a ha-ha, or trench, just below her porch and plant her flower garden there. Today, stone steps at either end of the porch lead down about six feet to a graveled path that wends through a lush and romantic double border of roses, poppies, mallows, gaura, Joe-pye weed, and the beloved hydrangea. It is a surprise, a secret garden. From a rocking chair on the porch, you can gaze out at sailboats on the sea without knowing the garden is there just below you.

Susan says that her favorite part of her garden, however, is not the hidden flowers in the ha-ha, but the boundaries of the property, where it segues into wild salt marshes. On the landside, colonies of sea myrtle, *Baccharis halimifolia*, which is native to the eastern coast, make a graceful transition from a small lawn to the marsh. "I know it's a thug," Susan says of the twelve-foot-high shrub, "but I love it. Its cottony white flowers are followed by silvery seed heads, and, as the marsh grass turns golden, the baccharis leaves turn red. It pleases me in every season, and you can't kill it."

Susan started the Open Days program on Nantucket a dozen years ago, and now it is a yearly event, with six or seven private gardens opening to the public in late June.

Succulents flourish in a pot appropriately decorated for a garden in Nantucket Harbor.

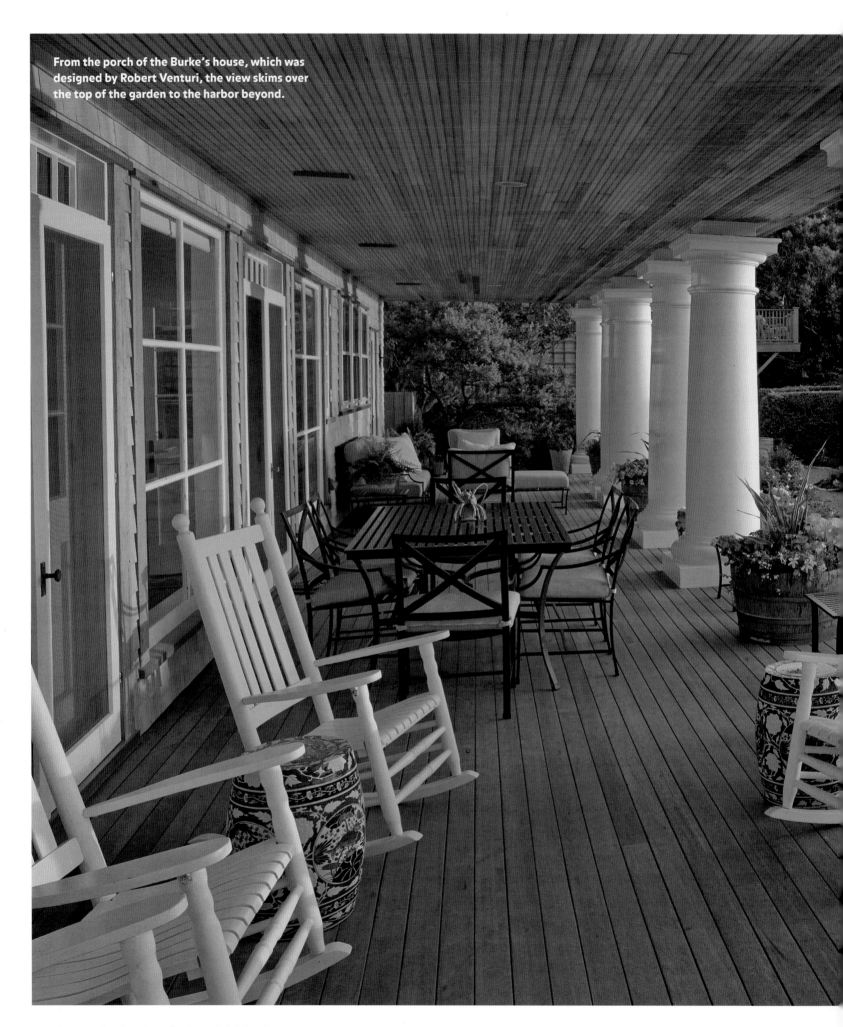

From the porch of the Burke's house, which was designed by Robert Venturi, the view skims over the top of the garden to the harbor beyond.

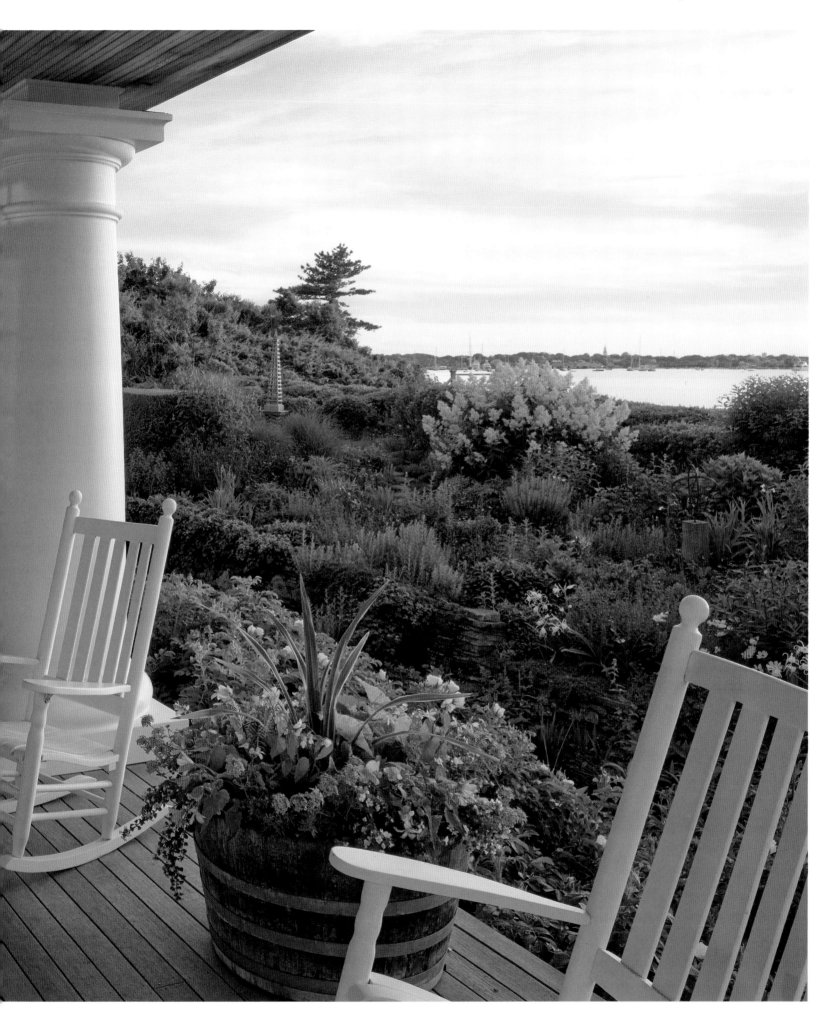

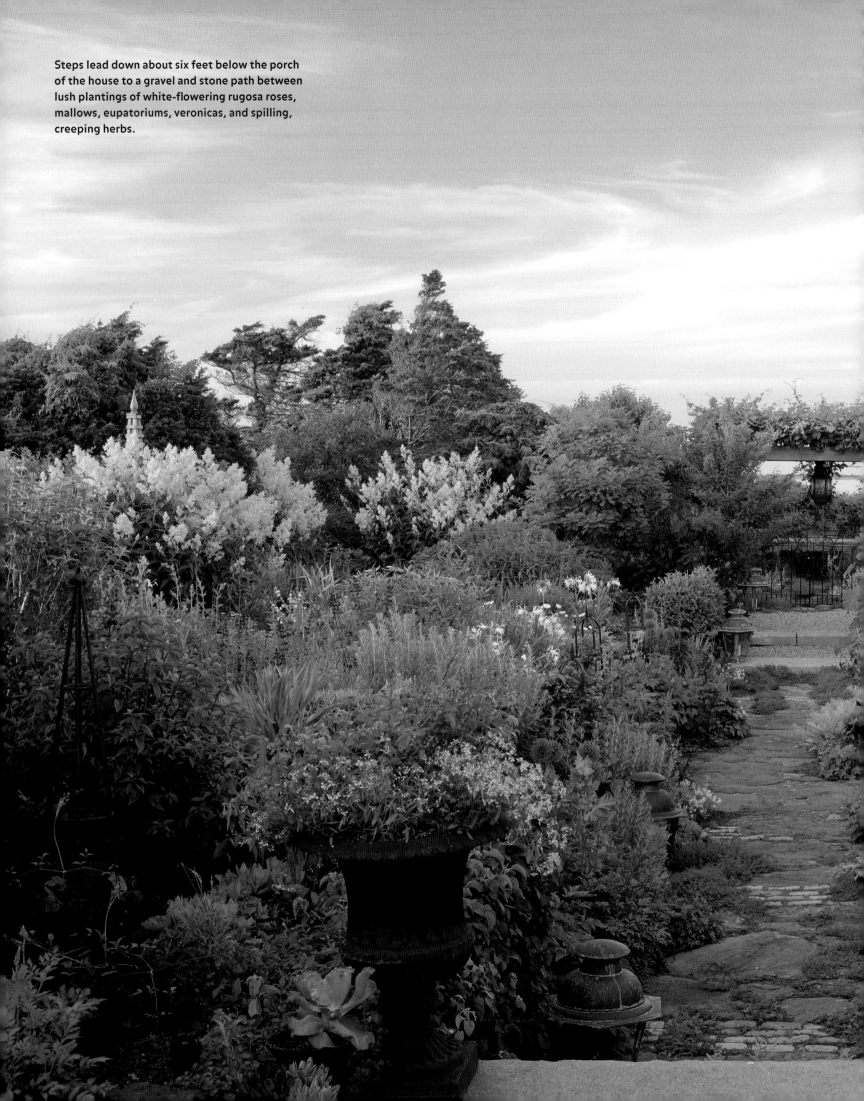

Steps lead down about six feet below the porch of the house to a gravel and stone path between lush plantings of white-flowering rugosa roses, mallows, eupatoriums, veronicas, and spilling, creeping herbs.

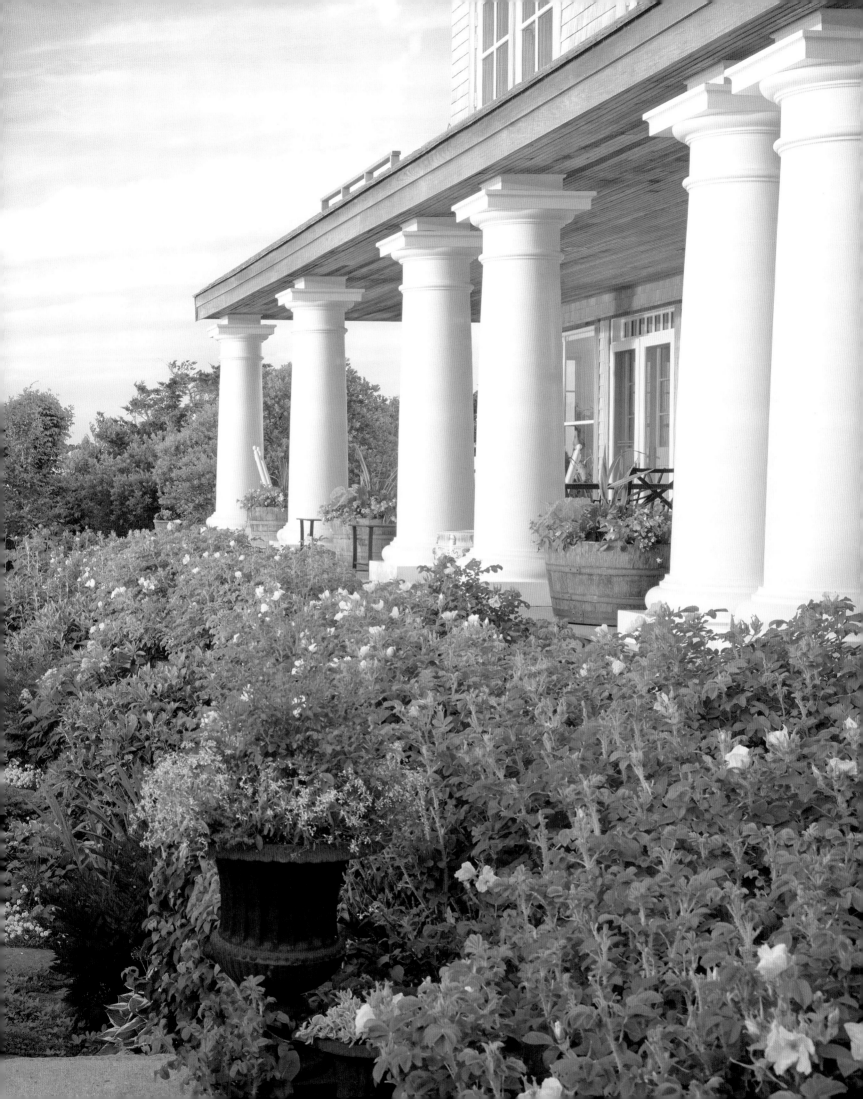

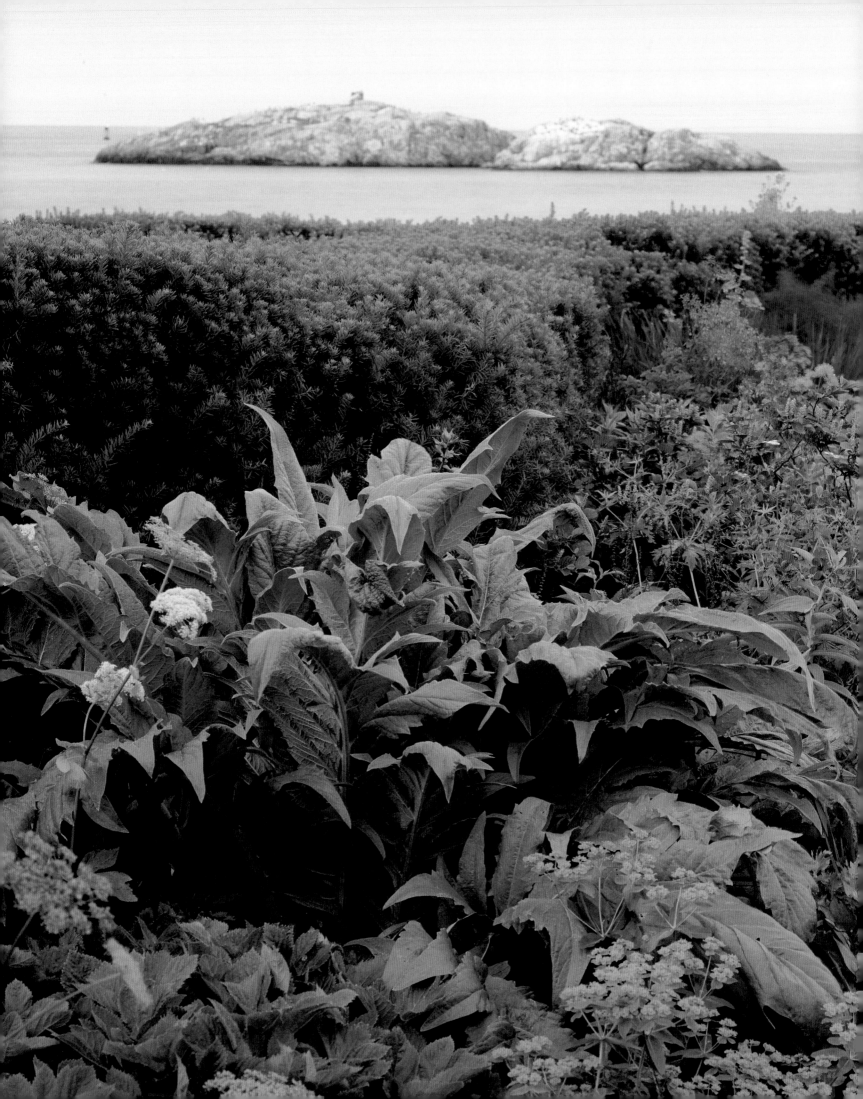

Grey Gulls, the Garden of Peter & Carolyn Lynch

Marblehead, Massachusetts

The stretch of craggy coastline that defines the North Shore of Massachusetts presents a challenging environment to any gardener, not least because of winter winds so harsh that wattle fences are needed to protect the plantings. Grey Gulls is just such a garden on the very tip of the rocky peninsula of Marblehead, a coastal town treasured for centuries for its deep, sheltered harbor merely thirty miles north of Boston. With the protection of hedges and a high seawall, a rich variety of perennials, annuals, and bulbs thrives here in the sea air. The design of the garden reflects its stunning location, with sinuous beds mirroring the curves of the shore and rock ledges that seem like slumbering seals. Clipped hedges of yew back the curvaceous flower beds and are, in themselves, as satisfying as the garden's pattern. This becomes especially apparent when seen from the curved deck of the modernist house, which dates from 1929.

To protect the hedges from salt and wind, woven willow fencing, custom-made in England, is added to the yew in the fall, like a giant basket. This wattling is, in itself, a handsome, weathered gray structure in the garden. "There are essentially no woody plants in the garden because of the wind," Larry Simpson says, who has gardened here for twenty-five years. "Carolyn loves bold, bright, tall perennials because we can't have trees—perennials like artichokes, Scotch thistle, ornamental teasels, aconites, bronze fennel, *Thalictrum flavum* ssp *glaucum.*" One exception to the lack of trees is a weeping Camperdown elm in the center of the garden, which miraculously survives the weather. Curiously, because of the ocean, plants from the temperate climate of Zone 7 survive here, such as acanthus and fuschias. But their growing year is late. "Our June first is your May first," Larry says, comparing the seasons at Grey Gulls to those of inland gardens. "But we have fresh tomatoes in December."

The bold silvery foliage of cardoons contrast with the yew hedge at Grey Gulls on the North Shore of Massachusetts. Marblehead Rock floats in the distance.

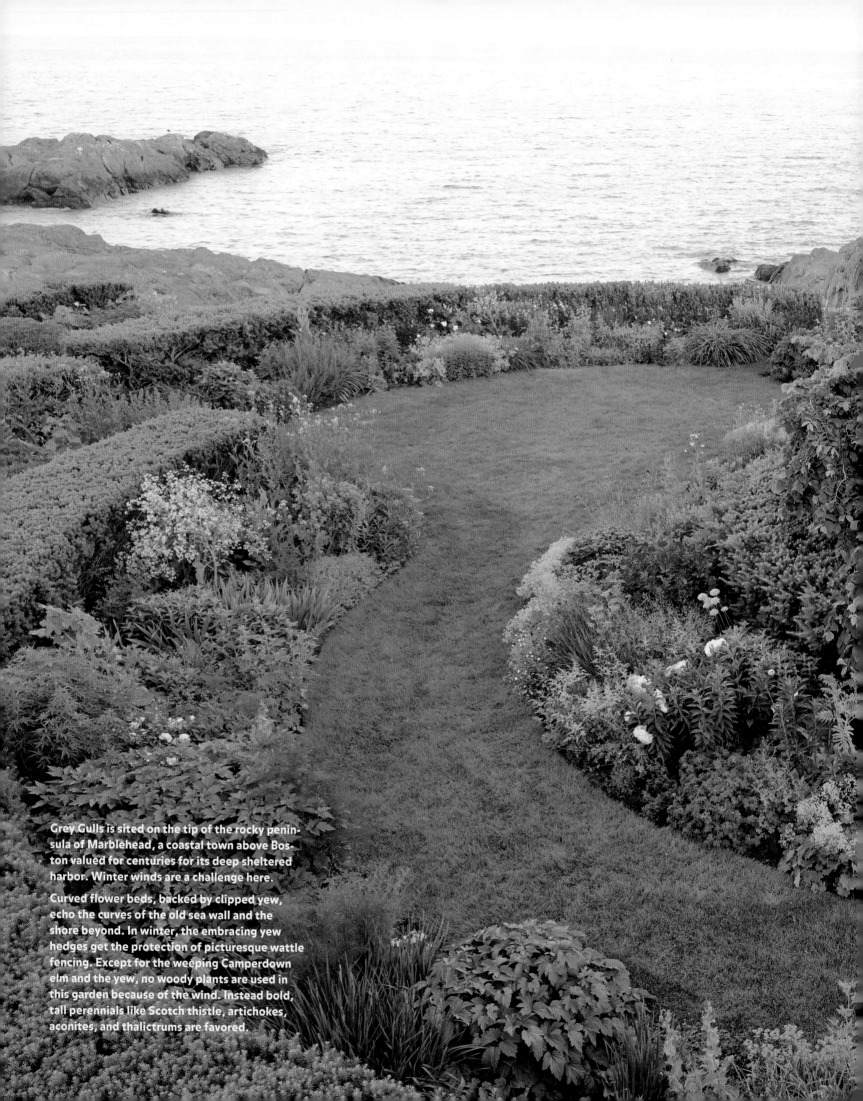

Grey Gulls is sited on the tip of the rocky peninsula of Marblehead, a coastal town above Boston valued for centuries for its deep sheltered harbor. Winter winds are a challenge here.

Curved flower beds, backed by clipped yew, echo the curves of the old sea wall and the shore beyond. In winter, the embracing yew hedges get the protection of picturesque wattle fencing. Except for the weeping Camperdown elm and the yew, no woody plants are used in this garden because of the wind. Instead bold, tall perennials like Scotch thistle, artichokes, aconites, and thalictrums are favored.

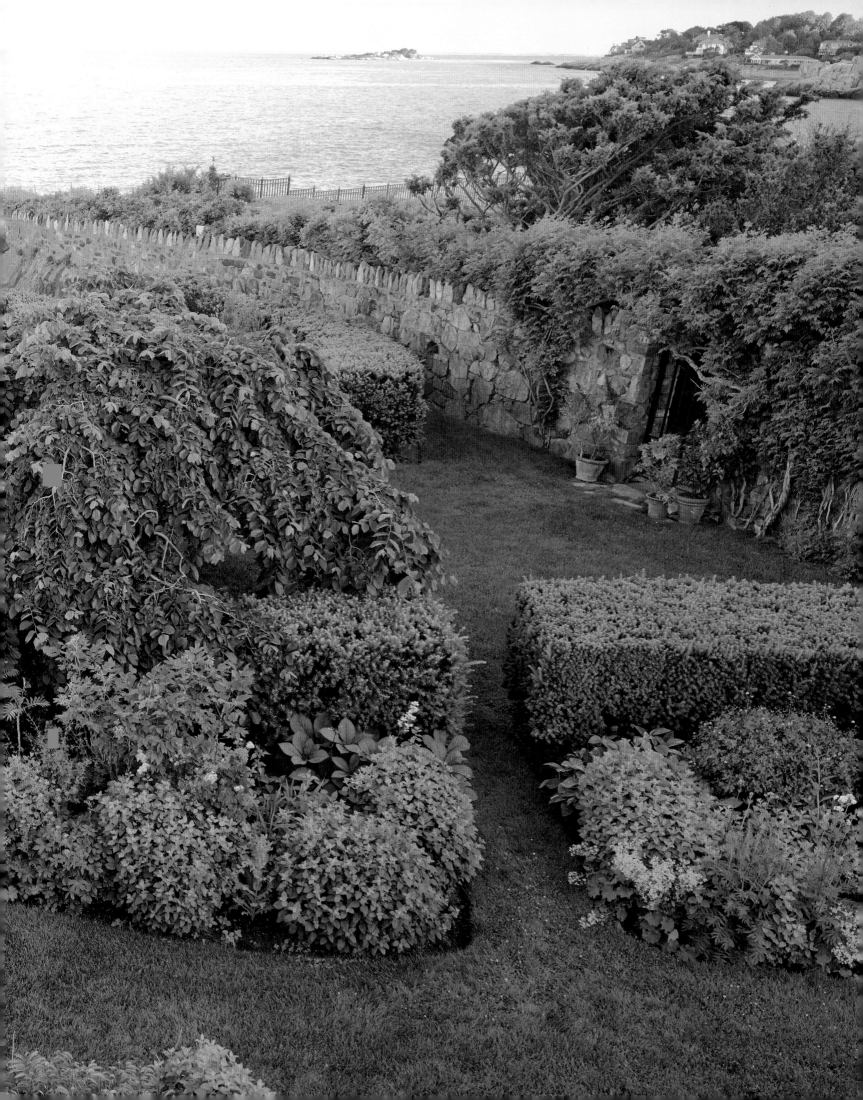

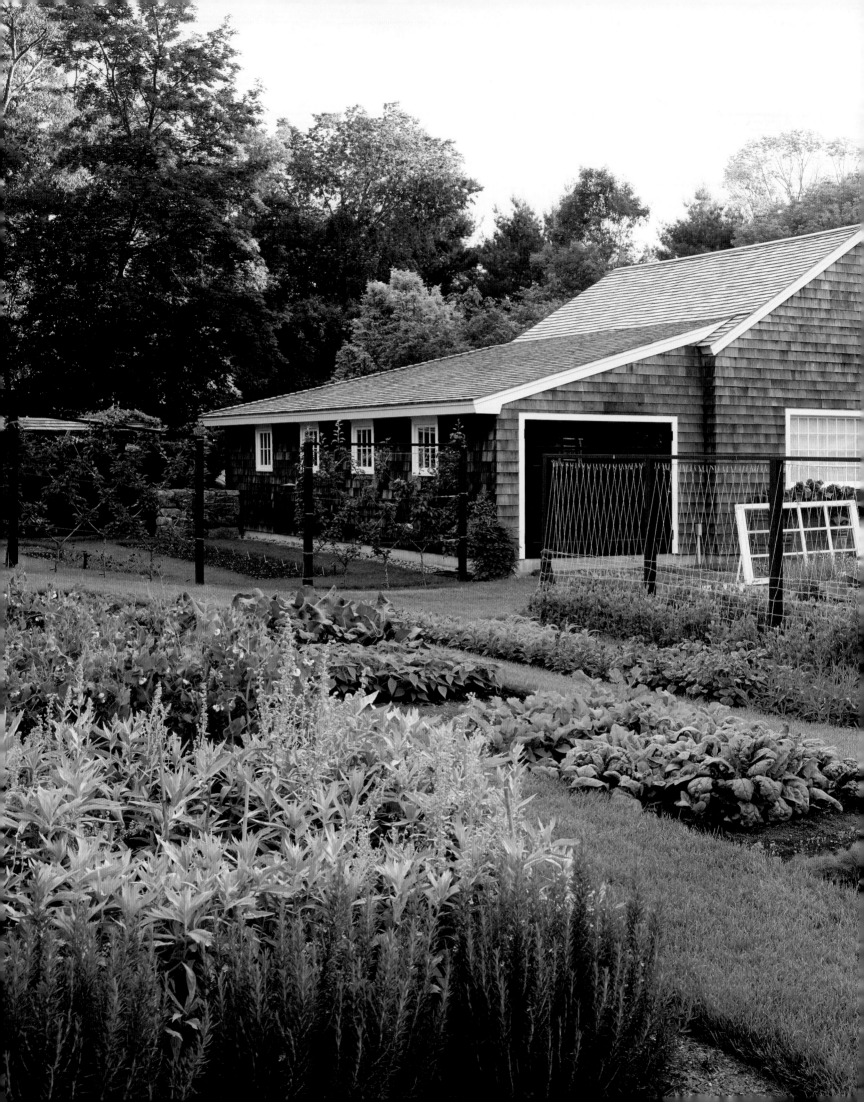

Maureen Ruettgers's Gardens at the Clock Barn

Carlisle, Massachusetts

East and inland from Marblehead, in rural Carlisle, Massachusetts, Maureen Ruettgers plants and tends her beguiling cottage gardens. She and her husband, Michael, bought the three-acre property thirty-five years ago, charmed by the shingled saltbox farmhouse—dating from the early 1700s—an old greenhouse, and assorted barns in an open field surrounded by oak trees. Long fascinated by herbs and their uses, Maureen set out immediately to make an herb garden, enclosing an area fifty feet by seventy feet just beyond the house with a low, dry-laid stone wall, so typical of New England farms. Within the walled garden, a pattern of small rectangular beds were defined by stone-dust paths and an edging of cobbles. Scented geraniums, thymes, calendulas, nasturtiums, and foxgloves mingle here with lettuces and tender sages such as *Salvia guaranitica* 'Black and Blue,' a favorite of Maureen's not only for its beauty but also because it attracts hummingbirds and bees. A massed planting of *Salvia viridis* with edible flowers in shades of white, pink, and purple surrounds an armillary sphere in the center of the garden.

The original greenhouse, built in 1939 and now extended on each side to make a T, stands at one end of the walled garden on axis with the central path. Here, Maureen grows all her vegetables from seed and winters her large collection of scented geraniums and rosemary. A small chicken coop and run are at the end of the cross axis in this garden, handy for tossing weeds and collecting eggs. An even larger vegetable and cutting garden stretches out in neat rows near the drying barn where Maureen hangs her herbs for the winter. She and her husband grow parsnips, chard, rhubarb, radishes, tomatoes, and an assortment of basils to eat, can, and freeze. *Scabiosa atropurpurea* 'Black Knight', giant zinnias, *Salvia* 'Amistad,' and dahlias are among the many cutting flowers they grow here. A forty-foot wire fence supports a fragrant mixture of sweet peas.

There is a woodland garden, an apple orchard, and a cordoned pear Belgian fence from which Michael is attempting to make eau-de-vie Poire William, growing some of the pears inside the bottles. Behind the farmhouse, a handsome shingled barn with a large round clock face above its door gives the property its name.

The extensive vegetable/cutting garden at Maureen Ruettgers's charming country garden, thirty-five minutes from Boston, is lined out in rows near the drying-room barn. In the 1930s, digitalis (foxglove) was processed here for use in heart medication as part of the war effort. Today, Maureen continues the tradition, cultivating and drying a variety of herbs. She and her husband Mike can and freeze their vegetables and supply cut flowers for their daughter's cookery shop.

The Ruettgers extended the original 1930s greenhouse to make a T. Here, Maureen houses her extensive collection of scented geraniums and rosemaries, citrus, and bay in winter and raises her vegetables from seed.

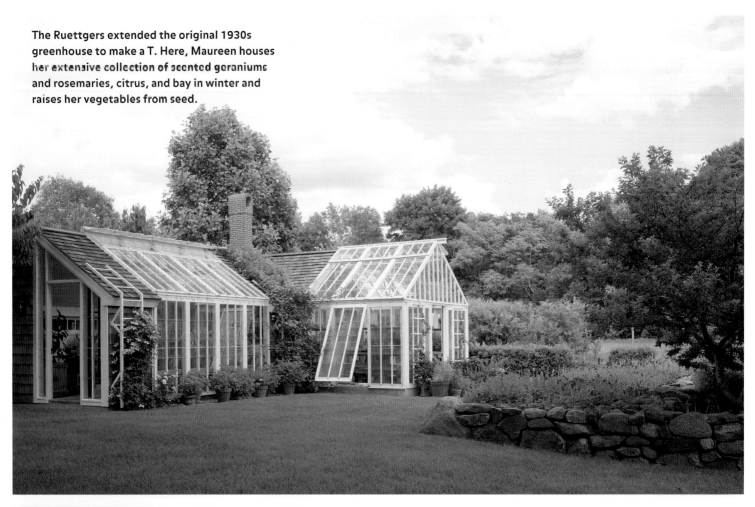

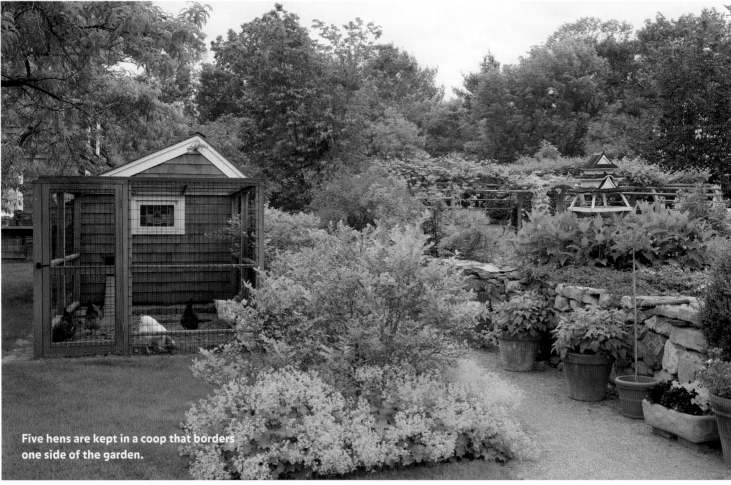

Five hens are kept in a coop that borders one side of the garden.

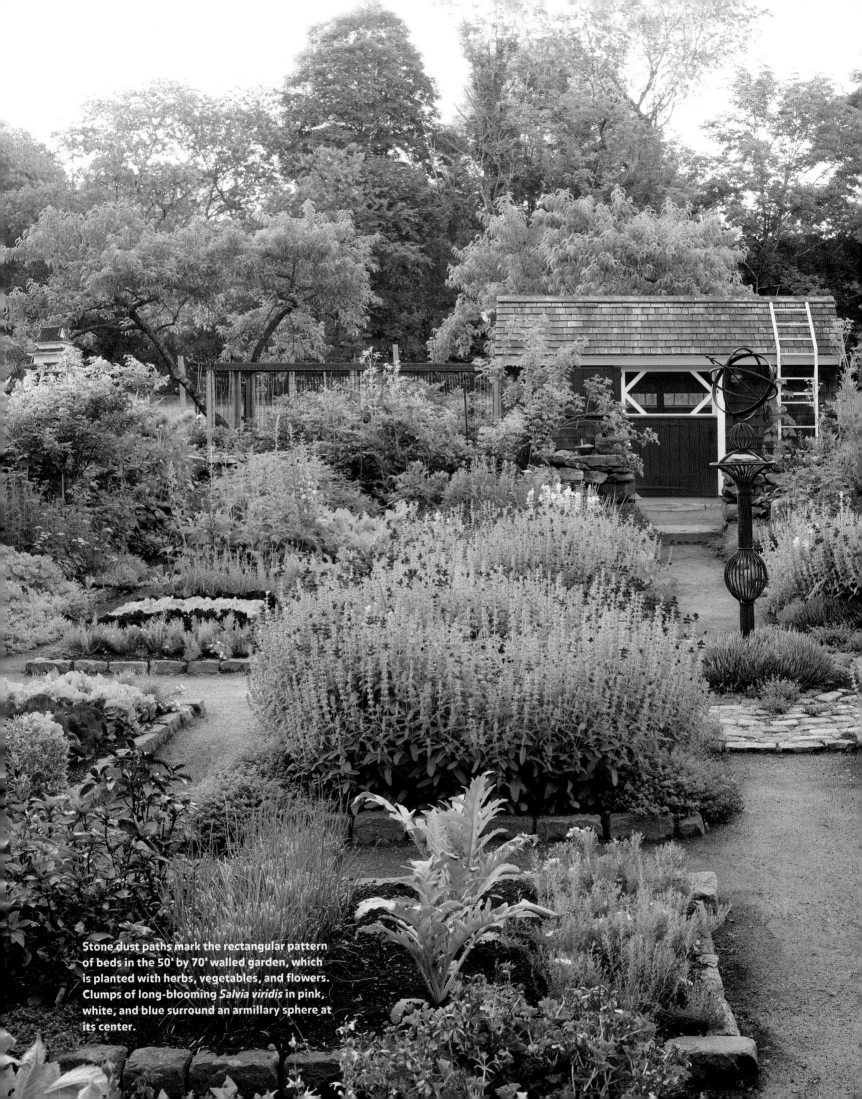

Stone dust paths mark the rectangular pattern of beds in the 50' by 70' walled garden, which is planted with herbs, vegetables, and flowers. Clumps of long-blooming *Salvia viridis* in pink, white, and blue surround an armillary sphere at its center.

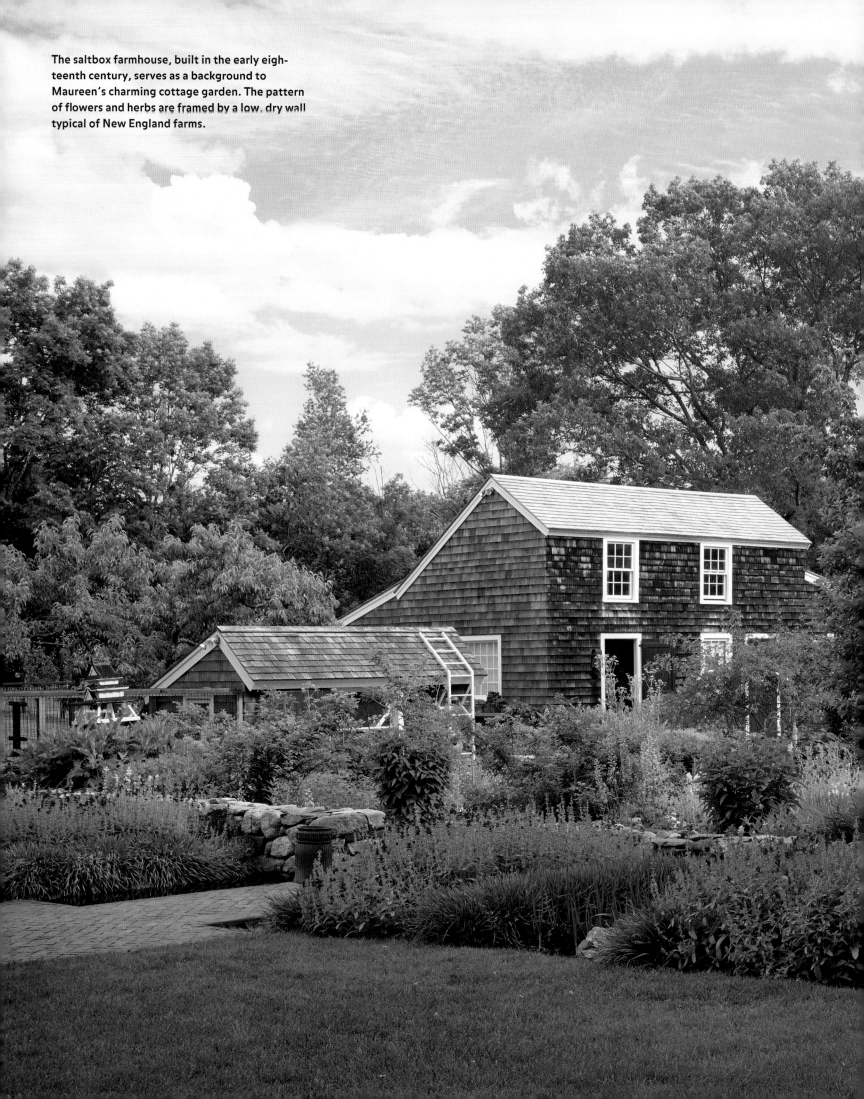

The saltbox farmhouse, built in the early eighteenth century, serves as a background to Maureen's charming cottage garden. The pattern of flowers and herbs are framed by a low, dry wall typical of New England farms.

Bill Noble's Garden

Norwich, Vermont

Five Lombardy poplars—the disease-resistant cultivar 'Theves'—act as tall and romantic exclamation points at the end of Bill Noble's flower garden, distinguishing it from the farm fields and soft mountain views beyond. In 1991, Bill moved with his partner, classics scholar Jim Tatum, to this idyllic spot: twenty-two acres in Norwich, Vermont, a few miles west and uphill from the Connecticut River Valley and Dartmouth College. In 1996, he started planting the flower garden on the site of the previous owner's large vegetable garden. Only one-third of the long, rectangular beds are now reserved for vegetables. Bill planted four large, purple-leaved barberries to serve as structure among his flowers as well as to provide a repeated depth of color. "Almost everything is repeated," Bill says, for effect and emphasis. Besides the barberry there are repeated plantings of peegee hydrangeas, filipendula, and Joe-pye weed. This year he spotted the pretty blue *Browallia americana* all along the edge of the borders.

Bill's goal is to have horticultural interest in his gardens from May to October. In May, the emerging foliage of perennials and shrubs offers all the different tones that make a garden appealing. Among them he adds more than one hundred 'Purple Sensation' alliums for a punch of color. In June, Bill says, "It's the pink and blue thing," with delphiniums, roses, and peonies—his least favorite bloom time, he admits. "I like the deep, saturated colors of the garden in July and August," with its summer phlox and the deep blues of monkhood and agastache. "And then the garden becomes very 'Piet Oudolf' in September."

Like so many experienced gardeners, Bill is a collector of plants, and this is most evident in the shaded borders near the walls and stone foundation of an old barn, long gone. There is not a willow he doesn't love, nor an ornamental rhubarb; he thrills to the contrast in leaf size, color, and pattern. Collections of rodgersias, sedges, saxifrages, and ferns all find a home among the stones of the old foundation. This two-acre garden is Bill's laboratory, his canvas on which to combine different leafy pictures. For many years, Bill was the Garden Conservancy's Director of Preservation Projects, commuting long hours to the Conservancy's offices in Cold Spring, New York, when he wasn't traveling the country. Now he works as a freelance consultant in garden design and preservation and is enjoying more free time to work on his own land.

Single red hollyhocks give a punch of color to Bill Noble's Vermont flower garden, where purple-leaved barberries and sand cherries are repeated for richness. "I like the deep saturated colors of July and August," Bill says.

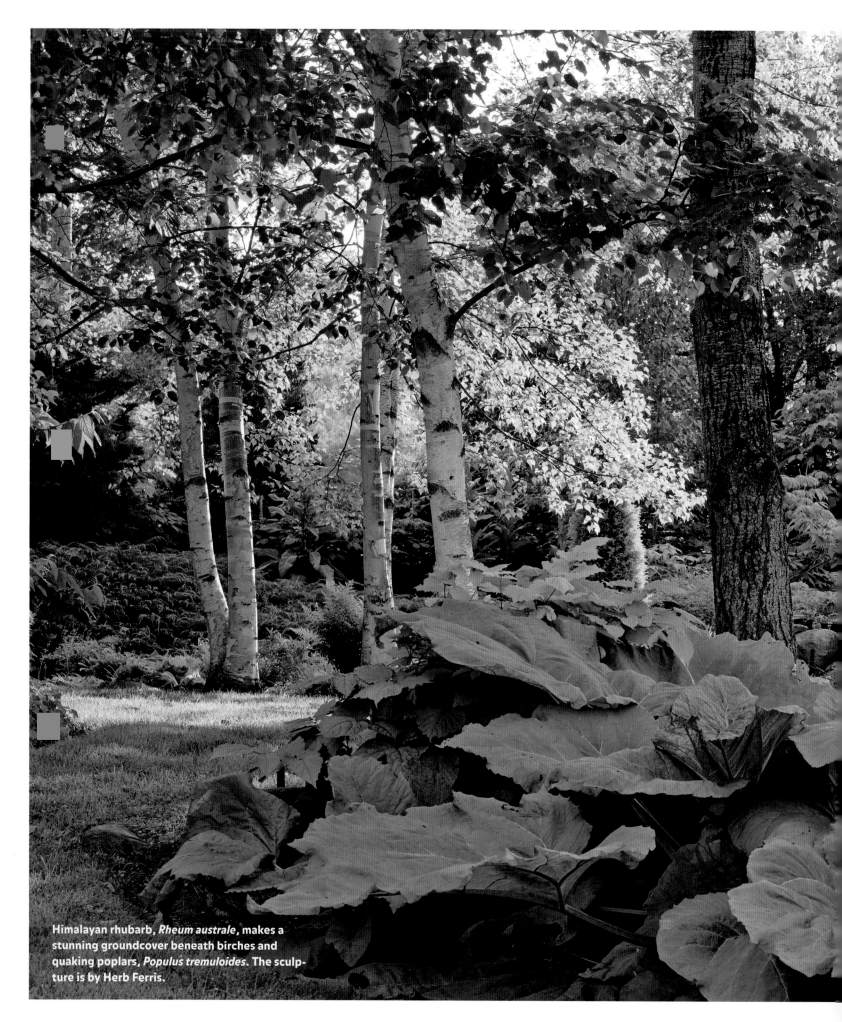

Himalayan rhubarb, *Rheum australe*, makes a stunning groundcover beneath birches and quaking poplars, *Populus tremuloides*. The sculpture is by Herb Ferris.

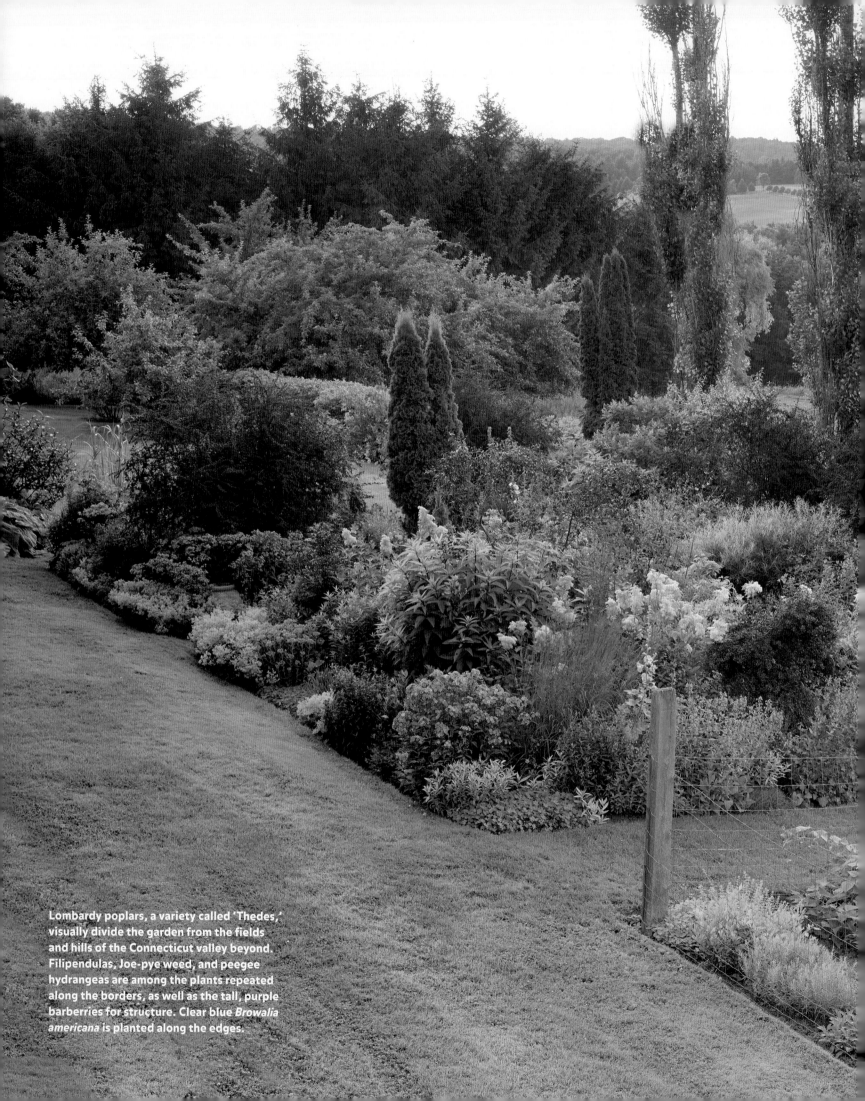

Lombardy poplars, a variety called 'Thedes,' visually divide the garden from the fields and hills of the Connecticut valley beyond. Filipendulas, Joe-pye weed, and peegee hydrangeas are among the plants repeated along the borders, as well as the tall, purple barberries for structure. Clear blue *Browalia americana* is planted along the edges.

The Garden of Margaret Roach

Copake Falls, New York

In 2007, Margaret Roach left her New York City fast-lane life as a top executive for Martha Stewart Living Omnimedia to live on a country road in Copake Falls, New York. She did not move for a life of leisure; instead, she filled her days exercising her personal creativity and what she calls "a spiritual practice" of gardening, writing, and living with the land.

She has, indeed, become a garden guru of sorts, writing three successful and inspiring books, hosting a weekly local public-radio show, and communicating regularly with followers of her blog, awaytogarden.com. Margaret's pursuits go well beyond gardening and the thousands of plants she grows, although she is incredibly knowledgeable about each and every one. She is also obsessively interested in the entire ecosystem she has nurtured on her country property. Serious organic practices and vigilant observation of life in her garden ensure that more than sixty kinds of birds, native toads and frogs, bees, dragonflies, and even bears can share this special place with her. She is committed to learning as much as she can about all these living things, and she happily bestows that knowledge on anyone who will listen. Lots of people listen—hundreds of thousands of people visit her Web site every month.

They also come in droves to meet Margaret when she opens her garden four times a year for Open Days. They line up to learn about gardening and organic practices—what Margaret calls "horticultural how-to and woo-woo." She tirelessly answers questions, encourages and inspires everyone who gardens or is just starting to, and gives autographs and poses for pictures with her adoring fans and followers.

Over the years, her Open Days have taken on the atmosphere of a garden fair. She invites her friends who share her interests (she has many) to give lectures on everything from birds and bees to meadows and woodland wildflowers. One of her favorite nurseries, Broken Arrow, comes to her Open Days to sell many of the same plants Margaret grows in her garden, and handmade furniture tempts visitors to find a special spot in the garden for a place to rest.

The hillside, behind the house, is a native habitat for birds and insects.

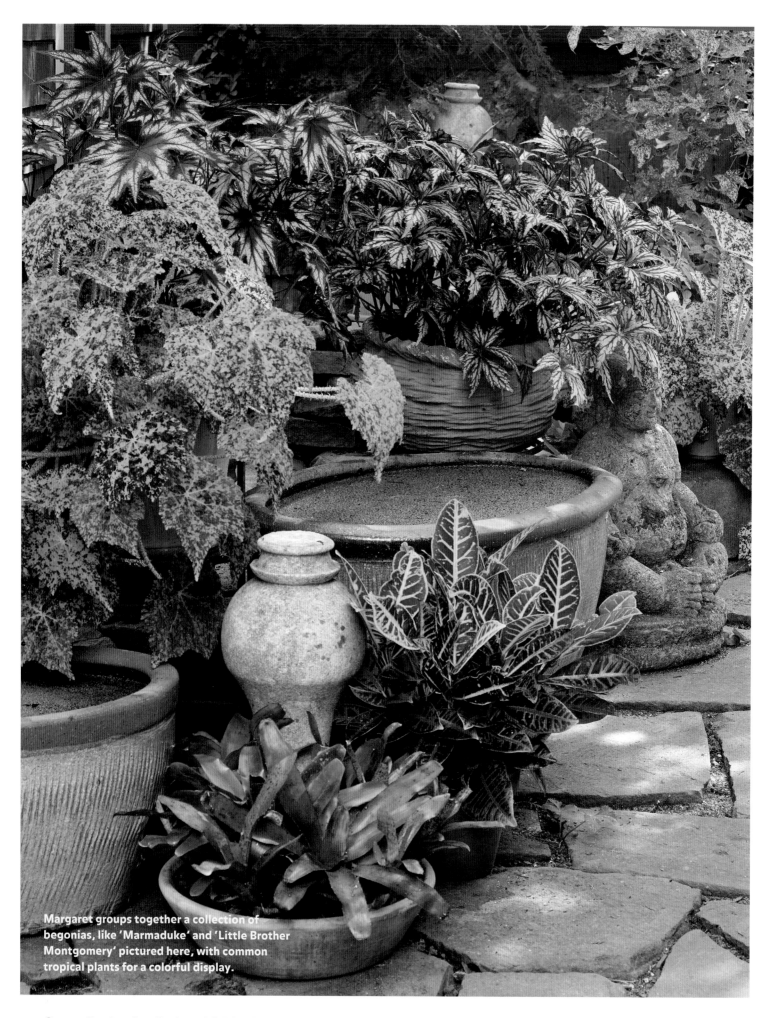

Margaret groups together a collection of begonias, like 'Marmaduke' and 'Little Brother Montgomery' pictured here, with common tropical plants for a colorful display.

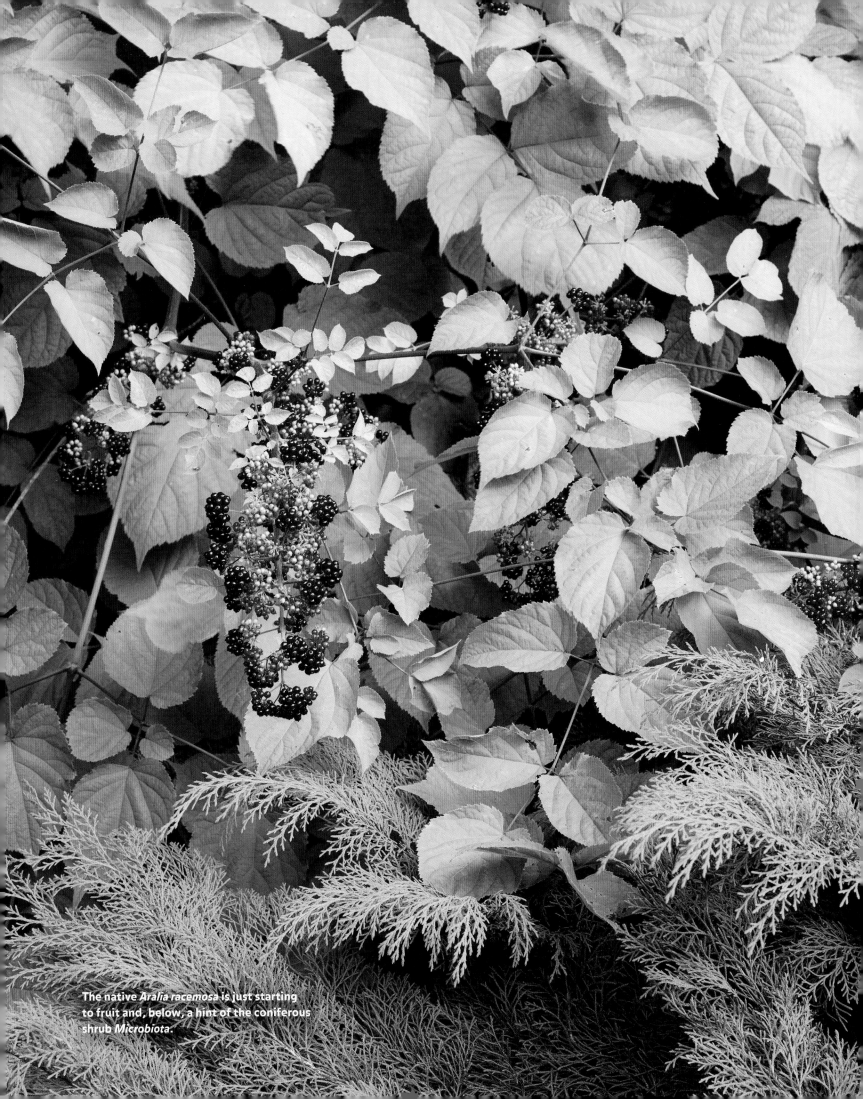

The native *Aralia racemosa* is just starting
to fruit and, below, a hint of the coniferous
shrub *Microbiota*.

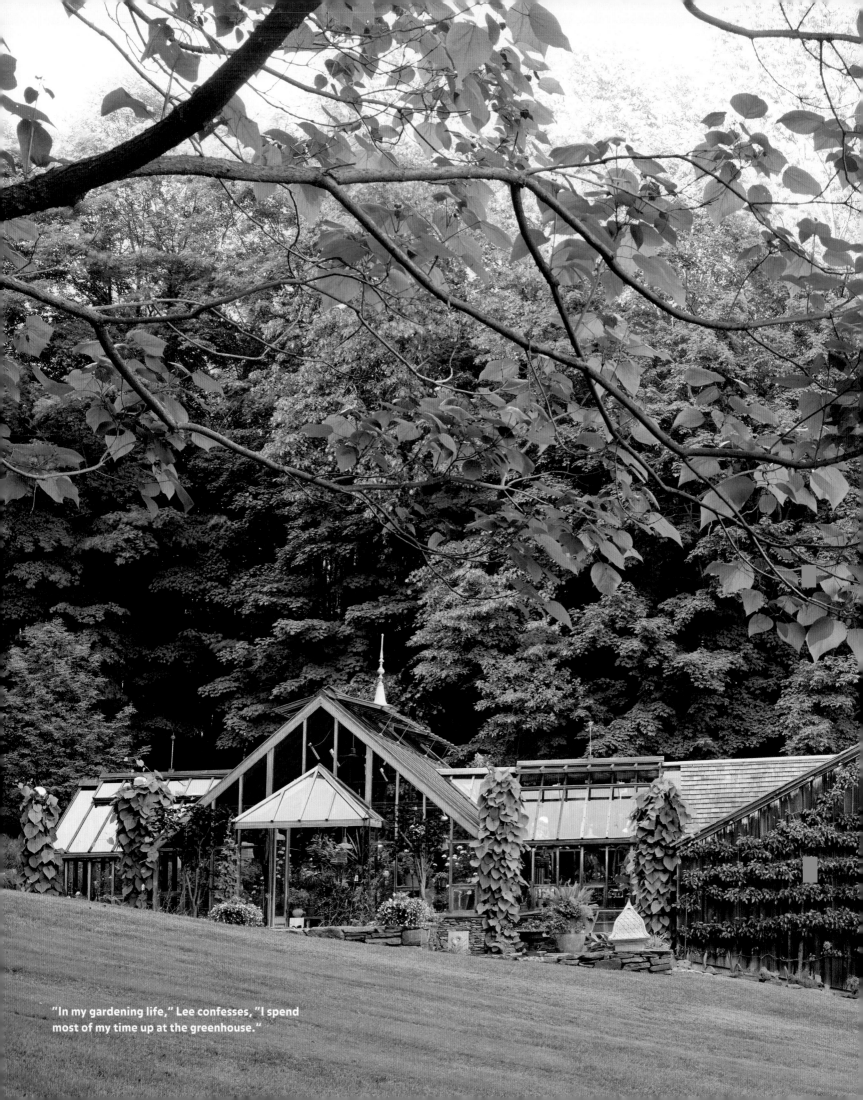

"In my gardening life," Lee confesses, "I spend most of my time up at the greenhouse."

The Garden of Lee Link

Sharon, Connecticut

"I don't have any boxwood," Lee Link says, referring to plantings in her Sharon, Connecticut, garden. This is a startling declaration in this day and age, when box bushes are planted by the dozens, mounds of them, at nearly every doorstep in the suburbs and exurbs—the new favorite evergreen where deer browsing is an issue, since deer don't seem to relish box. But Lee doesn't have a deer problem, perhaps because of the steep mountain ledge behind her house and garden, and she thinks boxwood not appropriate. "I'm on top of a hill looking at a valley, and I didn't want the country citified."

Gradually, over the last thirty-five years, Lee transformed the plain, wooden, A-frame bungalow she and her husband, Fritz, bought as a weekend house. It is perched high on a hill overlooking the rolling landscape of northwestern Connecticut. She added architectural details to its outline, mullions to the windows, and extended the house with two screened-in porches and a conservatory, which she calls the winter dining room. It is also now the entrance to her home. She leveled the ground around the house to make stone terraces, where she stages pots of summer bulbs, succulents, and geraniums. And she planted a bold flower border of perennials, annuals, and shrubs just below the porches. But that mixed border was high-maintenance and, after a number of years, became a burden. So, recently, Lee tossed out the flowers and simplified this ten-foot-deep border dramatically. It now features an architectural planting of three Kousa dogwoods in gravel, beautiful in every season and demanding little care.

Where Lee's heart is, and where she now spends the majority of her gardening time, is in her splendid greenhouse, added twelve years ago to the back of her garage. In the shape of a Greek cross, the greenhouse has two zones: the cold outer wing, with temperatures kept around forty-five degrees in winter, and the main central area slightly warmer, with the nighttime temperature in winter not below fifty-five. The greenhouse shelters all types of geraniums and succulents in winter, while under the bench summer bulbs are allowed to go dormant. Outside the glass structure, gravel terraces become the summer setting for many of her potted plants. Some years, pumpkins romp across the gravel, and this year, dahlias were planted in the gravel and flowered there. Four twelve-foot-high iron tuteurs (four-sided obelisk-like trellises) are also sunk into the gravel outside the greenhouse and in summer support the bold-leaved perennial Dutchman's pipe.

Against the dark gray wooden façade of the garage, just below the greenhouse, Lee planted two tiny sapling pear trees fifteen years ago. Every year she carefully trained their branches into a cordon espalier, which now covers the entire garage in stripes. "There's great satisfaction in putting in a small tree," Lee wisely says. "I picked between forty and fifty pears this year."

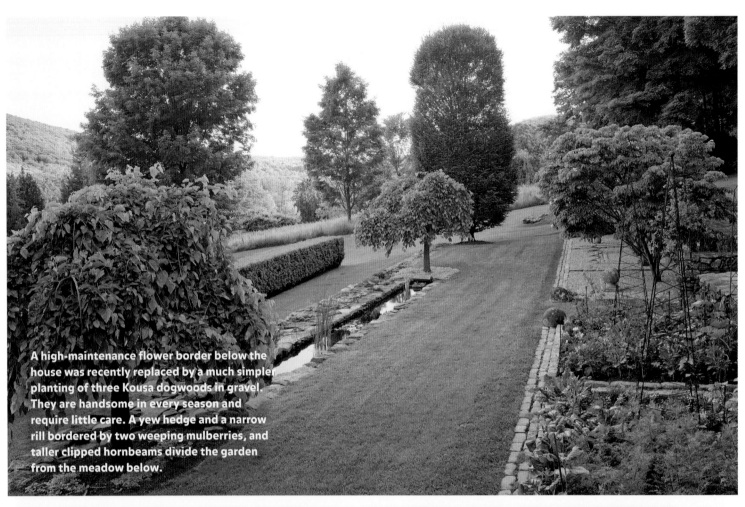

A high-maintenance flower border below the house was recently replaced by a much simpler planting of three Kousa dogwoods in gravel. They are handsome in every season and require little care. A yew hedge and a narrow rill bordered by two weeping mulberries, and taller clipped hornbeams divide the garden from the meadow below.

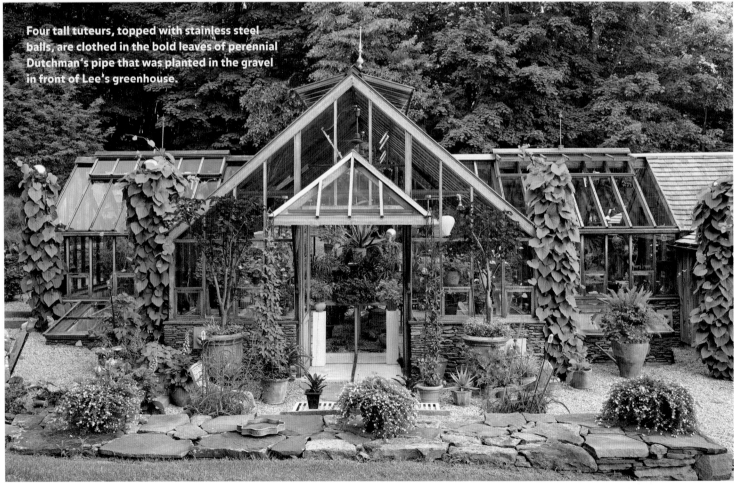

Four tall tuteurs, topped with stainless steel balls, are clothed in the bold leaves of perennial Dutchman's pipe that was planted in the gravel in front of Lee's greenhouse.

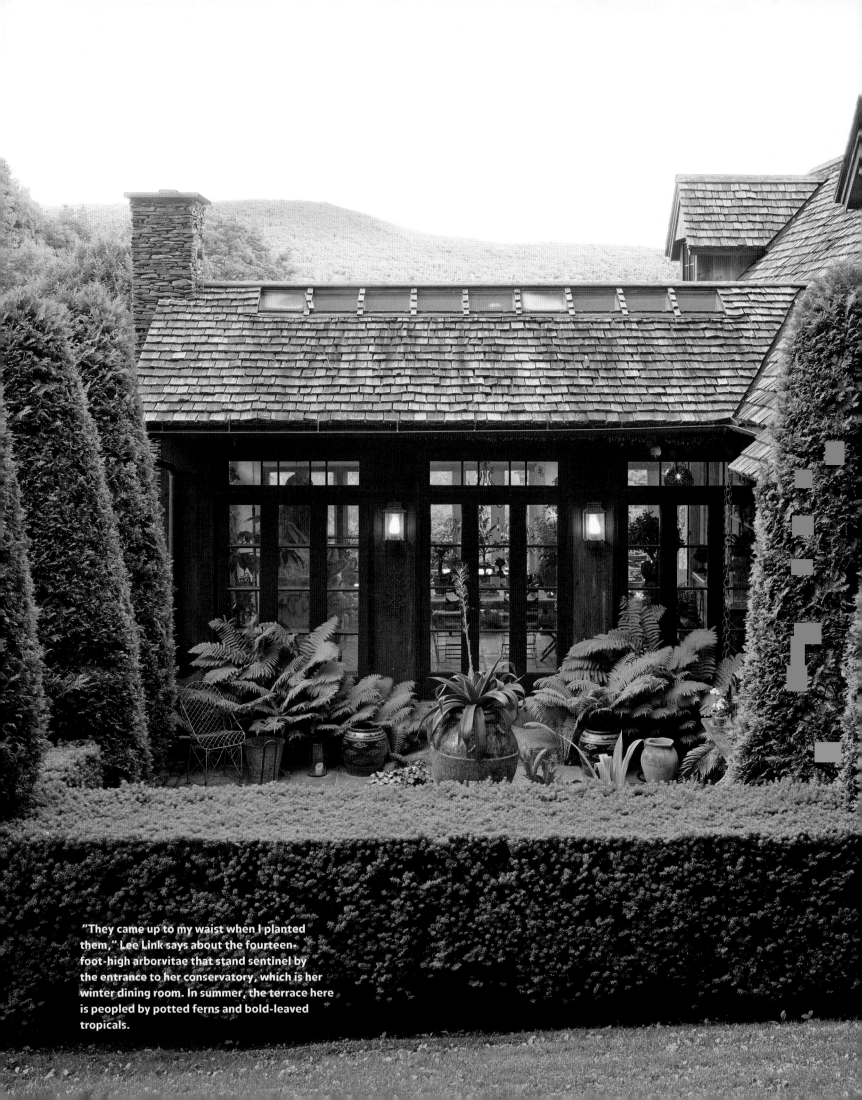

"They came up to my waist when I planted them," Lee Link says about the fourteen-foot-high arborvitae that stand sentinel by the entrance to her conservatory, which is her winter dining room. In summer, the terrace here is peopled by potted ferns and bold-leaved tropicals.

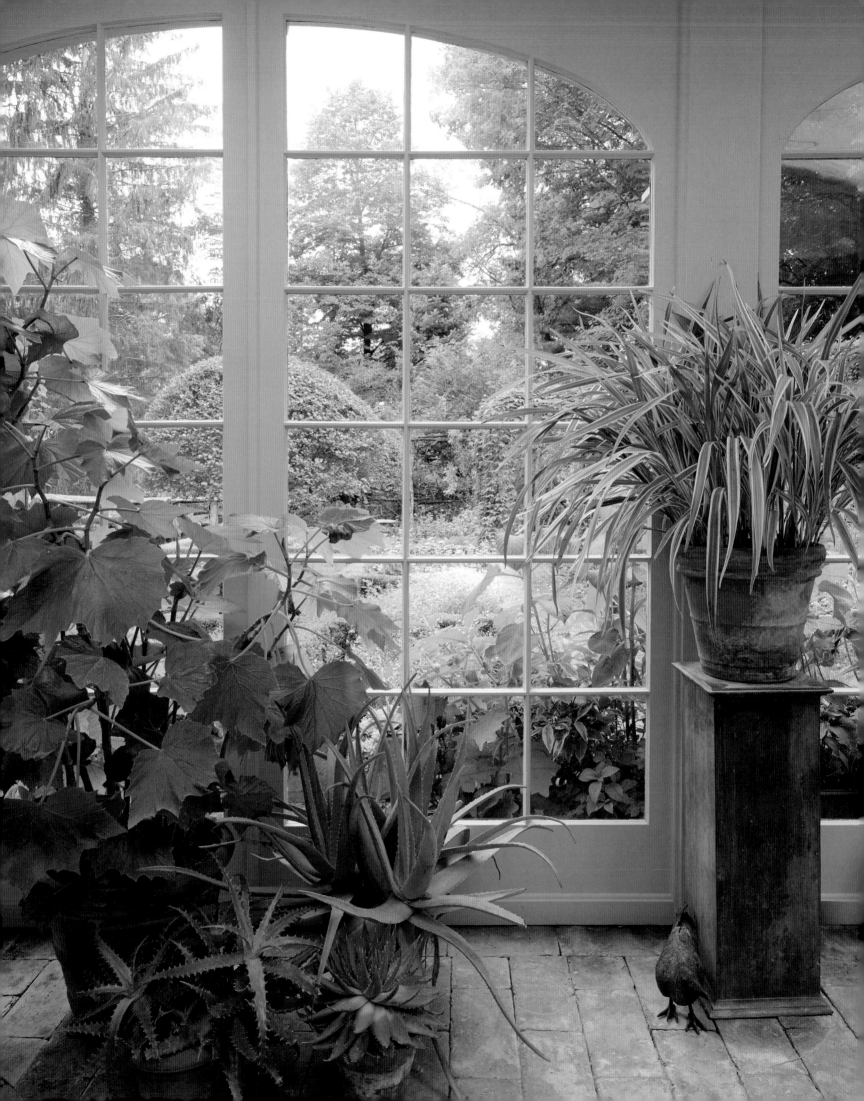

Bunny Williams's Garden

Falls Village, Connecticut

Driving down a rural side road in this sleepy village, you may be surprised to suddenly come upon an elegant, classic Federal manor house set back on a broad lawn, reached by a gravel drive lined with old, deeply furrowed black locusts. This is the retreat of renowned interior designer Bunny Williams and her husband, antiques dealer John Rosselli, the place where they relax and cook and entertain, surrounded by the garden Bunny has created. Not surprisingly, that garden is divided into outdoor "rooms," each with its own character—the parterre garden, the sunken garden, the vegetable garden. "Inside the house and out, you need to break up the space into a size your eye can take in," Bunny says. And just as hallways and doors connect one room of a house to another, so, too, are the garden pathways essential to lead you from one space to the next.

One path lures you from the driveway down the side of the barn to a gate that opens to a charming, small parterre garden enclosed on three sides with a board fence. On the fourth side, a series of tall, arched windows enclose a conservatory at the back of the barn. Clipped boxwood hedges define the pattern of beds, which are filled in summer with the froth of an annual—just one for each bed, in either blue or white, simple and effective—angelonia, or *Euphorbia* 'Diamond Frost,' or the tall blue ageratum. Two standard dwarf Korean lilacs add stature to the garden, as do arches and tuteurs of climbing roses and vines.

From the parterre garden, a path through a pergola leads you around to the back of the house, where Bunny has recently framed a lawn area with yew hedging clipped into swoops as though they were curtains, backed by the tawny white plumes of hydrangeas. Terraces here are shaded by great old maples and lead to the sunken garden down broad stone steps. A long, narrow pool is the central feature of this garden with bold mixed borders of tropicals and perennials flanked against lattices on two sides. Around the pool, a lawn has recently been replaced by stone paths and six box-edged beds. Two center beds contain low-growing herbs and dianthus; the outer four explode in summer with the waving purple heads of *Verbena bonariensis*. "A combination of formality and randomness," Bunny says, "is what a garden should be."

The arched windows of the conservatory look out onto the parterre garden where clipped dwarf Korean lilac standards are underplanted with *Euphorbia* 'Diamond Frost,' pale blue *Angelonia* 'Wedgewood Blue,' and *Ageratum* 'Blue Horizon' within the strictures of boxwood.

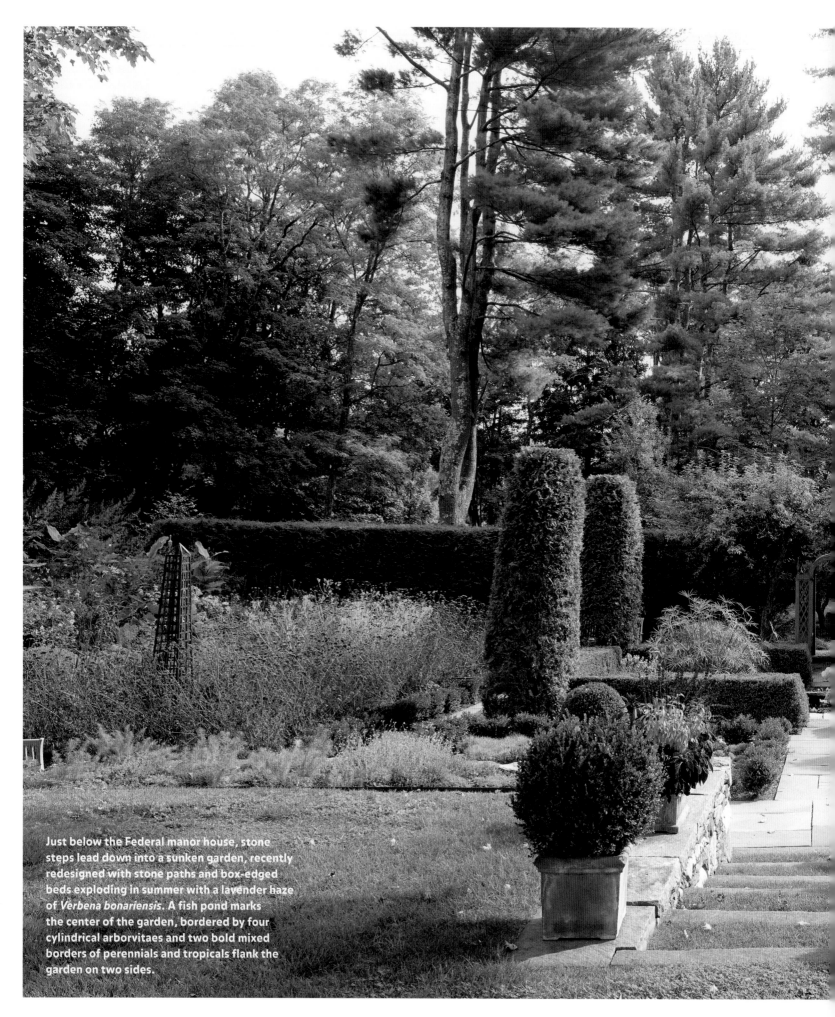

Just below the Federal manor house, stone steps lead down into a sunken garden, recently redesigned with stone paths and box-edged beds exploding in summer with a lavender haze of *Verbena bonariensis*. A fish pond marks the center of the garden, bordered by four cylindrical arborvitaes and two bold mixed borders of perennials and tropicals flank the garden on two sides.

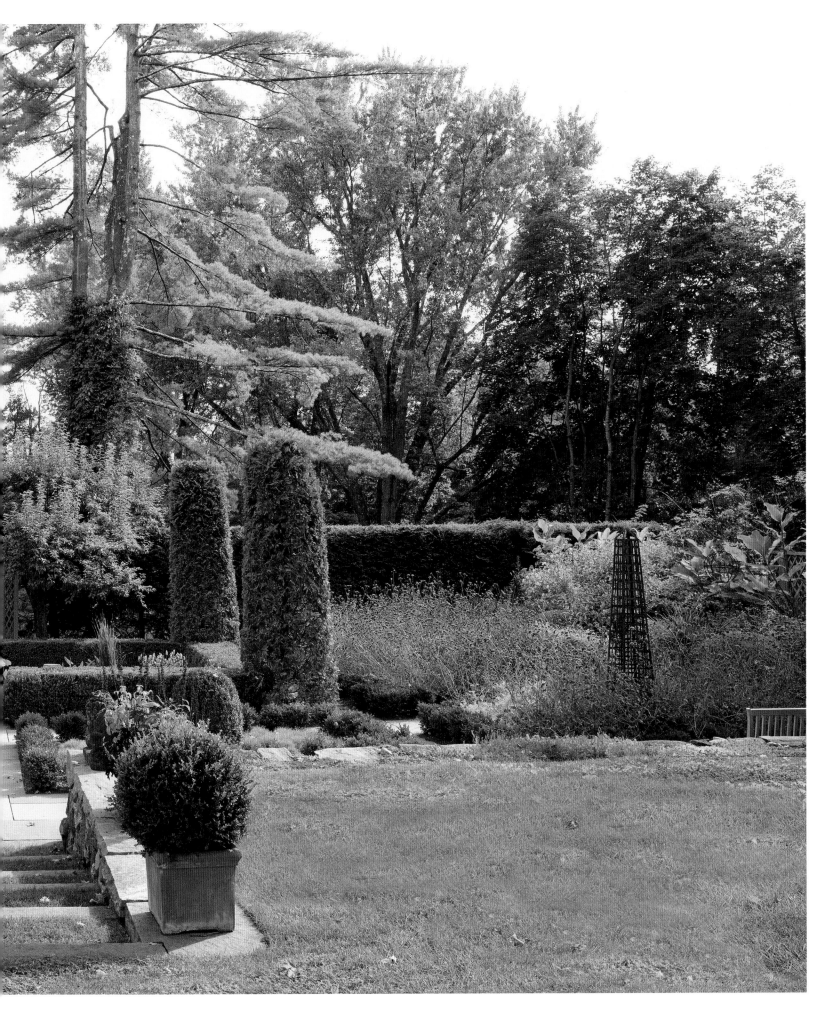

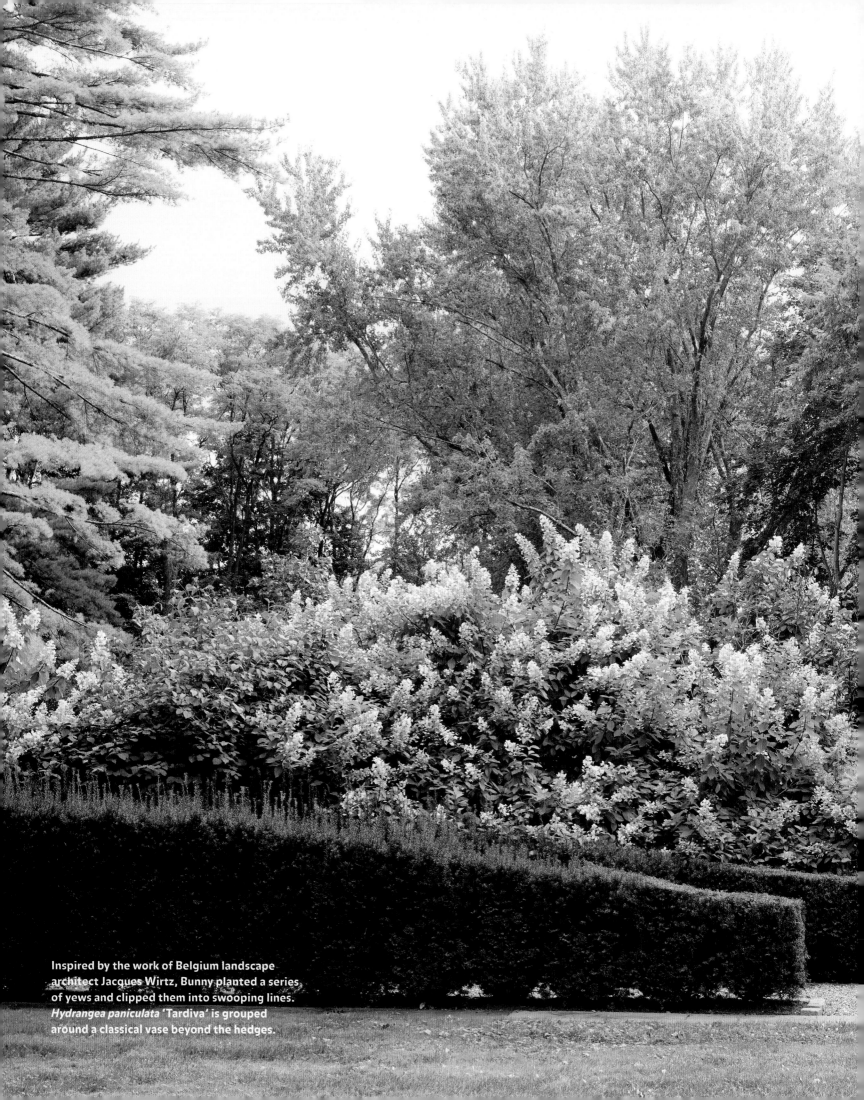

Inspired by the work of Belgium landscape architect Jacques Wirtz, Bunny planted a series of yews and clipped them into swooping lines. *Hydrangea paniculata* 'Tardiva' is grouped around a classical vase beyond the hedges.

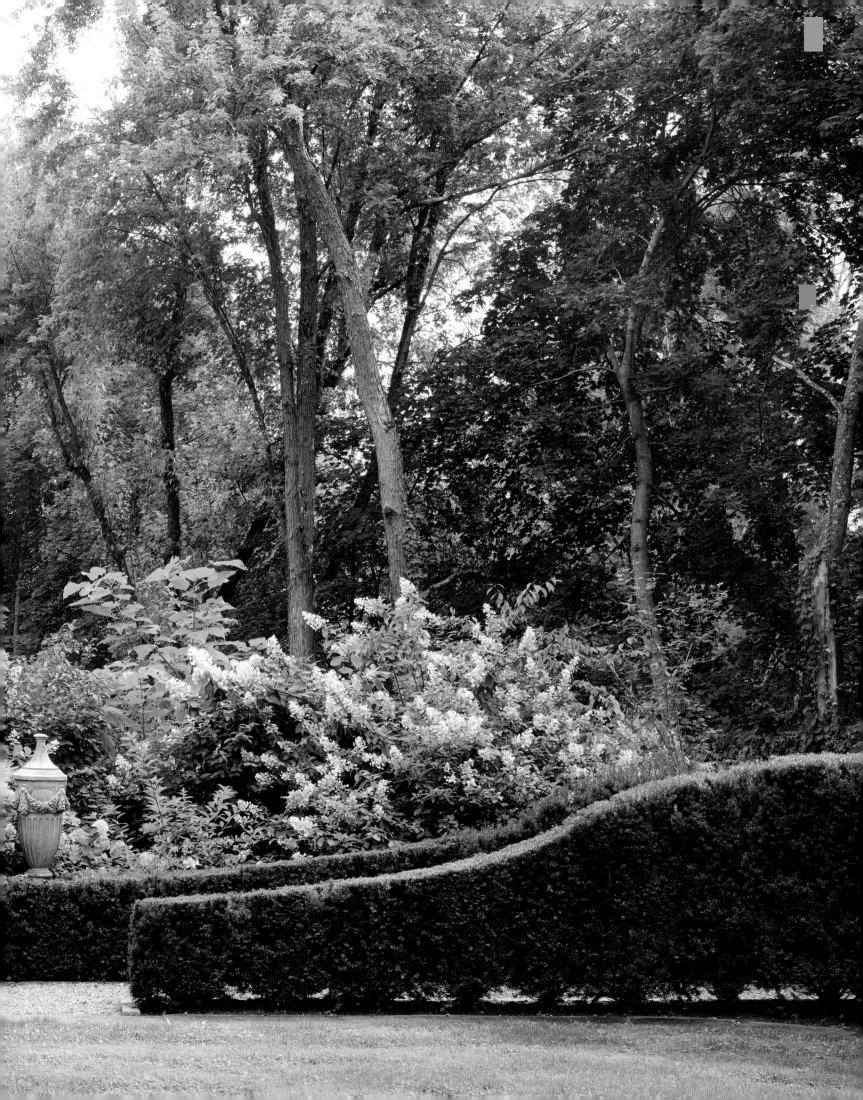

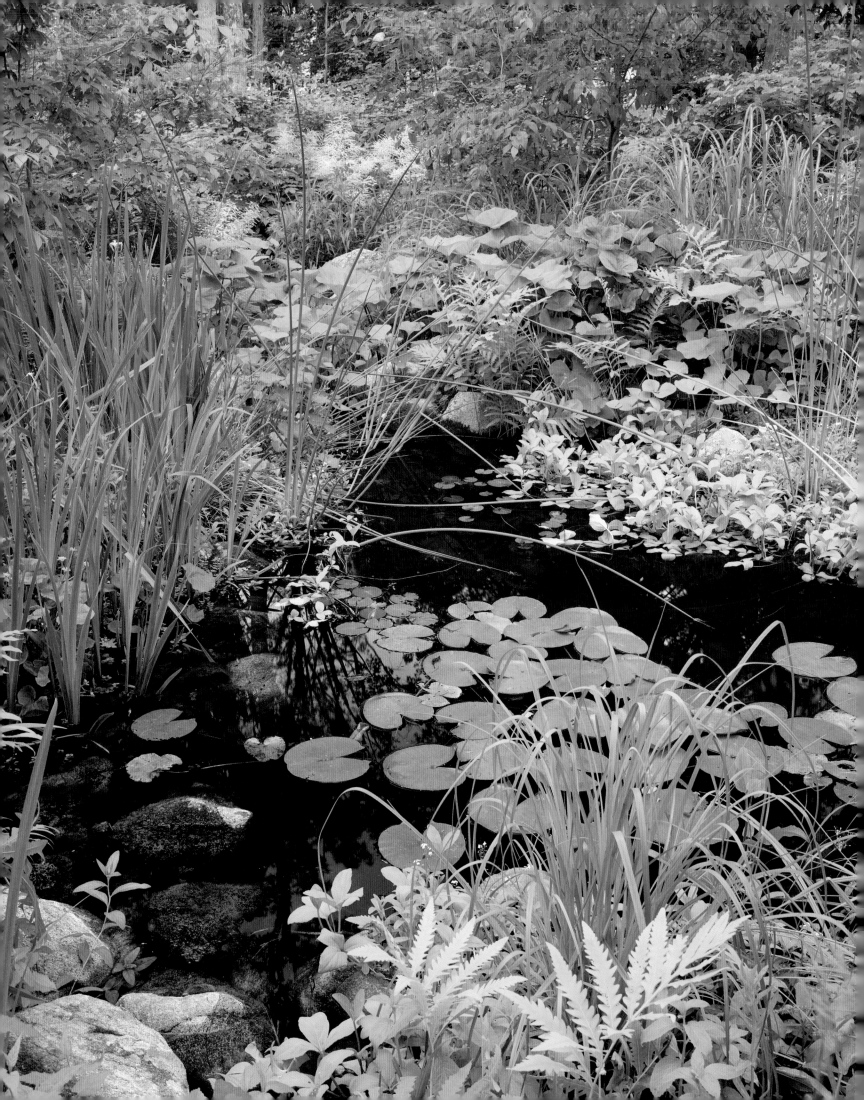

Ken Uhle's Woodland Garden

Ridgefield, Connecticut

Ken Uhle's one-acre woodland sanctuary has a rocky stream running into lily ponds and a tracery of paths through an exceptional array of shrubs and small trees, all of which he singlehandedly cultivated over the last twelve years. A landscape architect for the Westchester County Parks Department, Ken spends his free time honing his own back-yard garden. The brook is man-made, with water recycled from a single pump, coursing down the hillside and coming to rest in two small rock-bound ponds surrounded by ferns, hostas, goatsbeards, and rushes. Ken is first of all a plant collector, his focus narrowed on several species. He is crazy about magnolias and is growing as many native sorts as will survive his Zone 6 climate. He has a "mini collection" of winter hazels, the graceful clan of spring-blooming corylopsis. Hydrangeas abound, with half a dozen varieties of oak-leaf hydrangea and about seven different cultivars of native smooth hydrangea, *H. arborescens*. Of the latter, he says, "They are hardy, and they take dry shade well."

The paths in Ken's garden are covered in wood chips and marked occasionally by low stakes cut from cedar trees. "I try to be sort of sustainable," he says. "I leave leaves in place, and I haven't bought mulch in years. I shred leaves myself and chip branches. And I try to put water back into the soil by building stone-lined swales for infiltration. I don't use any herbicides or pesticides"—a good lesson for Open Days visitors who thread their way through his garden every year to enjoy how it flourishes.

A brook runs down Ken's rocky, wooded hillside and comes to rest in two small naturalistic ponds—all dug and planted by him over a period of years and powered by one pump. The upper pond is in a spot sunlit enough to grow water lilies.

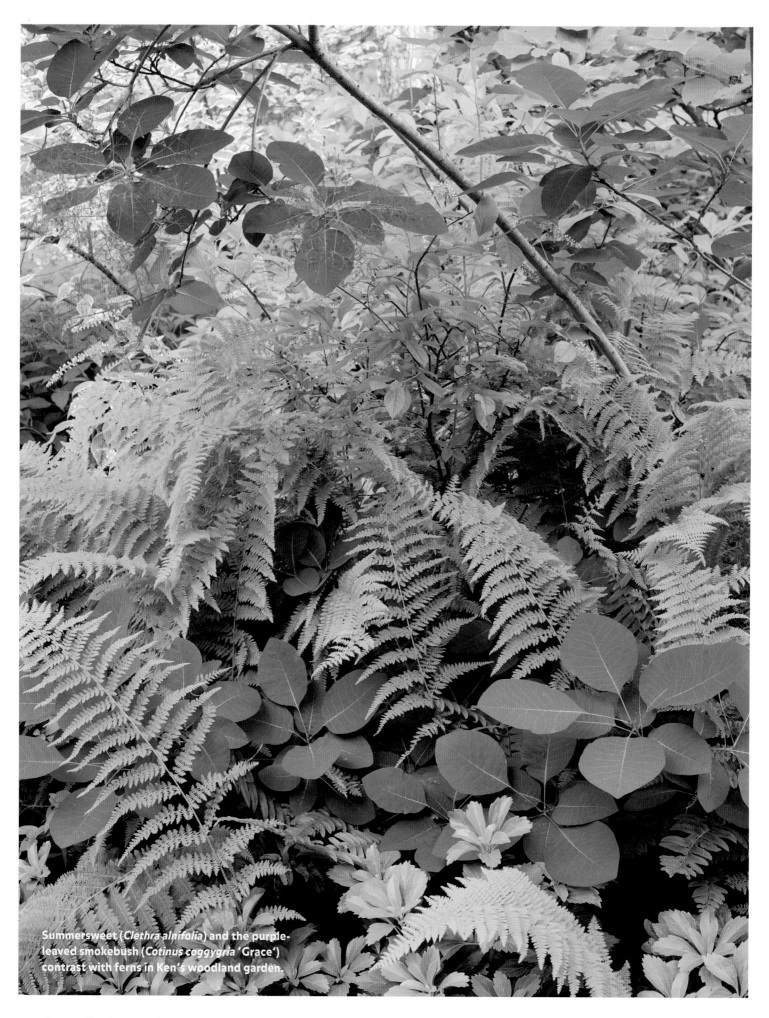

Summersweet (*Clethra alnifolia*) and the purple-leaved smokebush (*Cotinus coggygria* 'Grace') contrast with ferns in Ken's woodland garden.

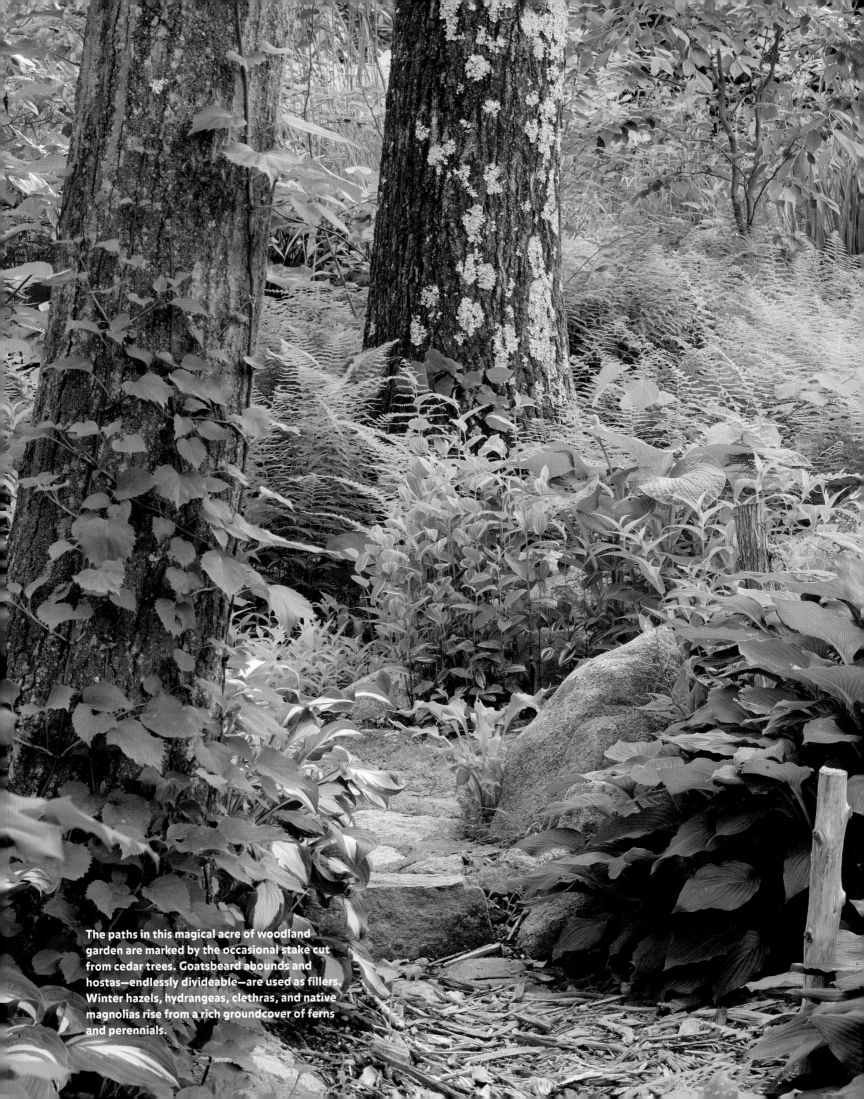

The paths in this magical acre of woodland garden are marked by the occasional stake cut from cedar trees. Goatsbeard abounds and hostas—endlessly divideable—are used as fillers. Winter hazels, hydrangeas, clethras, and native magnolias rise from a rich groundcover of ferns and perennials.

In Situ

Redding, Connecticut

This eight-acre utopia of open fields and woods punctuated by small creeks in rural Redding, Connecticut, has a mission. Its owner offers it as a setting in which art, fashion, music, and culinary-arts companies can stage charity events; the resulting funds help provide college scholarships to underprivileged art students. With that mission in mind, landscape designer Richard Hartlage has created a series of garden spaces, or "rooms," that each offer a sense of surprise and celebrate the softly rolling land. In September, when In Situ welcomes the public for Open Days, visitors can lose themselves on paths through native meadows or on woodland walks that might suddenly lead to a pool of water surrounded by a sea of black-eyed Susans, or an arbor framed by goldenrod and white hydrangeas. Below the rustic, cedar-shake house, an arching sweep of native grasses meets a generous sward of lawn. Native dogwoods and viburnums, heavy with fruit, are massed with ground covers of cranesbills and epimediums. This garden offers an excellent example of the aesthetic effectiveness of sweeps of plants.

Sculptures appear unexpectedly within the garden areas—a pierced copper sphere in that sea of rudbeckia, a stone plinth amid ornamental grasses. Hartlage says he started with simple, austere, garden architecture—stone steps and terraces, reflecting pools, wood and stone arbors—and filled in with soft, romantic plantings. A meadow of native grasses and a non-running selection of goldenrod (*Solidago rugosa* 'Fireworks') cover a one-and-a-half-acre slope, which is romantic, indeed, when seen from the stone terrace and geometric reflecting pools below the house just opposite it. Stone steps carve a path up through the meadow so you can get lost in its beauty. "The meadow," Hartlage says, "is the heart and soul of the place."

Steps through a meadow of goldenrod lead down to the house and terrace pools in this garden designed by Richard Hartlage.

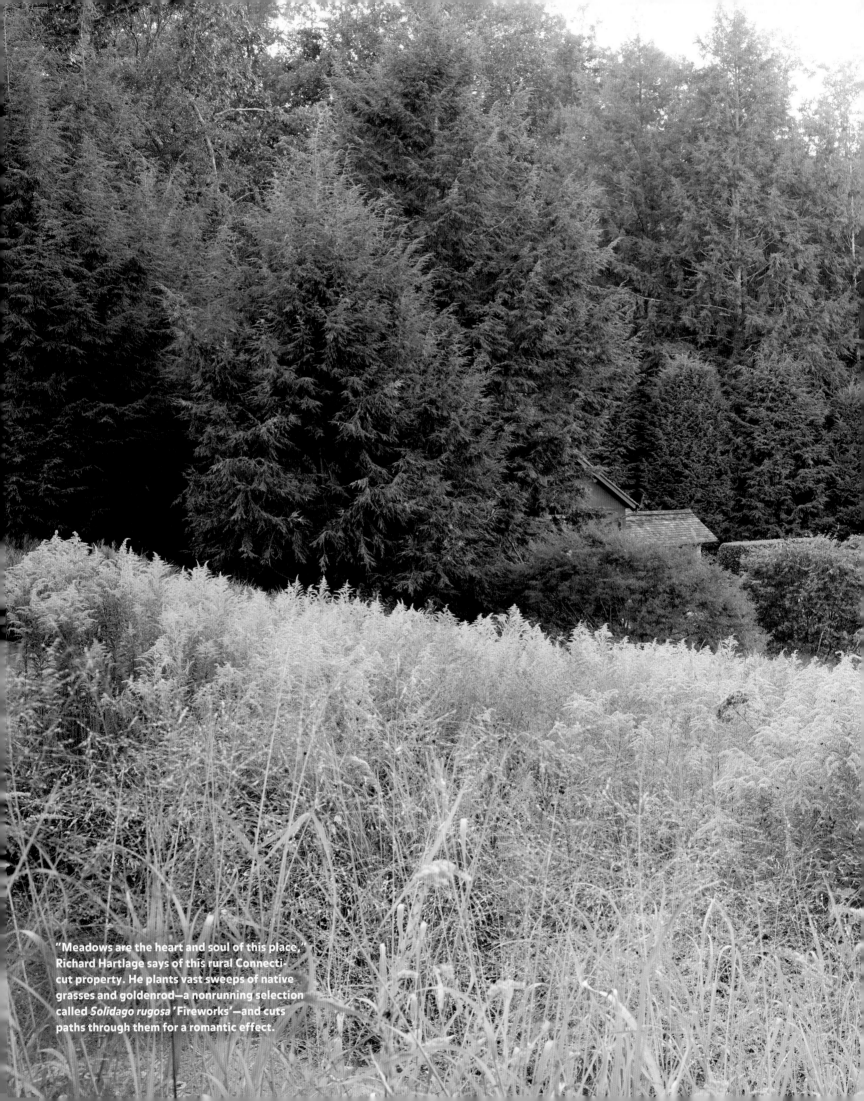

"Meadows are the heart and soul of this place," Richard Hartlage says of this rural Connecticut property. He plants vast sweeps of native grasses and goldenrod—a nonrunning selection called *Solidago rugosa* 'Fireworks'—and cuts paths through them for a romantic effect.

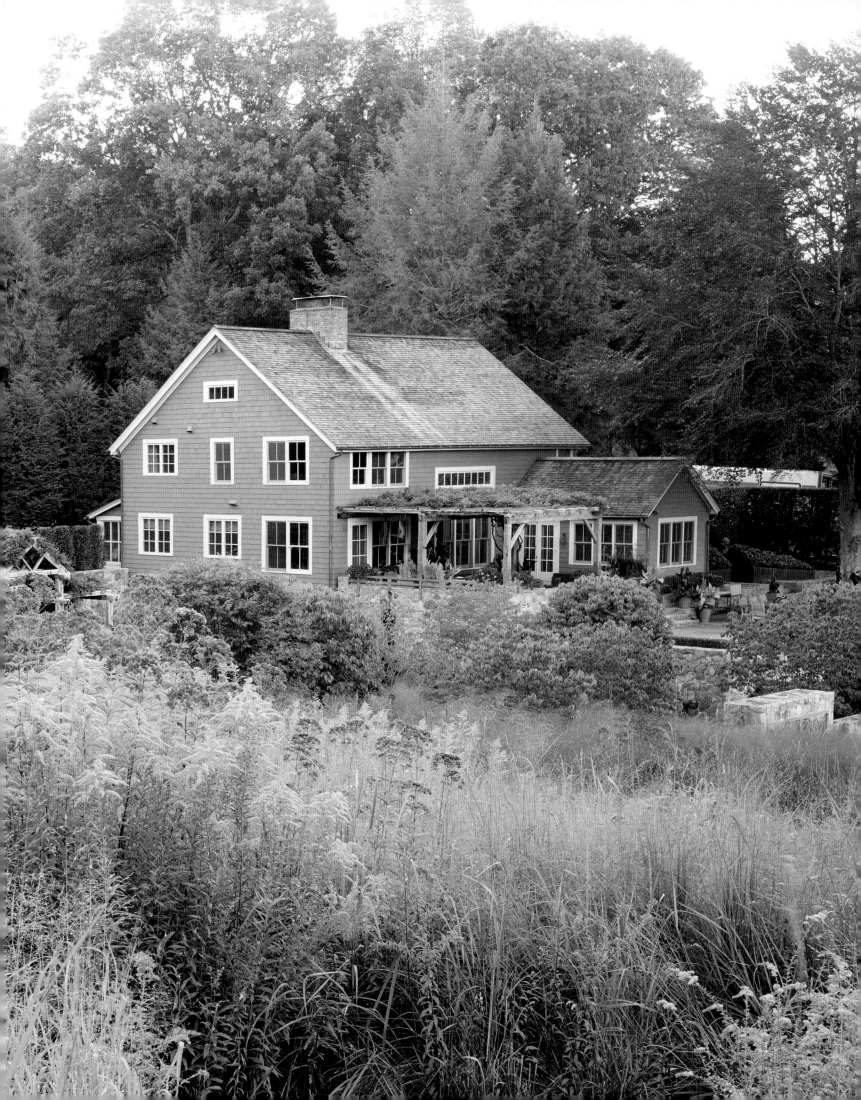

THE
SOUTH

Blessed with a long growing season and abundant native vegetation, the Southern colonies of America attracted the attention of early botanists and naturalists as well as the English settlers who had brought along their favorite plants for both practical and commercial use. The original Southern gardens were often enclosed by walls or hedges, and they emphasized the use of flowering plants within a simple, geometric design. The American South's hot, humid climate and its profusion of native plants were to give these traditional elements a character all their own.

The gardens chosen for this section of the book represent present-day applications of European landscape designs and practices, in the great plantations of Virginia, in the bustling river towns of the mountainous interiors, and in coastal cities such as Charleston.

In the late eighteenth and early nineteenth centuries, wealthy Low-Country planters moved to their elegant Charleston town houses to escape the summer malaria season. These homes had a unique, vernacular style of architecture influenced by the subtropical weather and adapted to the urban density of the city. Long, rectangular houses were typically built along the property's lot line and set perpendicular to the street, with the rooms strung out in a single file for cross ventilation. The first floor was usually raised several feet above the ground to protect against the floods that regularly occurred in low-lying areas. Piazzas, or long porches, along the length of each floor faced the south or west, providing shade during the heat of the day and catching cool ocean breezes at night. The piazzas typically had a view of a parterre garden, designed to be seen from above. The street door opened into the piazza at the side of the house, and a carriageway led to the "dependencies," or outbuildings, arranged in a stable yard enclosed by the rear wall.

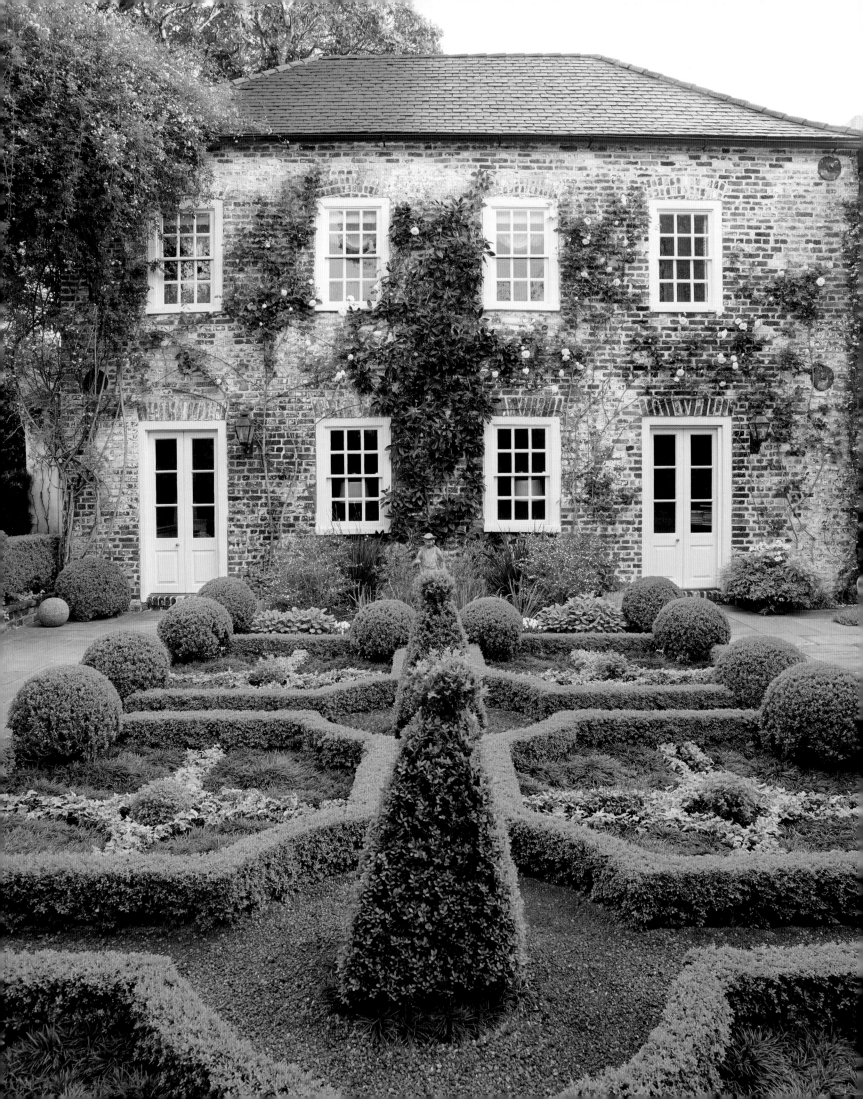

Cindy & Ben Lenhardt's Garden

Charleston, South Carolina

The Lenhardts' house in Charleston's historic district was built in 1743 by a young man who had inherited a large fortune from his father, an enormously wealthy plantation owner. Ben wished to create a garden in keeping with that period, which in the Southern colonies would have been patterned boxwood parterres. His choice of Southern plants and stone landscapes was also inspired by the work of Loutrel Briggs (1893–1977), the landscape architect who developed the distinctive Charleston style of gardening.

As with most historic houses, the original plan for the property has been altered over the years to accommodate a modern lifestyle, with no need for slaves' quarters, carriage houses, or stable yards. The separate kitchen house, where cooking and laundry were once done, is now connected to the main house, and the garden extends all the way to the property's original rear wall. The entrance from the street is through a colonial-style wooden fence, and the boxwood parterres around the house remain compatible with early-Charleston architecture. The former carriageway has become a driveway on an axis with an old stone mooring post that matches the ones in front of the house, where boats were once tied up in the marshes of the Cooper River. The small flower bed adjoining the kitchen house is planted as a white garden, with white climbing roses, an espaliered *Magnolia grandiflora*, and a white lantana.

A few steps lead up to the garden's second level, where white perennials share the space with such "exotics" as papyrus, ginger lilies, fig-leafed palm, and rice paper plants. The last garden "room" lies behind a southern yew hedge clipped to look like a stone wall. Ben calls it his "classic Charleston garden—camellias, Lady Banks' roses, dogwoods—call in blues, lavenders, pinks, and touches of white." His garden, he says, "is a good example of what has made Charleston gardens famous: small spaces filled with boxwood parterres, Southern plants, differing elevations, and varied hardscapes."

The Lenhardts designed a classic Charleston garden in keeping with their 1743 house. Its small spaces are divided by varying elevations and hardscapes and closely planted with boxwood parterres and Southern shrubs, trees, and flowers. A white Lady Banks' rose (*Rosa banksiae* 'Alba Plena') and an espaliered magnolia (*Magnolia grandiflora* 'Little Gem') cover the wall of the kitchen house, while a potato vine (*Solanum jasminoides*) hugs the corner.

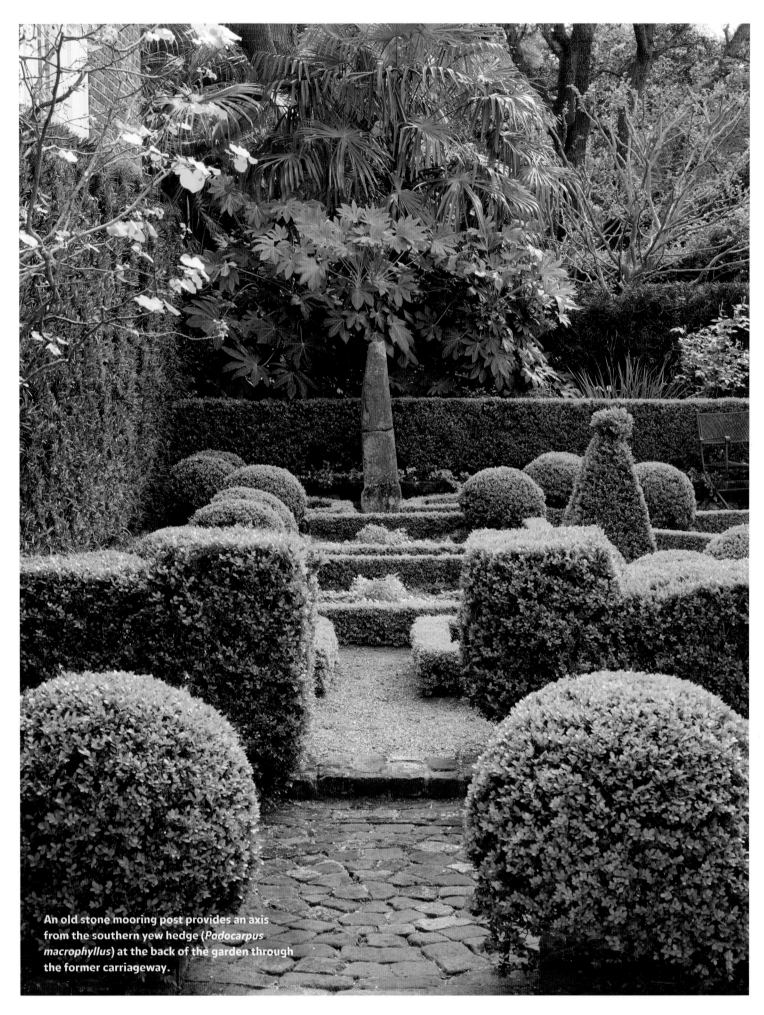

An old stone mooring post provides an axis from the southern yew hedge (*Podocarpus macrophyllus*) at the back of the garden through the former carriageway.

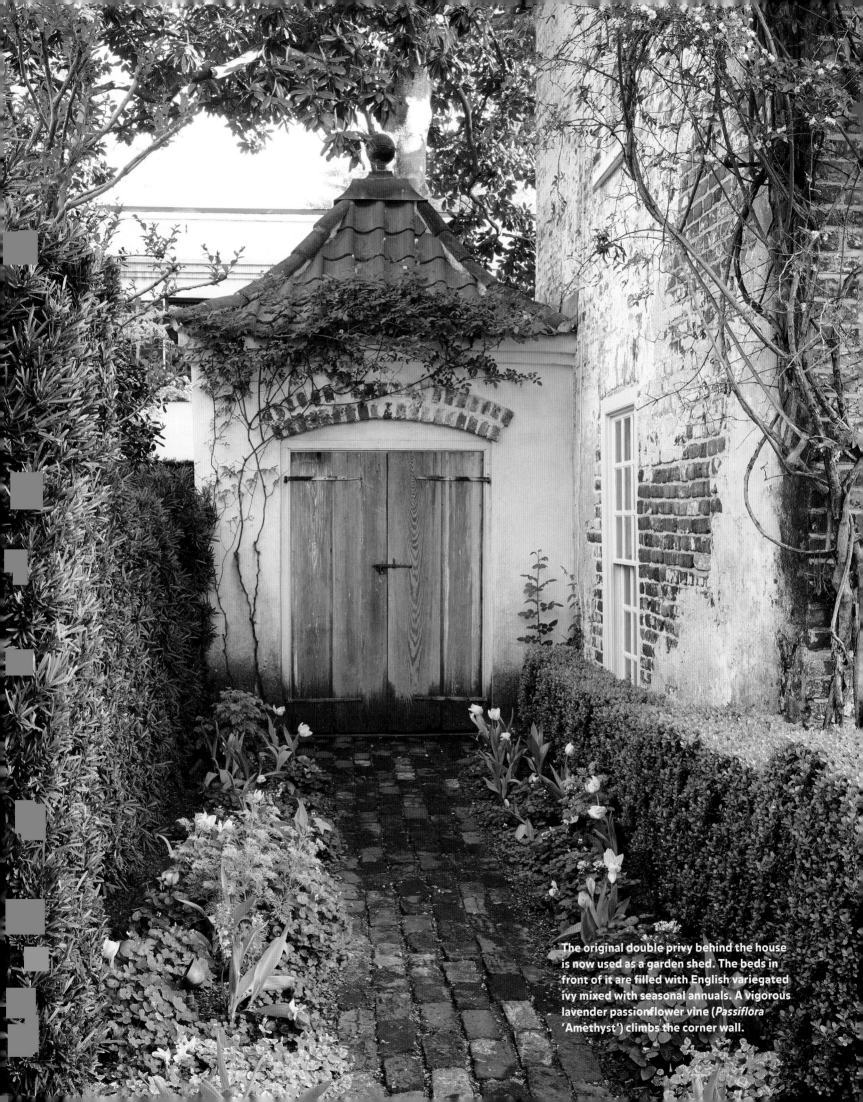

The original double privy behind the house is now used as a garden shed. The beds in front of it are filled with English variegated ivy mixed with seasonal annuals. A vigorous lavender passionflower vine (*Passiflora* 'Amethyst') climbs the corner wall.

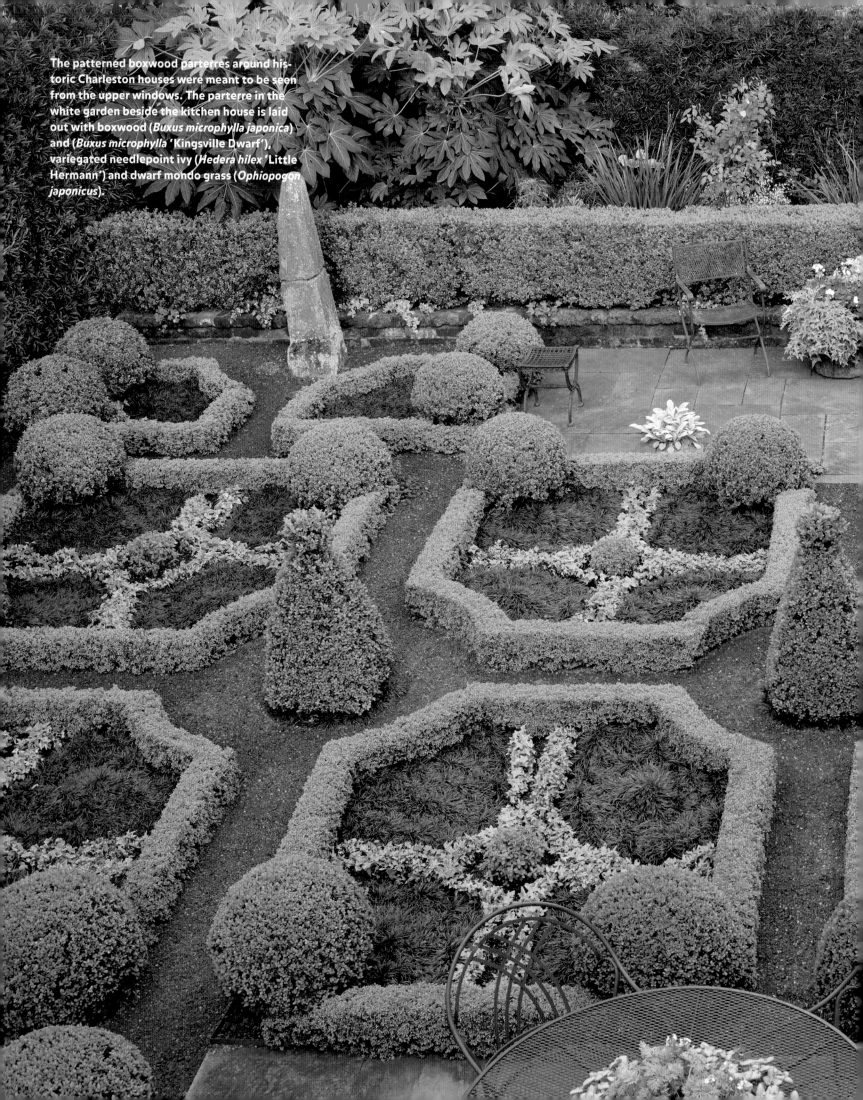

The patterned boxwood parterres around historic Charleston houses were meant to be seen from the upper windows. The parterre in the white garden beside the kitchen house is laid out with boxwood (*Buxus microphylla japonica*) and (*Buxus microphylla* 'Kingsville Dwarf'), variegated needlepoint ivy (*Hedera hilex* 'Little Hermann') and dwarf mondo grass (*Ophiopogon japonicus*).

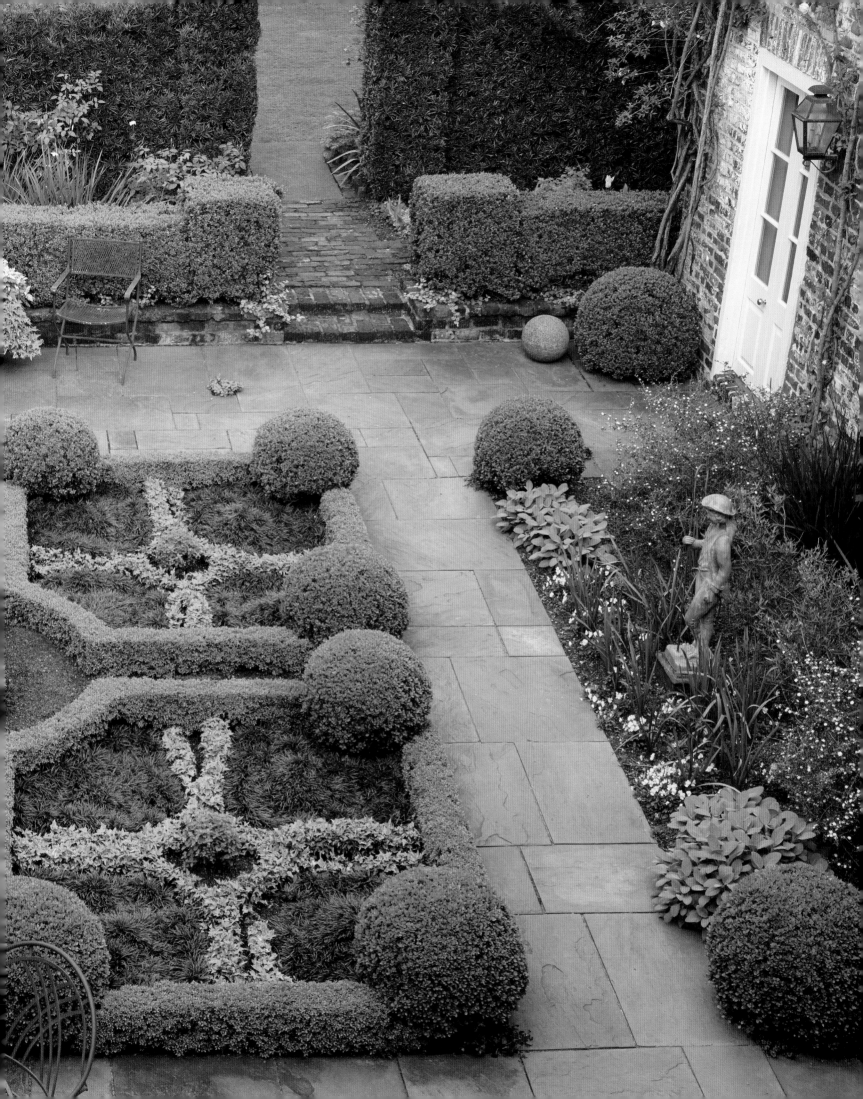

The Garden of Gene & Betsy Johnson

Charleston, South Carolina

In 1995, the Johnsons bought a property with two derelict buildings and a large asphalt parking lot. They lovingly restored the 1806 house and the late-nineteenth-century Gothic Revival carriage house behind it. After digging up the asphalt, Gene set out to create a garden in the appropriate Charleston style.

"I'm very visual," Gene says. "I look for symmetry; I like organizing space." Like an architect designing a building, he first laid out a plan with fencing, walls, and hedges to define the spaces, then connected them with paths lined with boxwood. A tall hedge of East Palatka holly punctuated with Italian cypress serves as one wall, and a southern yew hedge separates the garden from the driveway. The paths lead through five parterres laid out in geometric patterns and into a small shade garden, a rose garden, and an herb garden. The result is a continuous unfolding of different scenes, creating a sense of drama and discovery along the classic lines of a Charleston garden.

Gene built this charming tool shed that mirrors the gothic architecture of the carriage house. It stands at the end of the grass and stone driveway, a common feature of Charleston properties.

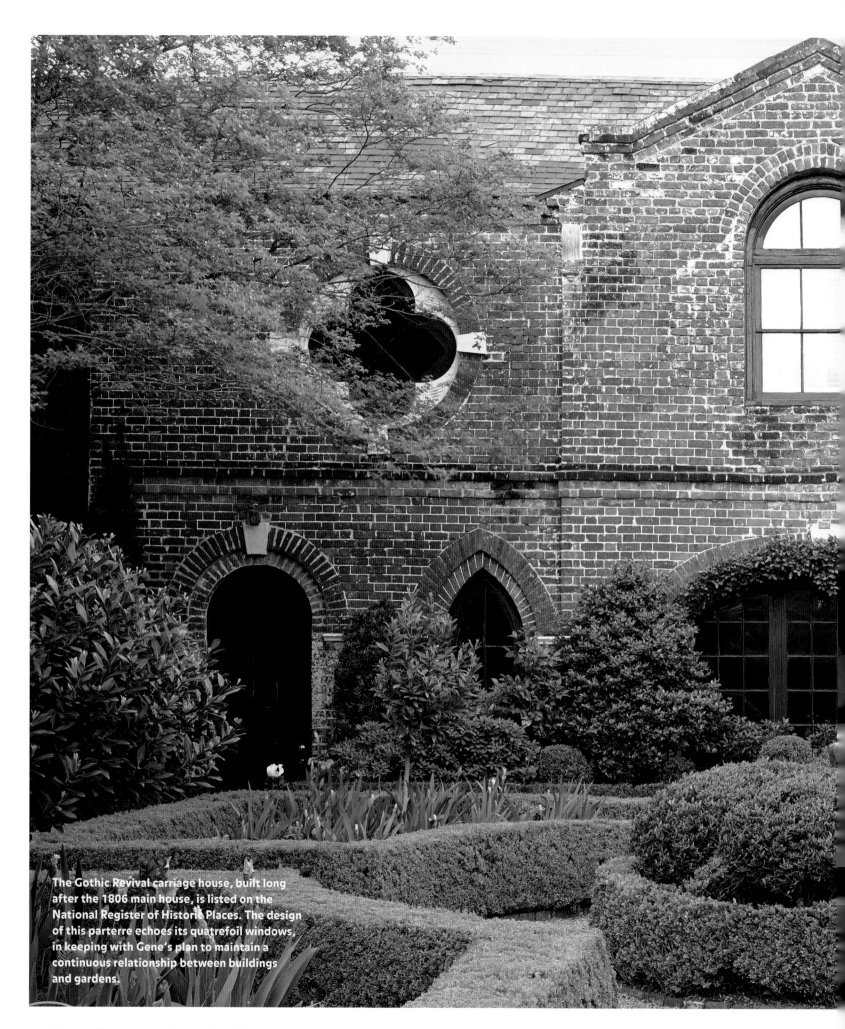

The Gothic Revival carriage house, built long after the 1806 main house, is listed on the National Register of Historic Places. The design of this parterre echoes its quatrefoil windows, in keeping with Gene's plan to maintain a continuous relationship between buildings and gardens.

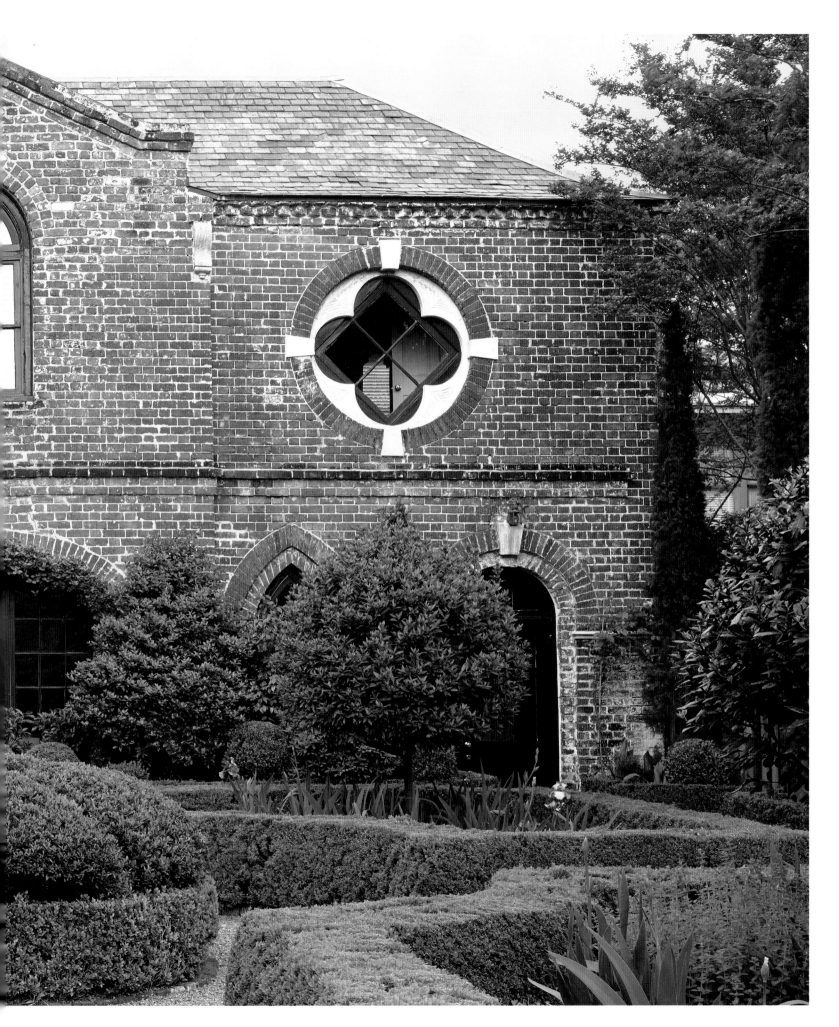

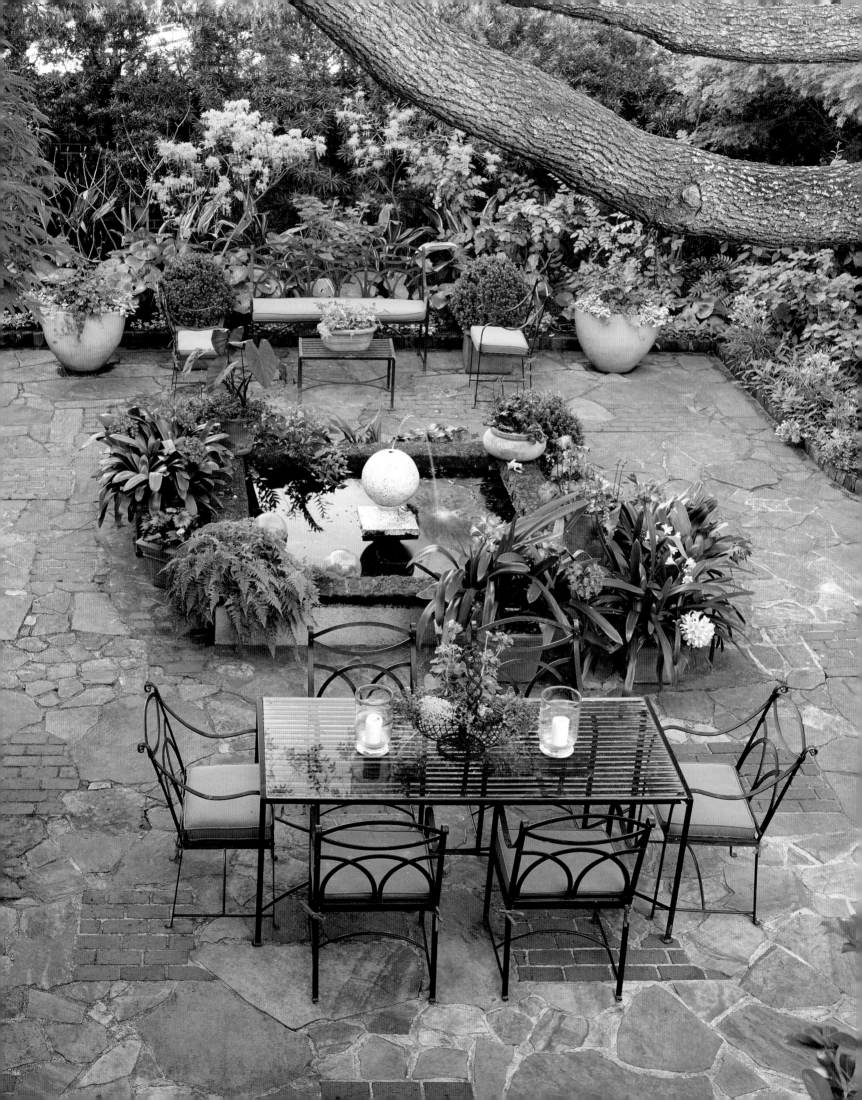

The Garden of Peter & Patti McGee

Charleston, South Carolina

When the McGees moved into their antebellum house in Charleston's Ansonborough, they inherited a garden that still had the bones of landscape architect Loutrel Briggs's design. Recognizing that his work should be preserved, they made few changes in the hardscape of brick walls and terraces. Within this formal structure, however, they needed new combinations of plants to meet the challenges of a forty-year-old garden. The handsome live oak tree that stood in the center of the original design, for example, had grown rapidly. While the tree provided welcome shade for the house, it also created a ceiling that shut out the sun over most of the garden.

A passionate gardener and connoisseur of Southern plants, Patti calls her new design for the garden "plant driven." The result of her enthusiasm is an exuberant display of shrubs and subtropical flowers and vines that bring new life to the garden. "I enjoy using old-fashioned, tried-and-true Southern plants in combination with new introductions, and I like to try plants not always happy in our . . . climate. . . . My plant selections must tolerate very little sun, and our summer heat and humidity offer another challenge. I believe gardening is always about editing and finding plants that speak to each other and to you."

The shade of an ancient live oak tree (*Quercus virginiana*) called for a new approach to a garden that Loutrel Briggs had designed in the late 1960s. Clivias, begonias, and other shade-loving plants thrive in pots during Charleston's hot, humid summers and then go inside for the winters.

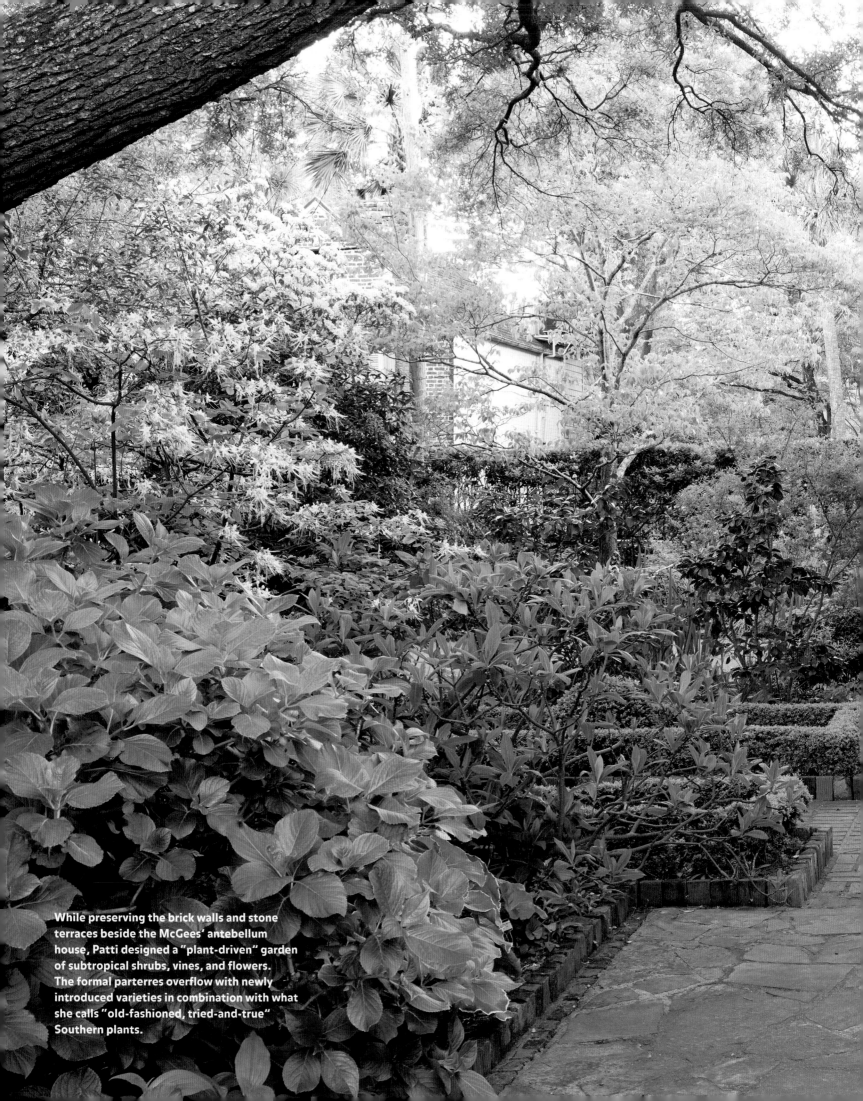

While preserving the brick walls and stone terraces beside the McGees' antebellum house, Patti designed a "plant-driven" garden of subtropical shrubs, vines, and flowers. The formal parterres overflow with newly introduced varieties in combination with what she calls "old-fashioned, tried-and-true" Southern plants.

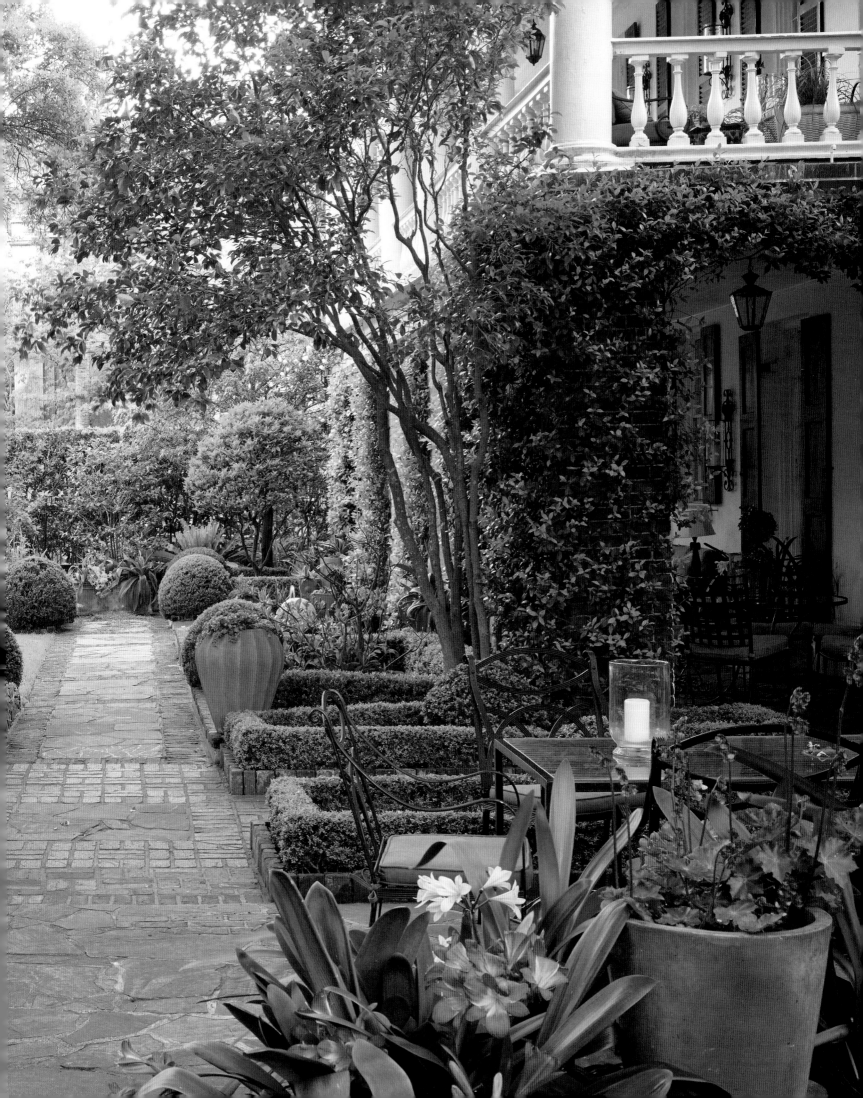

Whilton Farm, the Garden of Courtnay Daniels

Greenwood, Virginia

A painter's eye and a collector's passion have driven the creation of the extensive gardens at Whilton Farm, Courtnay and Terry Daniels's home in the historic countryside of Virginia. Starting with a simple yew parterre, which was all the garden that existed when the couple moved here in 1998, the garden has grown to about twenty-nine acres and boasts a five-acre arboretum and three greenhouses, a number of themed gardens, and a large canal garden.

Courtnay was already passionate about plants when she moved to the farm, and she has since amassed a very serious collection of more than 2,887 varieties, with special emphasis on Japanese maples, magnolias, and conifers. Her challenge and joy has been to display them in a way that brings out the best in each individual, and to settle it comfortably into the iconic landscape of Thomas Jefferson's Virginia. In designing these gardens, she insists that she is simply trying to please herself, but she trained as a painter and uses an artist's instinctive and observational skills to layer and combine the textures and shapes of her specimens, without losing sight of how they fit into a larger vision.

This is a garden with relatively few flowers but lots of color. Courtnay is particularly attuned to the possibilities created by foliage, and red-, gold-, and blue-hued trees and shrubs abound. In addition to knitting plant shapes and colors together, she uses exceptional specimens as sculptural elements, taking a particular expressively shaped Japanese maple, for instance, and presenting it in a slightly raised planter as the focal point of a parterre. She also enjoys pushing the boundaries of plant hardiness, and there is nothing she likes better than establishing a plant "impossible to grow" in her climate, as long as it seems at home visually in her beloved Virginia landscape.

A garden folly is viewed through a one-hundred-and-fifty-year-old white oak (*Quercus alba*).

TOP The parterre dates to the 1930s. Clipped hemlock hedges enclose two yew mounds. A Japanese maple (*Acer palmatum* 'Green Cascade') is the focal point, planted in a box with no bottom so the roots can grow into the ground.

BOTTOM Gates flanked by a white redbud (*Cercis alba*) and clipped arborvitae hedge open to the arboretum.

TOP The view from the parterre overlooking the main lawn. The white oak with a fused center dominates a shade garden in the summer.

BOTTOM The façade of the pool/guest house against the Blue Ridge Mountains. Native dogwood (*Cornus florida*) blooms near the strong verticals of the Emerald arborvitae (*Thuja occidentalis* 'Emerald').

Hilltop Farm, the Garden of Caesar & Dorothy Stair

Knoxville, Tennessee

Although it is just five miles from downtown Knoxville, Hilltop Farm seems to occupy a different universe. The garden overlooks a long stretch of the Tennessee River, and in the distance the blue-gray shadows of the Great Smoky Mountains roll to the horizon. For a long time there was no garden; even though Caesar has lived at the farm since 1956, it was not until 2001, when he and Dorothy met garden designer Ryan Gainey, that a garden seemed like a real possibility.

Gainey had been invited to Knoxville to discuss designing a public garden, and in the course of that visit he looked over some plans the Stairs had for an indoor swimming pool. He immediately informed them that their plans were all wrong. Soon he had them visiting gardens in England, particularly Edwin Lutyens and Gertrude Jekyll's Arts and Crafts masterpiece, Hestercombe.

Their pool house became an Arts and Crafts–influenced structure that forms one long side of an impressive loggia garden. A pergola inspired by Hestercombe faces the pool-house across the lawn. The loggia garden is green and dignified, with four tall, triangular, clipped hollies for punctuation and large rounded boxwood balls facing one another rhythmically across the lawn. Roses, lavender, and purple clematis as well as native wisteria clamber through the pergola.

Dumbarton Oaks was the inspiration for the demilune garden. A double aerial hedge of American hornbeam (*Carpinus caroliniana*) curves around a boxwood parterre, which has an ornately carved, hexagonal limestone font as its focal point. The shorn trunks of the carpinus create regular openings, partially filled with large boxwood balls, that afford tantalizing views of the mountains, but the aerial hedge offers just enough enclosure to create a sense of place. The terraces of the house have also been expanded, and Gainey designed a simple sundial fountain using the same indigenous stone that is used in the pergola and stone walls.

An Arts and Crafts–inspired pebble sundial fountain made from local stone sits on a terrace with a view of the Tennessee River. A hedge of the silvery green *Elaeagnus angustifolia* delineates the property.

Azaleas, rhododendron, dogwood, and a Japanese maple grace the entrance of the circa 1916 main house.

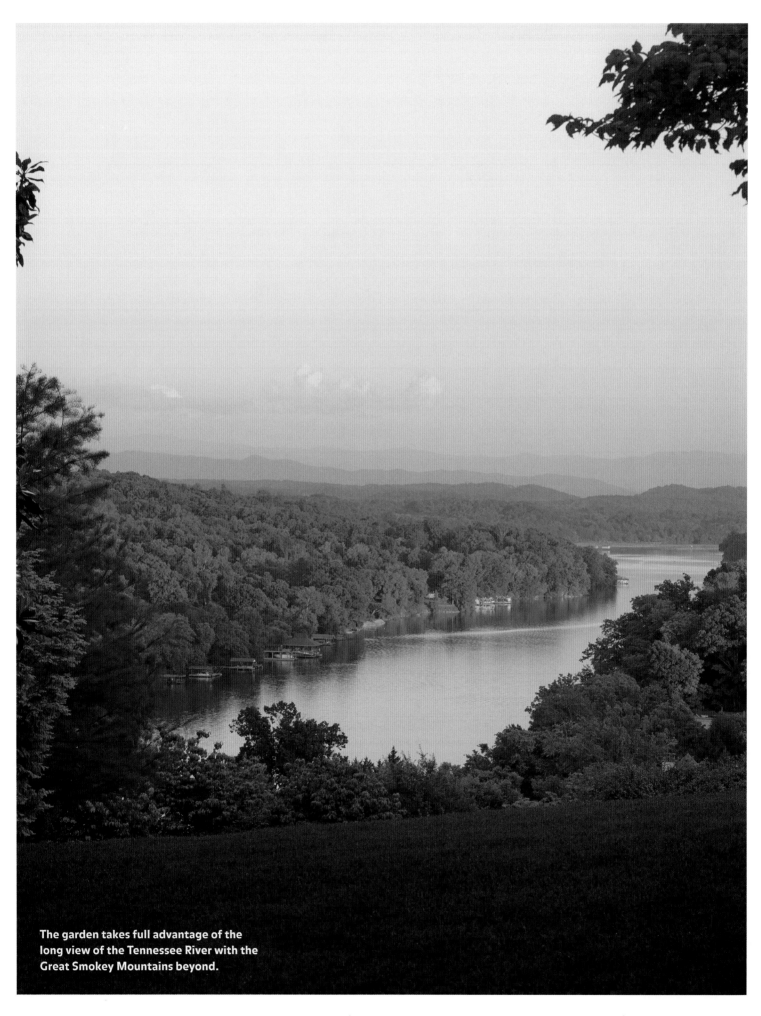

The garden takes full advantage of the long view of the Tennessee River with the Great Smokey Mountains beyond.

TOP The Loggia Garden is modeled on Hester-combe Gardens in England. The pool house and pergola, which is constructed from local stone, face each other across a rectangular lawn. Triangular clipped hollies anchor the corners, and boxwood balls line the sides.

BOTTOM Korean dogwood (*Cornus kousa*) and a giant willow oak overlook the driveway.

THE MIDWEST

Seeing the prairie for the first time was such an extraordinary experience that travelers in the early nineteenth century struggled to describe it. Some called the endless miles of unbroken grasslands the most beautiful landscape they had ever seen. Others felt the terrifying solitude of being adrift on a vast ocean of land that stretched from one horizon to the other. They all described colorful wildflowers and tall, sunlit grass that moved like waves in the wind. When settlers came to the Great Plains, they tamed the prairie by plowing under its sod and planting wheat and corn in the rich black soil. They used the immense grasslands for grazing herds of sheep and cattle. By the end of the nineteenth century, large towns and cities had grown up along the shores of the rivers and Great Lakes.

Agriculture brought the first economic boom to the Midwest, and commerce and industry in the cities caused a second, greater growth in population and development. In Chicago, the founding industrialists and manufacturers were determined to create places of beauty within the city, envisioning parks and gardens amid the crowded streets and factories. The famous "emerald necklace" of parks and boulevards around the Windy City is a continuation of their vision, as is the outstanding Chicago Botanic Garden.

One of the gardens in this section celebrates the wild expanses of the American prairie by re-creating its beauty and sense of wonder. Other gardens look back at the great estates on Chicago's North Shore, with their new designs for their expansive Midwestern landscapes.

Camp Rosemary

Lake Forest, Illinois

The owner of Camp Rosemary has done much of the gardening herself over the years, and her expertise and energy are essential to its spirit. Generous and fun loving, she never tires of having visitors. "What's the point of having all of this," she has said, "if I can't share it?"

The garden always looks ready for a visit, even though it is extensive and chock-full of plants. An astonishing twenty-one garden "rooms" are defined by hedges of immaculately clipped boxwood, pine, and yew. A boxwood parterre near the house sits next to an intimate thyme garden. Beyond that is a chapel-like white garden with two calm reflecting pools that mirror the foliage and sky. Lovely statues face each other across the quiet space.

The view in the opposite direction takes in the rose-and-vine-covered pergola—quite boisterous in contrast. The perennial beds are planted in stunning combinations of the owner's favorite colors: blue, pink, and lavender. Nearby, wide, grassy steps lead into an extraordinary walled garden that the owner installed in 1998. In this grand space, four generously planted perennial borders enclose an expansive and manicured lawn. Here the owner introduced stronger, hotter reds, oranges, violets, and blues with well-placed silver and burgundy touches throughout.

The lovely, two-story brick pool house is approached by another series of steps and is lined by a pair of rose borders. The structure is flanked by intricate knot gardens and hosts climbing ivy over much of its façade.

Nearby, there is also room for a shady linden allée, a greenhouse and immaculate potting shed, a neat and tidy vegetable garden, a grass labyrinth, and a lush, wooded ravine.

Visitors to this classic Lake Forest estate find delight in its astonishing number of garden experiences. This charming vignette of plants on this brick wall greets you at the kitchen entrance.

TOP AND BOTTOM Grass steps lead down to a sweeping lawn surrounded by mixed borders of shrubs and perennials. Urns and large pots, filled with luxurious combinations of annuals, decorate a brick wall and terrace.

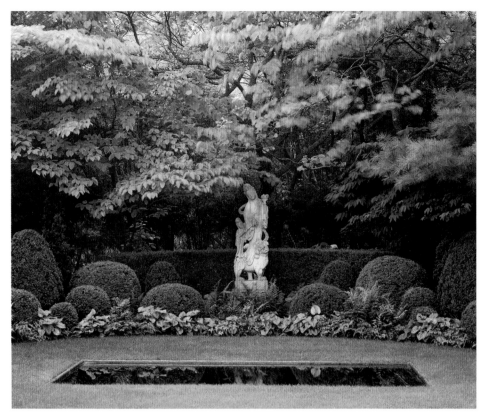

TOP The peaceful white garden has two pools with constantly changing reflections of trees and sky.

BOTTOM An old garden bench offers a perfect place to sit and admire the view. Located in the background is the ivy-covered pool house.

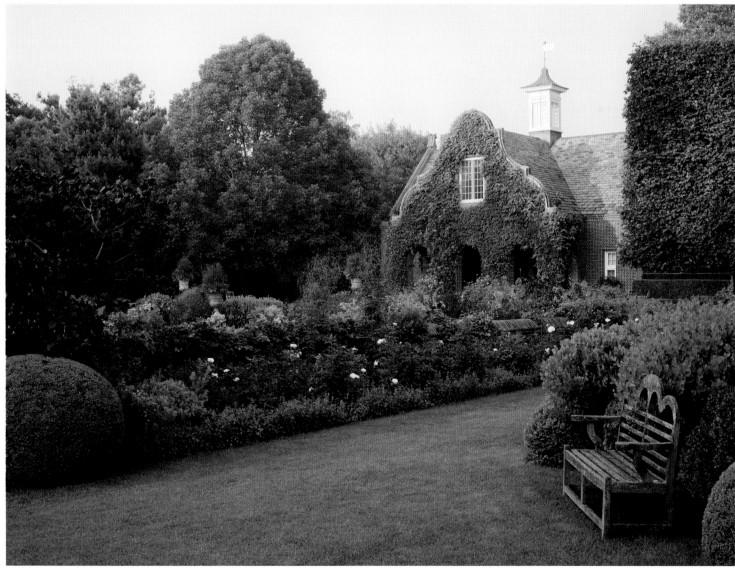

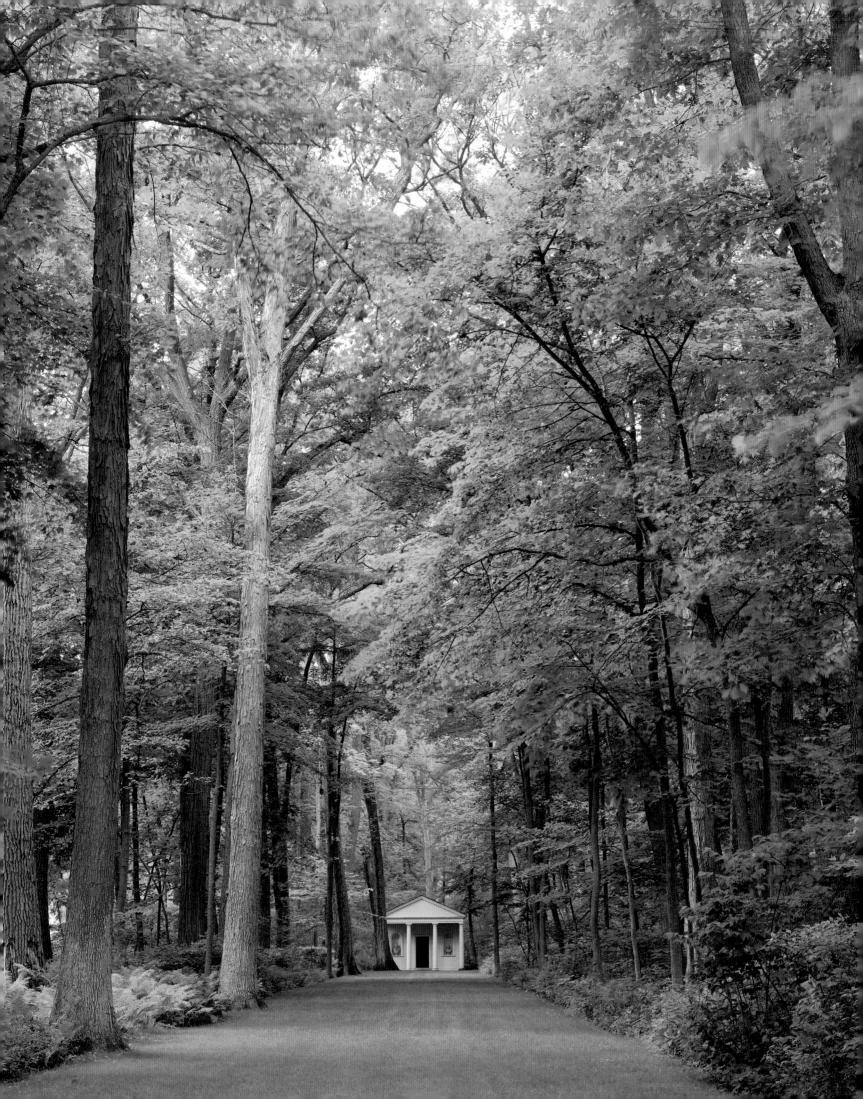

John
& Neville Bryan's
Crab Tree Farm

Lake Bluff, Illinois

In 1984, John and Neville Bryan purchased the summer residence of William McCormick Blair, a prominent Chicago businessman and philanthropist. One year later, they purchased Crab Tree Farm, the adjoining hundred-plus acres of the Blairs' former dairy farm. It contained an enormous central barn with a clock tower, four additional buildings, and a pair of silos. Today, the combined property is the only remaining farm in all of Illinois that overlooks Lake Michigan, and the Bryans are devout stewards of this important site.

The impressive farm buildings have been beautifully restored to house displays of Arts and Crafts collections. The farm is home to cattle, horses, sheep, chickens, and turkeys, and several crops are planted each year. This part of the property is easily viewed from Sheridan Road, but the extensive and historic gardens near the house remain secret to those driving by.

A 1920s Colonial Revival house, designed by architect David Adler, sits on eleven acres overlooking Lake Michigan. A ravine path and wooden walkways lead to a private beach. A lovely cottage garden designed by landscape architect Ellen Biddle Shipman is tucked in close to the house. Neatly pruned boxwood hedges provide year-round structure to the garden, and throughout the summer, soft pink roses are abundant.

As one moves away from the house into a forest of massive trees, charming follies begin to show themselves. Created by owner John Bryan, they can be found nearly anywhere— tucked into a woodland garden or at the end of a long, shady promenade. Well-placed classical sculptures populate the extensive paths. There is even a golf course, surprisingly at home among the abundant wildflowers that adorn the understory.

As one emerges from the woodland at the other end of this property, yet another series of gardens waits to be discovered. A beautiful and productive vegetable and cutting garden is the domain of Neville Bryan. An adjoining greenhouse and potting shed allow her to work here year-round. A nearby lush, walled garden presents soft colors and layers of texture, and a 1926 indoor tennis court is covered in espaliered ivy walls.

Serving as a focal point from the main house, tall oak trees form a stunning promenade that ends with the Jefferson Pavilion, designed by David Adler.

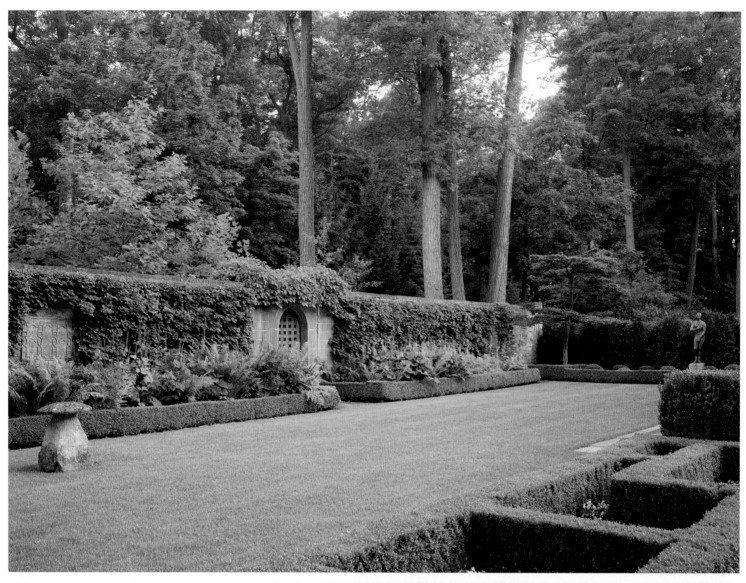

TOP The walled garden features structural arborvitae and boxwood hedges. It is the perfect setting for the eighteenth-century lead statue of *Mercury* by John Cheese.

BOTTOM The grand tennis house features an indoor tennis court built in 1928 and used by previous owners for winter weekend tennis parties.

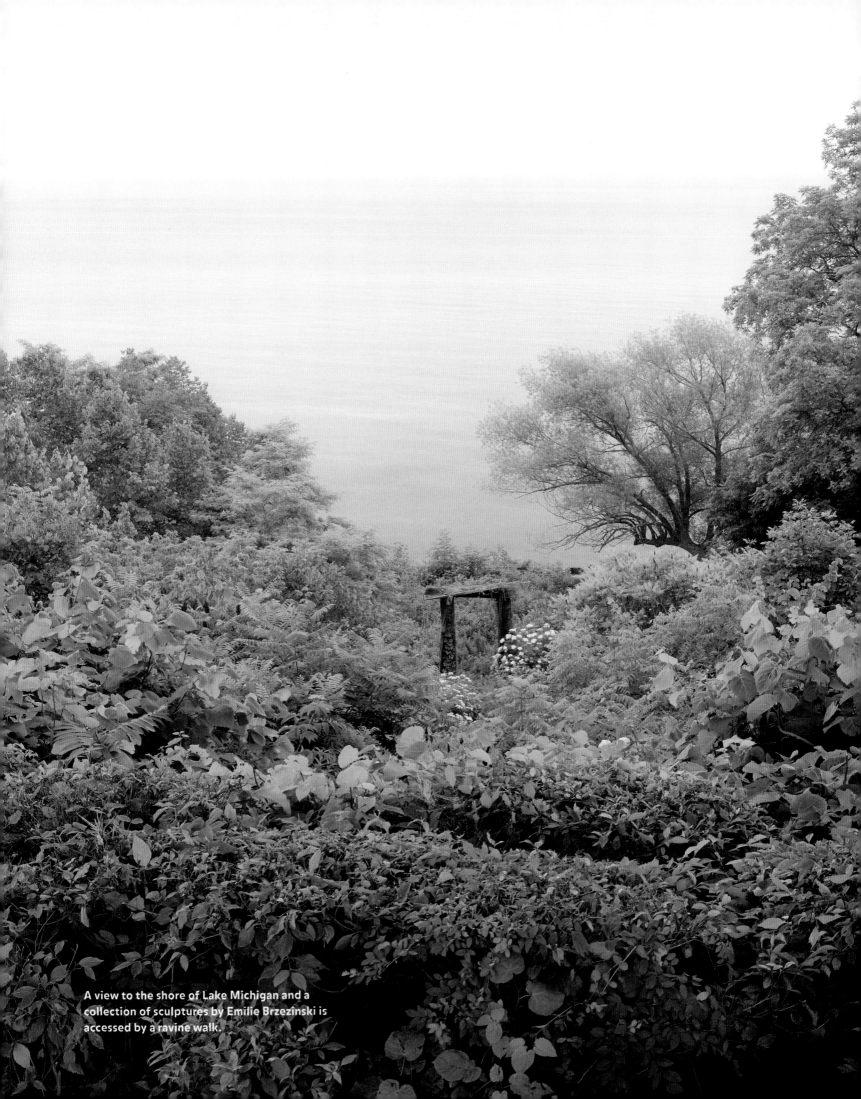

A view to the shore of Lake Michigan and a collection of sculptures by Emilie Brzezinski is accessed by a ravine walk.

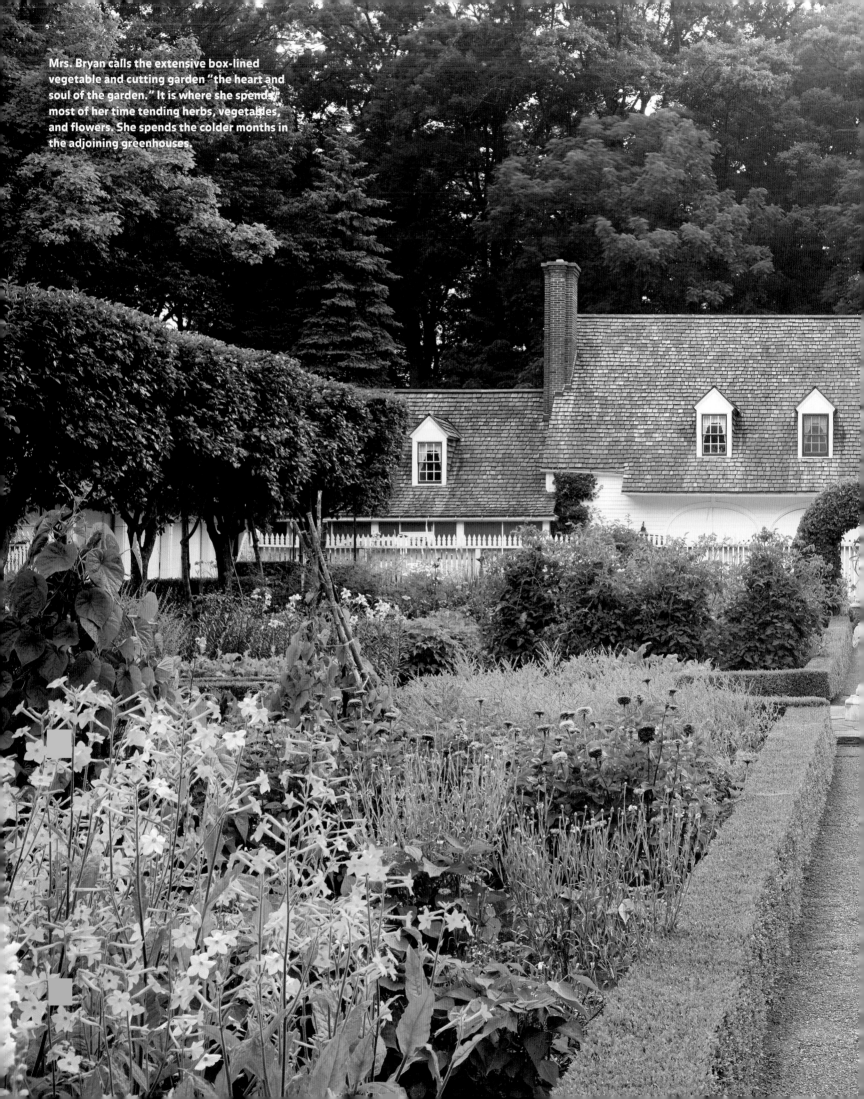

Mrs. Bryan calls the extensive box-lined vegetable and cutting garden "the heart and soul of the garden." It is where she spends most of her time tending herbs, vegetables, and flowers. She spends the colder months in the adjoining greenhouses.

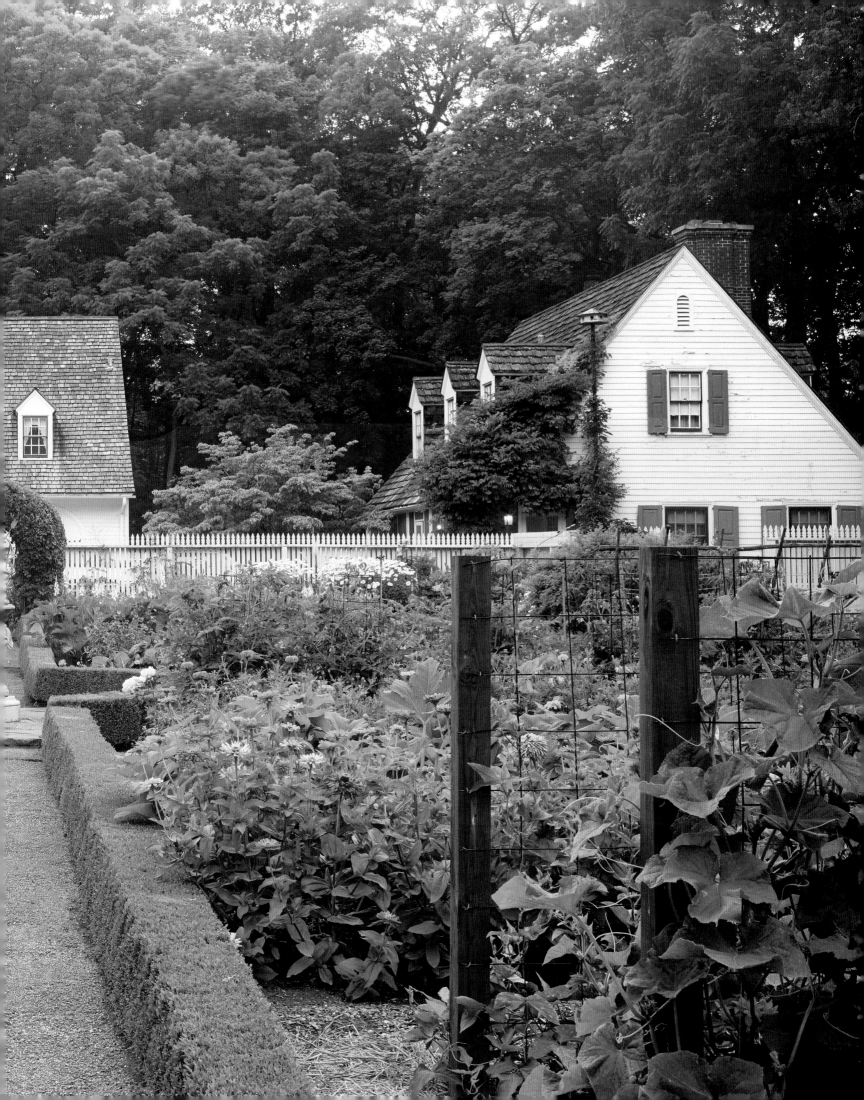

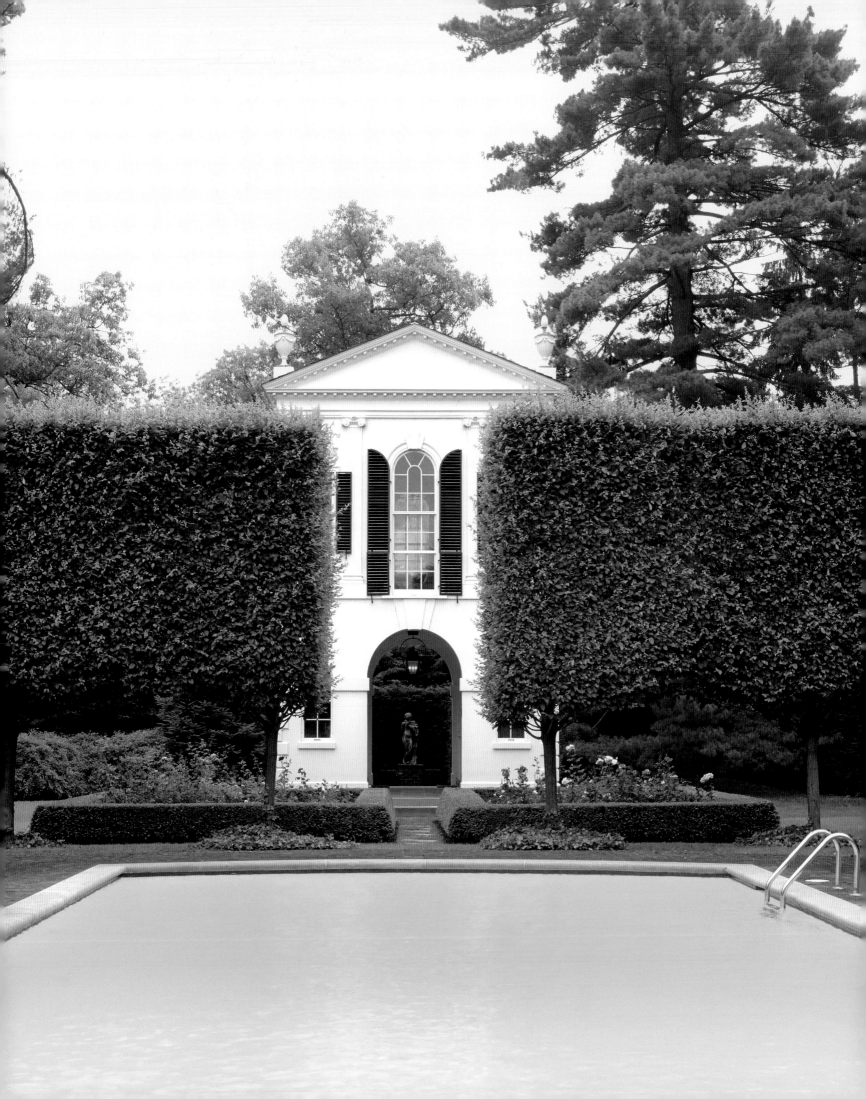

The Garden of Peggy & Jack Crowe

Lake Forest, Illinois

Soon after meeting English-garden designer Rosemary Verey at the Chelsea Flower Show, Peggy and Jack Crowe invited her to design the lovely walled garden they have meticulously maintained for more than thirty years since. Descending the steps from the terrace around their house, the couple still enjoys how their view changes from a glimpse of lilacs against a distant background of large trees to a lawn with perennial beds enclosed by clipped hedges to an intimate space surrounding a bubbling fountain. A gate opens to a broader view with a visual surprise: a perfectly rendered, loving replica of a summerhouse, or folly, originally built in Massachusetts in 1793. Used here as a pool house with a second-floor art studio, the Crowes' garden folly has Palladian proportions very much in keeping with those of their neoclassical house and traditional garden.

An exact replica of a 1793 folly, or summerhouse, overlooks the Crowes' eighteenth-century-style pool garden.

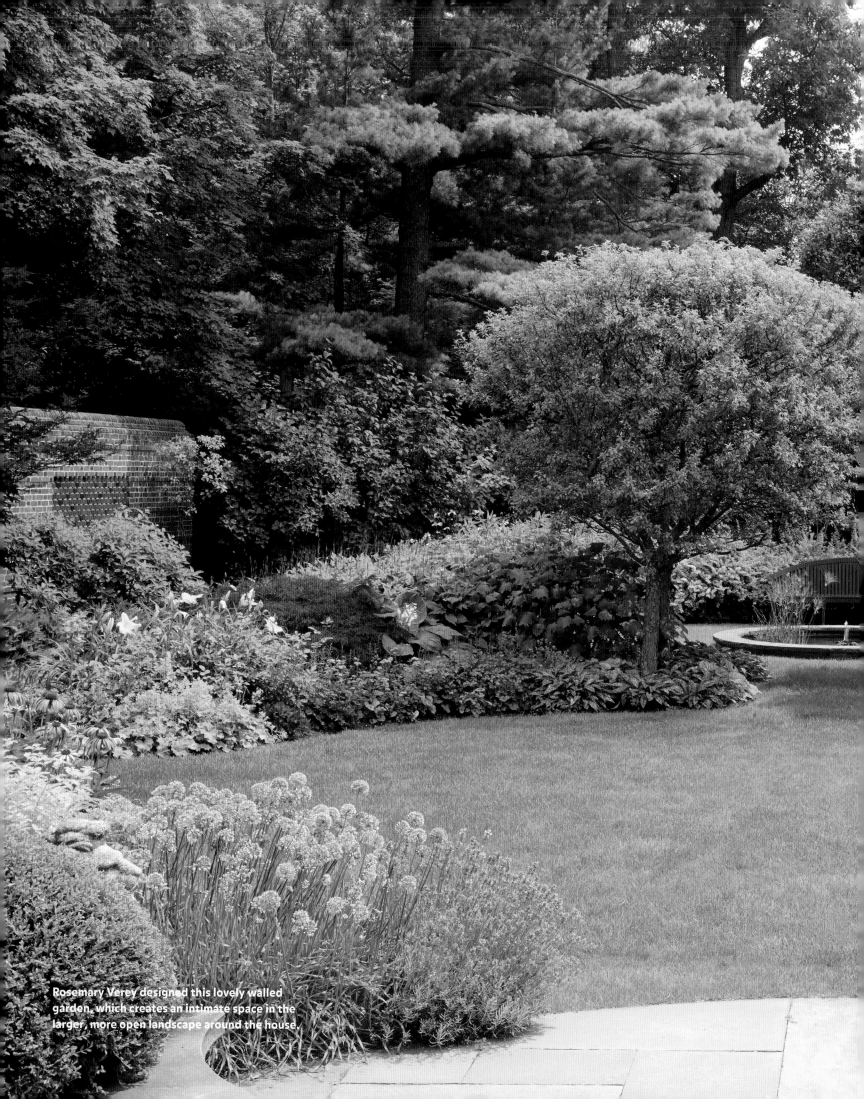

Rosemary Verey designed this lovely walled garden, which creates an intimate space in the larger, more open landscape around the house.

Greenfire Woods, the Garden of Hattie & Ted Purtell

Milwaukee, Wisconsin

Hattie and Ted Purtell have lived and gardened on this piece of land, which lies along the Milwaukee River, for fifty years. When they moved in, it was an area of open fields and mature beech and maple woods teeming with wildlife, and their neighborhood still retains much of its natural, rural character. Hattie is deeply committed to preserving the region's flora and to being a careful steward of her land. Walking paths thread through the woods to the river, and the Purtells have worked to restore the prairie, which is planted—as is all the property, with the exception of the vegetable garden—with native species. By the end of the summer, the prairie grasses and flowers are four to five feet high, and the native asters, rudbeckia, echinacea, and goldenrod put on a show that rivals any perennial border.

The organic vegetable garden also builds to a crescendo in the late summer. This is a productive as well as decorative potager. Although Hattie does not confine herself to native species in this garden, her methods are organic, and she focuses on growing heirloom varieties, doing her part to preserve genetic diversity. Brightly colored tomatoes, squash, and cabbage spill over the raised beds, which are mulched with hay. Here, this avid gardener can have fun with nonnative species such as nasturtium and dahlias.

Soil health has long been a focus of the Purtells—their magnificent vegetables attest to that—and in addition to composting, Hattie keeps chickens, which provide excellent manure for the garden—the eggs are a bonus! Here again she chose an heirloom variety, Swedish Flower chickens, as they are bred for colder climates. And, as another bonus of chicken keeping, the coop provided the Purtells the opportunity to plant a very attractive green roof!

The green roof of the chicken house is just visible above the sweep of native prairie flowers.

Heirlooms in the kitchen garden include tomatoes, dahlias, and Swedish Flower chickens.

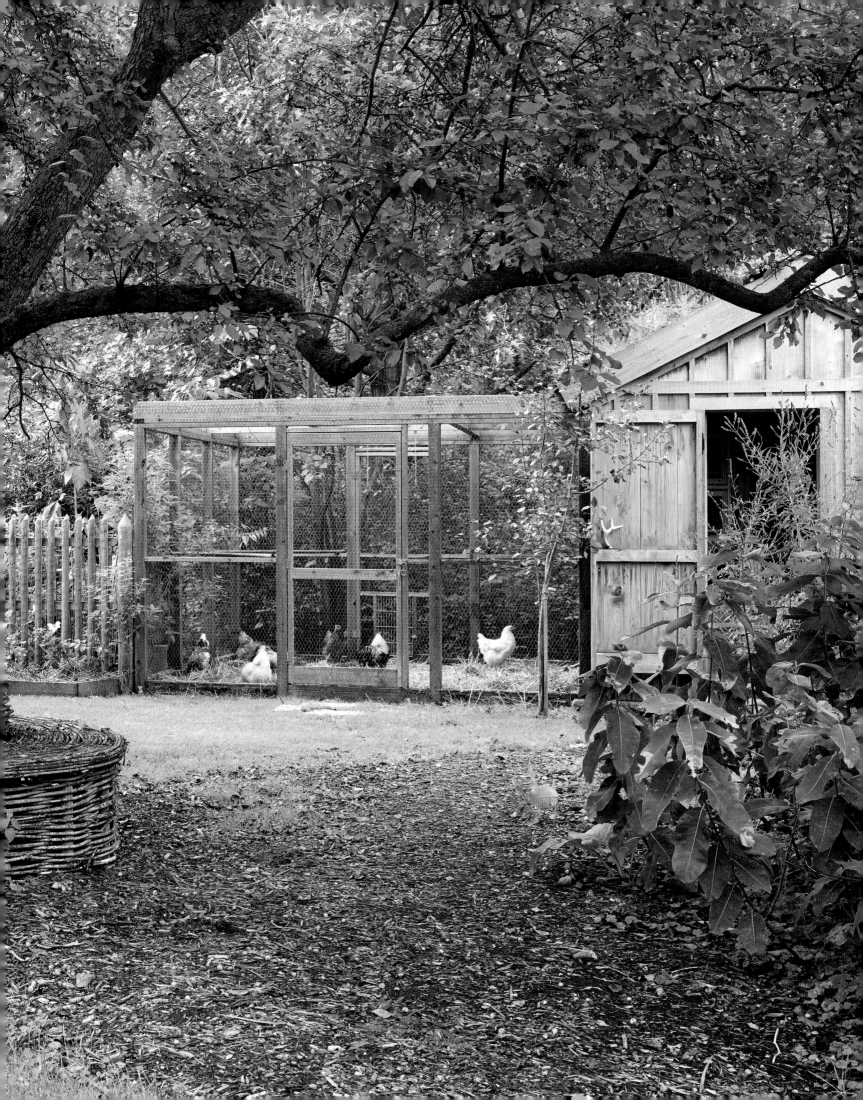

THE WEST

The landscapes of the American West are dramatic and diverse. From the slopes of the Rocky Mountains to the deserts of the Southwest, the Western states challenge the gardener with many different growing conditions. Texas alone has an amazing variety of environments for horticulture: forests, deserts, wetlands, and beaches nurture a profusion of native trees and wildflowers.

Gardens in the West evolved from the landscapes around them. Plants in the Rockies must tolerate low rainfall, hot summers, cold winters, and the dry mountain soil. The desert gardens of the Southwest use drought-tolerant native plants for their silver foliage, seasonal colors, and sculptural effects. Many local features are derived from the region's Spanish heritage, brought to the New World by the conquistadors who colonized the Southwest in the sixteenth century. They built their haciendas with thick adobe walls that retained the evening's coolness by day and the heat of the sun by night. Tiled courtyards, or patios, in the center of the house were based on Moorish models from southern Spain and often included fountains and shaded arcades. The vital importance of water in desert gardens is still celebrated today in the central position of swimming pools and patio fountains, and in the use of adobe walls and terra-cotta planters for nonnative flowering plants.

The Stitelers' Garden

Phoenix, Arizona

The contemporary house John and Ellen Giddins Stiteler built in Phoenix, Arizona, boasts great expanses of floor-to-ceiling glass, all the better to connect with the stunning native Sonoran Desert landscape that is their view. They were lucky to find this two-acre plot of land, virtually in town, for it not only looks out onto the mountains in the distance but also encompasses a desert wash, or arroyo. Here, in what is virtually a dry creek, scarce rainwater collects, prompting native desert plants to flourish. You cannot build on a desert wash—these lands are protected—which was fine with the Stitelers. They built their house on the land beside it, which had already been scraped clean of plant life by the previous owner. Then they called on landscape architect Steve Martino, a champion of the native desert, to build outdoor spaces that would marry their house to the wild land.

Steve sited the driveway along the arroyo, all the better to savor the native mesquite, ironwood, brittlebush, and goldeneye, and then repeated these plantings in drifts throughout the rest of the property. With masonry walls, he created two courtyards on either side of the house, one open to the desert wash, the other closed and private. A narrow pool in each courtyard establishes a main axis through the house and adds the magic of coolness and reflections. Specimen mesquite and palo verde trees, now handsomely mature, soften the bold lines of these interior spaces and add a note of grace. "We have shade, we have shadows," Ellen says. "We are in the middle of the city, and we feel like we're in the Sonoran Desert."

Spindly ocotillo and the trunks of a palo verde tree are played against the masonry walls of Ellen and John Stiteler's Phoenix home.

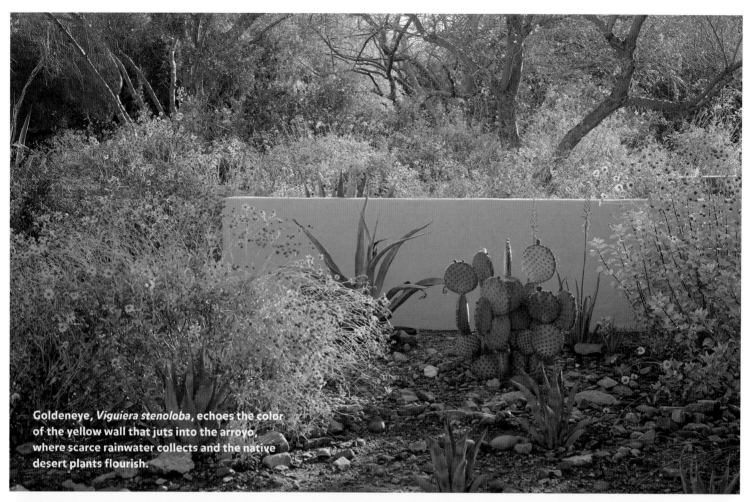

Goldeneye, *Viguiera stenoloba*, echoes the color of the yellow wall that juts into the arroyo, where scarce rainwater collects and the native desert plants flourish.

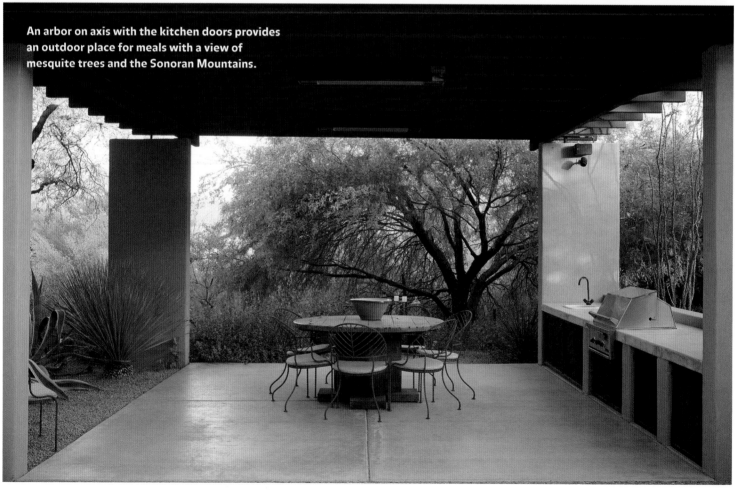

An arbor on axis with the kitchen doors provides an outdoor place for meals with a view of mesquite trees and the Sonoran Mountains.

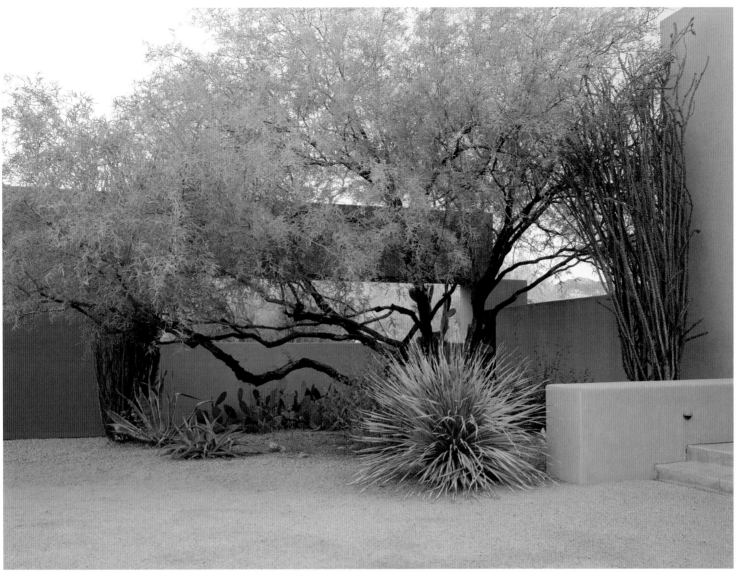

TOP An ocotillo and a graceful mesquite tree cut the lines of the masonry walls in the entrance court to the Stitelers' home.

BOTTOM A wall-enclosed courtyard on the street side of the house features a trough. The sound of water spilling into it conceals any traffic noise outside the wall. Yellow blossoms from the palo verde speckle the water.

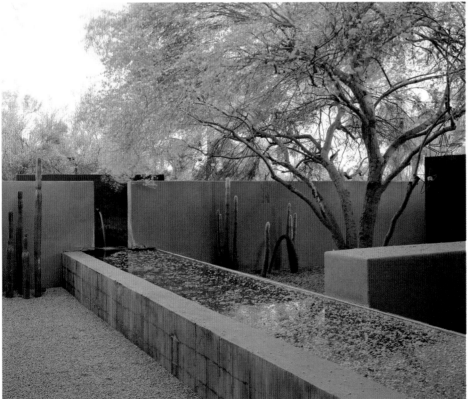

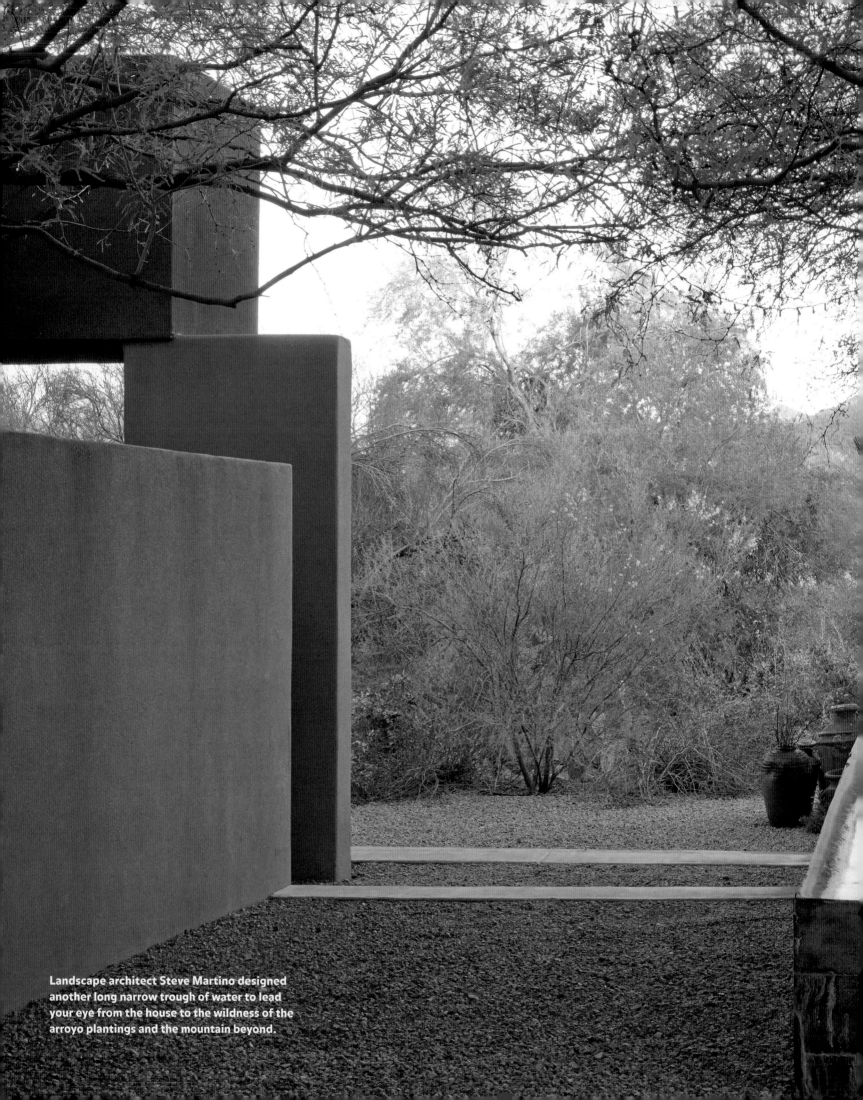

Landscape architect Steve Martino designed another long narrow trough of water to lead your eye from the house to the wildness of the arroyo plantings and the mountain beyond.

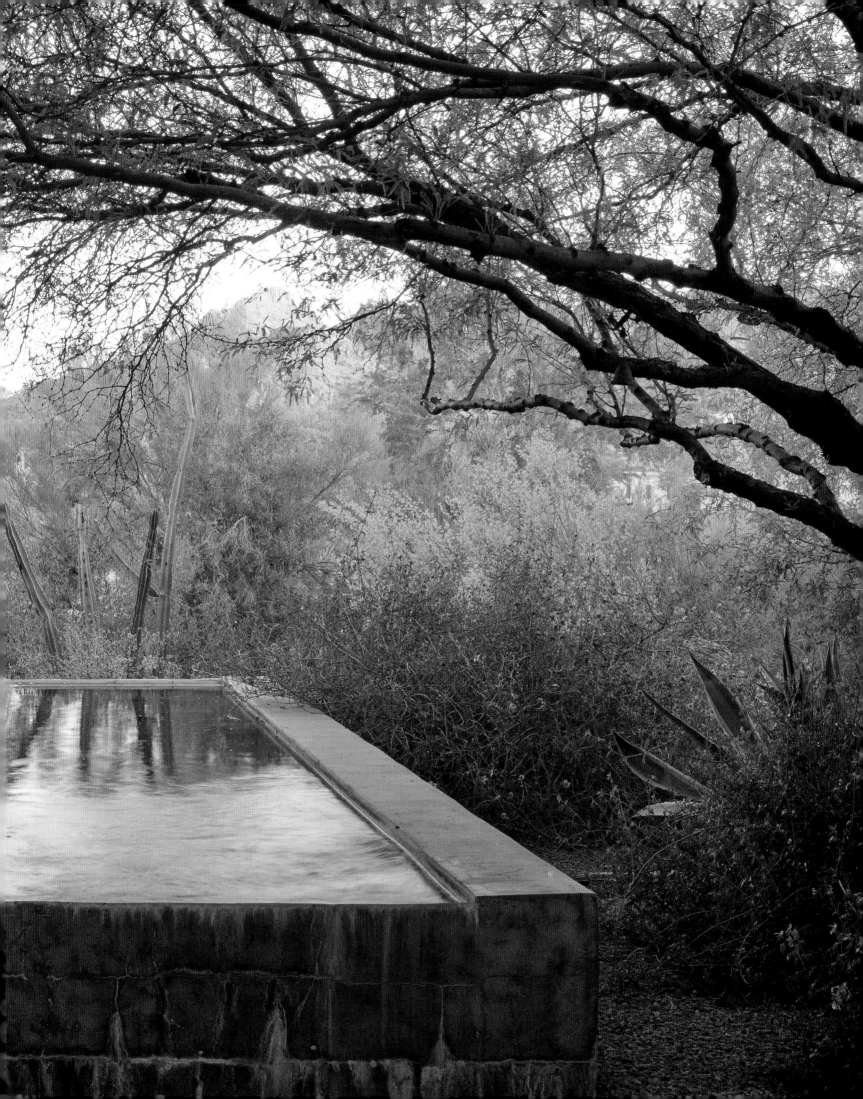

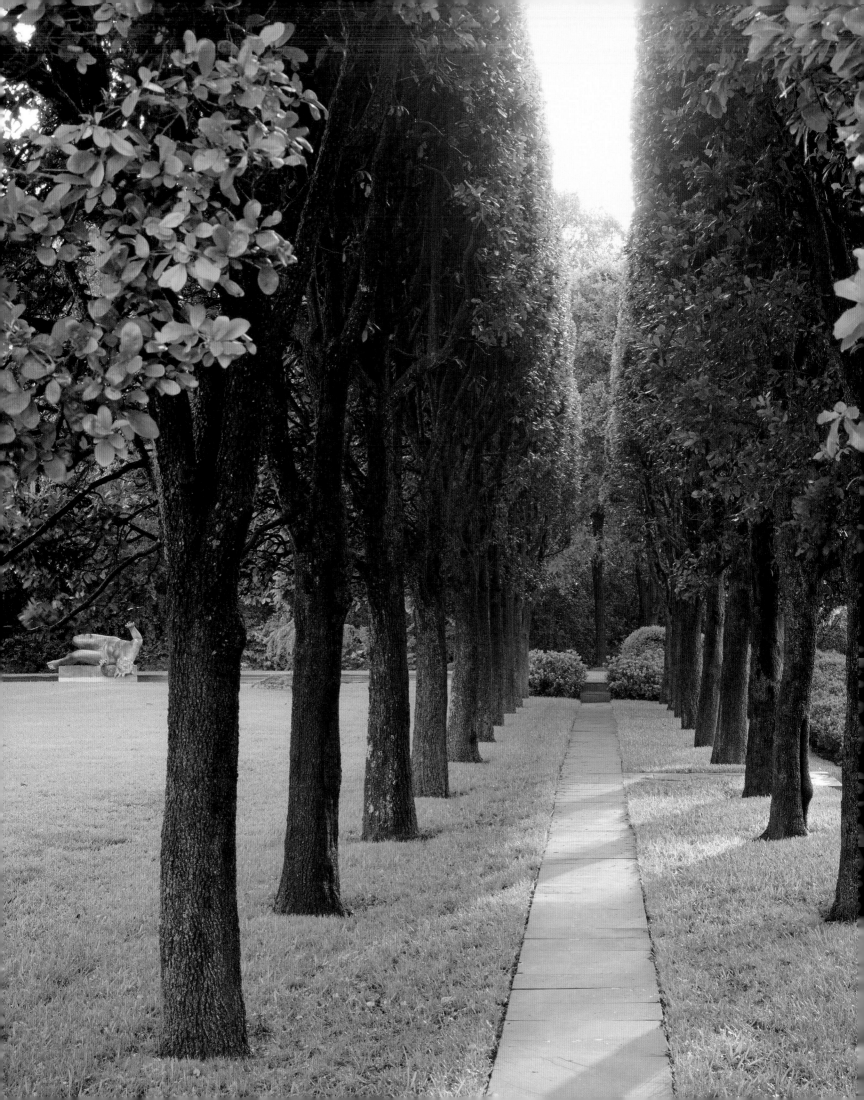

The Anne Bass Garden

Fort Worth, Texas

The Anne Bass garden is the result of a unique collaboration between a leading New York architect and a famous English-garden designer. In 1970, Anne Bass asked Paul Rudolph to design an elegant, modernist house for their steeply sloping and heavily wooded property outside Fort Worth. Set on the brow of a hill overlooking a ravine, the house they built resembles a spectacular stack of glass and white steel boxes, whose wide balconies are cantilevered at right angles and seem to float above the treetops. Ten years later, the owners decided to connect the house more closely with the landscape and to provide a panoramic view of a garden on the hillside. They invited Russell Page, the pre-eminent garden designer at the time, to make a rose garden in the lawn below the house. Although Page was not enthusiastic about modernist houses, he was able to work with Rudolph's design.

To link the lower garden to the house, Page planted grass steps leading to a wide green lawn and reflecting pool. An allée of pleached wild oaks and more steps lead down to a formal rose garden, a water-lily pond, and box-hedged squares of flowers planted in muted colors of pink, lavender, and white. Along the length of Rudolph's glass orchid house he created a pergola covered with wisteria, where Anne could sit and admire her favorite old-fashioned roses.

The Bass Residence is, indeed, a masterpiece created through the remarkable partnership of a modernist architect and a classical English-garden designer. The straight lines and square beds in the garden complement perfectly the horizontal planes of the house, which seems to hover serenely above the terraces and the pools reflecting its image.

The Bass Residence is a spectacular glass-and-white-steel structure placed at the edge of a steeply sloping ravine. Russell Page, the famous English-garden designer, added this allée of pleached wild oaks, which leads down to the lower garden he designed.

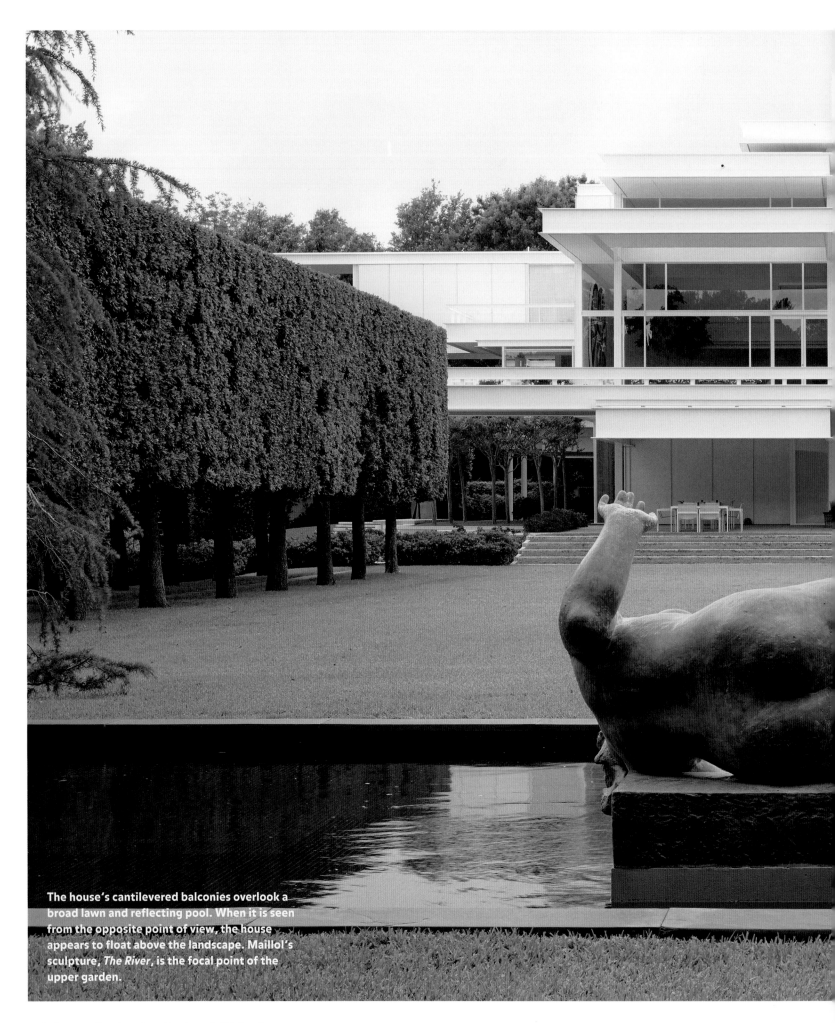

The house's cantilevered balconies overlook a broad lawn and reflecting pool. When it is seen from the opposite point of view, the house appears to float above the landscape. Maillol's sculpture, *The River*, is the focal point of the upper garden.

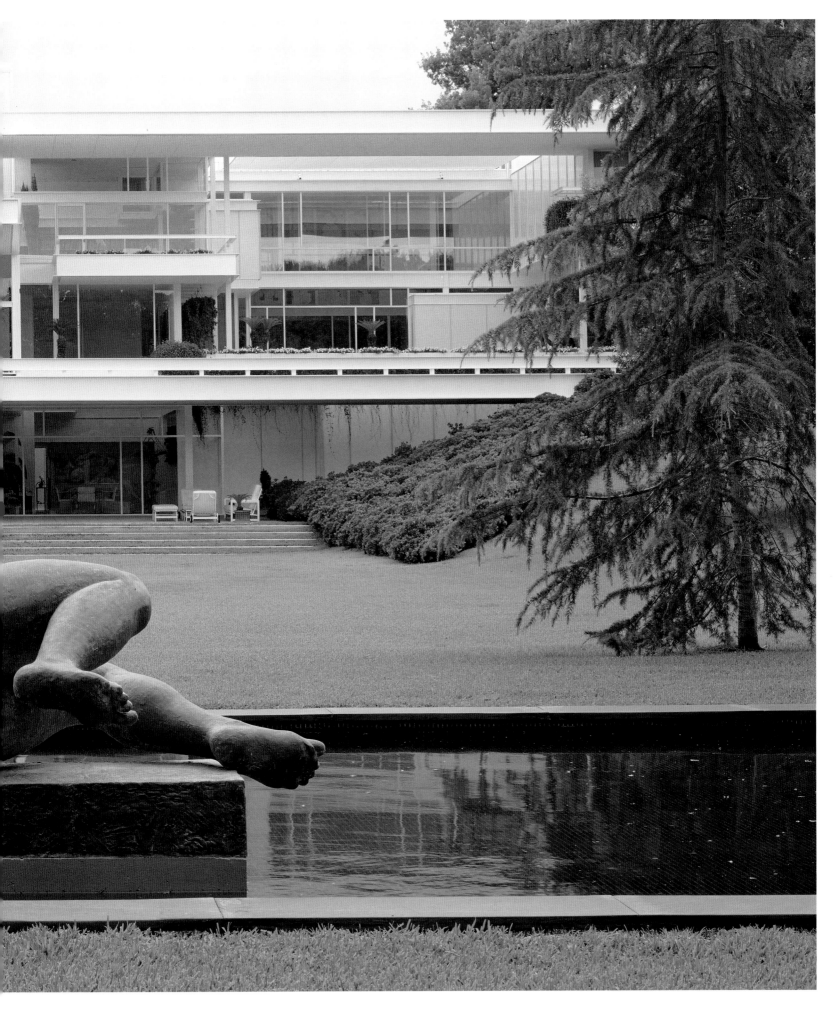

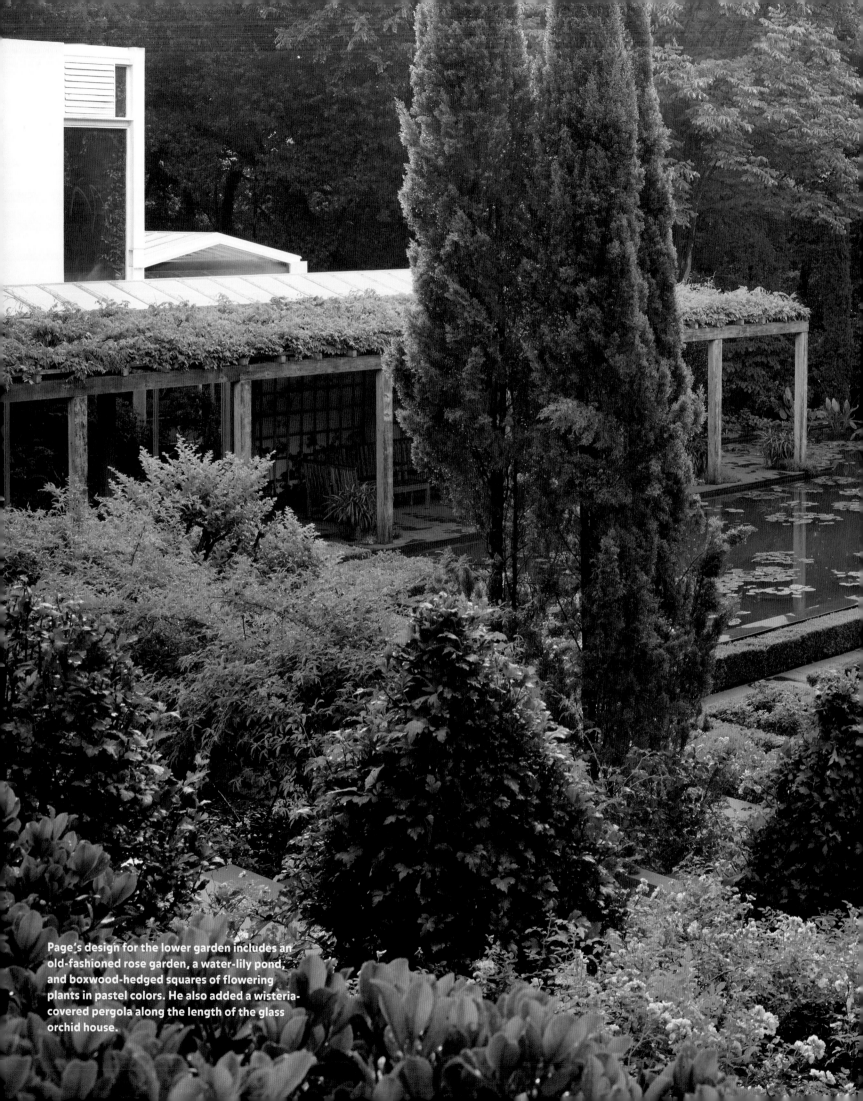

Page's design for the lower garden includes an old-fashioned rose garden, a water-lily pond, and boxwood-hedged squares of flowering plants in pastel colors. He also added a wisteria-covered pergola along the length of the glass orchid house.

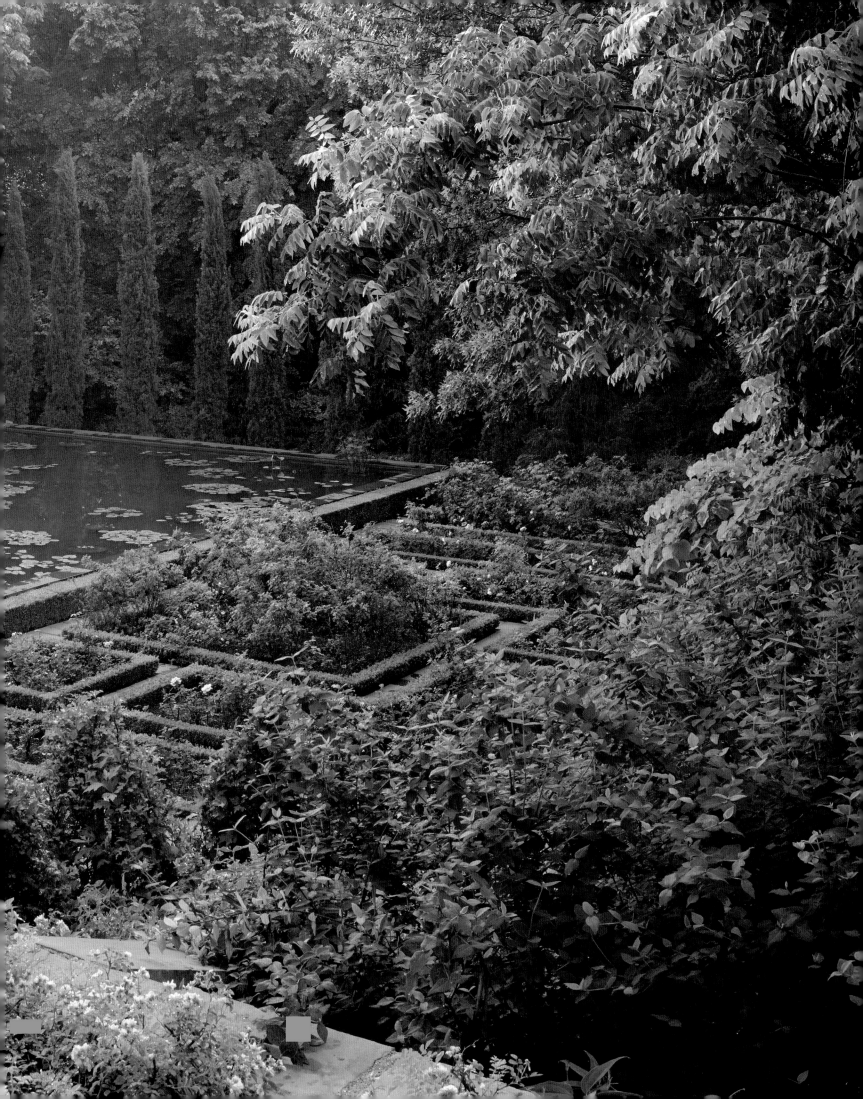

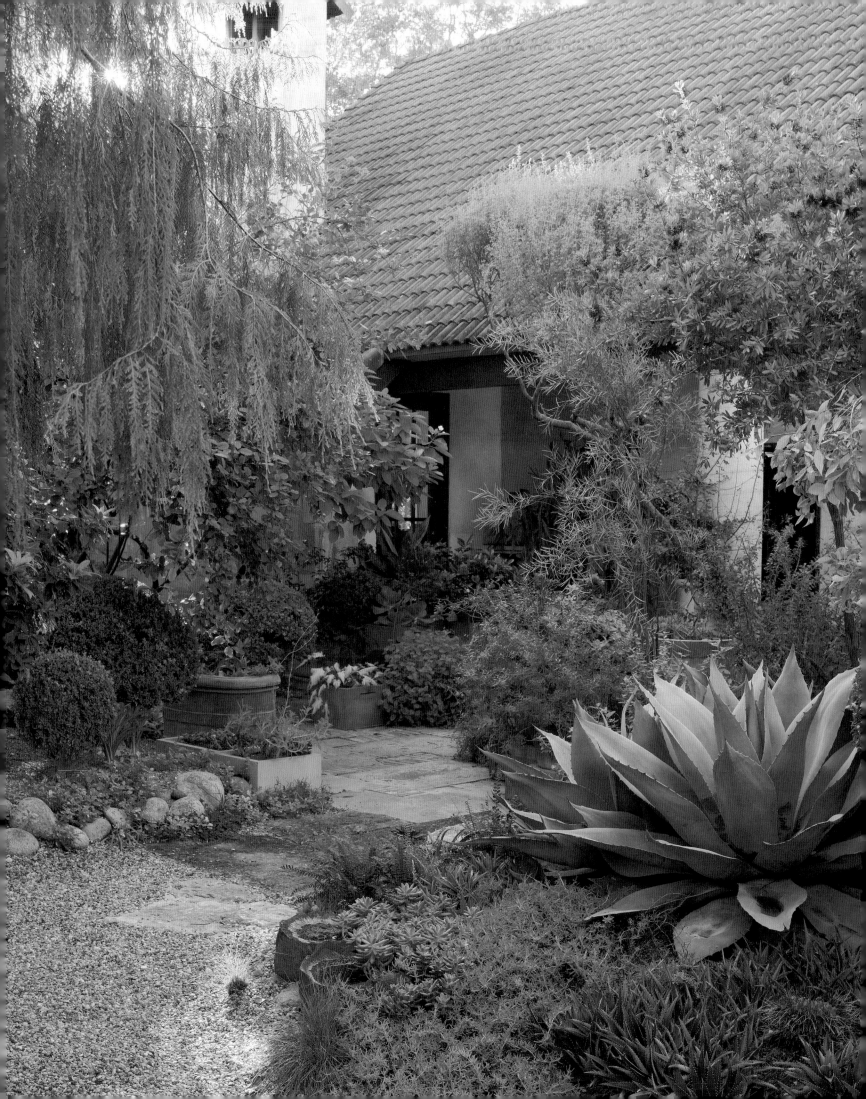

James David & Gary Peese's Garden

Austin, Texas

For more than thirty years, James David and Gary Peese were the trendsetters of the gardening scene in Austin, Texas. They owned and operated the popular and influential retail store Gardens, designed both residential and commercial gardens in Texas and California, and developed an extraordinary and captivating private garden in Rolling-wood, southwest of the Austin city limits.

Inspired by frequent trips to the Mediterranean and Mexico, and challenged by the hot and humid Texas summers with virtually no rain, James and Gary developed an aesthetic that was simple and elegant but sensitive to the demands of their climate. The garden is big and bold, incorporating tons of the limestone that lies underneath Austin; hundreds of responsibly selected, drought-tolerant plants both native and introduced; and clean and simple lines.

The sunny entry garden is anchored by a giant whale's tongue agave. A pomegranate topiary and beautiful specimen plants artfully arranged in pots of all shapes and sizes add color and texture to the design. A gravel path leads around the side of the house to a surprisingly lush woodland with clipped boxwood and shade-loving plants.

Behind the house, the garden plunges down a series of limestone steps bordered by 'Will Fleming' yaupon hollies and cleanly divided by a rill. The rill's stream finishes at a busy goldfish pond featuring fat koi and blooming water plants. On the other side of the pond, a second staircase leads to a pool lined with fig trees and a greenhouse filled with orchids and other plant collections. Mexican sycamores line a wooden boardwalk.

While design is clearly paramount in this garden, entertaining in it is a very close second. Gary is the accomplished and enthusiastic resident chef. And since vegetables can be grown year-round in Austin, he tends a productive, beautiful, and delicious vegetable garden that boasts heirloom and unusual varieties. He is also the master of a rustic chicken coop populated by exotic fowl who earn their keep by supplying eggs for the kitchen table.

A giant whale's tongue agave (*Agave ovatifolia*) greets visitors and sets the tone for this very textural garden.

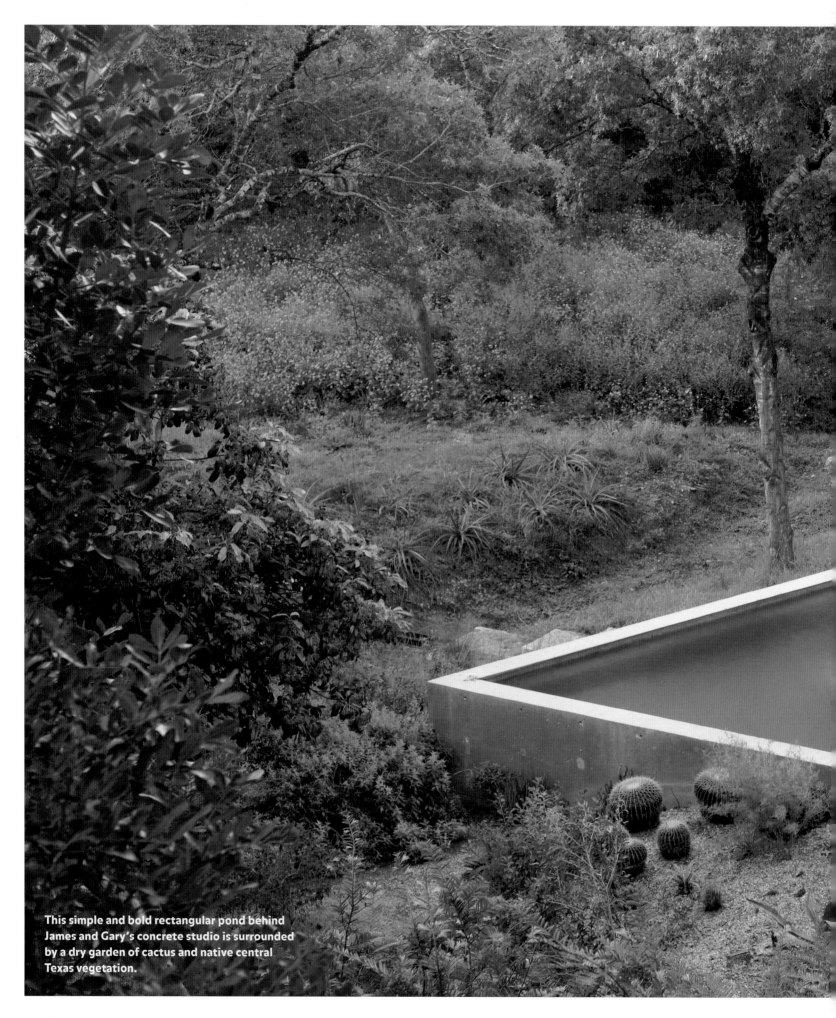

This simple and bold rectangular pond behind James and Gary's concrete studio is surrounded by a dry garden of cactus and native central Texas vegetation.

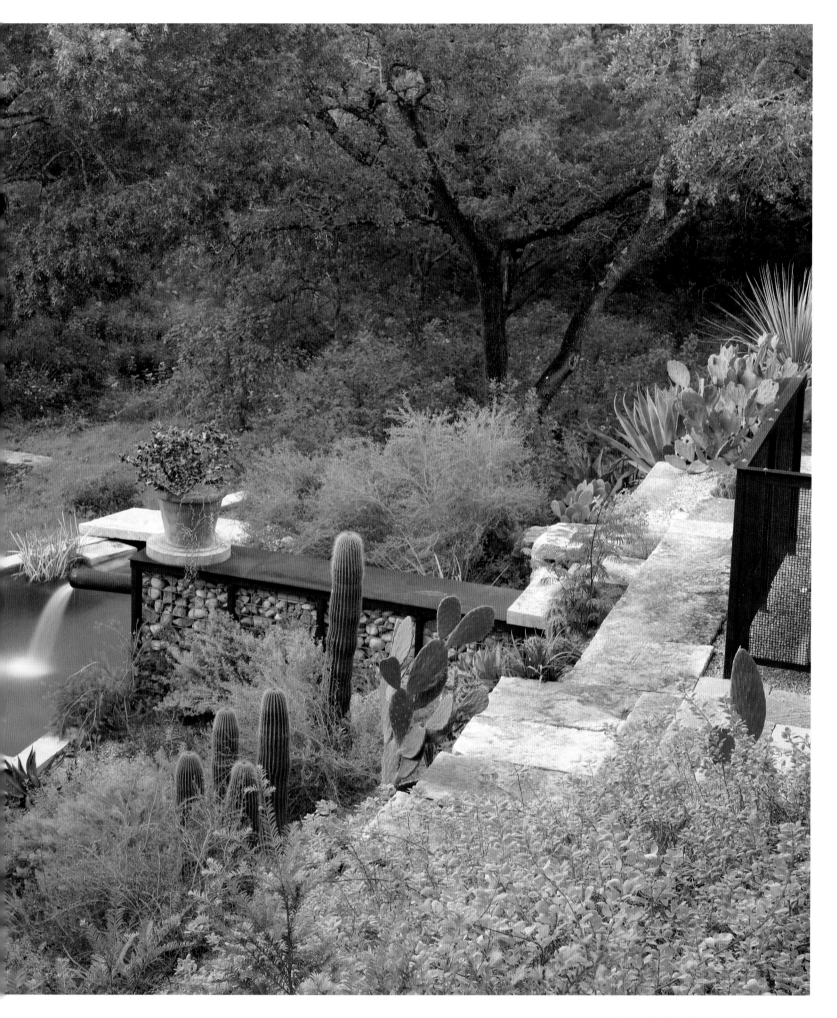

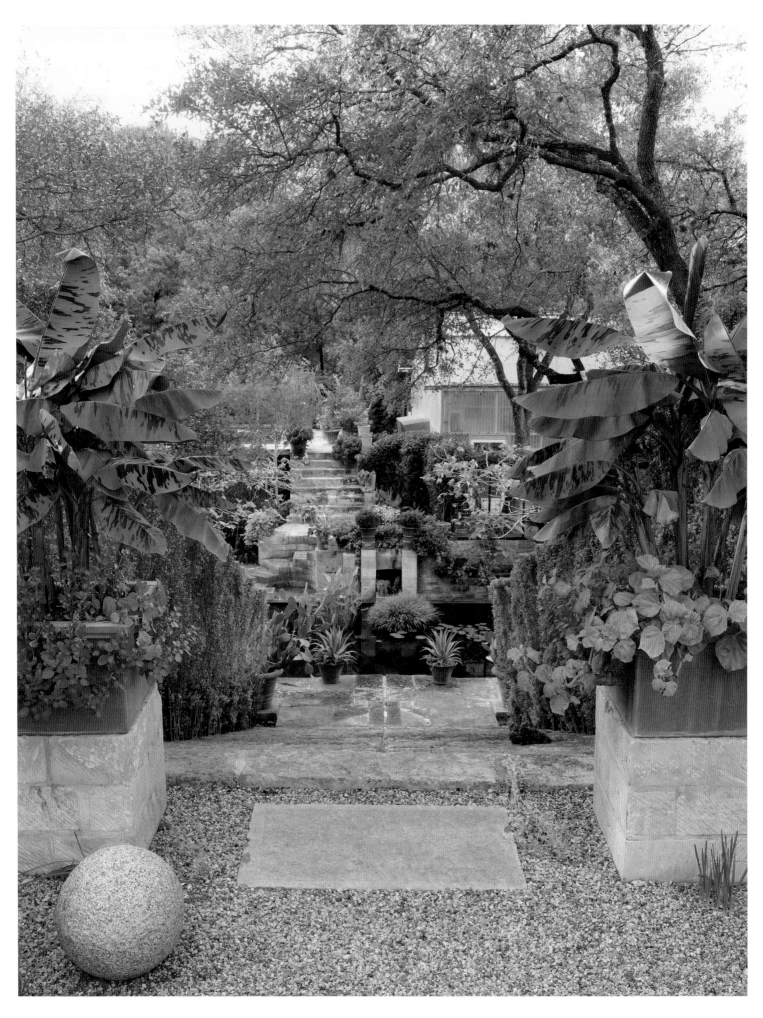

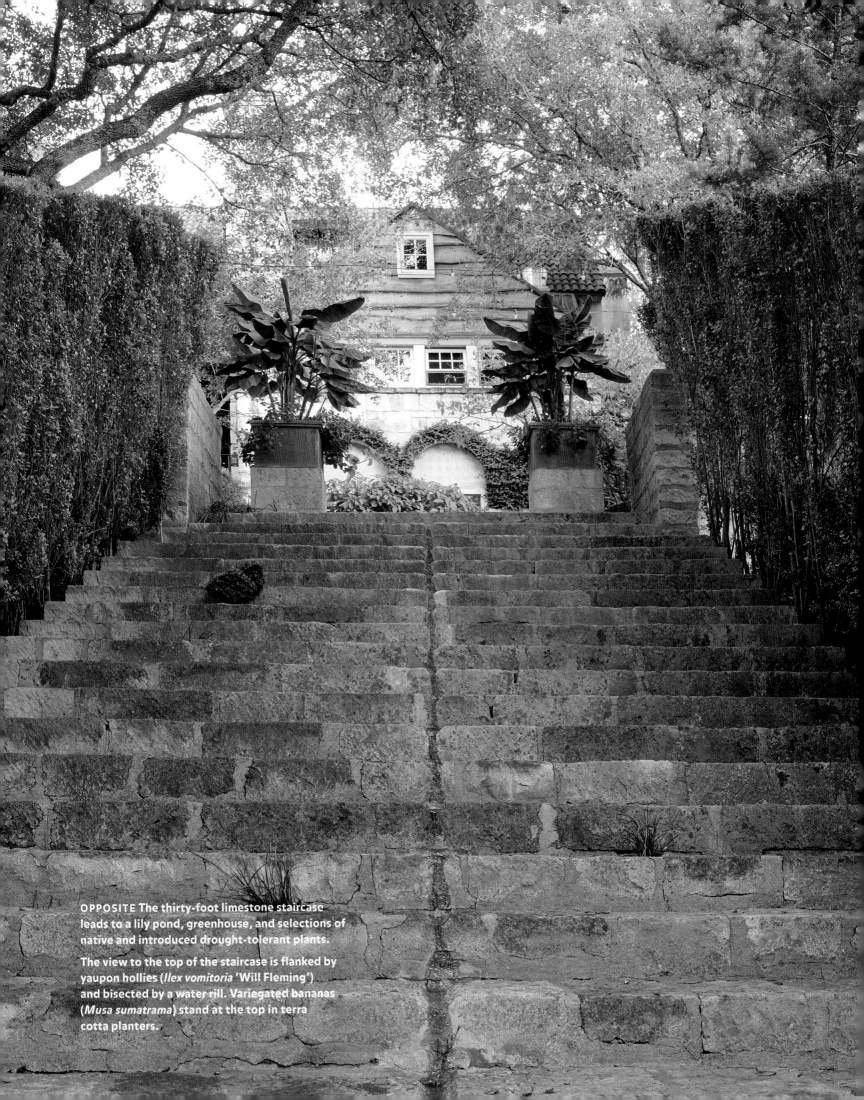

OPPOSITE The thirty-foot limestone staircase leads to a lily pond, greenhouse, and selections of native and introduced drought-tolerant plants.

The view to the top of the staircase is flanked by yaupon hollies (*Ilex vomitoria* 'Will Fleming') and bisected by a water rill. Variegated bananas (*Musa sumatrama*) stand at the top in terra cotta planters.

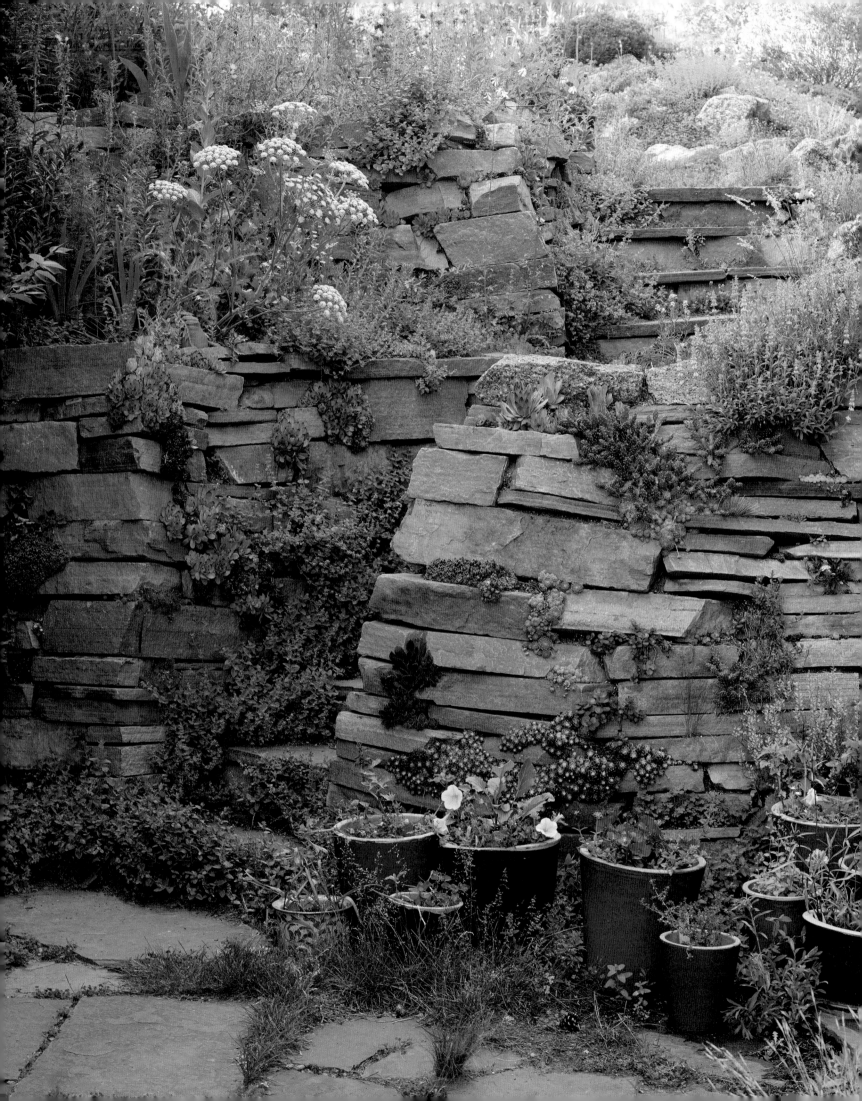

Panayoti Kelaidis's Garden

Denver, Colorado

Horticulturist Panayoti Kelaidis gardens on a mere half acre on a hill in Denver. Views of Colorado's majestic Front Range provide the backdrop for his astonishing display of more than six thousand kinds of plants. It is clear that Panayoti is a plant collector—not the type who brings home one of everything from the local nursery, but one who has traveled the world "discovering" plants and introducing hundreds of them to gardeners back home. On his small personal plot, he has put them on display.

When Panayoti purchased the property more than twenty years ago, it was filled with overgrown hedges, suffering trees, and deteriorating retaining walls. Bit by bit, he transformed every square inch, amending the soil and transforming the hardscape into a true showcase where biodiversity reigns and everything from giant trees to tiny alpine cushion plants thrive.

The entry to the garden boasts hundreds of potted blooming cacti and succulents, and Panayoti is passionate about each one. Next comes the largest part of this small garden, an area designed not to be watered and that is filled with a riot of colorful steppe plants: veronicas, western American penstemons, cacti, and orange horned poppies. Beyond that, a small blue-gamma-grass prairie is planted with a thousand or more mariposa lilies.

The real focus of the garden, however, and the most densely planted, is the rock garden. Here Panayoti displays one of the largest collections of alpine plants in America around a waterfall constructed of Pikes Peak granite. Thousands of cushions and mat plants bloom profusely in the spring.

Panayoti is more than merely a gardener and collector; he is considered one of the true champions of Western gardening. For the past decade, he has shared his obsession for plants in an even more public way as the Senior Curator and Director of Outreach at the Denver Botanic Gardens and, since 1977, as an advisor on their now world-famous rock garden.

Stone steps on the east side of the house lead from the garden level to the first floor. The flagstone walls are the ideal home for a variety of hens and chicks (*Sempervivum ciliosum* and *S. arachniodeum*). The unidentified white umbrel at the top of the staircase on the left is from Panayoti's recent expedition to Kazakhstan.

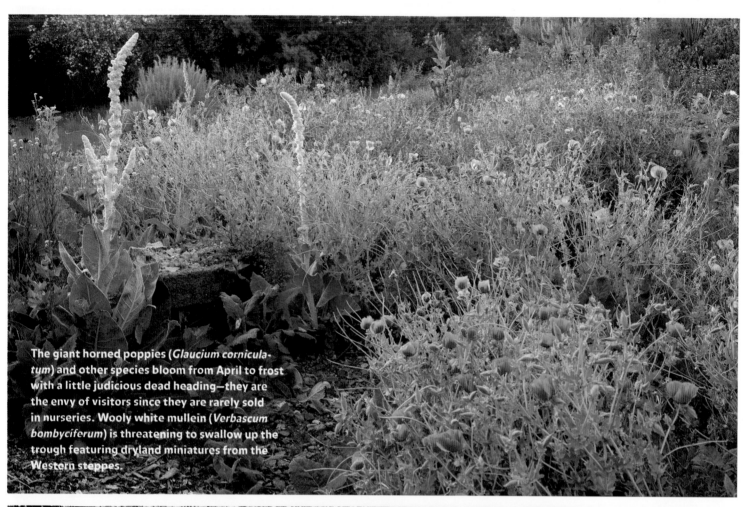

The giant horned poppies (*Glaucium corniculatum*) and other species bloom from April to frost with a little judicious dead heading—they are the envy of visitors since they are rarely sold in nurseries. Wooly white mullein (*Verbascum bombyciferum*) is threatening to swallow up the trough featuring dryland miniatures from the Western steppes.

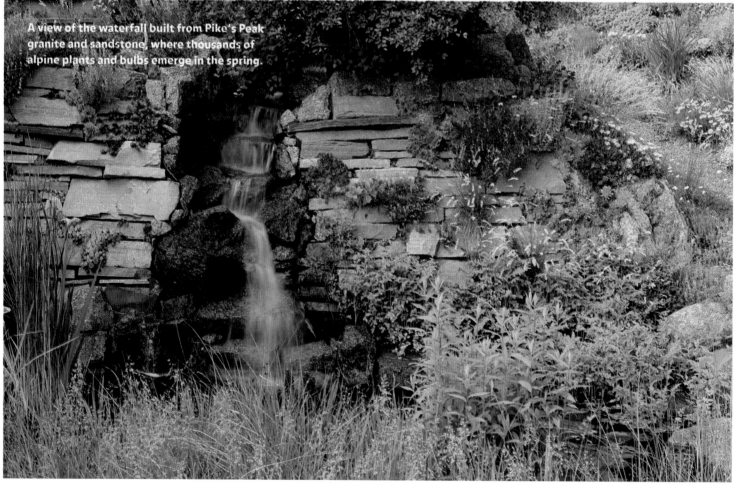

A view of the waterfall built from Pike's Peak granite and sandstone, where thousands of alpine plants and bulbs emerge in the spring.

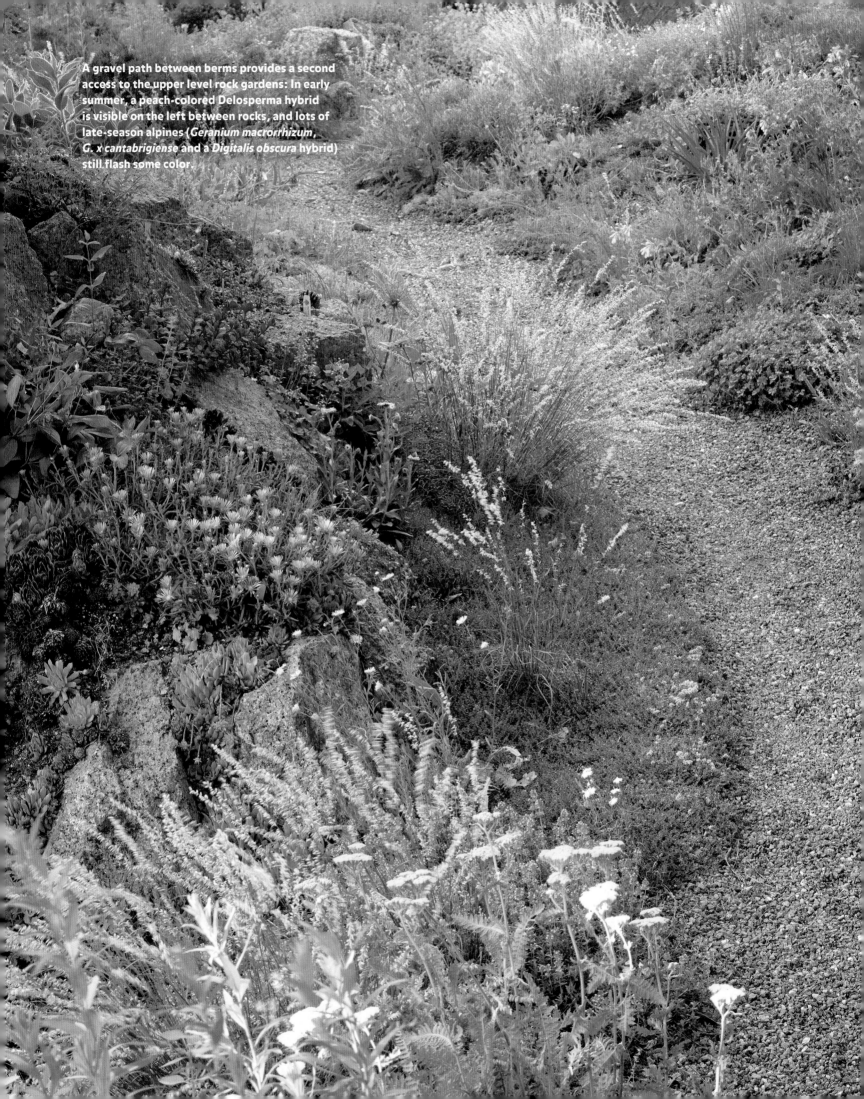

A gravel path between berms provides a second access to the upper level rock gardens: In early summer, a peach-colored Delosperma hybrid is visible on the left between rocks, and lots of late-season alpines (*Geranium macrorrhizum*, *G. x cantabrigiense* and a *Digitalis obscura* hybrid) still flash some color.

THE WEST COAST

The Pacific Coast of the United States is composed of many different climatic regions united by a single shoreline. Southern California is a subtropical zone with arid deserts and high mountain reaches. Northern California's temperate climate permits great horticultural diversity, and plant species from Asia, Australia, and the Mediterranean thrive there. The weather in the Pacific Northwest is cool and damp, so plants associated with traditional English gardens adapt well to its similar soils and temperatures.

The gardens in this section show the diversity of gardening styles appropriate to each region, as well as providing examples of the California way of integrating houses and gardens into modern outdoor living spaces. In their use of drought-tolerant native plants and their concern for the environment, West Coast garden designers are also changing the way Americans will garden in the future.

Ernie & Marietta O'Byrne's Garden

Eugene, Oregon

In the Pacific Northwest, where "anything grows," Ernie and Marietta began collecting plants more than forty years ago. They are now legends in the horticulture world and have fashioned a magical garden out of thousands of choice plants from around the globe—many of them coaxed to life from seeds.

Their surprisingly small one-and-a half-acre property provides a suitable home for an astonishing array of plants. A large rock and scree garden is built from boulders and slabs of stone from nearby quarries. There is also a crevice garden, a damp-peat garden for acid-loving plants, a conifer and heather garden, and, the most recent addition, a rarely watered chaparral garden.

According to Marietta, she and Ernie grow "anything we can get our hands on—vegetables, tiny alpines, colorful perennials, and huge trees." They sell them, too. In 1992, they opened Northwest Garden Nursery after years of propagating hard-to-find plants to use in their landscaping business.

After twenty years in the nursery industry and a long love affair with all plants, the O'Byrnes have focused their attention on one extraordinary plant: the hellebore. After "dabbling" in breeding them for decades, Ernie and Marietta now produce hybrid hellebores that are "colorful and interesting from above," as Marietta explains, "so that their beauty can be enjoyed without bending over."

A profusion of alliums and lady's mantle line this woodland path, which features one of many stone mosaics by Jeffrey Bale.

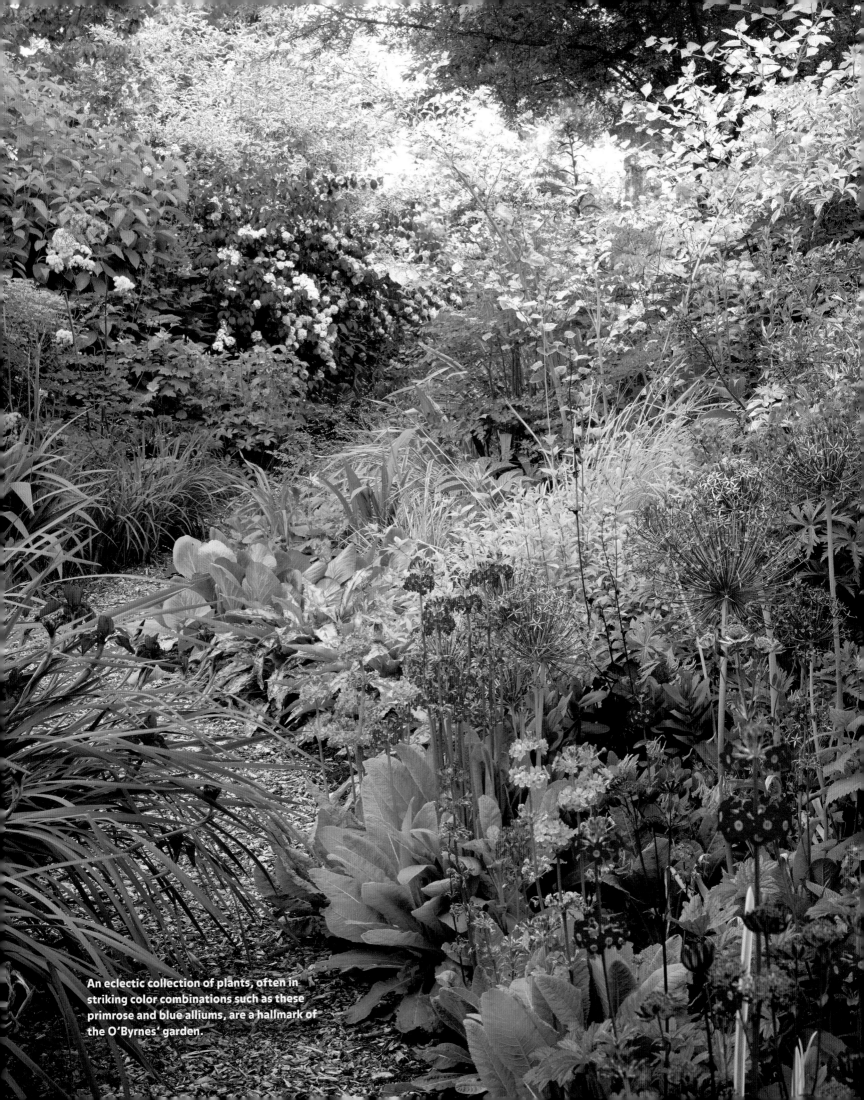

An eclectic collection of plants, often in striking color combinations such as these primrose and blue alliums, are a hallmark of the O'Byrnes' garden.

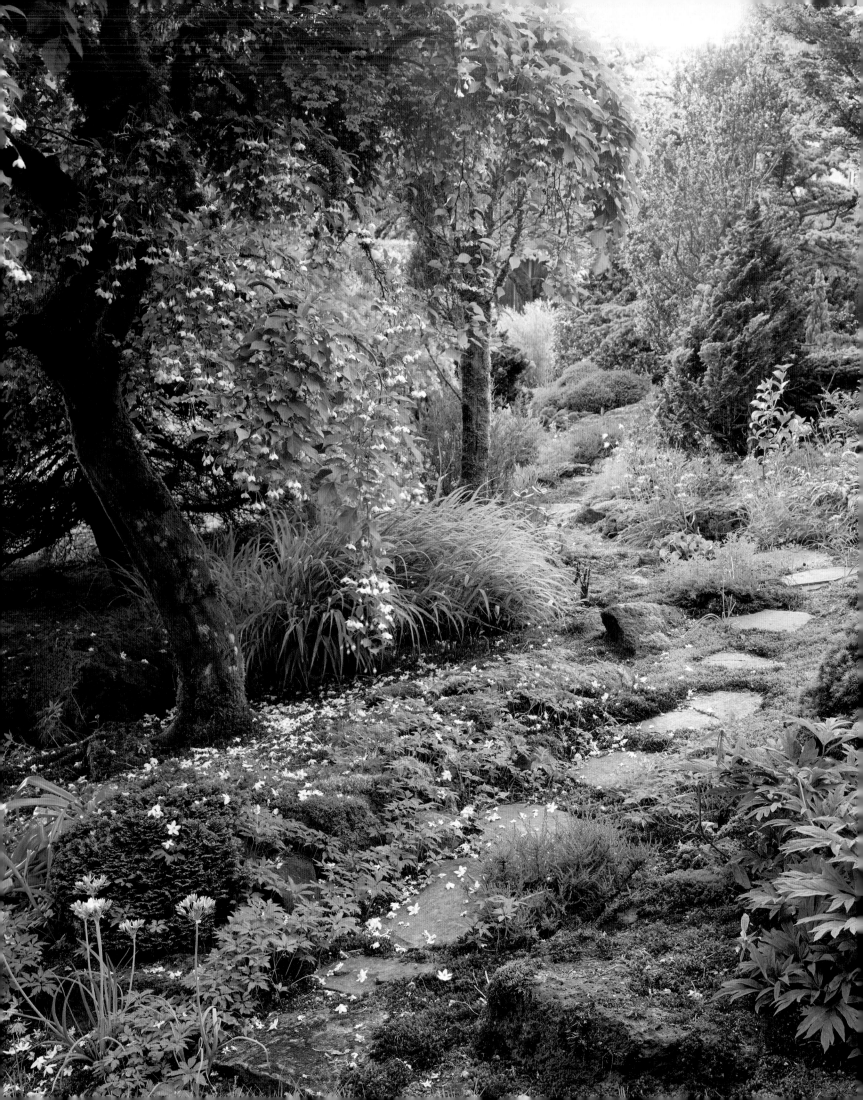

The
Jane Platt Garden

Portland, Oregon

The late Jane Platt inherited her love of gardening and rare plants from her father, Peter Kerr. Kerr was a Scottish immigrant who, at the end of the nineteenth century, developed Portland's Elk Rock Gardens of the Bishop's Close, a magnificent, thirteen-acre expanse perched on a hillside overlooking the Willamette River. Jane and her sister endowed and donated their father's garden to the Episcopal Diocese of Oregon after his death.

Having grown up in the middle of this horticultural institution, Jane, to no one's surprise, would eventually create her own renowned garden. In 1939, she married John Platt and moved to his cottage on the site of a former Portland apple orchard. The garden had to wait until they built a more suitable house, but people teased Jane that she had married John for this gently sloping piece of land with its rich, loamy soil.

After the house was completed and John returned from World War II, Jane started cultivating the property in earnest, dividing the broad sweep of land into a number of separate and distinct gardens. For "walls," she used choice deciduous trees and conifers and a variety of shrubs that produced seasonal colors, complex textures, and subtle fragrances. She was especially fond of rhododendrons and incorporated hundreds of the finest specimens into the landscape.

The first plot she planted was a gravel garden on the property's highest point, a rectangular space divided into narrow sections edged by wood. Like her father, Jane was interested in specimen plants, unusual and unique plants, and she used many here. Other cultivated areas were soon to follow, including a large rock garden built from massive slabs of basalt from a nearby quarry. Here, too, Jane used rare plants from around the world, many procured by friends and family when they traveled, as Jane rarely did.

By the time she was finished, Jane had created a world-class garden, and today, many of the specimens she planted are among the oldest and largest to be seen outside their native habitats. In 1988, Jane's youngest son, David, took over the maintenance of the garden. He consults with his daughter Kailla, a landscape architect, on the garden, and his wife, Lisa, urges him "toward the big changes that need to be made." Together they welcome visitors to the garden to share in the long family tradition started by Jane's father more than one hundred years ago.

A weeping Japanese snowball (*Styrax japonica* 'Carillon') greets visitors on this inviting path through the rock garden.

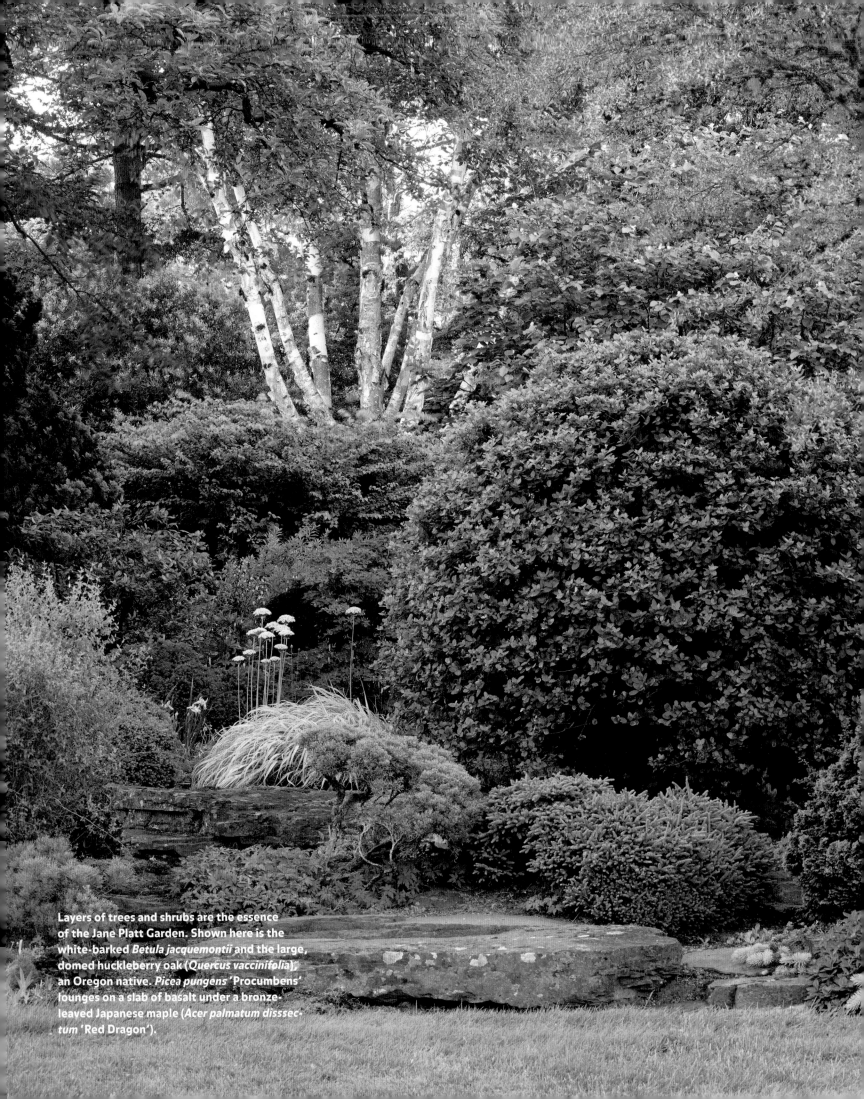

Layers of trees and shrubs are the essence of the Jane Platt Garden. Shown here is the white-barked *Betula jacquemontii* and the large, domed huckleberry oak (*Quercus vaccinifolia*), an Oregon native. *Picea pungens* 'Procumbens' lounges on a slab of basalt under a bronze-leaved Japanese maple (*Acer palmatum disssectum* 'Red Dragon').

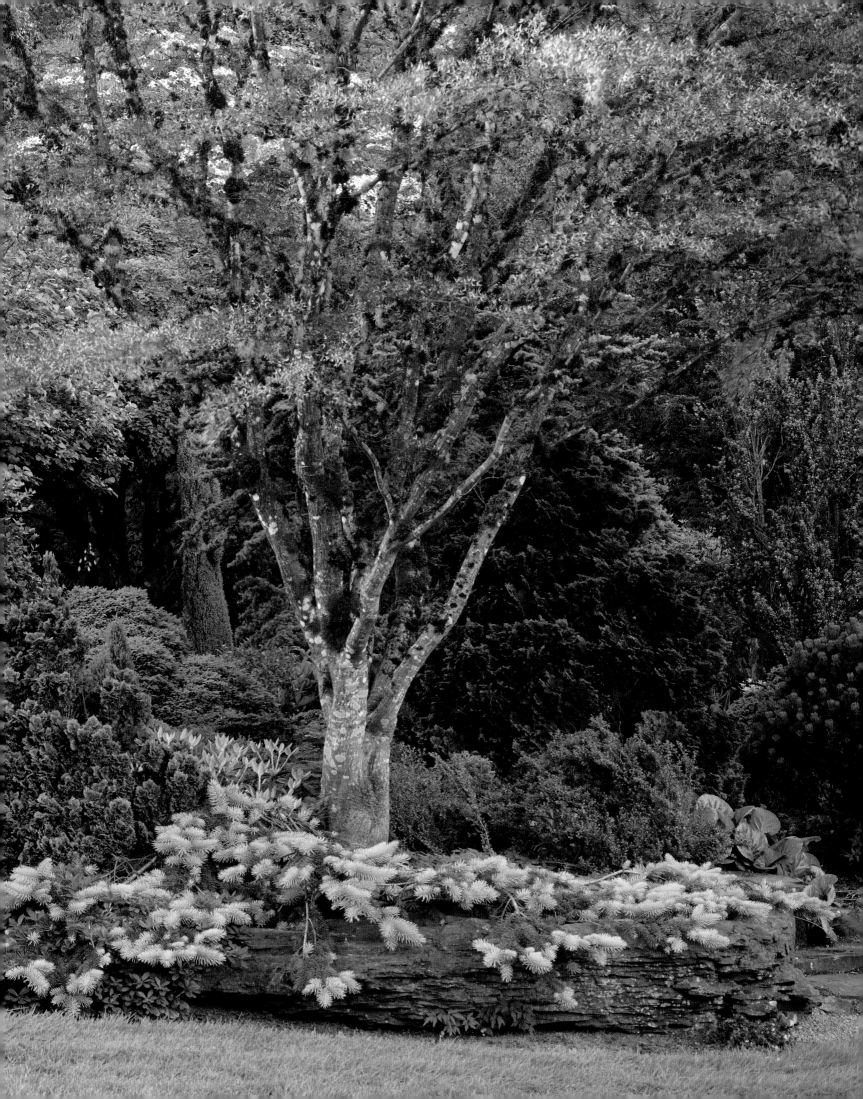

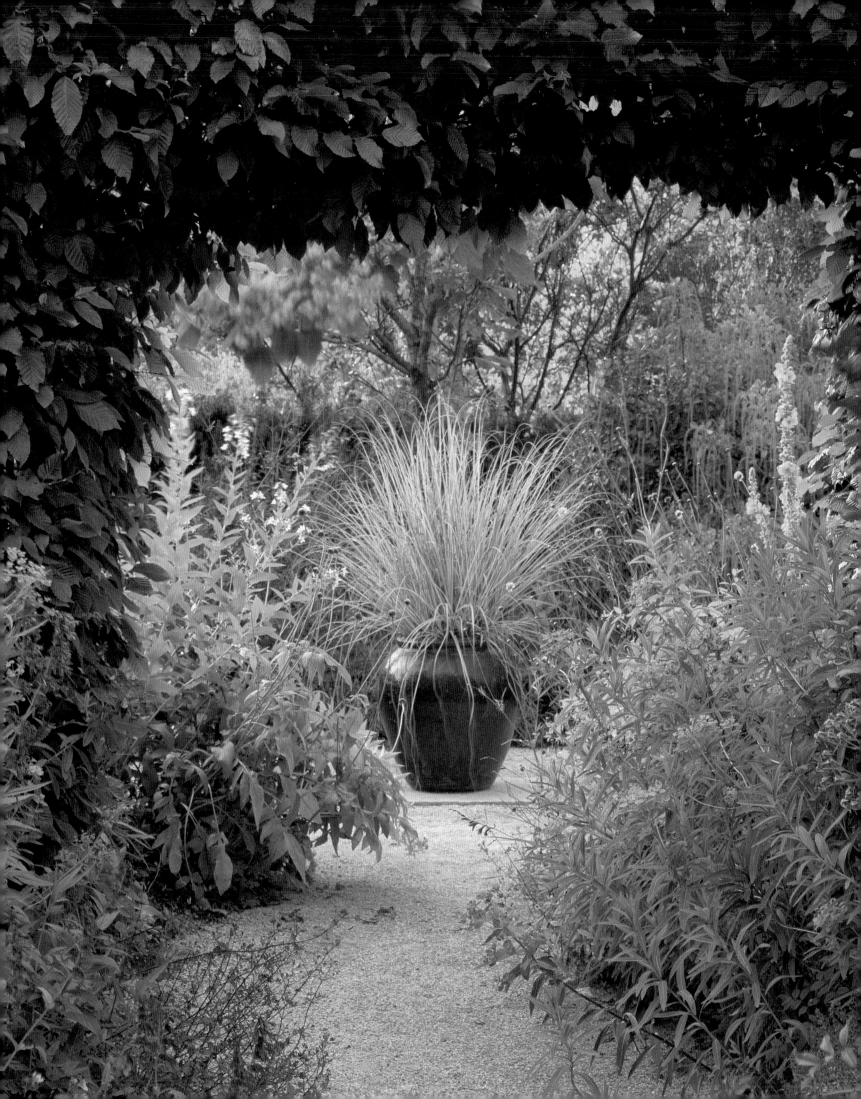

The Gardens at Digging Dog Nursery

Albion, California

In the middle of a fourteen-acre California redwood forest on the Mendocino Coast is a surprising and mesmerizing oasis—a secret spot in the quiet town of Albion, where the plants easily outnumber the people. Within a solid structure of hornbeam, beech, and yew hedges, a rowdy display of thousands of colorful perennials is simply enchanting.

Co-owner Gary Ratway has been designing gardens since 1980, when his first endeavor in nearby Mendocino grew into the Mendocino Coast Botanical Gardens. He was their first executive director and is still actively involved. His wife, Digging Dog Nursery co-owner Deborah Whigham, is a weaver, but she has found it much more fun and active to trade in her textiles for plants. Their combined talents have produced amazing results.

They are the first to admit that their creation is a bit bipolar. Deborah calls it "structured informality." The beds are sharply edged and backed by tightly clipped edges, but generous proportions in between allow for a crazy population of plants in all possible postures—arching, draping, mounding, upright, sprawling . . . and thriving!

Urns and benches, plus stairways and stalwart arbors, also provide architectural structure throughout, and even though almost every inch of space seems to be planted, the design is always changing. With so many glorious plants in their palette, Gary and Deborah want to give each of them a chance to participate.

At the nursery, the couple grows and sells plants that they promise will thrive anywhere. They are especially good at introducing new varieties to the market and seem to be endlessly surprised by their own accomplishments. "Each day brings a chance pleasure that leaves us feeling awestruck and humbled by these wondrous plants we grow and share with you."

This view through the clipped hornbeam hedge (*Carpinus betulus*) reveals richly varied perennials, including campanula, itea, verbascum, and euphorbia. The path comes to rest at a planter full of pampas grass (*Cortaderia* 'variegata').

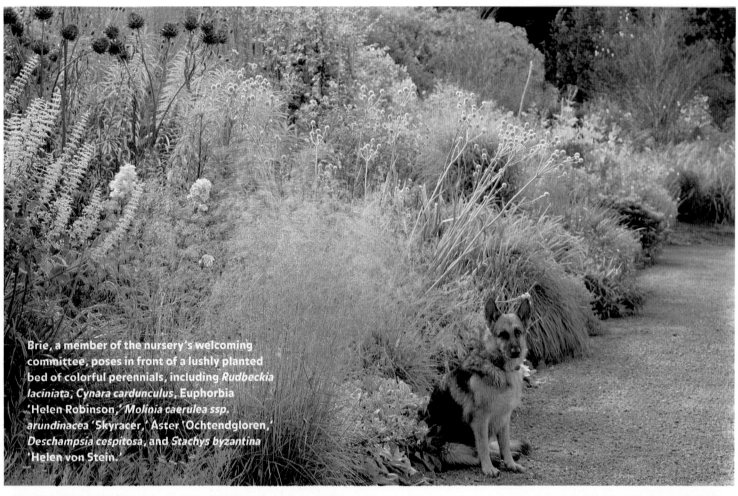

Brie, a member of the nursery's welcoming committee, poses in front of a lushly planted bed of colorful perennials, including *Rudbeckia laciniata*, *Cynara cardunculus*, Euphorbia 'Helen Robinson,' *Molinia caerulea ssp. arundinacea* 'Skyracer,' Aster 'Ochtendgloren,' *Deschampsia cespitosa*, and *Stachys byzantina* 'Helen von Stein.'

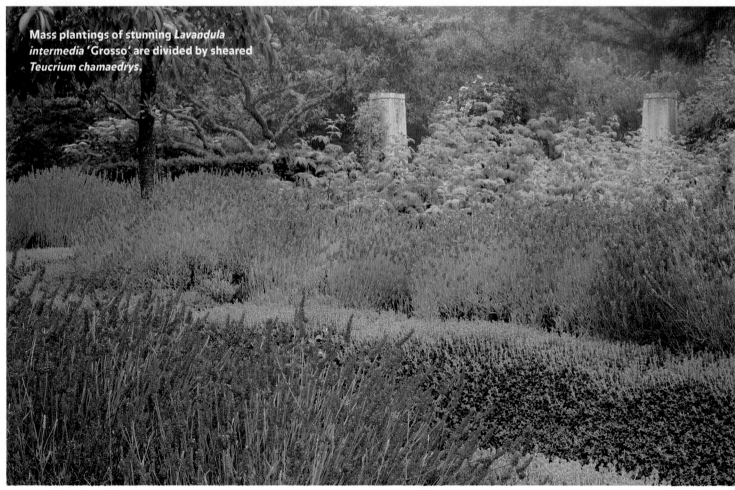

Mass plantings of stunning *Lavandula intermedia* 'Grosso' are divided by sheared *Teucrium chamaedrys*.

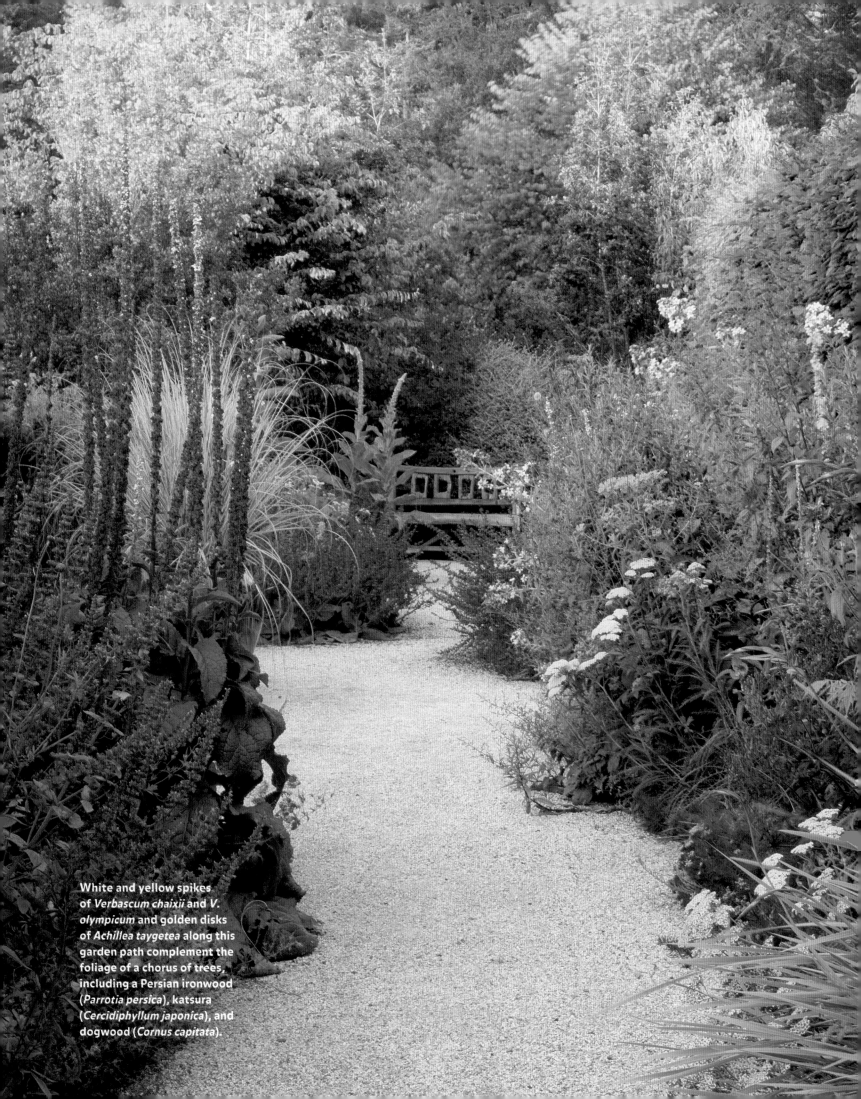

White and yellow spikes of *Verbascum chaixii* and *V. olympicum* and golden disks of *Achillea taygetea* along this garden path complement the foliage of a chorus of trees, including a Persian ironwood (*Parrotia persica*), katsura (*Cercidiphyllum japonica*), and dogwood (*Cornus capitata*).

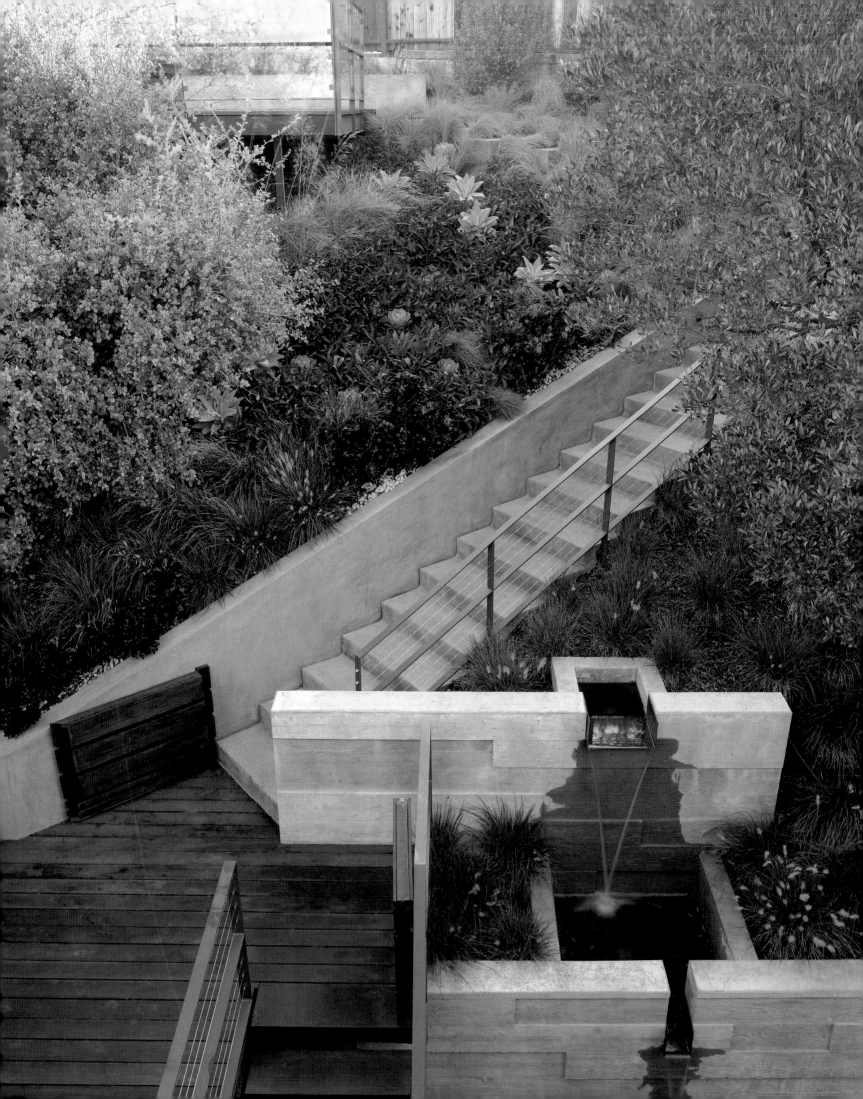

The Rieder Garden

San Francisco, California

In San Francisco, few gardening challenges are more daunting than the steep, nearly vertical slopes that are a signature of the city. When Rob and Lillian Rieder purchased their single-family house in Laurel Heights, they waited five years before deciding how to tackle their inclined backyard. Knowing that they wanted an outdoor living space for entertaining and where the children could play safely, as well as for secure and easy access to the spectacular views at the top of their property, they turned to Surfacedesign, Inc.

The project started at the bottom of the tract, where a failing retaining wall was replaced with a grotto-like approach to the property. A cascading water feature, which travels throughout the garden, ends here and provides this entrance with welcoming splashing sounds that drown out of the buzz of the city. The new retaining wall was designed to be heavily planted, and shade-loving plants such as *Helleborus orientalis* thrive there.

A comfortable ascent up a generous staircase leads to a second level, which houses the much-desired outdoor living space for the family. Here the Rieders saved an existing oak tree and installed native grasses and other drought-tolerant plants on the sunny hillside. Generous seating areas were fashioned out of strong black-cedar decking and walls, and agave, sedum, and aeonium soften the strong lines of the infrastructure.

The third and final level is a viewing platform—a garden penthouse. It rewards the Rieders and their visitors with magnificent views of the surrounding city, the Golden Gate Bridge, and the massive Pacific Ocean, which is especially dazzling at sunset. It is an aerie above the city, uniting this unique garden with its extraordinary surroundings.

A soothing water feature welcomes visitors at the lower level of the steep property.

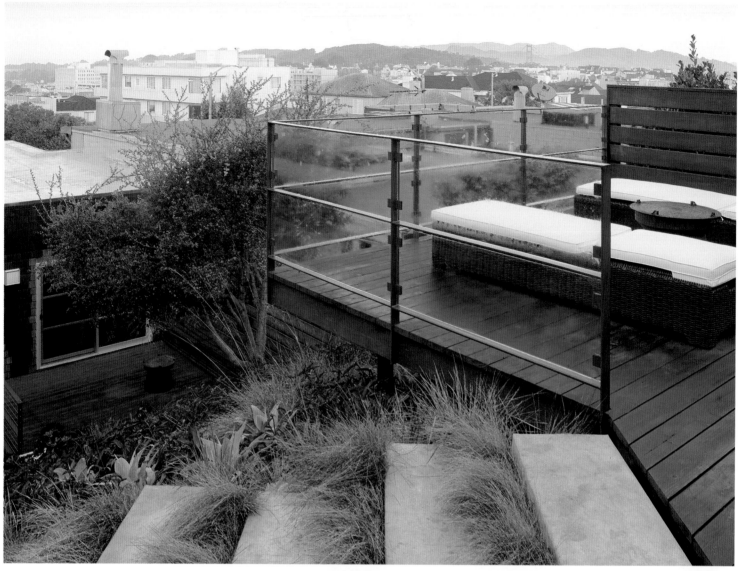

TOP A hilltop viewing platform offers views of San Francisco and the Pacific Ocean beyond.

BOTTOM Plantings within the retaining wall include *Trandescantia pallida*, agaves, aeoniums, and sedums.

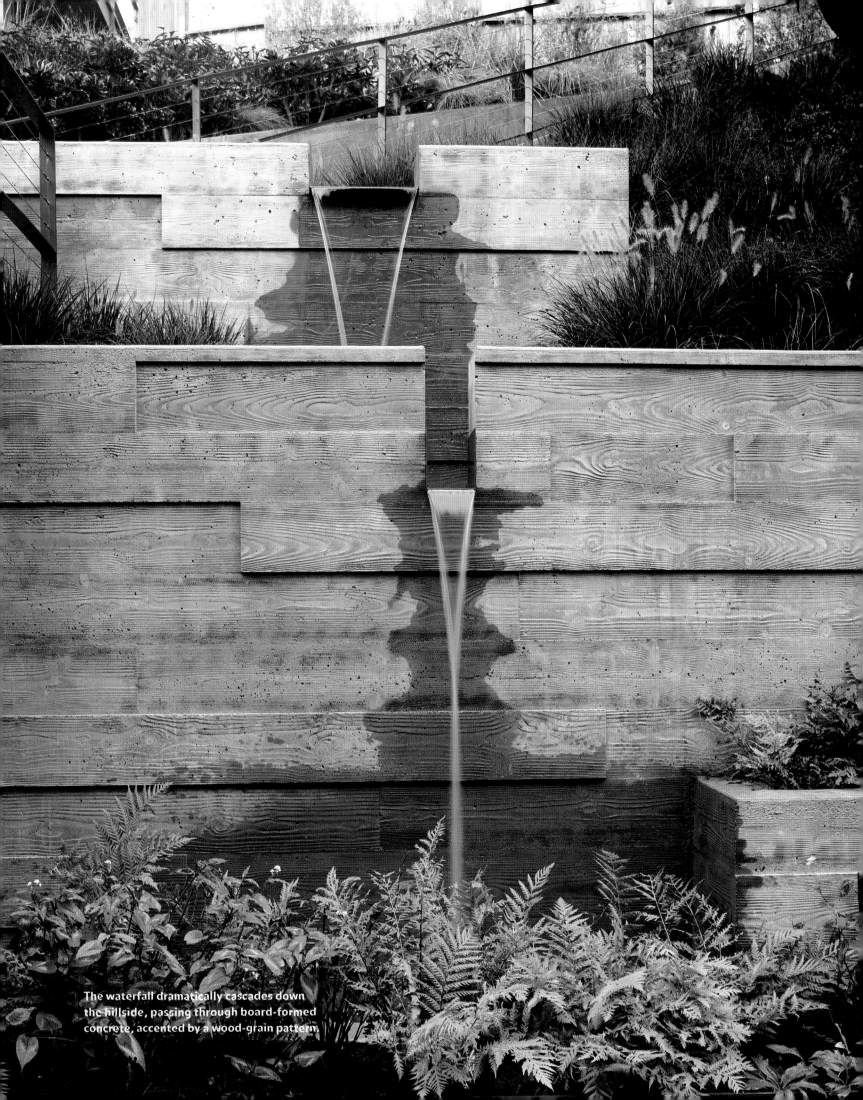

The waterfall dramatically cascades down the hillside, passing through board-formed concrete, accented by a wood-grain pattern.

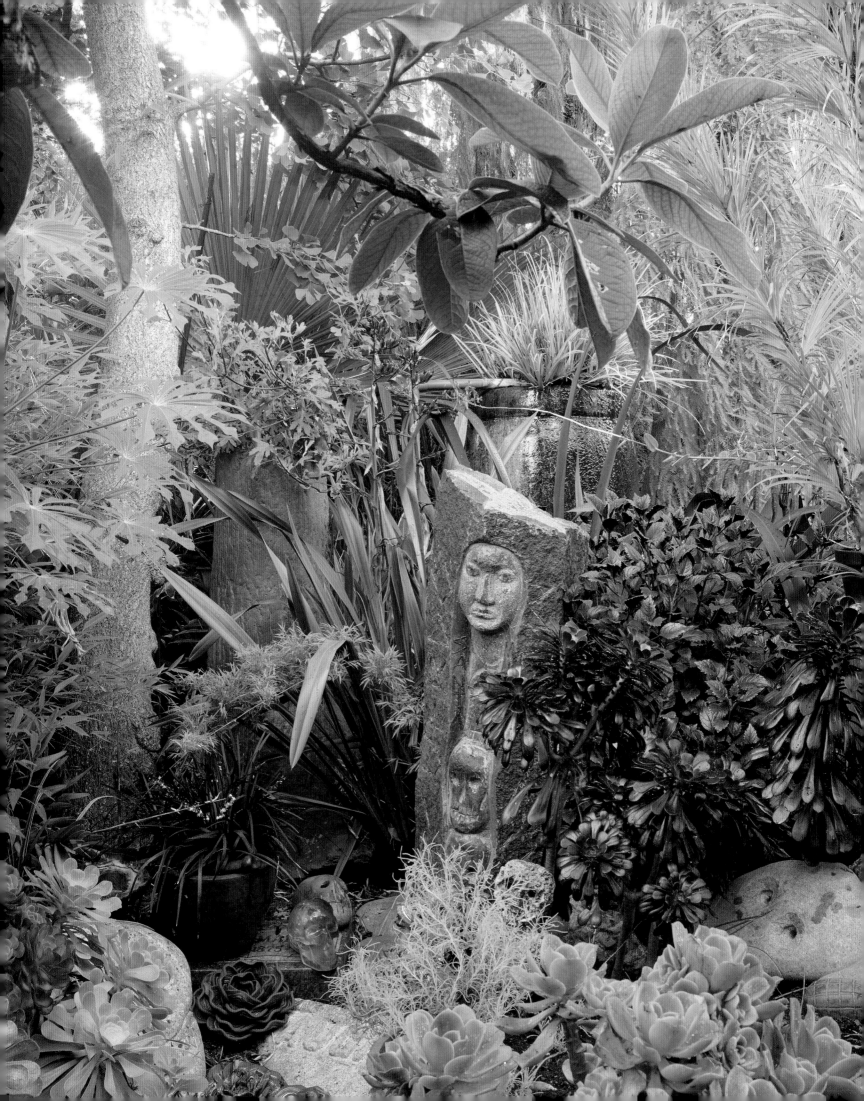

Marcia Donahue's Garden

Berkeley, California

In Marcia Donahue's world, there is no distinction between making art and gardening. They're both part of a creative process she has engaged in since the late 1970s, when, as a young artist, she moved into a two-story Victorian house in south Berkeley and began to work in the yard. Her garden is a mixture of boldly textured plants, found objects, and her own sculptures, and the ingredients come together to create an idiosyncratic and magical world. Every Sunday afternoon she shares it with the public.

A passionate gardener drawn to subtropical plants, Marcia searches for the unusual and rare, and her garden features specimens from many continents. As she explains, "I go for plants that call my name," and once she has them, she works to find them a place where they will thrive. The intense textures and colors of these subtropicals infuse the garden with drama. The sly humor and quirky commentary on life comes from the found objects and the sculpture.

Marcia has a strong sense of whimsy. Bowling balls, "planted" in pots decorate the stairs to the house and others are tucked in among the plants. Figures, stylized and fantastical, populate the garden. There is a "beach" made of shards of ceramics and tumbled glass. A "Poultry Pagoda" topped with glass sculptures reminiscent of Russian Orthodox onion domes or Buddhist stupas is draped with a string of egg-shaped ceramic beads. The raccoon-proof koi pond is overhung with lush foliage and animated with pots, glass floats, and all manner of repurposed objects.

Bamboo is a recurring theme; she grows at least sixteen different varieties and she has fashioned ceramic bamboo, some of it so realistic it looks like a new variety. As an astute garden visitor noted, the upward thrust of the real and the ceramic bamboos adds a strong dose of energy and dynamism to the world she has imagined.

One of Marcia's pieces, *Santa Muerte, Recuerdo de Mexico*, surrounded by dark-leaved phormium, plectranthus, liriope, and aeonium. She also made the ceramic aeonium that sits beside an altered gravestone at the foot of the statue. In the foreground is the bold foliage of *Rhododendron nuttalli*.

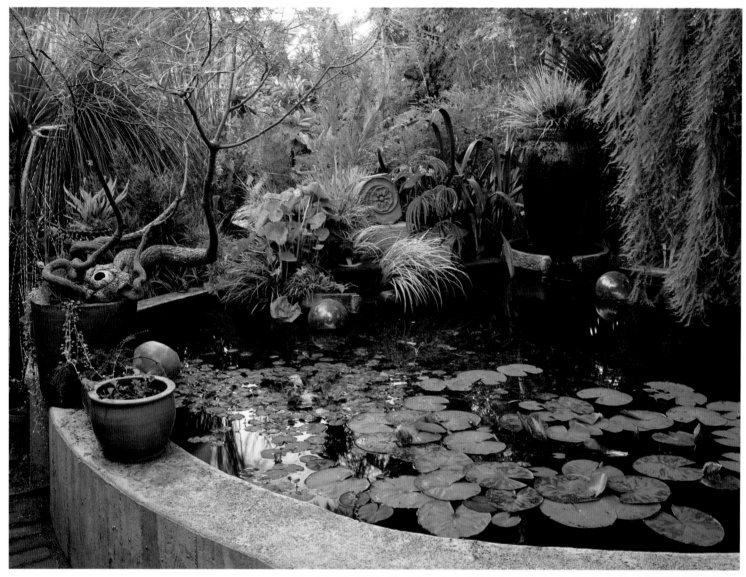

TOP A raccoon-proof koi pond has three fountains; at left is a bonsai *Brachychiton rupestris*. The bright yellow grasses are Acorus 'Ogon' and the weeping *Taxodium* (swamp cypress) on the right is planted in a huge pot with no bottom.

BOTTOM The bantam chickens live in the Poultry Pagoda at night but have the run of the garden by day. The stone pieces are from China, and the palm, *Trachycarpus wagnerianus*, is underplanted with *Billbergia* bromeliads.

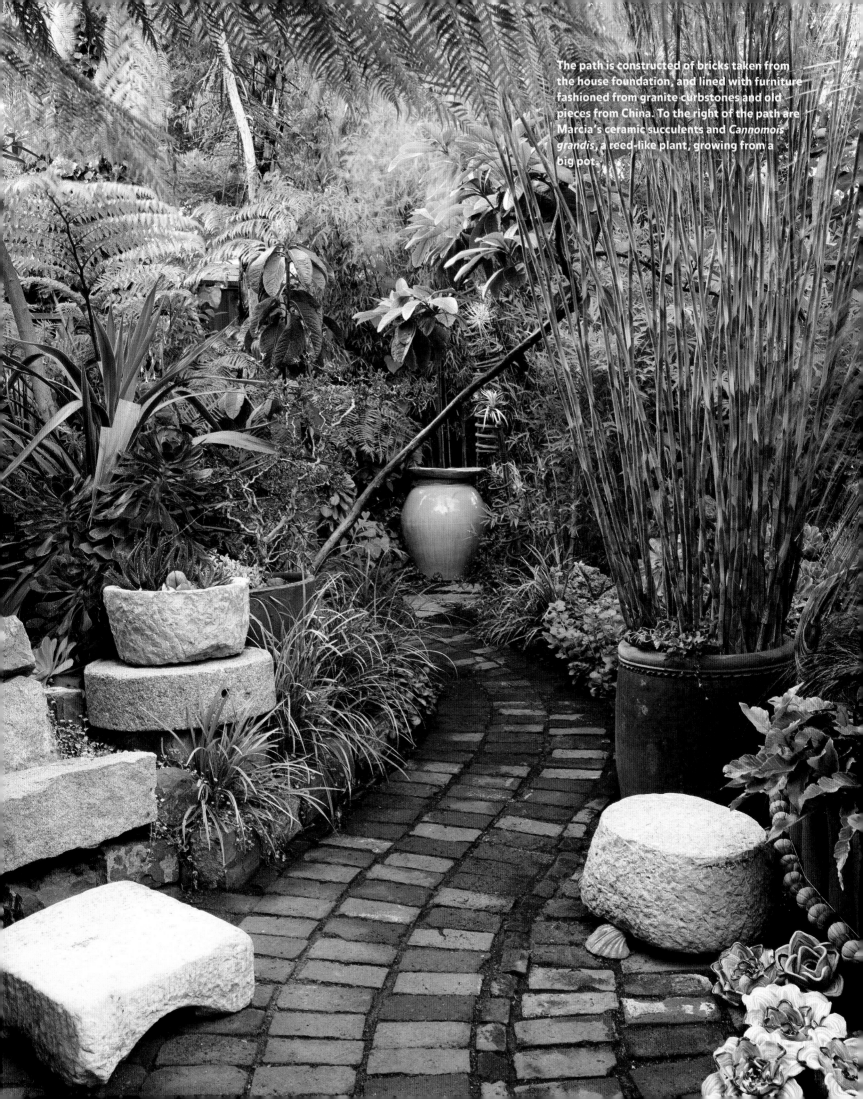

The path is constructed of bricks taken from the house foundation, and lined with furniture fashioned from granite curbstones and old pieces from China. To the right of the path are Marcia's ceramic succulents and *Cannomois grandis*, a reed-like plant, growing from a big pot.

Donivee Nash's Garden

Pasadena, California

When Donivee Nash moved to Southern California in the 1980s, she began working on a parklike, English-style garden in the hot, dry climate of Pasadena. Having grown up in the Brandywine Valley of Pennsylvania and Delaware, Donivee was inspired by that region's nineteenth-century grand estate gardens. She wanted to bring some of those same elements, on a smaller scale, to her new home almost three thousand miles away.

Extensive lawns and beds of short-lived annuals surrounded her 1938 New England–style saltbox. With Pennsylvania's Longwood Gardens and Delaware's Winterthur in mind, Donivee introduced beautiful specimen plants, dozens of trees, and a shady poolside pavilion inspired by the one landscape architect Beatrix Farrand had designed at Dumbarton Oaks in the 1920s. The effect was elegant and gracious—an Eastern estate–like spaciousness in a sunny Pasadena neighborhood.

In 2009, as water usage continued to be a concern for gardeners in Southern California, Donivee brought in local garden designer Judy Horton to update the garden and reduce its need for irrigation. Sycamores, Japanese maples, birch, and oak trees replaced the thirsty lawn—demoted to a ground cover in this new landscape. A fig-tree garden and an olive terrace introduced a Mediterranean atmosphere. Planted generously with basil, rosemary, lavender, and sage, these new groves now provide habitat for hummingbirds, bees, and butterflies.

The English-style garden is still visible in beautiful and productive grape arbors, delightful topiaries, and fragrant and colorful roses, but now the greater variety of plants in this clever garden provides visual interest year-round.

With the San Gabriel Mountains as a backdrop, dozens of shrubs clipped into balls roll down the slope, as the level changes from house to lawn in the foreground.

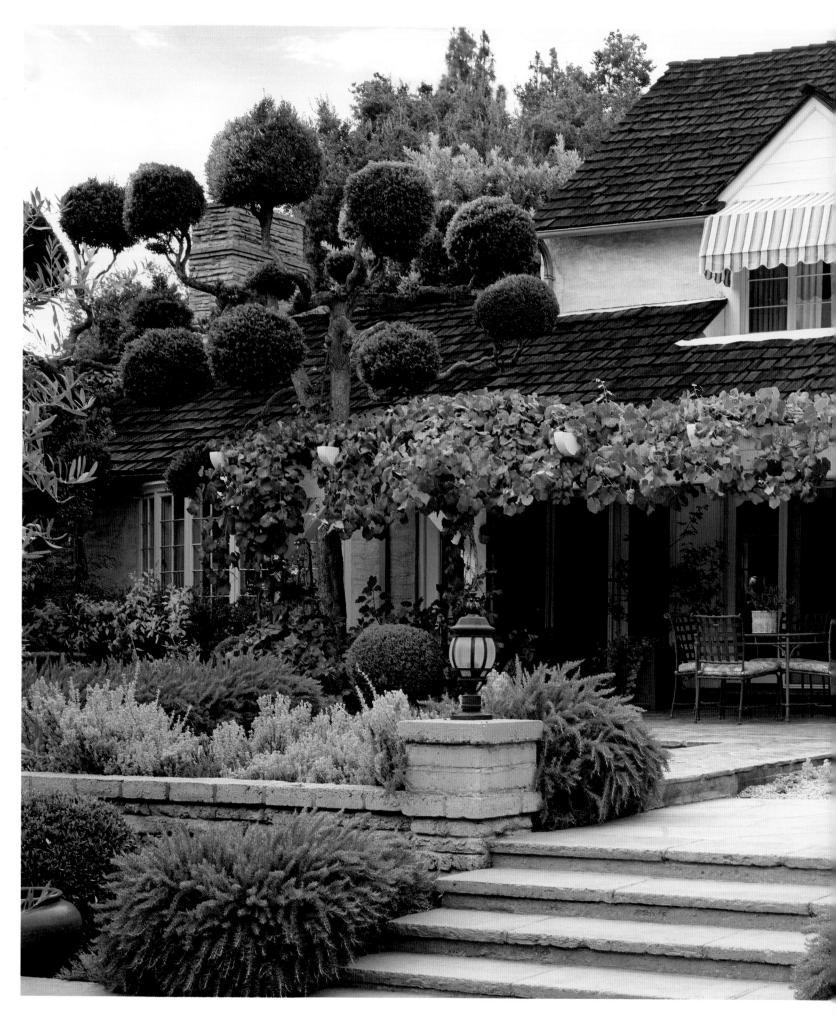

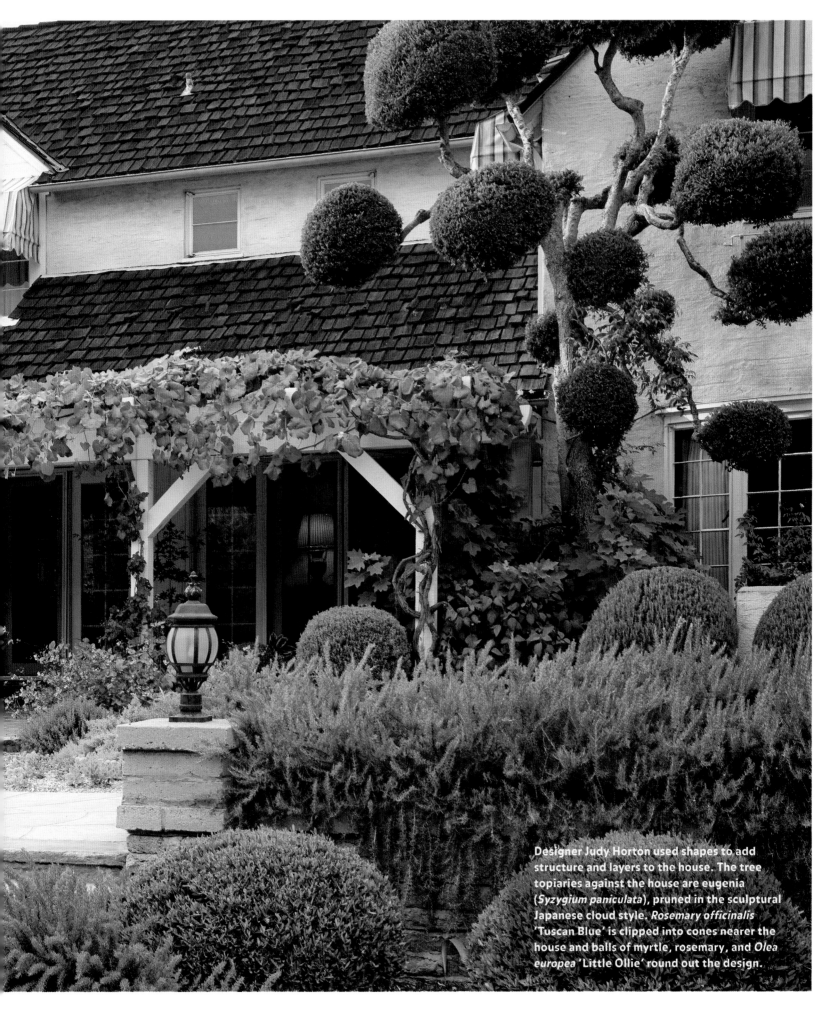

Designer Judy Horton used shapes to add structure and layers to the house. The tree topiaries against the house are eugenia (*Syzygium paniculata*), pruned in the sculptural Japanese cloud style. *Rosemary officinalis* 'Tuscan Blue' is clipped into cones nearer the house and balls of myrtle, rosemary, and *Olea europea* 'Little Ollie' round out the design.

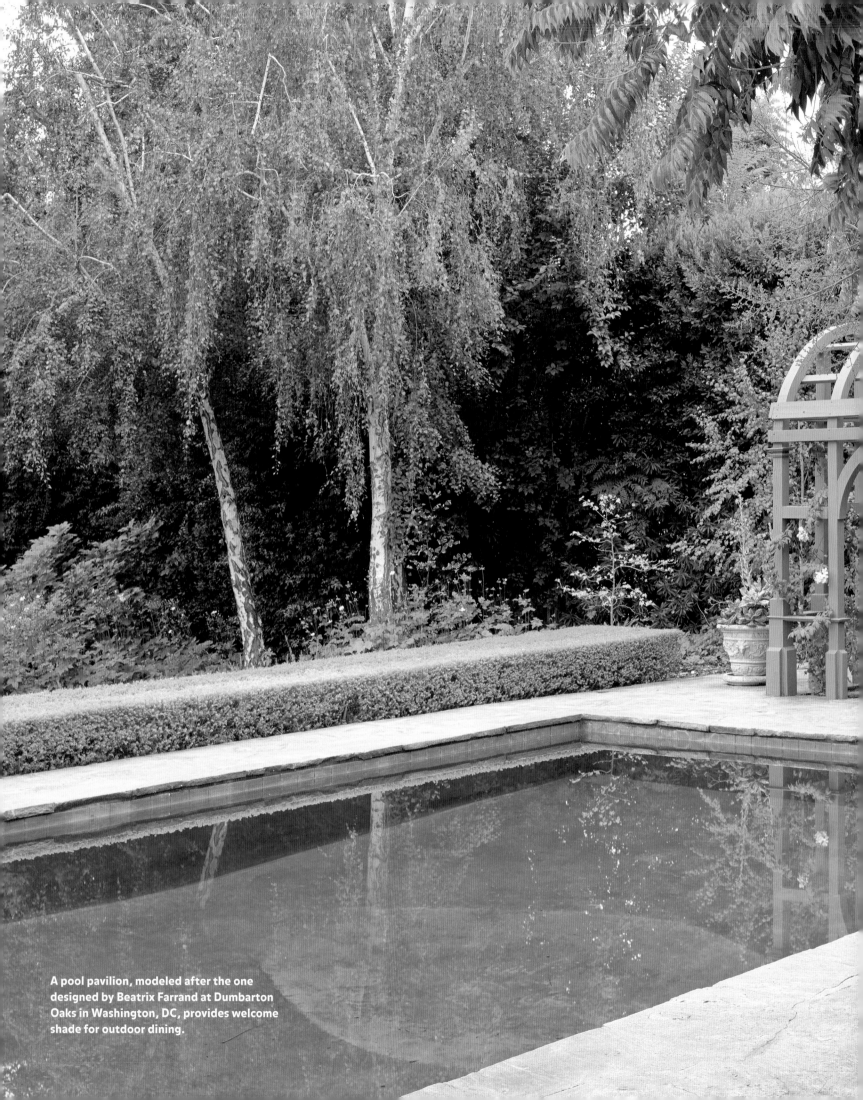

A pool pavilion, modeled after the one designed by Beatrix Farrand at Dumbarton Oaks in Washington, DC, provides welcome shade for outdoor dining.

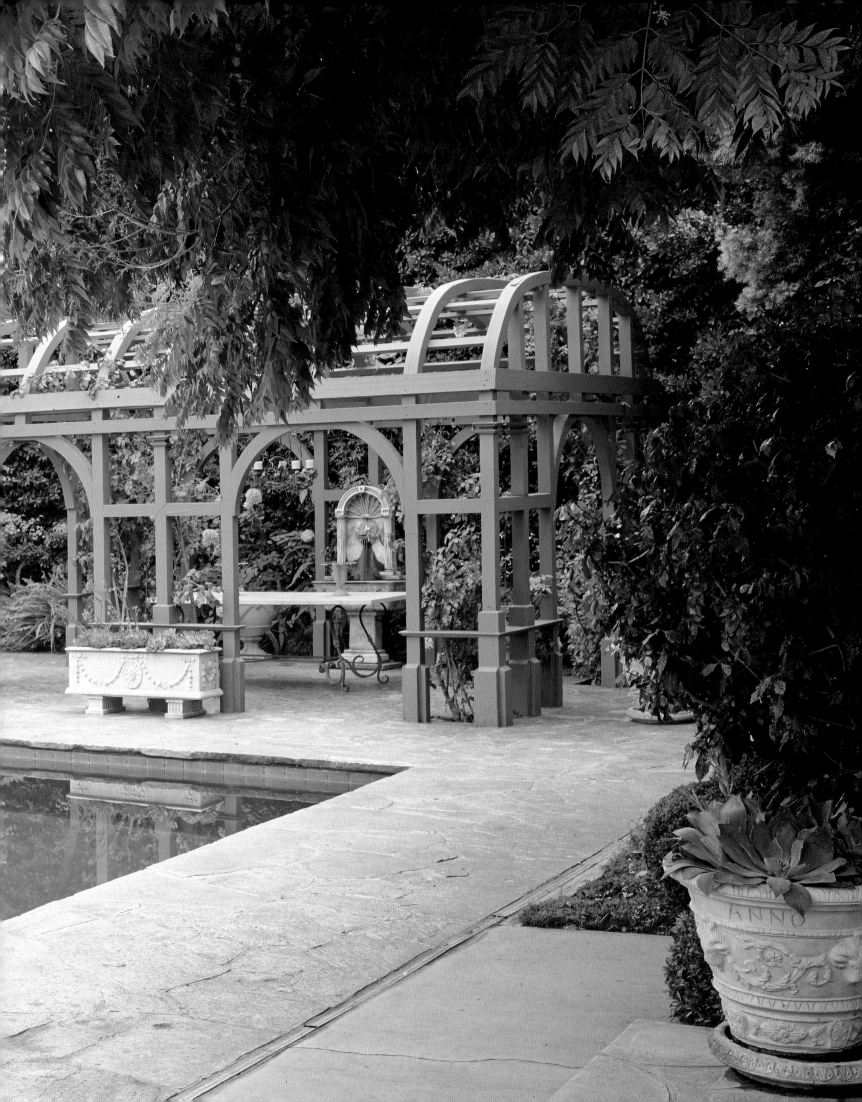

Woodacres, Suzanne & Ric Kayne's Garden

Santa Monica, California

Two great modern masters have shaped the experience of Woodacres, Suzanne and Ric Kayne's one-acre garden overlooking the legendary golf course of the Riviera Country Club (it is literally on the sixth hole). In the distance, an expansive view of the Pacific Palisades draws the eye to the horizon.

In a bold move, the Kaynes turned to the eminent Belgian firm of Wirtz International to replace a traditional, English-style country garden with something quite different. The task of translating their sensibility to a suburban garden in Southern California fell to local designer Lisa Zeder. Working in tandem, the Wirtzes and Zeder used hedges of Japanese boxwood (*Buxus japonica*) and Carolina cherry (*Prunus caroliniana*) to shape the spaces, transforming the property into a series of serene green terraces, each with a different (but stunning) view. Flowering trees and shrubs enliven the garden spaces, notably the dramatic Chinese flame trees (*Koelreuteria bipinnata*) and 'Iceberg' and 'Just Joey' roses, which all emerge from billowing hedges. Where once the wide view was evident from every vantage point, now the many distinct views entice the visitor to proceed through the garden to the ultimate terrace, where all is revealed!

The second modern master to work on the site is the visionary light artist James Turrell. The Kaynes' daughter Maggie brought her parents into Turrell's orbit, and they asked him to create a piece for them, a work that could be a solitary or a social experience. Turrell chose a site at the end of the swimming pool. Down came the wisteria pergola, and up went a light pavilion, built with a hydraulic lift so that at rest it conforms to the local construction-height limits, but when turned on, it rises toward the sky. Turrell's work is both mathematically precise and poetically romantic, and both elements are fully evident in this light sculpture, which changes from green to blue to pink to orange over a forty-five-minute cycle. For those enjoying it up close, it is a transcendent experience, but its soft glow also brings enjoyment to friends and neighbors all along the ridge.

James Turrell's light sculpture, extended, changes color over a forty-five-minute cycle.

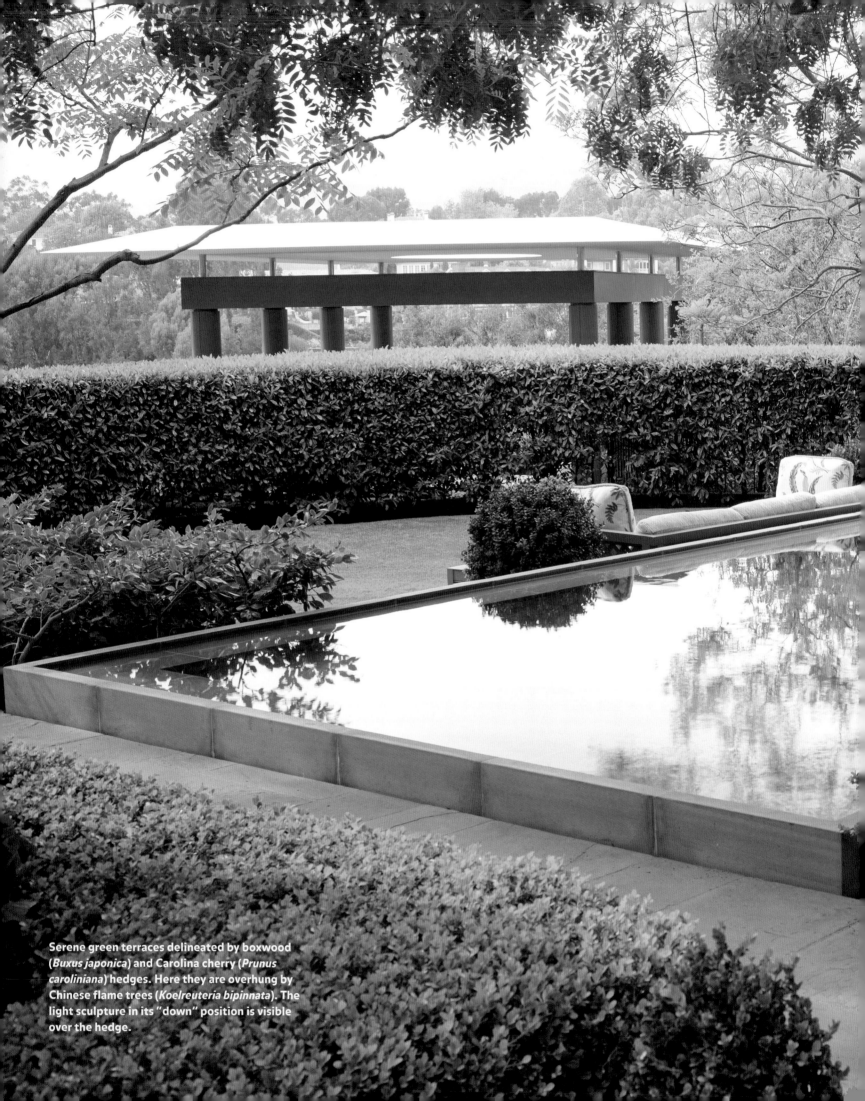

Serene green terraces delineated by boxwood (*Buxus japonica*) and Carolina cherry (*Prunus caroliniana*) hedges. Here they are overhung by Chinese flame trees (*Koelreuteria bipinnata*). The light sculpture in its "down" position is visible over the hedge.

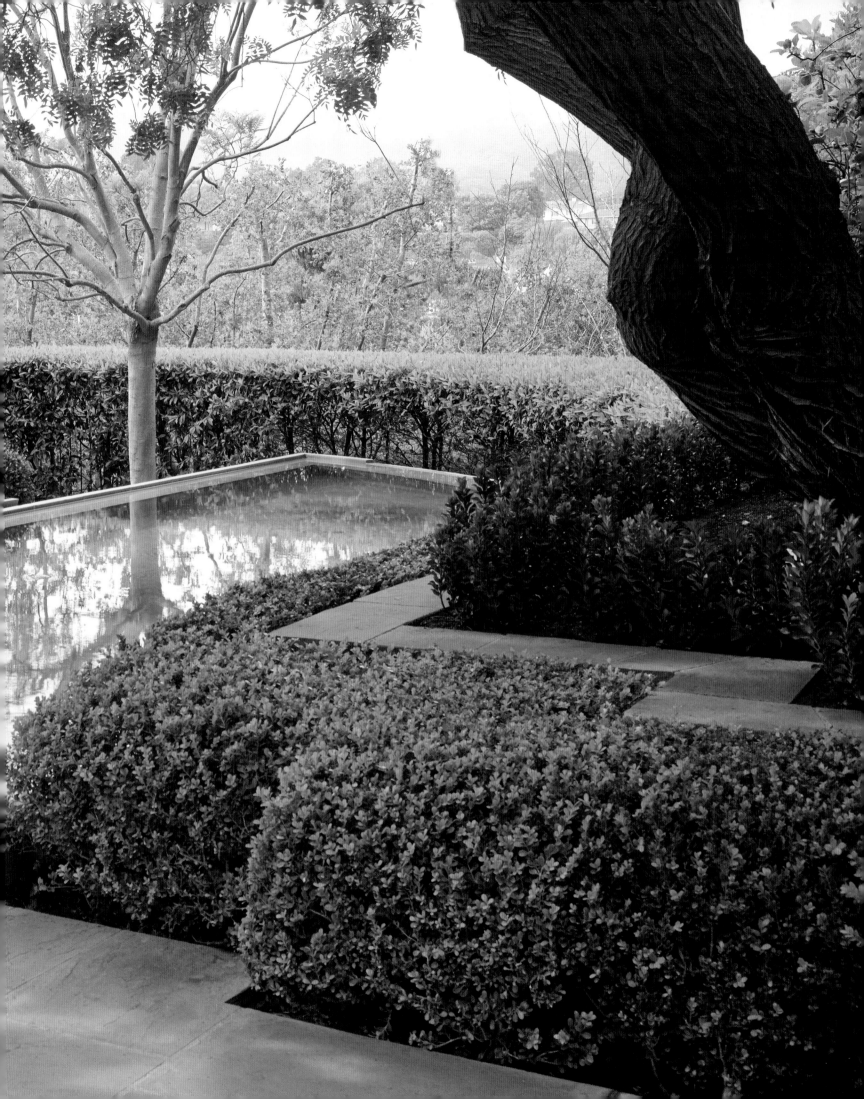

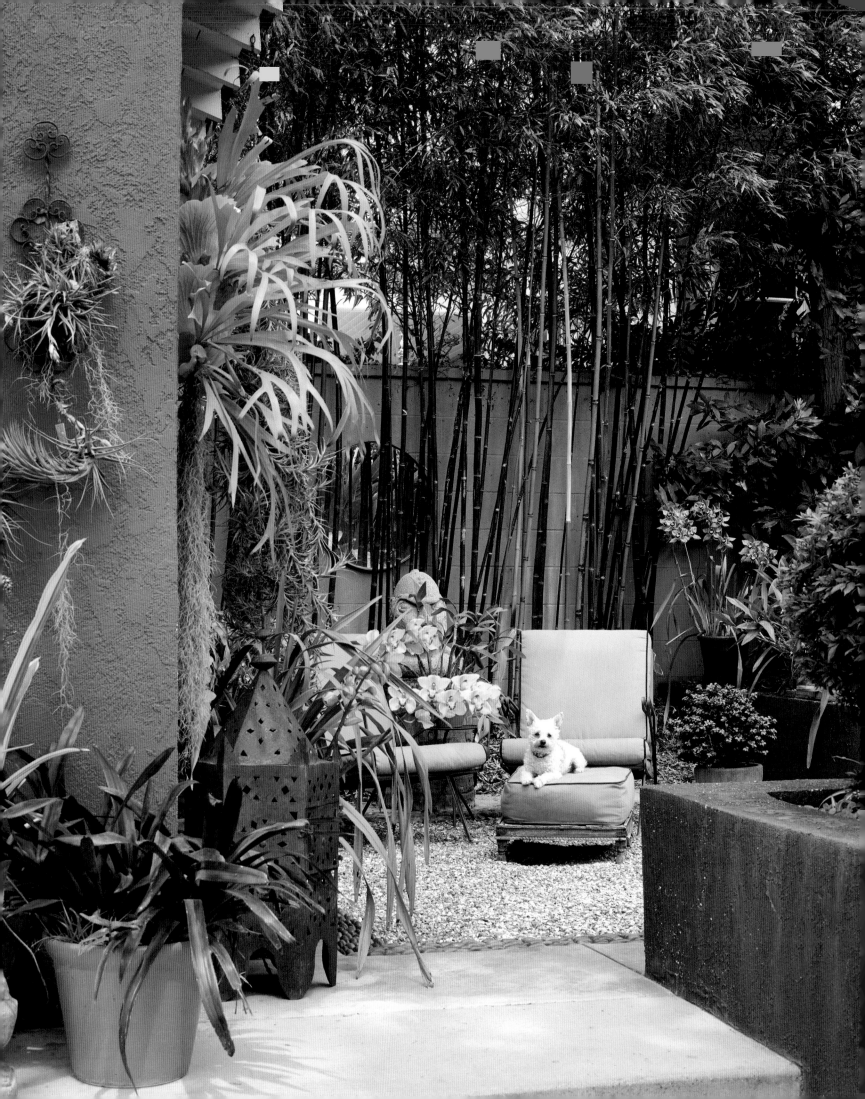

The Garden
of Joseph Marek
& John Bernatz

Santa Monica, California

When Joseph Marek and John Bernatz saw this 50-foot by 150-foot city lot in Santa Monica, they knew that the typical front yard and driveway would have to go to make room for fountains, found art and sculptures, and Joseph's beloved plants. They immediately began transforming the plain bungalow and detached garage into a vibrant and inviting outdoor scene where they could live and work.

Today, the approach is much different. A welcoming entry path leads visitors through a tall juniper hedge into the first of two courtyards. Lined with golden gravel, it features a chattering fountain and is bordered by the wonderful textures and subdued colors of aloes, agaves, and olive trees. A second courtyard, at rest on a sandstone checkerboard, features another fountain, found objects, and pots of cactus, echeveria, and bromeliads.

The transformation of the back garden is even more extensive. Divided into distinct spaces, this area features an intimate gravel courtyard and a comfy, inviting outdoor living room both the couple and their family of adopted dogs can enjoy.

An immense Chinese elm dripping with Spanish moss provides shade for lush tropical plantings bordered by bright, colorful walls. A potting area has become the home for Joseph's burgeoning obsession with propagating roses. Ever on the hunt for the perfect color and form, he is carefully documenting his work and is determined to find a fragrant rose that gives a big show of bloom without succumbing to plant rust or mildew—a challenge in a garden so close to the ocean.

Possibly the most satisfying transformation in this garden is the conversion of a four-hundred-square-foot dark, cramped garage into a sunny and colorful design studio for Joseph's work as a landscape architect. Its French doors bring the outdoors in, and majestic staghorn ferns and a growing collection of tillandsia adorn the walls as living works of art.

The back garden is a vibrant living space for John and Joseph and their dogs (Duncan is shown lounging here). Colorful walls and furniture echo pots of cymbidium orchids throughout the garden. Black bamboo (*Phyllostachys nigra*) and a giant staghorn fern (*Platycerium bifurcatum*) round out the décor.

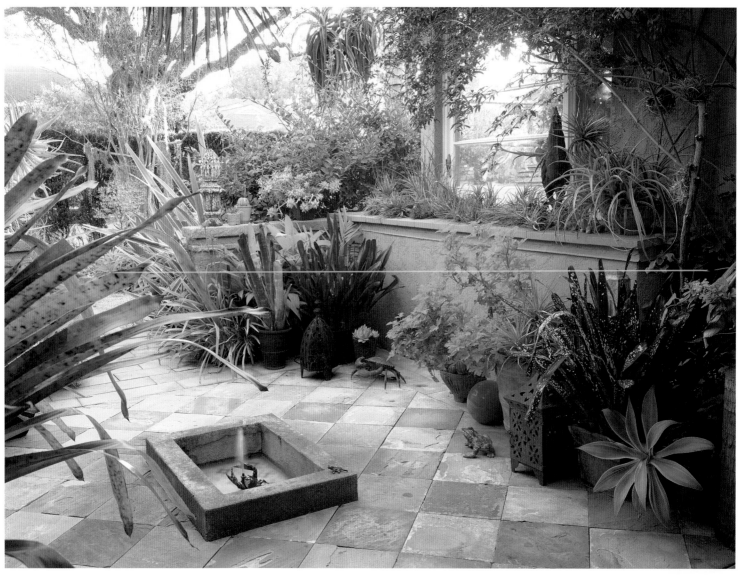

TOP Pots of agave, pelargoniums, sedum, billbergia, and a lineup of tillandsia on top of the wall populate the second courtyard.

BOTTOM The deliciously fragrant *Rosa* 'Tradescant,' a David Austin rose, shows off its rich crimson flowers against one of the garden's colorful walls.

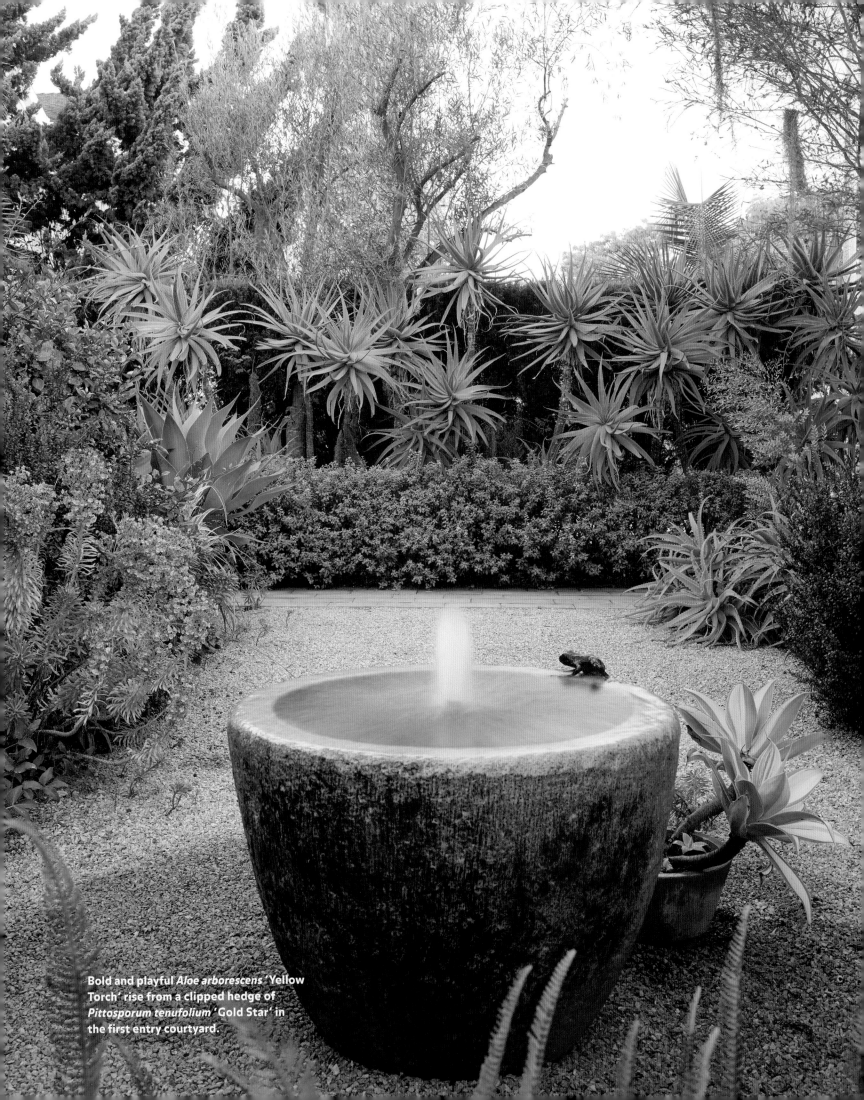

Bold and playful *Aloe arborescens* 'Yellow Torch' rise from a clipped hedge of *Pittosporum tenufolium* 'Gold Star' in the first entry courtyard.

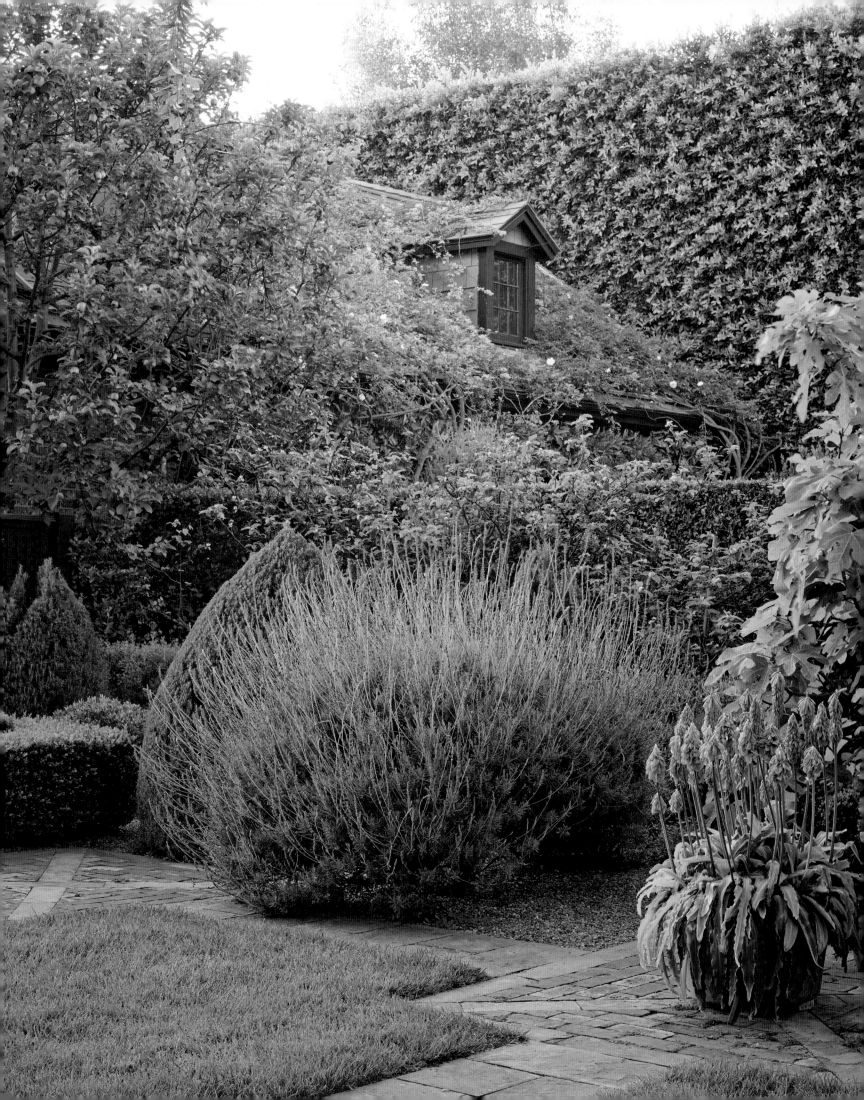

Suzanne Rheinstein's Garden

Los Angeles, California

This interior designer's New Orleans roots are evident in the layout and atmosphere of her garden in the elegant Windsor Square area of Los Angeles. Climbing vines reach to the second story of her 1914 Georgian Revival house and perfume the bedrooms; wrought iron furnishes the wide, welcoming porch, from which the green garden "rooms" present a serene picture.

Even though she was an avid gardener, Suzanne and her late husband, Fred, had lived in the house for fourteen years before she decided to renovate the existing garden. Years of visiting gardens in Europe had fine-tuned her taste, and she invited her friend, noted landscape designer Judy Horton, to create a crisp space that would please her sophisticated eye for design and that was traditional but not staid.

The delight is in the details in this restful garden. In the main "room" directly behind the house, bluestone and brick pathways delineate two precise panels of grass, one of which features a round, stone-edged pool with a discrete fountain just big enough to provide the refreshing gurgle of running water. A two-tiered topiary boxwood hedge subtly echoes in the vertical the cutouts in the lawn panels. The straight stone-and-brick path divides the grass panels and leads from the back porch to a little "antechamber" encircled by hedges and paved with gravel, in the center of which a weeping Chinese elm shows off its beautiful bark. Suzanne used two colors for the furnishings: chartreuse for the many pots, and Charleston green—so dark it reads as black—for the benches.

For all its restraint and serenity, this is clearly the garden of someone who loves plants, especially ones with prominent fruits, seeds, and berries. Citrus, grapes, figs, mulberries, loquats, guavas, persimmons—she grows them all, but she also takes delight in bold foliage and the fragrant climbers that remind her of her youth in New Orleans.

Three different roses reach to the top of the "Black House" (the pool house), which is partially obscured by a fruiting apple tree. In the foreground, the unusual form of the potted South African bulb *Veltheimia* is seen against lavender and a cone-shaped topiary rosemary.

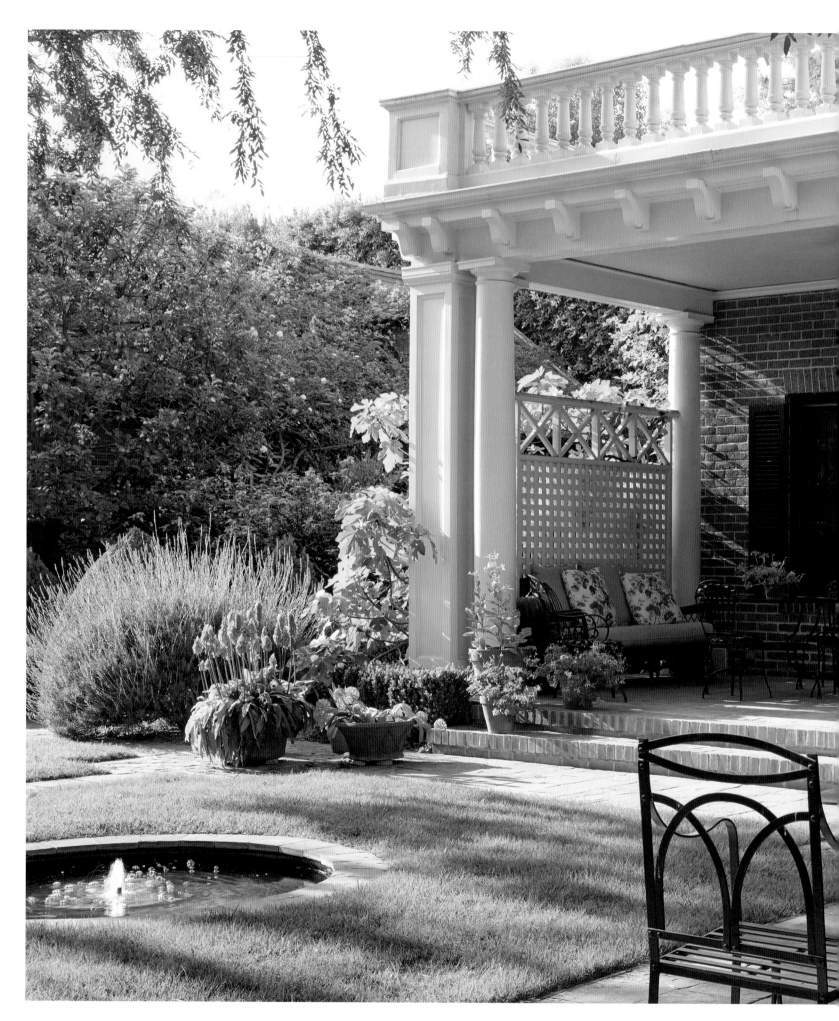

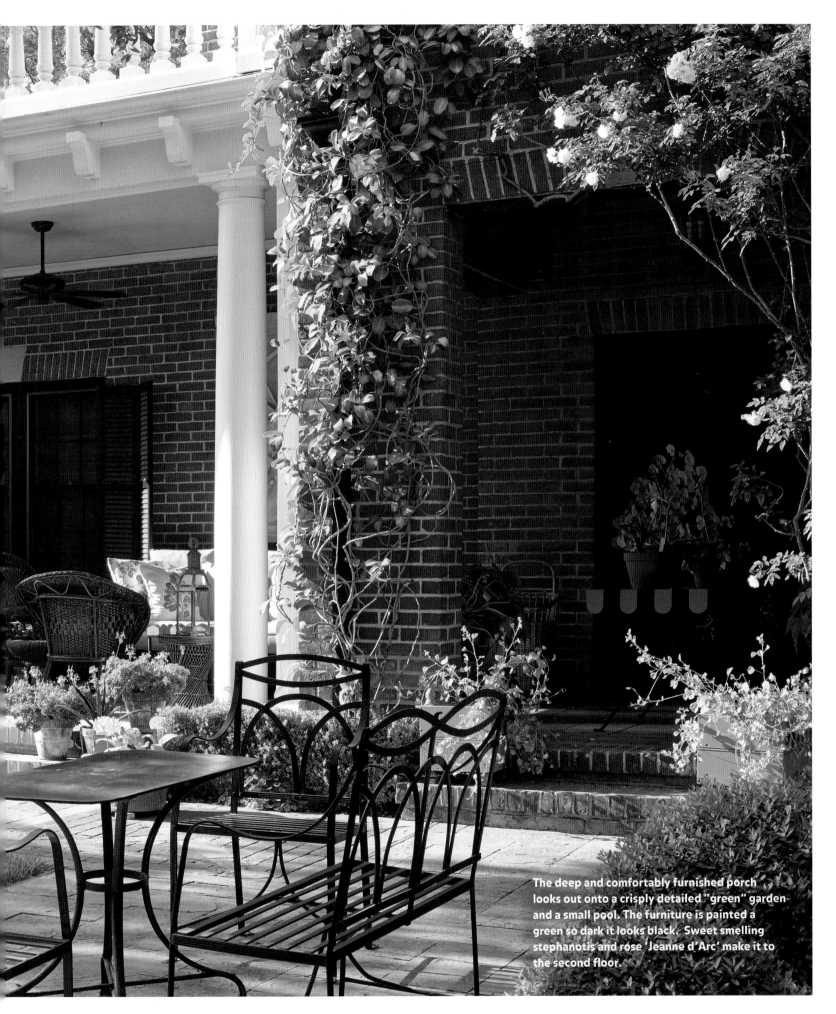

The deep and comfortably furnished porch looks out onto a crisply detailed "green" garden and a small pool. The furniture is painted a green so dark it looks black. Sweet smelling stephanotis and rose 'Jeanne d'Arc' make it to the second floor.

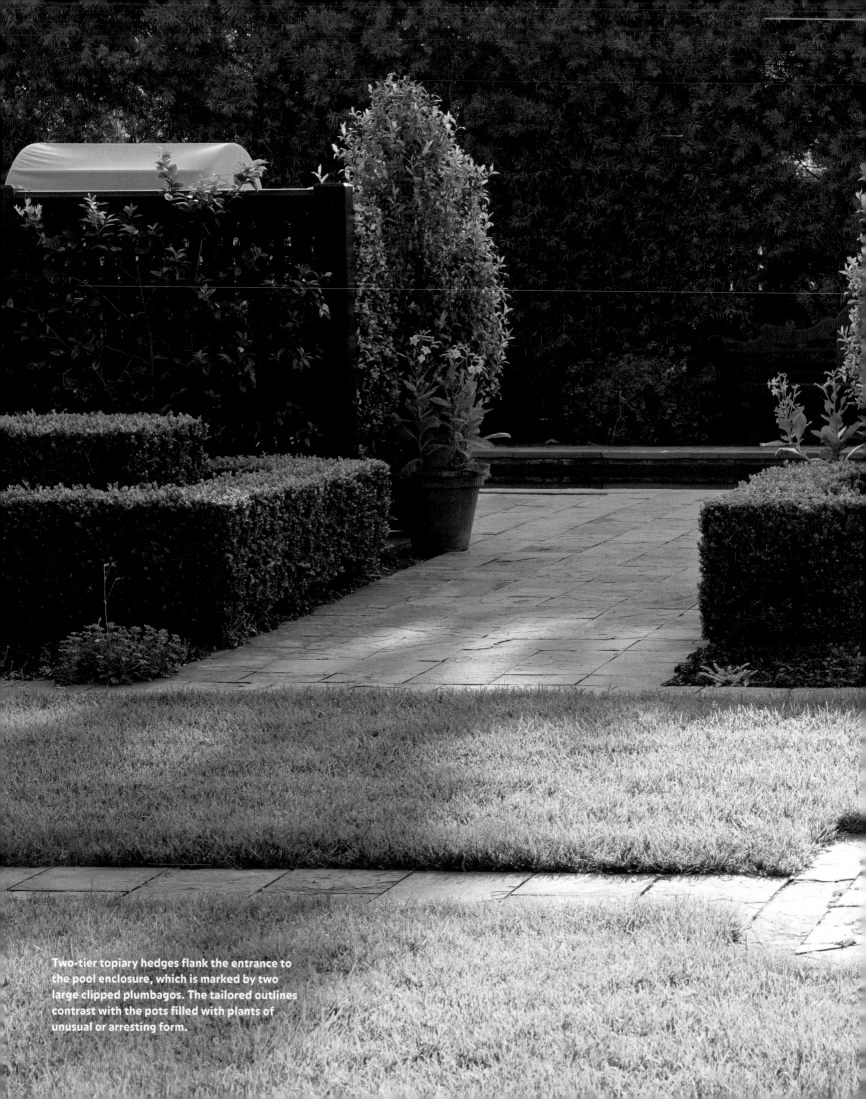

Two-tier topiary hedges flank the entrance to the pool enclosure, which is marked by two large clipped plumbagos. The tailored outlines contrast with the pots filled with plants of unusual or arresting form.